1990

The Eternal Moment

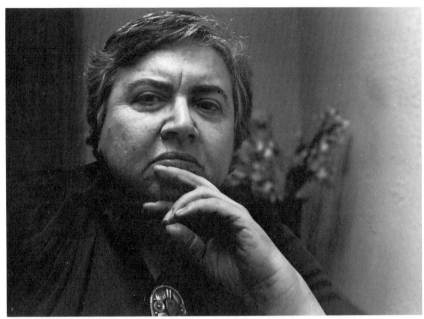

Anne Noggle. *Estelle Jussim*, 1985.

ESTELLE JUSSIM

The Eternal Moment

Essays on the Photographic Image

APERTURE

The paper used in this publication meets the minimum requirements of American
National Standard for Informational Sciences—Permanence of Paper for Printed
Library Materials, ANSI Z39.48-1984. ∞

Library of Congress Catalog number 88-82883
Hardcover ISBN 0-89381-360-5; Paperback ISBN 0-89381-361-3

The staff at Aperture for *The Eternal Moment* is Michael E. Hoffman, Executive
Director; Steve Dietz, Vice President, Editorial—Books; Lisa Rosset, Managing
Editor; Barbara Levine, Assistant Editor; Sarah Adams, Editorial Work-Scholar;
Stevan Baron, Vice President, Production. Book design by Wendy Byrne.
Series editor: Steve Dietz. Series design: Wendy Byrne.

Aperture Foundation, Inc., publishes a periodical, books, and portfolios of fine
photography to communicate with serious photographers and creative people
everywhere. A complete catalog is available upon request. Address: 20 East
23 Street, New York, NY 10010.

Acknowledgments

Among the many people who have inspired me, taught me, corrected me, helped me, I would like especially to thank the following individuals:

Margaret Ann Roth, publisher of *The Boston Review,* for her astute comments and her frequent invitations to contribute to her lively journal.

Dr. Heinz Henisch, editor of *History of Photography,* and his wife, Bridget Henisch, for their friendship, encouragement, and spirit-lifting good humor.

Dr. Elizabeth Lindquist-Cock, historian of art and photography at the Massachusetts College of Art, for her exceptional store of knowledge, for freely sharing ideas, and for making many productive suggestions. I owe her an enormous debt of gratitude.

Steve Dietz, editor and vice-president at Aperture, for his patience, tough-mindedness, and general good sense. We worked well together, and I look forward to working with him in the future.

Andrew Eskind, Linda Watkins and Terry Pitts for so many efforts on my behalf.

Since I prepare all my own manuscripts, I must add a note of thanks to my late parents, who insisted that I learn to type long ago when I was just out of college. I like to imagine that they can laugh about this and say, "I told you so!" in that special loving-annoying way that parents have. The fact that they were involved in photography during my childhood had obvious repercussions in later life.

Contents

BIO-HISTORY

Visual Communication

The Self-Reflexive Camera

WHETHER WE KNOW IT OR NOT, whether we like it or not, we have been attending the funeral rites of modernism for many decades, and it has been a bizarre wake: none of the joviality one might cherish, no wild celebration for the passing of a tyrannical regime, no whiskey (a glass of white wine, perhaps), no unrehearsed bawling, certainly no exultant memorializing (since modernism forbade retrospective yearnings), and an extraordinary amount of detritus underfoot (a shattered steel cube, a mangled form once used for pouring concrete, dangerous glass shards, and a tattered sign reading *Form Follows Func----*).

On hand and enjoying the proceedings are the unindicted co-conspirators who administered the death blows to modernism: Robert Venturi, clutching his *Complexity and Contradiction in Architecture* (1966), loudly admires the coffin's neoclassic décor, lit by neon; Andy Warhol, swathed in his painting of a *Campbell's Soup Can* (1964), assures everybody they can be famous for at least fifteen minutes; Joseph Kosuth sits resolutely on his *One and Three Chairs* (1965)—photograph of a chair, the chair itself, and a placard bearing the dictionary definition of "chair"; Donald Barthelme reads aloud from Jorge Luis Borges's *Labyrinths* (1962), intoning the sentence "To speak is to fall into tautology" over and over again; in a dark corner behind the potted palms, Bruce Nauman, accompanied by his hologram *Making Faces* (1969), covers his naked body with tiny television monitors in which you can see nothing but the ceiling and the back of your own head.

Never invited to join any rituals of the macho moderns, women artists and feminist critics have been forced to crash the party, Lynda Benglis dons a T-shirt emblazoned with an erect phallus, then thumbs her nose at Willem de Kooning and *Vogue*. Rosalind Krauss offers Lucy Lippard a Jacques Derrida sandwich stuffed with Roland Barthes, but Lippard prefers a Third World omelet. Now several women artists light a bonfire, into which they toss all known copies of Horst W. Janson's *History of Art,* which mentions not one woman artist (and not one photographer), bundles of *The Story of O,* and all issues of *Hustler.*

1. Matt Mullican. *The Bulletin Board*, 1982.

As the smoke rises, enthusiastic performance artists swarm over a field of television monitors that have been computer programmed to display endless variations of the following images: Josef Stalin's mustache, Hitler's bunker, the assassination of John F. Kennedy, buckets of Budweiser, Johnny Carson kissing a baboon baby, Walter Cronkite flirting with Gerald R. Ford, Joan Collins and Joan Rivers smacking each other with custard pies, sixteen thousand soap-opera couples fornicating, and many, many pictures of chocolate cookies, cakes, and pies, interspersed with comments like IMAGES TRIVIALIZE PAIN—REDEEM REALITY and POLITICS IS NOT CHOPPED LIVER. A cry goes up for free video cameras and MTV as we see pictures of the massacres of Cambodians, Afghan peasants, and Nicaraguan children.

Small wonder that photography finds itself in a state of crisis. Innocent photographers, whose education consisted of three assignments on the street, four assignments of correct lighting for shells, faces, and fruits, and five projects out on the Arizona desert using Ansel Adams's Zone System, might—understandably—fall into a dazed state approximating catatonia when faced with the contemporary chaos of images. Photographers in the postmodernist era are sore pressed to defend the very activity of image making. No longer trusted for its presumed objectivity and transparency, no longer the reliable guide to visual "truth," documentary photography has had its authority devastated by technologies like computer graphics (which can dismantle a photograph, remove some of its parts, and reconstitute it as if it were an original), and the mass media (which trivialize each event, hypnotize our children, and increase the likelihood of violence from terrorists and neighborhood punks).

Yet it never seems to occur to many photographers to ask themselves certain painful questions: Why photograph? What is left to photograph? What does a photograph convey? Is photography, in the words of Susan Sontag, cannibalizing experience? Are we any longer able to see the world except as reified image?

The contemporary photographer must ask what it means to have outlived modernism, which provided its adherents with a specific program, one that can be summed up in a paragraph by one of its earliest popularizers, Sheldon Cheney: "Art is an activity, inextricably bound up with life, but only incidentally concerned with the surface aspects of nature, with an emotional realm of its own, concerned with expression rather than representation, with creation rather than imitation, and characterized in each separate work by a particular and essential quality in the nature of expressive *form*. . . . The core of any absolute statement of modern art theory is the inclusion of the one word 'form.' "

Cheney's extensively reprinted *A Primer of Modern Art,* first published in 1924, is still an excellent introduction to the heroism and spirituality of the early abstractionists, whose goal was "an art of color as free from associative and objective interest" as the art of music. In words that still ring with glo-

rious dogmaticism and naive absolutism, Cheney stated, "Painting must be stripped of the trivial and extraneous elements that give rise to the pleasures typical of drama, anecdote, photography, etc."

For modernists (primarily of the New York–Paris connection), photography was too full of drama, anecdote, and illusionism to be tolerated. Photographers who wanted to be moderns—with all the excitement of rebellion and discovery that term conveyed—had to liberate their images from storytelling, from any taint of theater, and from any lingering dependence on Renaissance perspective. Thus developed the admirable, frequently majestic photographs of the modernists, works that are aesthetic abstractions in which the photographer has carefully established forms parallel to the picture plane, forms whose negative and positive spaces ricochet off the four boundaries of the rectangular field and only modestly invade three-dimensional space.

If modernism is lying in state in the funeral parlor of history, it is possible that we will be forced to consider the grand masters of photography—Alfred Stieglitz, Paul Strand, Edward Weston, Minor White, et al.—as "Members of the Family" and bid them a fond and sad farewell. For it is questionable today whether these highly respected creators, men who challenged the sentimental photography of the academies with cries of "Truth" and "Beauty," can remain influential in the era of the Anti-Aesthetic. Many younger photographers consider the work of these masters as both monuments to the formalist age and hopeless anachronisms, divinely beautiful but useless as models in our contemporary chaos.

What does a postmodernist photographer do? Rejecting aestheticism as irrelevant to the production of images are four considered to be postmodernists: Sherrie Levine, Cindy Sherman, Barbara Kruger, and Martha Rosler.

Levine, before turning recently to making watercolor copies of El Lissitzky paintings, would photograph a photograph by, say, Walker Evans, and sign her name to it. *Appropriation,* after all, is the key to postmodernism. If architects can appropriate Palladio, Alberti, and McKim-Mead-and-White, if Philip Johnson can mount the back of a Chippendale chair on top of a skyscraper, if post offices can sprout gothic revival towers, why should not a photographer appropriate the modern "masters" of photography? This is not simple plagiarism (despite rumors that the estate of Edward Weston has promised to sue Levine if ever again she signs her name to a copy of one of Weston's photographs).

To adapt Linda André's useful paradigm, from "The Politics of Postmodern Photography" (*Afterimage,* October 1985), to looking at a Sherrie Levine copy of a Walker Evans, we are to imagine the experiences of three different gallery-goers. The first viewer, unfamiliar with Walker Evans, assumes that Levine is a documentarian. The second viewer recognizes the image as a famous

one by Evans, and therefore notes that Levine's photograph is a copy, but is hazy about how to react. The third viewer, a sophisticate who has read Roland Barthes, instantly understands Levine's commentary on the strategy by which Walker Evans conventionalized and mythologized everyday scenes so that they can be considered "Truth." Thus Levine's appropriated images are to be considered coded messages, to be interpreted only by a knowledgeable audience.

This characteristic of postmodernism—addressing elites with special knowledge—assumes an entirely different purpose in the photographs of Cindy Sherman. We see Sherman herself posing as a terrified starlet in a 1950s *film noir* encounter with an always unseen villain (the personification of female terror), as a vapid lingerie model, as a screeching opera diva, or as other manifestations of the stereotypes of women. All of these impersonations embody male fantasies about women and are directed against men who would like to create permanent and humiliating identities for women. But the notion of using stereotypes for commentary presupposes that we all maintain a thesaurus of common meanings, an iconography of popular culture. Unfortunately, there can be no assurance that a general audience, male or female, will recall the origins of Sherman's recreations or, that recalling these, will provoke meaning beyond the fleeting pain or pleasure of recognition.

While the ambiguities inherent in her program have confused critics who see her as engaging in narcissistic posturing, it seems clear that Cindy Sherman is attempting to frame stereotypes within Roland Barthes's notion of the "mythology" of socially distributed images. Why, she asks, do men enjoy gazing at women who are being terrified by men? How do stereotypes evolve and become models of communicative behavior while being incorporated on an unconscious level by individuals? How do they change into new models, and what is the role of photography in accomplishing such change? Since Sherman's images are fundamentally antiaesthetic and antiformalist, she belongs in the vanguard of photographic postmodernism. Not only does she appropriate images (or styles of images) and recreate them, but she comments on their status within the ideological structures of specific societies. Ultimately, her goals are political.

In the work of Barbara Kruger, we find photographs as large as the posters in New York subway stations, with words sutured onto the body of the photograph, creating a new kind of politicized poster. The basic operation of imposing words onto images elicits a variety of reactions. One of her best-known "posters" contains the upside-down head of an attractive woman, facing us as if she were resting on grass. Her eyes are covered with two eye-shaped leaves. The words that slash into the picture, set in boldface modern typography, are *We won't play nature to your culture* (an attack on the stereotype of Man = Intellect and Art; Woman = Body and Fecundity). In another montage, the

scrambled fragments of what must have been the head of the Venus de Milo underlie the ferocity of *Your fictions become history*. On a nuclear mushroom cloud that fills the rectangle, we read *Your manias become science*. A group of men clasping, thumping, and pulling at another man, all the while grinning and laughing, are injected with *You construct intricate rituals which allow you to touch the skin of other men.*

In a brilliant essay about Kruger, ''The Medusa Effect, or the Spectacular Ruse,'' Craig Owens observed, ''Many artists today work within the regime of the stereotype, manipulating mass-cultural imagery so that hidden ideological agendas are exposed—or so it is supposed. But most of these artists treat the stereotype as something arbitrarily imposed upon the social field from without, and thus as something relatively easy to depose. Kruger, however, regards it as an integral part of social processes of incorporation, exclusion, incorporation and rule—that is, as a weapon, an instrument of power.'' Kruger is not attacking stereotypes for the purpose of raising consciousness in an intellectually or emotionally barren maneuver. She intends to stop us in our tracks, to make us reconsider, to force us to work at deciphering her messages.

Martha Rosler, by contrast, has no faith in either words or images as transmitters of messages. In her sequence, *The Bowery in Two Inadequate Descriptive Systems* (1974–75), Rosler alternates photographs of Bowery buildings and storefronts with pages of scattered typewritten words that are slang or vernacular equivalents to ''drunkenness.'' Unlike the captions in picture magazines, which are intended to clarify or ''name'' the contents of a picture (since no photograph names itself), these word clusters explain nothing in the picture and the picture explains nothing about the words. Rosler would have us recognize that neither symbol system adequately represents the reality about this borderline subculture of the Bowery. In addition, she is convinced that photographing the victims of a society exploits them; it is a collaboration with the system responsible for their condition, and a serious misinterpretation of what is real.

Along with many of her postmodernist colleagues, Rosler rejects photography as a reliable way of documenting reality. Strongly influenced by recent French theorists, she is an advocate of one of their fundamental propositions: since ''reality'' is always *represented* to us through symbol systems, it can never be known ''as it is.'' Representation can never deliver reality. It follows, then, that the supposed realism of reform-minded photographers like Dorothea Lange, Margaret Bourke-White, and the Walker Evans of *Let Us Now Praise Famous Men,* is a hoax. In talking about her Bowery work, Rosler comments, ''If impoverishment is a subject, it is more certainly the impoverishment of representational strategies tottering about alone than a mode of surviving. The photographs are powerless to *deal with* the reality that is totally comprehended-in-advance by ideology. . . .'' For Rosler, it is apparently in-

sufficient that the Farm Security Administration photographs of Great Depression victims of the dust bowl aroused the American public and Washington legislators to some recognition of the disasters overwhelming poverty-stricken families. Using victims as the propagandistic content of photographs reveals only the smallest fraction of what their lives encompass.

Extreme as Rosler's stance may seem, it calls into question aspects of documentary as a strategy for "truth" already under attack from many quarters. Given its history as the quintessential focus for arguments about theories of representation, photography has remained controversial. It is not only the purported realism of photography that is mistrusted, but art photography—which makes no pretense at representationalism—is also regarded with hostility by modernist, Marxist, and postmodernist critics alike.

For its ability to copy and reproduce, photography has been charged with removing the prized aura of original art objects. Worse: for its role in the numbing multiplication of images, it has been accused of robbing art—especially painting—of the idea of the authentic and unique. Demanding above all else originality and innovation, the embattled avant-garde of early modernism saw photography as an all-too-easy method of both capturing and duplicating images. Photography was therefore a distinct threat to the notion of the original genius who was expected to rise above politics, social concerns, and the "real world" itself in order to achieve eternal fame and metaphysical transcendence.

To outraged postmodernist critics, such lack of political commitment was not the only moral failing of modernist photography. In the 1970s, there was a stupefying inflation of the prices of all art. Even minor impressionist paintings were beyond the reach of all but the most wealthy. Still modest in price, photographic prints by the certified "great masters" of modernism (Stieglitz, Coburn, Charles Sheeler, Paul Strand) began to attract the attention of collectors. Suddenly legitimated by the marketplace, as well as by connoisseurs and critics, photography could no longer be denied a suitable niche in the text of art history. It was a photography whose status seemed determined by *Time* magazine, whose cover was finally awarded to Ansel Adams as the first—and still the only—photographer to be so honored. It was a photography well suited to late capitalism, where bourgeois tastes are flattered by museum exhibitions and arty magazines. It was a photography that did not seem as concerned with *what was represented* as with what would gratify an art market.

For Marxist critics like Lucy Lippard, the price inflation of photographs is not a sign of social utility but a symptom of the cooptation of a medium, once used to social advantage by the likes of Lewis Hine, into "commodity fetishism." To Lippard, photography has to serve the revolution, especially in the Third World. Also an ardent feminist, she declares that the vital contribution made by feminism to "the future of art" is precisely "its lack of contribution

to modernism." She sees the later stages of modernism as encompassing all those strategies of image making deriving from the ideal of the isolated protean creator (male) who is obsessed with competing in the marketplace and the academy, and who has no hesitation in accepting support from corporations. Modernism had not only rejected drama and anecdote in images (along with realistic photography), but, in Lippard's view, it also dismissed the rich heritage of women's "anonymous" works. During the 1970s she was instrumental in encouraging the emergence of women in performance arts, body arts, video, and artists' bookworks. Like Judy Chicago, she challenged the definitions of "high art," and insisted on elevating hitherto scorned women's productions like ceramics, weaving, embroidery, and activities like communal guerilla theater. In this she was not superficially encouraging artistic pluralism but rather rejecting the male politics of modernism. As she puts it in *Get the Message? A Decade of Art for Social Change* (1984), "The goal of feminism is to change *the character of art*." Such change, she asserts, requires a sense of community among artists, a commitment to political action, a rejection of self-referential art, and, of course, the abolition of exclusive privilege for males in museums, galleries, and the academy.

If Lippard argues for changing "the character of art," and therefore for a photography no longer aesthetic but revolutionary, it seems obvious that her concept of change does not challenge photography as a tool of propaganda. Photography can be trusted to relay messages. Sherrie Levine, Cindy Sherman, Barbara Kruger, and Martha Rosler do use photography for message making, but not naively. If persuasion and propaganda are their aims, they see photography as a coded system for cryptically attacking the methods and content of representation. But to attack representation *by means of* representation is a subtle and often difficult pursuit.

Martin Heidegger once called this "The Age of the World Picture." To him, "the fact that the world becomes a picture at all is what distinguishes the essence of the modern age." Nothing in the world, he contended, *exists any longer* except in and through representation, that is, in images. And this implies that there exists someone, a subject, who "believes that he is producing the world in producing its representation." Our understanding of the world, our relationship to that world, our relationship to each other and to ourselves, therefore, depends entirely on who is representing the world to us. Each maker of images believes that he or she will decide on what is to be pictured, and how "it" will be pictured. Each maker of pictures is the maker of a world.

The postmodernist rejects such privileged creation. The stereotypes attacked by Kruger, Sherman, and Rosler are the products of image makers who demand the imposition of their exclusive "world picture" on the realities of others. Representation is not merely the imitation of nature, but includes *who and*

what are being represented, and by whom, for what purposes (conscious or unconscious), and with what effect on which viewers.

This formula was articulated long ago by Harold Lasswell, decades before artists began worrying about the impact of representation—representation being communication, after all. Lasswell was concerned with politics and the study of public opinion; he rejected monolithic political representations of the world.

Totalitarianism consists precisely in the rigid imposition of a single world picture, and it is no wonder that totalitarian states so carefully monitor and control all forms of *representation*. Lasswell's notion of political pluralism serves to challenge as well the absolutist dogmas of modernism concerning the universality of art, the worship of abstract ideas, and the liberation of the working classes through science and utopian design (of which the Bauhaus was the perfect model).

When Lasswell created his formula for the study of communicative events back in the 1940s, he included among the who, the what, the where, and the purposes and effects, the idea of the *how*. While he may have been pointing toward the investigation of each medium as medium (a pet project of modernism, by the way), the *how* involves the content as well as the form of representation. It has us question in what substantive ways human beings and social relations are represented. For example, if photographers consistently depict women as the passive object of the masculine gaze of sexual desire, then women will believe that they are expected to turn themselves into objects. (In extreme cases, as in the fashion pictures of Helmut Newton, they are also expected to be terrorized, brutalized, and enslaved in chic sadomasochistic poses.) If photographers consistently depict young men as lovers of violence, then war will seem inevitable, even natural. While the war photographers, by and large, do not glorify the sufferings of soldiers and civilian populations, they are hardly a sufficient counterfoil to a movie like *Rambo,* which represents brutality as an ideal. If the constant, ubiquitous, unavoidable content of images is that of conspicuous consumption, motivated by the creation of envy (''Crystal'' perfume, ''Carrington'' men's cologne, as if the characters in *Dynasty* were both real and admirable *people*), how can individuals become cooperative and compassionate?

Not everyone sees postmodernism as the healthy antithesis to modernism, no matter how needed were the attacks on representation. At least one critic, Charles Newman, in *The Post-Modern Aura* (1985), sees postmodernism as ''an uneasy amalgam of high modernism and popular culture.'' Mocking modernism's high seriousness and its emphasis on art as a sanctuary ''when the evidence suggests that it can be clearly a maze, a prison, a battlefield, a gladiola, or anything else one wants to make of it,'' Newman observes that postmodernists punctured the pretentiousness of modernism. Postmodernism does,

indeed, amalgamate aspects of modernism with popular culture, but only to use a few strategies of assemblage or collage to invite a political attack on representation or to create multiple images that ''read'' like sentences. Unlike some modernists, who believed that the art object was an independent totality unto itself, the postmodernist demands the intellectual participation of the audience. The postmodernist working with photography insists the image is completed only in the viewer's mind, and the strategy is to force the viewer away from aesthetic contemplation toward an understanding, or at least an awareness, of a message.

Photographers who have abandoned the photographic modernists' insistence on ''straight photography'' (the unmanipulated print), combining words with pictures, painting on prints, or fabricating situations and objects to be photographed, are not necessarily postmodernists. To certify as a postmodernist, a photographer must also challenge the photograph as a reliable, or even rational, system of representation, and deny its aesthetic intent.

Aestheticism had long ago been challenged by the style called realism in painting, which was born simultaneously with the medium of photography around 1840. Some say they both came from the same parents: secularism, the rejection of aesthetic hierarchies of subject matter (including, for example, the insistence that George Washington had to be represented as a Roman senator in a toga), empiricism, scientism, and the impulse to mechanize all forms of work. To one of its inventors, William Henry Fox Talbot, photography was simply mechanized drawing. Realism was counter to ''Beauty,'' and the argument between art for art's sake and art for society's sake raged all through the nineteenth century.

The antithesis of realism was modernism, which came not only out of the mysteries of new scientific theories but out of a simultaneous longing for a metaphysics of transcendence, out of the need to counterbalance the irritating little facts assembled by Auguste Comte and the gross materialism of the greedy industrialists. Postmodernists scorn modernism as our last great romance with idealism—if you discount the increasingly wobbly romance with undiluted Marxism—and yet there is the possibility that the first phases of modernism, which lasted until the 1930s, died because idealism itself died. (How could idealism survive the Holocaust, Hiroshima, or the suspicions of the cold war?) Later phases of modernism (including action painting, abstract expressionism, and the glass-curtained monolithic edifice) did not die natural deaths: they were killed off by a revolution, still in progress, against their rigid dogmas, their macho biases, and their tightly controlled academicism.

Photography, despite its seemingly intrinsic bias toward realistic representation, had imitated the modernists, attempting both idealism and transcendence through a pursuit of abstraction. So much abstraction was produced in all the visual media that the world seemed emptied of people, trees, rocks, and emo-

tional realities. Simply photographing the external world did not prove sufficient antidote. Photography, then, had to be brought to a recognition of its affiliation with other languages. If photographers today are uncertain about the content, meaning, value, and impact of their images, they are not alone. This is the postmodern condition. Either photographers will examine the complex implications of the act of representation or they will continue to believe that representations—and the act of making representations—are beyond politics and innocent of perpetuating social stereotypes or serving entrenched financial interests. There can be no question that it takes a serious effort of distancing oneself from the immediate appeal of an image to discover its context and what implicit messages are being conveyed simply through its existence.

To accept what Roland Barthes called ''The Rhetoric of Images'' is to submit to uncertainty, for if modernism lies dead, then formalist aesthetics, as a method of judging or responding to images, is also about to be buried. Unfortunately, like all passionately committed movements, postmodernism may be in danger of becoming a new, intolerant academy, rejecting all other approaches to the production of images. Yet, we must grant postmodernism its own heroic status: it has forced us to pluck ourselves out of a dream world of acquiescence and into a recognition of what images do to us.

The Boston Review, April 1986.

The Royal Road to Drawing
FOX TALBOT AND THE INVENTION OF PHOTOGRAPHY

OF ALL THE CONJECTURES about the origins of picture making, none is so simple as the suggestion that we began by tracing the silhouettes of our shadows as the sun cast them on rock walls or bare ground. In that sense, we have always recognized that the sun makes its own pictures. But the idea of causing nature to impress its forms permanently on surfaces by capturing the sun's reflected rays in small boxes has made rather slow progress from Aristotelian physics to the chemical magic of the late eighteenth century. And of the four inventors—Nicéphore Niépce, Louis Jacques Mandé Daguerre, Hippolyte Bayard, and Sir William Henry Fox Talbot—credited with the first successful solutions to the problem of making permanent images, it is Talbot who is considered the "Father of Modern Photography" and the only philosophical genius among the gaggle of inventors who followed him.

That he was born in the first year of the nineteenth century had a prophetic charm, for his monumental contributions to the revolution in visual communication were closely tied to nineteenth-century obsessions with scientific truths, romantic metaphysics, and the mechanization of all human crafts, from spinning and sewing to computing and image making. A typical English eccentric, a gentleman of both substance and means, an established mathematician and Assyriologist, he was a chubby-faced recording angel who was so involved in myriad projects that he actually had to make a note in his diary so that he would not forget the idea of photography. Across the Channel, meanwhile, a much more monomaniacal artist, Louis Daguerre, whose illusionistic dioramas were the rage of Paris, was pursuing the chemistry of sun-pictures with ferocious zeal. It is this antithesis between the artist Daguerre and the scientist Talbot that creates so many paradoxes in the early history of photograpy.

Although in *Fox Talbot and the Invention of Photography,* Gail Buckland provides an exceptionally detailed and useful view of the ensuing struggle for primacy of invention between these two giants, she neglects some of the most fascinating implications of the Talbot-Daguerre controversy. For the paradox is that Daguerre, the *trompe l'oeil* artist whose announcements electrified the scientific community as well as the public, never attempted the ideal of "art"

with his daguerreotypes, while Talbot, who could hardly draw a simple tree
without the aid of a sketching instrument called the camera lucida, was the
first master artist of photography. The resulting confusion about photography
as chemistry and technique on the one hand and as concept and expression on
the other, has haunted us to this day. Daguerre conceived of photography as a
chemical adjunct to illusionism; Talbot wanted to to bypass his clumsy fingers
and mechanically record the picturesque scene before him, simply to document
a charming image. What is not often recognized is that ''the charm of the im-
age'' was a concept and, in Talbot's case, a subjective response to early Vic-
torian cultural conditioning about the picturesque and the sublime, about God
in nature, and about the transitory character of perception.

Talbot's story is oft-repeated, but demands its own moment—for it was
nothing short of momentous. Aged thirty-three, and on his honeymoon, no
less, sketching on the romantic shores of Italy's Lake Como, William Henry
Fox Talbot struggled irritably with various drawing aids like the camera lucida
and the camera obscura, and wondered if there might not be some way for am-
ateurs like himself to be spared such failures. If only there were a way ''to
cause these natural images to imprint themselves durably, and remain fixed
upon the paper!'' There and then, the idea of photography came to him, and
for this idea to cohere, he had first to conceptualize what a picture was in its
ultimate nature. Buckland delightfully supplies us with the essence of his
thought: ''The picture, divested of the ideas which accompany it, and consid-
ered only in its ultimate nature, is but a succession or variety of stronger lights
thrown upon one part of the paper and of deeper shadows on another. Now
Light, where it exists, can exert an action, and, in certain circumstances, does
exert one sufficient to cause changes in material bodies. Suppose, then, such
an action could be exerted on the paper, and suppose the paper could be visi-
bly changed by it. In that case surely some effect must result having a general
resemblance to the cause which produced it. . . .''

With such seemingly straightforward logic did the subsequent history of
photographic experimentation proceed. But what remains the most difficult
problem in art criticism is the very first part of his statement, where Talbot
airily divests the picture of the ideas that accompany it. And here is where the
idea of the purely mechanical nature of photography originates, even if it is a
typical scientific and logical ploy to isolate one factor of a situation in order to
study it. Eventually, that factor must be considered in its gestalt, and the ges-
talt of picture making encompasses not only the mechanical means of its pro-
duction but the ideational processes accompanying it both in production and
interpretation. Thus we soon find Talbot unable to differentiate between pro-
ducing a document of nature and selecting an approach, a viewpoint, an atti-
tude toward both nature and his document of it.

Sometimes he made the mistake of thinking that the camera would liberate everyone from the need for talent, that pictorial dolts could be transformed through the camera into individuals capable of conveying "picturesque imaginings." While no one can deny the many pleasures of the vernacular photograph, Talbot was fantasizing more about "art" in the high art sense, as witness his advertisement for his *The Pencil of Nature,* the first major work illustrated by mounted photographic prints: "It has been often said, and has passed into a proverb, that there is no Royal Road to Learning of any kind. However true this may be in other matters, the present work unquestionably demonstrates the existence of a *royal road to drawing,* presenting little or no difficulty. Ere long it will be in all probability frequented by numbers who, without ever having made a pencil-sketch in their lives, will find themselves enabled to enter the field of competition with Artists of reputation, and perhaps not infrequently to excel them in the truth and fidelity of their delineations, and even in their pictorial effect; since the photographic process when well executed gives effects of light and shade which have been compared to Rembrandt himself.''

We have here the extreme statement of the equation of the visual arts with the verisimilitude that Baudelaire so vehemently decried. Although even Talbot manages to distinguish between "truth and fidelity" and "pictorial effect," the distinction is only temporary. We soon find him lapsing into statements that reveal a wonderfully naive prejudice toward the straight document: "The instrument chronicles whatever it sees, and certainly would delineate a chimney-pot or a chimney-sweeper with the same impartiality as it would the Apollo of Belvedere.'' A sophisticated modern like Garry Winogrand would take this statement to imply that photography is generous, that it gives us all the camera sees that we cannot see, and impartially. With the amazed wonder of the discoverer, Talbot himself remarks on this generosity of detail; he is looking at photographs for the first time that anyone has looked at them, and his delight and awe have been misinterpreted to imply that only what the camera discovers matters, and that photography is not a conceptual art but a simple process of selecting a bit of nature.

Buckland herself reveals a confusion about photography as art and photography as document. She remarks, "There is one photograph in *The Pencil of Nature* that excels all the others, is unquestionably a work of art, and has been copied and reproduced many times. *The Haystack* is an imaginative and bold image. Its strong geometric shapes and chiaroscuro arouse emotion and interest. . . .'' The implication here is that only design makes a photograph a "work of art," and she even hauls in Stieglitz's *The Steerage* to support her argument. But Talbot's madly surreal picture *Horatia at the Harp* or the equally bizarre *Lady Elisabeth on Chaise Longue* are far more interesting pictures.

Buckland's use of the phrase "unquestionably a work of art" directly contradicts the prevalent notion that the art of photography derives from our sense of the uniqueness of the medium itself.

Fox Talbot and the Invention of Photography is a book rich in pictorial documentation not only of Talbot's work but of the work of intimates usually confounded with him. The book's astonishing array of color illustrations should put to rest, once and for all, the notion that pure photography has always been "black and white." It has been golden, pink, purple, mauve, lavender, red, yellow, and sepia. While the volume's reproductions could have been a bit better here and there, the overall impression is that of a volume well designed and of major significance to any library of the history of photography. Buckland has given us a lively introduction to the complexity of Talbot; her interpretation, however, may be somewhat less persuasive than her excellent selections from Talbot's diaries and correspondence.

I want to return now to Talbot's most famous statement, about chimney-pots and the Apollo of Belvedere. Talbot seemed to be saying that the camera is impartial; what he really means is that the mechanics of photography can be turned to any subject successfully if we judge that success only by transcription from nature. His statement would seem to lead to an art of realism, an art that, like so much of nineteenth-century painting, records with equal fidelity the wretched street beggar and the demigoddesses of the academy. When we consider Talbot's astonishing range of pictures, and encounter his naively poetical sense of wonder at the infinite variety of nature, we should perhaps recall the symbolism of Apollo. Both sun god and god of poetry, he encompasses within his personae both the capacity for brilliantly lighting the documentarian's world of fact and for arousing the darker fantasies of imagination. Perhaps the documentarian and the poet are both aspects of one creative impulse: an ancient, deeply human, almost primitive need to make marks, to draw our shadows on the rock walls.

Sir Herbert Read once postulated that picture making derives from a need for cognition through the senses. His belief was that humankind could study and think about the visible world only by attempting to stop time long enough to permit the contemplation of images. The photographer-theorist Nathan Lyons and the photographer–art historian Carl Chiarenza strongly support this hypothesis. We may be able to solve the dilemma of "photography as art" or "photography as fact" only when we have abandoned outmoded paradigms of both knowledge and art.

The New Boston Review, May-June 1981.

The Syntax of Reality
PHOTOGRAPHY'S TRANSFORMATION OF
NINETEENTH-CENTURY WOOD ENGRAVING
INTO AN ART OF ILLUSIONISM

AS THE RECENT NEW YORK GROLIER CLUB exhibition on the nine-teenth-century photographic book confirmed, it was through the printed book that photography made one of its greatest impacts on the visual responses of the public. Whether we think of the mounted albumen prints of Maxime Du Camp, the Rejlander heliotypes for Darwin's *The Expression of Emotion,* or all the superb Emerson photogravures of the English marshes, the fact is ines-capable that the printed narrative was, and is, a major transmitter of the photo-graphic image.

Paradoxically, although photography was itself the miraculous reproducer of so much of the nineteenth-century world, it could not easily reproduce itself in a technology that had to be print-compatible. The problem was apparent from the very beginnings of photography.

It is not difficult to imagine the look of genuine consternation on the face of Henry Fox Talbot when he discovered, sometime in the late 1840s, that all the labor of gluing, steam-ironing, and mounting his calotypes into the fascicles of *The Pencil of Nature* had gone for nought. While the printer's ink words of his text were as brilliantly legible, as permanent as printer's ink had always been, the pictures themselves were fading away. ''Fading Away'' was, of course, the title of Henry Peach Robinson's most famous photographic tableau, and the two Henrys had more in common than one might suspect. They were con-fronted with the same problem: the noncommunicability of photographs in *printed* form. Despite Talbot's ensuing search for some reliable means of en-coding the syntax of photography into a typography-and-printer's-ink-compati-ble medium, despite his tentative solutions—and generous awards promised by the Duc de Lynes in 1856 to encourage both the development of permanent photographs and of print-compatible photographic technologies—when Robin-son came to publish *Pictorial Effect in Photography* in 1869, he had to content himself with a number of rather ironic compromises.

He could mount charming small albumen prints on separate pages inserted into the binding, but when he wanted to talk about landscape composition *within the body of the text,* he could not use his own photographs. When he

2. Elbridge Kingsley, his wife and friends, with camera, 1882.

wanted to discuss paintings by Turner that might provide models for his read-
ers to emulate, he was forced to rely upon grotesquely inadequate wood en-
gravings, about which he made unconsciously ludicrous assertions concerning
their fidelity to the originals. Perhaps the saddest admission of the technologi-
cal absurdities came in his observation: "As an example of the possibilities of
success when the figure and landscape are nearly equal in interest, I have
etched a beautiful little picture by Mr. Slingsby, of Lincoln, entitled 'Rest'
. . . . The delicacy and beauty of the photograph are lost in the etching, but it
will recall the original to the memory of many who saw it and admired it."[1]

This statement represents the crux of the problem. What, exactly, does "re-
calling to the memory" imply? In the typical mid-nineteenth-century art book,
as Williams Ivins observed, this simply meant supplying a kind of "map" of a
painting. The contour of its forms, emptied of all color, texture, chiaroscuro,
atmospheric and volumetric perspective, was expected to suffice as information
presumably because all that the public expected to appreciate was "a subject."
Precisely those essential characteristics required for an illusion of reality that
James J. Gibson categorized in his *Perception of the Visual World*—namely,
texture gradients, undulations of contour and form, chiaroscuro, and color—
were largely absent from the work of the European reproductive wood engrav-
ers. They had evolved a simplified decorative outline method for conveying
what they believed was the essence of a painter's *content,* and for the occa-
sional harder contours of paintings this could perhaps suffice.

In America, meanwhile, wood engravers were chopping out methodically
hatched "maps" of nature scenes, with the intention descriptive, not illulsion-
istic. The situation in 1872 is typified by the wood engravings produced for
the monumental two-volume work *Picturesque America* and the heliotypes for
landscape and travel volumes like Wilson Flagg's *Woods and Byways of New
England*.[2] Not only was the early heliotype unable to compete visually with
the crisp outlines of the wood engraving, but its delicate collotype process was
expensive and incompatible with typography. Each heliotype had to be pro-
cessed twice, once for the highlights and once for the shadows, then separately
inserted into the binding of a book. The wood engraving, on the other hand,
could cheerfully withstand thousands of impressions, be locked into the forms
with metal type, and transmit a permanent durable picture on fairly cheap pa-
per. By 1872, the decorative conventions of wood engravings were largely de-
pendent on a code established by the English wood engraver, Linton, whose
reproductions of Turner paintings had appeared in Henry Peach Robinson's
book.

William J. Linton emigrated to America in 1866 to take charge of Frank
Leslie's illustrated journals. When he arrived, wood engravers were working
much as they had for centuries. An artist sketched a design on the block in In-

3. Henry Peach Robinson. *Rest*, 1869, etching from photograph.

dia ink washes, pen, or pencil. If his lines did not conform to established
standards, it was up to the engraver to supply them. Linton, who quickly be-
came the dean of American wood engraving, revitalized the industry by reviv-
ingsome of the white-line practices of Thomas Bewick, drawing with the
graver. It soon became evident that Linton believed rather vigorously that the
wood engraver was far more important than the designer, that "cutting a line"
was a distinctive art, and that each area of an engraving deserved an appropri-
ate and strictly standardized treatment. In other words, it was *his* work that
was to be admired as the true art, not that of, for example, the artist Thomas
Moran, whose illustrations Linton cut for Longfellow's *Hanging of the Crane*
in 1875. As his colleague, John P. Davis, remarked in 1880, "A few years
ago, it was thought that beyond certain formal limits the engraver could not
venture. A certain kind of line, it was held, should represent ground; another
to represent foliage; another to represent sky, another flesh. . . ."[3] The true
art of the engraver, for Linton, lay in his work's crisp printability, a certain
decorativeness of effect, and the rigor of the line utilized.

Unfortunately, under his widespread influence, everything came to look predictably alike. What might be called the "Lintonesque syntax" of the 1870s had only two advantages over other graphic processes: it could be printed easily in a magazine or book, and it could be jobbed out to any commercial hack. One followed the prescribed codes for palm trees and milkmaids' faces, and a reliable ideogram could be produced in a hurry.

The beginning of a major revolution in the goals and techniques of American wood engraving was established in what should be recognized as a landmark volume of *Scribner's Monthly* for the year 1878. What happened was that a group of wood engravers almost simultaneously decided to abandon the formal prescriptions of the Linton school and to concentrate on what was an utterly daring proposition: that it was important not simply to relay the *content* of a visual image, but the manner in which it was created.

There is universal agreement among all the members of what came to be known as "The New School of Engraving" that it was photography which accomplished this revolution, specifically, by transferring artists' designs directly to the block by photographic means. The process of photography-on-the-block had been available since the late 1850s, but for a variety of reasons it was not universally adopted until the late 1870s.

Before wood engravers could even begin to pursue the specific characteristics of pictorial images in their reproductions, there had to come the observed need to develop appropriate techniques, the technical advances to make such renderings possible, and the ideological posture that could break with tradition. Photography provided the motivation, the technological advance, and the ideological potential, for if it could reproduce on the wood block pictures of any size and of any technique, the illustrator was freed from the necessity of producing standardized lines in his original drawings, and he could begin to work in larger sizes, different media, and different combinations. The engravers then began to render not only the "subject" of pictures, but the specific texture and coloristic characteristics of art objects. For twentieth-century sophisticates such as we are, the revolutionary aspect of this step can only with difficulty be apprehended. But even as late as 1916, A. V. S. Anthony, an old-timer who had worked with Linton back in the 1870s, was still fulminating about it. "Just what has engraving to do with brush marks? Why not reproduce the threads of the canvas? Did any intelligent man ever buy a painting on account of the manner in which the brush strokes forced themselves upon him? Are not such things incidental, and not of positive importance?"[4]

In 1878, when Linton saw the edition of *Scribner's* containing Timothy Cole's meticulous and illusionistic rendering of the specific characteristics of a crayon portrait by Wyatt Eaton, he almost had apoplexy. Raging in an article in the *Atlantic Monthly,* he vowed that any engraver who stooped so low as to imitate the texture of a crayon drawing had absolutely lost his reason. He at-

tacked Cole and the New School as madmen. The task of the engraver was to be a sublime translator! The goal of the engraver was to make beautiful lines! But American wood engravers were no longer listening. Photography-on-the-block had suddenly made it possible to transcribe textures of any sort of original, and the challenge would have to be met.

In that same 1878 issue of *Scribner's,* photography transferred a pen-and-ink Wyatt Eaton portrait to the block for Timothy Cole's bravura facsimile, a reproduction that aroused so much public curiosity that the editors felt called upon to explain its technique. This time, however, Cole's labors made less sense, as photographic technologies had already discovered a means for producing relief printing blocks from originals drawn in pure black and white.

What photography still could not reproduce for relief printing purposes was itself and its own syntactical codes for transcribing reality. Timothy Cole and his colleagues became adept at transcribing photographic portraits via photography-on-the-block, but it was by no means an easy method. For other media and other types of subjects, it was more complex. As John Tinkey observed at an 1880 "Symposium on Wood-Engraving" in which the New School adherents set forth their principles, the silver film on the block discolored it. Few photographs on the block had the knack of capturing details effectively, and he pleaded, "It would be advantageous for the engraver . . . if the artist refrained from using yellows, browns, reds, and blues—colors which the photograph does not reproduce."[5] If photography could not "reproduce" these essential colors (even in transcriptions to black and white), of what use could it be in transferring to the block the work of the Barbizon painters, for example, who were just then enjoying considerable public enthusiasm?

Obviously, the problems that the Barbizon painters presented to the wood engraver were, to put it mildly, substantial. As the critic Sylvester Koehler observed, "wood-engraving must adjust itself to the character of contemporary art."[6] That contemporary art, that new movement of the 1870s in America, was under the influence of France, of the "reign of technique and color" when the "how, rather than the what" had come to dominate. Thus the wood engravers were not only confronted with the diffuse forms and intense light of the colorists, but with the shadows cast by their impasto strokes, and by the tremendous compression of scale that photography-on-the-block could produce. To take a painting measuring perhaps two feet by four feet and reduce it to a block measuring no more than six inches wide was certainly to threaten the work with the complete extinction of significant detail and texture. To transcribe Barbizon—and, later, Impressionist—color into black and white terms seemed impossible, yet the 1880 Timothy Cole transcription of Millet's *The Sower* indicates that the men of the New School of Engraving were equal to the task. These men were influenced not only by photography-on-the-block but by the ideology of the Barbizon painters as well. Fidelity to nature, a devotion

3. Thomas Moran landscape from Longfellow's *The Hanging of the Crane*, 1875, engraved by W. J. Linton.

to plein air painting, combined with the opportunities of photography, all contributed to the evolution of a moment of *painter–wood engravers* whose development is fortunately epitomized in the career of one man.

THE CAREER OF ELBRIDGE KINGSLEY It is not difficult to imagine the Barbizon painters out in the Forest of Fontainebleau, nor to imagine Peter Henry Emerson photographing the marshes of East Anglia, but it may be somewhat more difficult to imagine a *wood engraver* sitting out in the Pioneer Valley of Massachusetts working directly from nature and succeeding so well that he was, however briefly, equated with the greatest of the Barbizons. "The masters who can interpret her—who can give a broadly human rendering of a rock, a hillside, or a piece of ploughed earth—men like Millet, Corot, Inness and Elbridge Kingsley—are few in any generation."[7]

Kingsley is one of the forgotten and neglected artist-engravers of the last century. However neglected, his career provides a fascinating insight into the transformation of the ancient art of wood engraving into a plein air art of illusionism, with photography and photographic processes as the prime movers in the transformation. With Kingsley, we can follow the final impact of photography-on-the-block, the problems that nineteenth-century wood engravers encountered in their direct competition with phototechnology, the presence of photography itself within the art and vision of wood engraving, the establishment of a school of painter–wood engraving based directly upon photographic codes, and the ultimate displacement of all their wood engraving achievements by a very ordinary kind of photographic technology.

137,189

Kingsley was born in 1842 and lived most of his life in the Connecticut River valley of western Massachusetts and in New York City. After studying drawing at Cooper Union before the Civil War, he went to work for one of the major New York commercial engraving houses, J. W. Orr, where Mr. Linton's work was much admired. *Gate of Cemetery,* an early Kingsley effort, reveals the characteristic Lintonesque syntax of the early 1870s. After the war, he returned to his native Hadley and went into the printing, engraving, and lithography business in Northampton, where he had the advantage of studying further with J. Wells Champney, the first art teacher at Smith College. The business panic of 1873–75 put that endeavor to a quick end, and back to the engraving shops of New York he went in 1876. But this time he encountered the beginnings of photography-on-the-block and the whole new point of view represented by Frederick Juengling and Timothy Cole. While Kingsley was by no means the founder of the New School of Engraving, he became one of its most unconventional innovators and, later in the 1880s, its champion and exemplar beyond all others.

Learning quickly from the achievements of Cole and John P. Davis, he soon took his place with them as an interpreter of their new interests. By 1880, he had mastered two techniques: transcribing photography itself, and gouache, both transferred photographically to the wood block. In another landmark publication, the volume of *Century Magazine* for 1882, Kingsley and his colleagues collaborated on many projects in which it was apparent that the New School was intent on rendering the brilliance and texture of original works, whether drawn for illustration or as independent paintings. Kingsley excelled in the evanescent atmosphere of the paintings of George Inness, which were reproduced in that issue, and he wrote of his problems with this painter's work: "The eccentric methods of the greatest of the landscape painters, and the poetic impulses of a colorist who had no law but the mood of the moment. All this to tie to for a black-and-white interpretation! Surely the old engravers had cause for antagonism; the cause would defeat itself in attacking such impossible problems. . . ."[8]

They may have been impossible problems, but Kingsley and Cole tackled them with gusto, all in the spirit of what was still a revoluntionary idea: to capture exactly what an artist had painted, to create the illusion that what the viewer was seeing was as close a sensation of the original work as could be conveyed. For Kingsley's work on Inness during the 1880s, the critics had nothing but eulogies. Concerning Inness's *Morning* engraved in 1885, the critic William Laffan wrote, "There is extraordinary truth and wonderfully intelligent fidelity—It is not an engraving, a technical exploit; it is the very life and essence of Inness's picture."[9]

Perhaps the major reason that Kingsley could achieve such sympathetic translations of Inness's work was that he had already begun to pursue his own

5. Elbridge Kingsley. *Gate of Cemetery,* ca. 1870, wood engraving.

Barbizon-inspired productions. *A Meadow Brook,* his very first engraving directly from nature, was produced in 1882. That, and his first published engraving from nature, *New England Forest,* were a far cry from the syntax of Linton's 1875 rendering of Thomas Moran. Only seven years had intervened, yet photography, the Barbizon influence, and Kingsley's extraordinarily patient detail had completely transformed the practice of wood engraving. For *New England Forest,* in 1882, the critic Philip Gilbert Hamerton sent Kingsley a letter of highest praise.

Kingsley was a devotee of Hamerton, and it would seem from his *A Meadow Brook* that he was following Hamerton's vehement admonition: "The artist who would truly *see* Nature must look at her works with the eyes that she has given him, and not see her at second-hand by the intervention of a glass lens and a mahogany camera."[10] Fortunately, Hamerton had also urged the taking of photographs as mementos from nature for study purposes. There stands Kingsley with his very own camera, perhaps the one he bought in 1880: "During the winter months I made some experiments with photography. There was a retired professional at my boarding house who helped me to a cheap outfit. He said it would be useful in getting quick detail, also I could reduce a large picture to the size of a block and know beforehand the effect on the engraving."[11]

Earlier, during 1878–79, he observed in his diary that he had been reading Hamerton's *A Painter's Camp* and was "attracted by the novel idea of an outfit for work in the woods."[12] He and his brother built a cart in 1879, and by 1881, Kingsley noted that they had converted it into a traveling photographic

6. Elbridge Kingsley. *New England Forest,*
1882, wood engraving.

darkroom and workshop. The cart itself became the symbol of the New
School's revolutionary ambitions, and Kingsley's colleagues often joined him
to work directly from nature, with, of course, the camera always present to act
as an intermediary between the picturesque vista and the obdurate block. In
any event, the cart was ready in 1882, and Kingsley, perhaps by more than
mere coincidence, wrote, "I put down the date of 1882 as the beginning of
special work for myself, the beginning of our Society, and the beginning of
the use of the Japan paper for our artistic proofs."[13]

"Japan paper," like photography-on-the-block, was another technological
necessity for the complete liberation of the wood engraver from the past. It
made possible the production of blocks of extremely fine textures, and its deli-
cacy seemed to make more acceptable the idea that the wood engraving could
be purchased on its own as an "art print."

Having made a sensation with his first originals from nature, Kingsley was
commissioned to illustrate the volume of Whittier's *Poems of Nature* of 1886.
His *November* from that book received especially favorable critical attention,
as did the unexpectedly fine textures of *Evening by the Lakeside*. The technical
exploit becomes even more remarkable in Hamerton's view to the effect that
boxwood was a singularly intractable material, that working it with a graver

was the opposite of spontaneous, autographic activity, and that it seemed an inappropriate art to pursue in the rough fields of New England.

Alas for Kingsley and all the fine revolutionaries of the New School of Engraving! For while they had been busily perfecting their craft, a Philadelphia engraver named Frederic Ives had been just as busy perfecting the photographic technology that would put them all out of business: the relief photo-engraving, type-compatible and, compared with the exquisite labors of Kingsley, cheap and fast. Using a screen in the manner suggested earlier by Henry Fox Talbot, Ives broke up the continuous halftones of originals in any medium and transformed them into relief dots of different sizes and of the same intensity that could print with type using permanent printer's ink. Miraculous as this 1885 process engraving was, wood engravers, artists, critics, and the public alike complained that the halftone screen was like a steam roller, uniformly squashing down the brilliance and texture and detail that the New School had achieved in wood engraving.

Not only was photography learning how to reproduce itself, but it was literally entering the picture. Most conspicuously in the works of the natural historian and illustrator William Hamilton Gibson, photographs became the physical basis for pictures in mixed media, with the photographic syntax left untouched in large areas of the finished work.

It is perhaps as Marshall McLuhan has suggested, that the greatest flourishing of any art occurs just before it passes away. In August of 1889, *Century Magazine* published a series under the rubric, ''Wood-Engravers in Camp,'' which featured Kingsley's *A Winter Idyll* and John P. Davis's *Autumn Hillside,* both originals from nature via the camera. Intermixed with sentimental anecdotes about Kingsley and his famous cart were vigorous attacks on the new threat of photomechanical engraving. After laboring to invent an exceptional variety of textures to imitate the realities of nature, it is understandable that Kingsley would remark:

> Many artists may justly feel that they are better reproduced by mechanical means than by engraving. This may be true if they can make the textures entirely themselves; if not, they are dependent on a monotonous texture that is entirely mechanical, thus antagonizing one of the most important principles of their daily teaching and practice—that is, that ''nature does not repeat herself, and no one surface of a picture should be like another.''[14]

If he objected to the monotony of the Ives halftone screen, Kingsley never objected to using the camera as an aid to his own work. To produce his original *Morning from the Shadows of Mount Holyoke,* for the 1889 article, he painted extensively over a reversed photograph that he had taken himself. His careful reworking of the values of his own photograph to simplify its masses and open up its detail to satisfy the demands of the small scale of magazine

7. Elbridge Kingsley with friends and family in cart, 1882.

and book illustrations puts the lie to Peter Henry Emerson's opinion that the effect obtained in photographs printed on albumenized paper became the effect that the woodcutter aimed for, and that the result was a print of wonderful detail and beauty. It was clear from everything that Kingsley wrote—and produced—that he was aiming not to match photographs on albumenized paper, but to transcend them.

Unfortunately, the words "wonderful detail and beauty" could not be applied to Emerson's own photographs transmogrified into unsightly splotches by some mysterious phototechnology for the small blocks in his *Pictures of East Anglian Life* of 1888. Even Ives's monotonous dots seem preferable to such disasters. Because we all know the impeccable beauties of his *photogravures* for this series, we may forget that Emerson was greatly saddened by the ruination of his tender landscapes by what seems to have been a heavy-handed application of photolithography. With the subtle chiaroscuro, warm detail, and overall mood of his 1887 portraits wrecked by this mechanical process, it is hardly surprising to learn that Emerson vowed that if photogravure were ever to disappear, he would give up photography. Without photogravure, he could not transmit his own photographs adequately. But he praised American wood engravers in the most enthusiastic terms, observing that as yet there was nothing to rival their brilliant reproductive effects for landscape or for portraiture from the photographic image.

In the *Century Magazine* series of 1889, Kingsley—by now the recognized master of Barbizon textures—was called upon to reproduce all the paintings for the article on Corot. He wrote, "In a general way, I can give the reader

the usual procedure in working from a painting. First, a photographer is called in, making a copy that will at least show the main masses of the picture. I preferred myself that this should be larger than the engraving. A light plain print was taken suitable for the engraver to work on, either with pencil or color. I liked to use color myself, sitting in front of the painting whenever it was to be found. . . . With his worked over copy the engraver had his study for a photograph on the wood in the usual way, and very likely visited the painting many times during the work.''[15] His *Landscape with Cattle* from Corot demonstrates the delicacy of this method.

But while such masterpieces of variety and subtlety of texture were being created by Kingsley, the inexorable Ives process was beginning to churn out cheap cuts for the art books, most of them too poor in quality to be capable of re-reproduction here. Kingsley even began to imitate the tiny dots of the mechanical processes in an art print, *Engraving from Nature,* reproduced on Japan paper for F. Hopkinson Smith's *American Illustrators* of 1892, but time was rapidly running out.

In 1896, Kingsley was represented by a number of plates in John Van Dyke's *Modern French Masters.* What was curious about the volume was that it combined both wood engravings by members of the New School (e.g., Kingsley's *Landscape with Cattle*) and advanced process halftone engravings. In his preface, Van Dyke observed,

> It is claimed by some that the wood engraving does not give the truth of fact so exactly as the photographic reproduction in what has been called "half-tone." It is said that the engraver personally intrudes and influences the reproduction, though a wood engraving is always photographed upon the block, and the engraver works directly from the photograph. On the other hand, it is asserted that the halftone [*author's note:* the process mechanical engraving] does not deal with subtle tones; that it is frequently faulty in light and shade; and that it fails in giving the true values of colors The present volume offers evidence upon both sides.[16]

The discussion, from Kingsley's point of view, was by this time wholly academic, for he was technologically unemployed in 1896. All of his engravings used in the Van Dyke volume had been produced years before in *Century Magazine,* while all the process engravings were manufactured especially for this publication. *A photographic process had begun the revolution of the New School of Engraving. A photographic process had terminated it.*

In 1894, Philip Gilbert Hamerton published a text to accompany forty hand-printed proofs for *The Art of the American Wood-Engraver,* in which he remarked, ''there is nothing in 'process' that can be accepted as a substitute for the engravers' wonderful craft. The process block gives no pleasure in itself like that which an appreciative critic derives from the best work of the bur-

8. Elbridge Kingsley. *In the Shadow of Mount Holyoke,* 1889.

in."[17] Kingsley could derive little satisfaction from such praise. He withdrew
to Massachusetts only one year after receiving a Gold Medal at the Paris Ex-
position of 1893 and devoted himself to competing with the new medium, con-
centrating on the camera and on the new technologies.

In his own photography, Kingsley was obviously a Barbizon. There was no
difference in intent between many Kingsley pictures and those of Rousseau
and Daubigny. He was passionately interested in light, in texture, in the idio-
syncracies of a specific locus in nature. Hundreds of his photographs remain: a
road in Hadley, a view of the city of Holyoke from the top of Mount Holyoke,
tree trunks, views through pines, a bridge in Worcester, meadow brooks,
snowy mornings. Interesting as his photographs were, Kingsley—at least in
the first years of the 1900s—could not seem to appreciate photography for it-
self. He was always trying to manipulate the print. In studies of birch trees,
the subject for which he had won the Gold Medal, he painted clouds over the
prints and rephotographed them. Sometimes he scratched the negative almost
as if he were working in cliché verre. He painted directly over photographic
prints, sometimes so skillfully that at first glance they resemble original water-
color and chalk drawings.

By about 1905, Kingsley succeeded in producing quite adequate photome-
chanical prints of his own. And he tried to sell these. Then he went one step
further. Starting with his own photograph, he made a process halftone engrav-
ing that he heavily retouched and graved directly onto the screened metal dots.

Working over the textures, he scraped pure whites into areas where the monotonous screen process simply stamped a sea of gray dots.

In *Fort River Birches,* he apparently shot a photograph, painted and drew with pen on a print, made a photomechanical screen process halftone plate reducing the original considerably, then further scraped, retouched with the burin, particularly to add areas of pure white. His diary, unfortunately, does not document his intentions, whether it was to triumph over the camera and its products, whether to produce images more quickly than by the laborious process of taking a photograph from nature, painting the photograph, transferring it to the block, and producing the wood engraving. He wrote that he became obsessed with experimentation, almost as if he were trying to discover some great new secret of photography, as if it were an adversary.

Rather sadly, at last, he made more and more unretouched blocks, giving up the attempt to modify the screen to resemble his own craft. Toward the end of his life, for every retouched plate he attempted, he made about five straight process halftones from his own photographs, even printing and mounting some of them on Japan paper, for sale as "art prints." But at last he was utterly defeated, and he began to produce process halftone blocks based on other photographers' prints.

Meanwhile, the illustrated press had blithely forgotten Kingsley and were flooding their pages with very ordinary little "Nature photographs," sometimes duotoned in monotonous greens, for "Nature articles." There was nothing seriously wrong with these pictures, but their textures were dead. It was almost as if visual communication were returning to the symbolic outlines of the earlier days, as if pictures were once again saying, "Since you cannot admire me for my technique, love me for my *subject.*"

SUMMARY The progression of a visual syntax during the latter part of the nineteenth century is paradoxical and full of artistic and technological ironies. It began with the bitter experience of Fox Talbot with the discovery that silver prints were impermanent. While Talbot struggled to perfect some method of breaking up the halftones of photographs into dots that would print with typography and in permanent printer's ink, artists like Henry Peach Robinson had recourse to the traditional graphic arts when they wanted to communicate about photography to the general public through the printed book. The art of wood engraving, revitalized by men like William J. Linton, became the normal means for transmitting the content of photographs as well as paintings and drawings in all media. Since "content" was seemingly all that could be transmitted by the Lintonesque syntax of the mid-1870s, wood engravers developed a decorative style unconnected to the characteristics of originals, including photographs.

9. Elbridge Kingsley. Evening by the Lakeside, 1886.

Then, with the introduction and adoption of photography-on-the-block, however inadequate the detail, however poor the color translation, a revolution occurred. With techniques developed by a group calling themselves The New School of Engraving, who depended entirely upon the transference of originals to the block by photography, wood engraving suddenly burgeoned as an art of imitation, the close imitation of the characteristics of originals. Brushstrokes and all textures were rendered illusionistically, as well as the flat continuous halftones of photographs. The artistic furor was considerable: the old school of engravers believed that their function was a metaphysical one, to translate the content of pictures into suitable printing surfaces. The New School believed that fidelity to nature—that is, to objects as they appear—was crucial, and this attitude was developed in part by the new emphasis on fidelity to the open air world so stressed by the Barbizon painters and the Impressionists. With a photographic technology that permitted the reduction of large originals to small blocks, the wood engraver was peculiarly suited to retranslate and make appropriate the tremendous compression of details and the distortion of values that ensued.

With the example of the Barbizons and the possibility of transferring photographs from nature directly to the block, a Massachusetts wood engraver, Elbridge Kingsley—inspired by Philip Gilbert Hamerton—took to the woods and began to perfect a painter–wood engraving that far surpassed all other graphic media in transmitting textures and the subtleties of chiaroscuro. But even as he was perfecting this illusionistic art, a photographic technology largely invented by Frederic Ives of Philadelphia was successful in bypassing the wood engraver entirely. Photography was ready to reproduce itself through the process half-

tone engraving, utilizing a screen suggested by Fox Talbot twenty years before.

While the illusionism of the early process halftone was far inferior to the range of possibilities that Kingsley and his colleagues developed, the blocks were so much cheaper than the handwork of the artist-engraver that the inevitable resulted. At the very height of an illusionistic wood-engraving art that was attempting to translate the tones, textures, and varieties of nature, photographic technology triumphed. By 1893, the new mechanical media had almost entirely replaced the wood engraver. But for all the literalness that the photomechanical engraving would ultimately provide, it lacked the sparkle and intelligence that had animated the blocks of the painter–wood engravers. Unlike photogravure, an etching process used by Peter Henry Emerson for the large plates in his splendid books, the evenhanded dots of the relief process engraving obliterated all subtlety and detail. Once again, the process that could transmit information cheaply in books, the type-compatible relief photomechanical engraving, seemed capable only of transmitting *content*.

This brings us to the heart of the philosophical problem implicit in this short history. While it may be true that more and more galleries and museums are presenting original photographs to the public, it is still primarily through the printed book that most people learn about photography. (Indeed, Susan Sontag recently admitted that she thought of photomechanical engravings of photographs as photographs.) Since the photograph is always reproduced through some phototechnology for inclusion in books, and since that phototechnology always interposes its own characteristics on the artifacts we view, have we really advanced so far from Henry Peach Robinson's problem in *Pictorial Effect in Photography?* With the market inundated with books about photography and purporting to be illustrated by "photographs," what aesthetics should be taught to students of the art? Are we always going to be confronted by a kind of metaphysical problem: that all we can expect from a book is that its photographic illustrations shall "recall to memory" original photographs? With illusionistic wood engraving, the viewer had a reasonably clear reference point: the handcraft of the engraver. With the fine-screen photomechanical reproductions of today, as Malraux observed, we are deluded into thinking we are looking at the original. But we are not. Just as with the Linton syntax of 1875, so in 1975 everything has come to look alike.

There is a further conundrum. A visitor to the International Museum of Photography can see his or her choice of Emerson *photogravures* or his *carbon prints*. Concerning Henry Peach Robinson's books, the reader can have his photographs "recalled to memory" in numerous editions, each with its own different photomechanical process. If this is so, is photography—which we all consider to be the ultimate document of reality—only an idea in someone's

10. Elbridge Kingsley. Photomechanical engraving from his own photograph, ca. 1908.

head? Shall we paraphrase Marcel Duchamp and say merely that "Photography is anything which is viewed within a photographic context"? Or are we heading back—as Sontag's recent article on Leni Riefenstahl might indicate—to an inevitable reexamination of problems perennial in art history: the mysterious nexus of form and content? Despite the inundation of the market by books of and about, photography, it would seem that many major problems remain to be solved.

Image, September 1976.

Technology or Aesthetics
ALFRED STIEGLITZ AND PHOTOGRAVURE

CRITICS AND HISTORIANS OF PHOTOGRAPHY, as well as practitioners of the photographic arts, are inevitably drawn to investigating the interconnections between technology and aesthetics, between the choices that artists make in the formal elements of their work and the characteristics of the artistic media available to them at any particular period of history. Yet many of the issues involved in these interconnections still seek resolution, as any investigation of the career of Alfred Stieglitz soon discloses.

If ever there was a photographer with lofty aesthetic aims, it was Alfred Stieglitz, patron saint of "straight photography," founder of the photo-secessionist movement, promulgator of abstract art and encourager of the *avant-garde,* idiosyncratic gallery owner, and resolute editor-publisher of one of the most famous of all photographic journals, *Camera Work*. It was here that the pantheon of early moderns was first widely reproduced: Clarence White, Gertrude Käsebier, Edward Steichen, Frederick Evans, Alvin Langdon Coburn, Frank Eugene, Robert Demachy, Joseph T. Keiley, and Stieglitz himself. A dazzling array of phototechnologies was employed to convey the works of these photographers to an as yet indifferent public. Among these technologies were "straight photogravure . . . mezzotint photogravure, duogravures, one-color halftone, duplex halftones, four-color halftones, and collotypes."[1] Of these, photogravure was the predominant medium throughout the entire publishing venture of *Camera Work,* from its optimistically polemical beginnings in 1903 to its almost unattended extinction in 1917. These tipped-in, double-mounted, Japan tissue, individual plates were so magnificent that, as Jonathan Green observed, "It has been frequently remarked that the reproductions in *Camera Work* are often finer than the original prints."[2]

Since this kind of comment on the extraordinary quality of the plates in *Camera Work* appears in so many sources, it seems astonishing that the implications of such a statement have gone unchallenged. Thus, in describing *Camera Work,* Doris Bry presented the following comment without elaboration: "For the most part its reproductions were photogravures, on Japanese tissue, that often surpassed the original photographs from which they had been

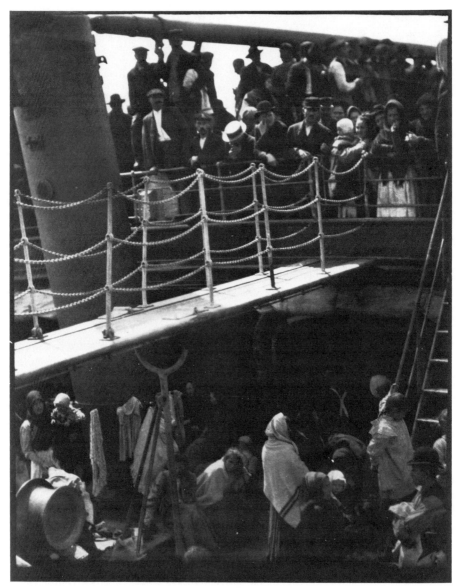

11. Alfred Stieglitz. *The Steerage* (1907), reprinted in *Camera Work*, 1911.

made.''[3] How is it possible for ''reproductions'' to *excel* original prints? In what conceivable ways might it be said that a reproduction could be finer than an original? Once this line of questioning is opened, it presents unnerving issues involving the traditional conceptualizations of the terms *reproduction* and *print,* not to mention the difficulties of defining the very term *photograph.*[4]

We know that Stieglitz was vexed by the photogravures manufactured by J. J. Waddington & Company in reproduction of the exquisite platinotypes of Frederick Evans for the fourth issue of *Camera Work.*[5] He even made an editorial apology for the quality of the reproductions, despite the fact that they were ''beautifully hand mounted, first on grey or tan submounts, and then on Japan tissue laid on top of the pages.''[6] In this example, photogravure was clearly being employed as a reproductive medium in an edition of 5,000 copies. However, when one considers the fact that most of Alvin Langdon Coburn's *originals* were produced in photogravure, or if one follows Stieglitz's own involvement with his most famous picture, *The Steerage,* one encounters profound confusions. Was photogravure essentially a reproductive medium or a direct medium, or both? If a phototechnological process can serve both Mammon and Apollo, two general issues are raised: ''What is a reproduction?'' and ''What is a print?''

The most instructive course is to begin with Stieglitz himself talking about the various phases of *The Steerage.* The negative was made on a boat trip to Europe in 1907, and the developing took place at the Eastman Kodak laboratories in Paris when Stieglitz arrived there.

> And when I got to New York four months later I was too nervous to make a proof of the negative. In making the negative I had in mind enlarging it for *Camera Work,* also enlarging it to eleven by fourteen and making a photogravure of it. Finally this happened. Two beautiful plates were made under my supervision, and proofs were pulled on papers that I had selected.[7]

Stieglitz had apparently made a glass-plate negative of relatively small size, of which silver chloride prints exist in various collections, including the Boston Museum of Fine Arts. The ultimate product, however, was not intended to be a silver chloride contact print but a photogravure. Of course, photogravure is not, strictly speaking, a direct photographic technology, but one that requires the assistance of the traditional graphic arts, including the manufacture of a metal plate, an etching press, and printer's ink. Stieglitz indicated that two plates were to be made: a slight enlargement for his journal, and a larger photogravure, undoubtedly for exhibition.

Lest there be any doubt that Stieglitz regarded the two photogravure prints equally and appropriately ''aesthetic,'' we note the following comment:

> The outstanding excellence of these photogravures is illustrated by the following incident recorded in *Camera Work* (No. 12). In 1904, the Exhibition Committee

of Société L'Effort, Brussels, one of the leading art societies, framed about thir-
ty *Camera Work* gravures, in place of the American photographs which had
gone astray, and hung them as representing, America in their exhibition. Accord-
ing to the criticisms published, this little American section proved the success of
the exhibition. It was not until after its close that it became generally known that
the American section had consisted entirely of *Camera Work* photogravure.[8]

Stieglitz would never have quoted such a tale if he had not believed that it
vindicated the extraordinary personal care under which he supervised the prep-
aration of these plates for his journal. Furthermore, he quoted the editors of
the Société L'Effort's program notes as remarking:

> In many instances, these ''reproductions'' can be in reality considered original
> prints, having been made directly from the original negatives and printed in the
> spirit of the original picture and retaining all its quality.[9]

Also on record are Stieglitz's happy boasts that, in its photogravure form for
Camera Work, The Steerage had ''created quite a stir wherever seen, while the
eleven by fourteen gravure created still a greater stir.''[10] When Paul Haviland
and Marius de Zayas, two Stieglitz friends, were putting out the new journal,
291 (named for Stieglitz's famous photo-secession gallery and greatly influen-
tial on the course of dada as an art movement), they wanted him to create a
double number devoted to photography:

> . . . with the ''The Steerage'' as a basis. ''The Steerage'' was considered by
> many the most significant photograph I had ever made. It had even attracted the
> attention of Picasso in 1912. De Zayas had taken a print to Paris to show it to
> Picasso. Picasso is reported to have said, ''This photographer is working in the
> same spirit I am.'' The print shown to Picasso was an eleven by fourteen photo-
> gravure proof of ''The Steerage'' made under my supervision.[11]

In talking further about *The Steerage*, Stieglitz noted that ''a similar
proof''[12] was purchased by Dr. Jessen of the Berlin Museum, as well as by
other collectors. In other words, photogravures distinguishable only by size
and number of edition from the photogravures produced for *Camera Work*
were purchased by connoisseurs.

Haviland and De Zayas convinced Stieglitz ''that it would be a great thing if
I were to have five hundred proofs of the photogravure plate pulled on Imperi-
al Japan paper for a small 'deluxe' edition on thin Japan tissue.''[13] Once
again, Stieglitz supervised the printing of these ''proofs'' and even paid for
them out of his own pocket, as a contribution to his friends' journal.

> The double number containing the Imperial Japan proofs was sold to subscribers
> for twenty cents each. The thin Japan ones for a dollar each. Hundreds of peo-
> ple, rich and poor, had been clamouring for ''Steerage'' prints. The poor could
> not afford the hundred dollars and the rich could not afford the hundred dollars.

I was in no position to give away the few proofs I had, before printing this edition for *291*.[14]

One hundred subscribers to the regular edition received their copies with the journal, and eight subscribers to the *de luxe* edition received theirs, at one dollar per copy. That was all. In 1917, when Stieglitz was forced to close his 291 Gallery, he found himself with 8,000 unsold copies of the editions. As it was war time, and there was a scarcity of good paper, he sold this pile of unappreciated materials to a rag picker for exactly $5.80, keeping most of the *de luxe* edition for himself. However, he says, "in time I destroyed most of that."[15]

In 1924, the Boston Museum of Fine Arts became the first American museum to acquire a collection of Stieglitz prints, selected by the master himself. They numbered twenty-seven, and included seven photogravures, four platinum prints, and thirteen called "Palladios." The latter were actually silver chloride prints toned with palladium, which gave them a soft-brown color of warm hue ranging all the way to a near black.[16] Two prints in photogravure of *The Steerage* are currently in the collection of the Museum of Fine Arts, and it is impossible to discern which of these two was originally intended for exhibition or whether they were manufactured for some other purpose. They were undoubtedly made under the personal direction of Stieglitz, but whether or not they are "reproductions" from his silver chloride prints or direct images from his negatives on photogravure plates is precisely the problem that confronts us in any further discussion of the famous pictures in *Camera Work* that are reputed to be "finer than the originals."

A recent exhibition at the Boston Museum offered the public examples from *Camera Work,* using bound volumes of that precious journal, to demonstrate the early pictorialist achievements of Edward Steichen, among others. On examining these exquisite small pictures from the April 1903 issue, we find certain characteristics that lend themselves perfectly to printing by photogravure. In Steichen's *Portrait of Rodin,* for example, the soft textures of the print look like charcoal smudges. The grainy silhouette has a decorative softness combined with a dramatic contrast of light and dark. The *Self-Portrait,* showing Steichen in his persona as painter, with full Rembrandtesque chiaroscuro, displays the scratchy qualities of a mezzotint, with velvety blacks and soft, scraped whites. When we look at such a picture, we are hardly aware that it *is* a photograph, for it has gone far beyond the conventional soft focus of someone like Julia Margaret Cameron into the closest possible approximation of traditional drawing or etching media. It is a perfect exemplar of pictorialist rather than pure photographic aesthetics.

The *Rodin* and the self-portrait of Steichen were originally gum prints reproduced in photogravure. But in that same April issue, for Steichen's *The Pool* and *Dolor,* both low-key pictures, we discover that the photogravures were

produced from "original negatives."[17] These cannot be considered "reproductions," since they do not attempt to transmit the characteristics of a previous production of a positive print, but must be considered to be either "replications" in positive, or "original prints." Since many other pictures in *Camera Work* are photogravures from "original negatives," we may be forced to consider photogravure to be a "direct medium," just as the printing of a positive from a negative in a darkroom is said to be "direct."

One may well ask why Stieglitz did not simply ask Steichen, and his other contributors, to supply his journal with palladium or platinum or other types of prints, which he could then have tipped on to text paper without the additional expense of double mounting. After all, several thousand titles had been published during the mid-nineteenth century by mounting albumen prints, for example, directly on text paper. By 1903, however, it would have been an absurd imposition to ask Steichen himself to turn out the thousands of prints for each edition of *Camera Work,* and it would have been aesthetically inappropriate to have these churned out by some commercial photographic printing house. Neither was it practical to hand-mount platinum prints, for example, as these were (and still are) exceedingly liable to suffer damage by finger markings or from the uneven pressure of the hot mounting iron. Platinum prints were expensive, but this was also true of photogravure: "up to the end of the century, one photogravure plate cost as much as the printing of a whole edition of the same picture by one of the other reproductive processes, such as collotype or Woodburytype."[18] Several practical reproductive processes existed, as a result of decades of sometimes frantic searching for a permanent, printer's-ink technology that could transmit the subtleties of photographic halftones without undue expense. There must, therefore, have been significant reasons for Stieglitz's choice of photogravure as the predominant medium in *Camera Work,* and some explanation for this comment: "By 1895 any book or periodical that expected to command the respect of the *cognoscenti* was illustrated with a few gravures."[19]

That photogravure offered snob appeal to the *cognoscenti* undoubtedly arose from the high regard afforded the traditional graphic arts at the very moment when they were about to be superseded by ignoble mechanization: the camera. Photogravures did not in the least resemble the popular silver chloride prints; gravures rather recalled the richness of mezzotints, the jet-black inks of lithography, the delicacy and fine lines of etching, the decorative capabilities of aquatint. Indeed, at an historic exhibition of phototechnological methods held at the Boston Museum of Fine Arts in 1892, the name given to the photogravure process had been, precisely, "photo-aquatint."[20] This was by no means a misnomer, for photogravure is essentially based on the properties of aquatint, in which the reticulation of a powder on a metal plate provides a wide variety of dot structures, varying in size and depth, which are etched with acid to pro-

duce an intaglio printing plate. While the name "photo-aquatint" did not last, the process was promptly acclaimed as the most beautiful, the most silky, dense, rich, of all the phototechologies, as permanent as the oil-base type of carbon ink that Gutenberg had created.

Perfected in one form during the 1870s by the Parisian firms of Amand-Durand and Goupil, and kept in greatest commercial secrecy during its first major American exposure during the Philadelphia Centennial of 1876, photogravure was curiously linked to the very origins of photography. The reader will recall that the inventor of the earliest process of photography, Joseph-Nicéphore Niepce, had been trying to "automate" lithography by some application of light-sensitive materials when he made the important discovery that Bitumen of Judea, an acid-resistant material used both in etching and lithography, had a most useful characteristic: it hardened with exposure to light. What had not been exposed to light could be dissolved and washed away, leaving a slight relief surface. It was Karl Klič, a Greek-Viennese painter and engraver, who perfected the process in 1879, again in greatest commercial secrecy. Like aquatint, the process involved resin dust adhering to a polished copper plate. Carbon tissue then effected the transfer of the photographic image by printing through a diapositive; the plate was then etched with ferric chloride. We have a complete description of the photogravure process of Stieglitz's day in Herbert Denison's treatise published in 1895.[21] In this lucid, short handbook, we discover that the final photogravure print represents something like a three-step remove from the original negative, owing to the fact that the image must be reversed to transfer it, then reversed again, and once again to print. That such complexity can nevertheless result in a print of such high quality is a tribute to the inherent superiority of photogravure over all its technological rivals, among them the collotype, a temperamental and beautiful process that remained largely European in its use, and screened halftone engraving, a process that was, in 1903, still insensitive to the subtleties of tonal variations. At best, it was heavy-handed and clumsy.

One has only to compare different issues of the same Stieglitz picture to recognize the limitations of the inexpensive halftone process. The reader is referred, for example, to *Scurrying Home* as it appeared in sepia gravure in *Camera Notes* for October 1899, and as it was reproduced by the screened halftone process in *Photo Era* for June 1900. It should also be noted here that the glassines over the reproductions in *Camera Notes* offered information about the originals, e.g., "from a platinotype," or "from a glycerine print," or "from a gum print." *Camera Work*, Stieglitz's own creation, offered no such information about "originals," and the absence of this kind of data was clearly deliberate. It must have been part of Stieglitz's scheme for the impression that *Camera Work* was expected to make on its public, an impression largely produced by the splendor of its photogravure plates. The reader was

clearly invited to respond to the plates in *Camera Work* as if these were original prints, and this very much suited Stieglitz's larger purposes, which included the attempt to raise photography into the Olympian heights of the more traditional fine arts.

Stieglitz had probably first encountered photogravure during his extended stay in Europe from 1882 to 1890, the years of his photographic apprenticeship. The Klič method had been licensed in England as early as 1883, having been introduced by Thomas Annan, father of James Craig Annan and an important photographer in his own right. Annan's Glasgow photogravure productions from 1883 to 1887 were famous throughout the British Isles. It was in 1887 that Stieglitz won his first recognition from Peter Henry Emerson, himself a practitioner of photogravure. Less well known, apparently, is the fact that Stieglitz became greatly influenced by Emerson, whose *Naturalistic Photography for Students of the Art,* published in 1889, was the first statement anywhere of the ideology of "straight photography," namely, that "photography was an independent and potentially great art form capable of expressing thoughts and emotions beyond the scope of the other and older art forms."[22]

Nancy Newhall's superb study of Emerson not only documents his impact on Stieglitz, but details the fact that, while writing this book, Emerson asked the bilingual Stieglitz if he would like to translate the manuscript into German. Stieglitz received the manuscript, read it, and did nothing with it, except, apparently, to incorporate its wisdom wholesale into his own thinking. Emerson worked in platinum and photogravure, swearing that if either were to disappear, he would instantly give up the practice of photography. Stieglitz also began working in platinum and photogravure, but not once did he either mention Peter Henry Emerson in *Camera Work* as his master or reproduce any of his superlative platinum prints or his magnificent photogravures of the English countryside.

It was, as Newhall makes abundantly clear, not Stieglitz but Emerson who first persuasively articulated the notion that photography might have unique aesthetic characteristics of its own. Emerson, not Stieglitz, originated the idea of "straight photography," buttressed (no pun intended) by the great architectural photographer, Frederick Evans, another advocate of photogravure. Again, it was Emerson and Evans, not Stieglitz, who originated the idea of the new exhibition techniques for photography, namely, simplicity of both mount and frame and simplicity of decor in the gallery. It was F. Holland Day, not Stieglitz, who, along with Evans, advocated the mounting of photographic prints on thin sheets of subdued colors in such a way that successive narrow borders would set off the picture, a technique for exhibitions that Stieglitz assiduously copied in the mountings of the gravures in *Camera Work,* almost suggesting to

the public that they were not only looking at original prints but they were looking at them as if they were on exhibition.

Stieglitz had also received a strong impetus toward this use of mounted prints from publications like the *Wiener Photographische Blätter* of 1892, where "Each gravure was printed with an ink of a different tone, and some like (Adolf) Meyer's were mounted on colored paper."[23] He was apparently also much taken with the publication by the Photo-Club de Paris in 1894, the *Première Exposition d'Art Photographique.*

> Stieglitz was able to vicariously experience the exhibit through the lavishly produced folio volume . . . of photogravures issued in a limited edition of thirty copies, printed on Imperial Japan paper and four hundred seventy copies on white Marais hand paper. . . . The finely printed gravures, each with a subtly different tone of ink, gave Stieglitz the opportunity to see reproductions of . . . Robert Demachy, whose work he perhaps saw here for the first time.[24]

Having accepted Emerson's ideas about platinum prints for exhibitions, and photogravure prints from the same negatives for use as illustrations in books, and having had outstanding models for fine reproduction from these European precedents, Stieglitz had found the essential ingredients for his own aesthetic leadership at *291.*

Stieglitz's reputation today rests partly on his insistence that photography be considered an art in its own right, but in what particular aspect might the uniqueness of photography be found? Steichen imitated nineteenth-century mezzotints, and any neophyte who opens the pages of the third issue of *Camera Work* will discover, even in that supposedly *avant-garde* journal, that most of the "photographs" imitated other media. In that third issue is Clarence White's famous picture, *Ring Toss,* eked out in a popular pastel shade called terracotta, imitating not only the color and texture of pastels, but the very spatial arrangements and formal informality of Degas's ballet-dancer pastels. Those were themselves imitations of the off-center snapshot configurations, mixed with a great deal of Japanese woodcut stylizations. Photography was imitating painting, which was imitating photography! In Stieglitz's own *The Street,* we find a typical impressionist composition. Other pictures masqueraded as aquatints, as lithographs, as etchings, as charcoal drawings, and not only was impressionism rampant, but Whistlerism, Sargentism, and Delacroixism.

As Jonathan Green explained it:

> When *Camera Work* appeared, the pictorial photographers were divided into two camps: those who favored hand manipulation of the negatives and prints and those who believed in the use of purely photographic methods. While their methods were different, their ends were the same, and Käsebier's and White's

''straight'' platinum prints are as diaphanous and elaborately posed as Steichen's and Demachy's painterly gum.[25]

Thus, one of the paradoxes about *Camera Work* was that ''straight'' photography as we understand it today was nowhere in sight in the early years, despite the supporting rhetoric.

It was not until Number 36, October 1911, of *Camera Work,* that Stieglitz reproduced his own photographs of the straight snapshot variety. All these exist in silver chloride contact print size, as well as photogravures in *Camera Work* and as large exhibition-size photogravures. Looking at these in print, e.g., *The Hand of Man, The Steerage,* and *The Terminal,* the discrepancy between the various sizes raises crucial issues: how does the size of an original negative relate conceptually to the size of any ultimate positives? Does the fact that the *Camera Work* photogravures are smaller than exhibition-size prints make them any less *prints?* Is the concept of a ''print'' confined to the ''limited edition'' idea or to some aspect of the manner of production?

Two more Stieglitz plates in the October 1911 issue of *Camera Work* are *The Aeroplane* and *The Dirigible.* The two images were produced from ''original negatives'' in photogravure and demonstrate how far Stieglitz was himself moving away from the pictorialist concerns of his colleagues toward a more abstract conception of photography. These may have been the last photogravures made of Stieglitz pictures by his very own plant, the Photochrome Engraving Company, which had a division devoted to the process of photogravure. Stieglitz had by this time left the company, of which he had been one of the founders in 1890. The company was credited on each masthead of *Camera Work* when they were responsible for producing the gravures under his personal direction. In 1912 or 1913, a house called the Manhattan Photogravure Company took over. One presumes this was the company to which Stieglitz refers when he talked about ''My share of the business eventually was turned over to the workmen; my one partner retired not long after I did; the other continued the photogravure branch under a new name, until he finally also got out.''[26]

This information should not be taken to imply that Stieglitz was somehow underhanded in using his own engraving house to produce what the world agrees are superlative plates for *Camera Work.* The fact that he had partly owned the Photochrome Engraving Company was no secret, and being a partner undoubtedly made it much easier for him to cajole his former staff into providing magnificent printing. Certainly, the best implication here is that Stieglitz had developed a highly sophisticated understanding of the propriety of one medium over another, in the purely technical sense of understanding which medium could best reproduce, or produce, what sort of original. He knew that photogravure, and photogravure alone, could produce the effects

that he wanted during the initial phase of the photo-secession, when so many of his contributors were working in gum bichromate. These manipulated imitations of etching, painting, or lithography had to be perfectly reproduced in all their soft and subtle tonalities. Stieglitz also recognized that photogravure worked best on Japan paper, a light tissue introduced from the Far East in the 1880s, which had been initially used as a proofing medium for the highly complicated white-line reproductive wood engravings of the time. Japan paper, in fact, had made it possible for the American wood engraving to achieve the stature of the traditional fine arts media like etching, for it made possible the finest of textures and the cleanest imprints. While screened halftone process engravings, a relief medium, printed best on a clay surface paper, photogravure and Japan tissue were made for each other. Indeed, the pictorialists, photogravure, and Japan tissue were all made for each other.

Among painter-engravers, painter-etchers, or painter-lithographers, all working autographically (that is, *directly* by hand) in media that had once been used simply to reproduce other graphic media or to make cheap pictures for the crowd, the idea of competing with photography was paramount during the 1870s and 1880s. Photography had already doomed the reproduction activities of the graphic arts and had already threatened the representational functions of painting. Indeed, it had become both the *bête noire* and the goddess of the academy painters, who often cursed photography even as they assiduously emulated naturalistic details. It was counter to the vested interests of painters and artists in the traditional graphic media to permit photography to achieve the status of the "Fine Arts," and yet this was precisely what Alfred Stieglitz had sworn to achieve.

At first, Stieglitz seemed to accept the idea that the imitation of paintings, along the lines of the pre-Raphaelitism of Julia Margaret Cameron (whom he reproduced in photogravure in *Camera Work*), or like those of Demachy's Barbizon style images, would automatically ensure the equality of photography with painting. What could be more painterly than Frank Eugene's marvelous *Frau Ludwig von Hohlwein?* In this quest for equality with the older visual arts, Stieglitz also depended on the fact that photogravure not only would beautifully present Cameron's or Eugene's pictures but also would connect photography to etching and aquatint by its intaglio richness of printer's ink.

Photogravure did not merely capture the soft gradations of chiaroscuro, which characterized the pictorialists; it could also be combined with color. Steichen's yellow tones in his originals (if one counts exhibition prints as "originals") of *Steeplechase Day After the Races* and *Late Afternoon, Venice,* are surprisingly well reproduced. Just as surprisingly, perhaps, in the final years of *Camera Work,* when photogravure was receiving intense competition from foreign collotypes and four-color process halftone engravings of a vastly improved sensitivity, it was discovered that the velvet density of photogravure

could also be used to communicate truly "straight" photographs, e.g., those of Paul Strand, whether in the abstract vein of *New York: Wall Street* or in the more realistic style of *Woman in a Wool Coat*. To this day, photogravure continues to be the medium of choice when the greatest fidelity to an original photograph is desired, with even popular journals boasting of their special monthly sections of gravure. And the younger generation of photographers is beginning to revive photogravure as a direct medium, even as Stieglitz used it in his original conceptualizing of *The Steerage*.

Apart from all its other conspicuous advantages, a photogravure *reproduction* looks exactly like a photogravure original print. There can be no doubt that this was, and is, anathema to print collectors, but it suited Stieglitz's purposes down to the ground. Photography has been plagued from the moment of its inception by the accusation that it could not be a fine art, since the camera was just a mechanical contrivance and photography was a mass medium to boot. Stieglitz would naturally take advantage of any medium that could bathe photography in a glow of High Art, to make it seem the equal of any of the traditional graphic arts, and, presumably, by the sheer force of that appearance, the *equal* of great art. This seems highly probable, given the fact that he took such pains to present each picture in a single or double border of colored paper, exactly as exhibition prints were mounted. Perhaps he thought that if the critics and the *cognoscenti* believed they were looking at *original prints* rather than *reproductions* of photographs, he would already have won half the battle of convincing them that photography had the hand-crafted attributes that they so revered. Once convinced that the hand of an artist was at play in the production of a picture, perhaps they would give up their incessant harping on the contemptible mechanical aspects of the camera.

There can be little doubt that it was his aesthetic judgment as to which technological process "looked best" that dominated Stieglitz's thinking, but he did not seem to sense the naïvety of the "equal status" notion in the arts, and failed to realize for a long time that even the most magnificent process can produce or reproduce visual junk. *Camera Work*, looked at as a cumulative venture of 50 issues, proved beyond question that a graphic medium is only as divine as its content is heavenly.

History of Photography, January 1979.

The Eternal Moment
PHOTOGRAPHY AND TIME

A FREQUENT THEME in popular culture fantasies, especially in motion pictures like *Back to the Future,* is the reversal of time, where we are magically transported to past decades. One such fantasy, the first *Superman* movie starring muscular Christopher Reeves, featured a truly spectacular time transformation, the progress of which the audience was allowed to see. After a gigantic earthquake had smothered the hero's beloved Lois Lane under an avalanche of rocks and dirt, Superman was so overcome that he did what his father Jorel had explicitly forbidden: he intervened in human affairs.

At a speed and with strength incalculable to mere mortals, Superman reversed the spinning of the planet Earth, asking the audience to believe that this action could reverse time. The hours shot back, the avalanche hurled itself uphill, spunky Lois Lane rose up from her buried car and was, amazingly, alive again. But in saving her, by reversing the supposedly inexorable march of time, Superman did more than intervene in human affairs. He did what we all know to be impossible. Only in human imagination can time be reversed, or so common sense tells us.

Common sense, or what Albert Einstein is credited with calling "that set of clichés you collect by the time you are eighteen," tells us that time moves forward and never can be stopped or reversed. Yet we talk about photography's stopping of time, and perhaps we need to determine what that might mean. Besides the presumed "stopping" of time, we should try to discover if there are any other aspects of time revealed to us by those peculiar objects we call photographs.

Photography (along with its progeny, film and television) is the only visual medium we know that provides us with a record of something that was actually *there,* in front of the camera, so we turn with sometimes misguided confidence to photographs to show us what existed in the past. Clues like haircuts and fashions, housing and horse-drawn carriages, paternal poses and studio props, all indicate that we are looking at the *then* of history. Yet we are looking at those clues *now,* with the intellectual apparatus of today. Our vision of *then* is perforce screened through our accumulated perceptions, misconcep-

tions, and assumptions concerning the past; more important, the photographic *then*, paradoxically, can only be experienced in the *now*. Any historian worth his or her salt would agree, since we can only know the past through evidence available in the present. When we hold a photograph in our hands, we are looking at it *now*. But how long is *now?* William James called it *the thickened present* and suggested that it lasted three seconds. A student of his claimed it lasted for twelve seconds. What *is* "now"? When do we think "now" is over? What takes its place, another "now"?

Marcus Aurelius wrote in the second century of our era, "Time is a sort of river of passing events, and so strong is its current, no sooner is a thing brought into sight than it is swept by and another takes its place, and this too shall be swept away."[1] Heraclitus put it more simply: "You cannot step twice into the same river." To that idea should be added the observation that *you* are changing also, not just the river.

There are continuing arguments about this notion of time as a ceaselessly changing river, with philosophers and scientists insisting that there is also *duration*, a duration of identity. The Mississippi River remains the Mississippi River. Ah, but does it? Mark Twain described the evershifting banks and sandbars of that mighty stream, and I have seen rivers in the Southwest that in the dry season were not rivers at all. The prime proselytizer for the notion of duration, Henri Bergson, argued that to call time a river was to spatialize it, thereby misrepresenting what he called real, concrete time *(durée)*,[2] which can be experienced only by the inner consciousness. Surely this notion, as his many critics aver, is metaphysical, subjective, and idealistic. Yet there may be merit in regarding time as a metaphor reflecting the difficulty of expressing in language a complex set of experiences concerning past, present, and future.

A photograph is presumably constant, however, despite what we know about the ongoing alterations in its chemistry, particularly color. It is the notion that a photograph stops time—through a brief exposure of light-sensitive emulsions to the actinic rays of the sun reflected from real objects in the phenomenological world—that may make us overlook a more global concept: photography may have altered our very ideas about time.

What if photography does not *stop time* but rather lets us see *through* time? What if photography somehow makes time transparent? In 1932, André Kertész climbed a tower to aim his camera through the face of a giant town clock down to the populated square below; the picture is the perfect metaphor for seeing through time.

THE GRAND CHAOS When I suggested that photography may have altered our sense of what time is, I was playing with a rather wild possibility, yet a possibility that photographic archivists and curators encounter every day. Imagine, if you will, an enormous flat field out in bright sunshine. To this

field a mysterious power has transported all the photographs that have ever been taken, all the daguerreotypes, ambrotypes, albumen prints, ivorytypes, tintypes, platinum prints, gum bichromates, gelatin silver prints—all of the billions and billions of images on paper, metal, ivory, glass, that photographers have taken since the third decade of the nineteenth century. The field is piled high with this stupefying aggregate of images, higgledy-piggledy, without order, a genuine chaos. If you happened to be standing to one side of this monstrous aggregate, and shut your eyes, extended your hands, and plucked forth two pictures totally at random, what might you come up with? Quite possibly, two images as absurdly disconnected as an 1850s Francis Frith photograph of the pyramids and a 1970s Garry Winogrand photograph of a pair of chimpanzees waving hello. Or you might find a prim and proper Queen Victoria and her consort Prince Albert looking askance from the 1850s at the shocking sexual mores of the 1970s as seen in a Danny Lyon photograph of two teenagers kissing on a bed. Or you could simultaneously look at John Thomson's picture of a Chinese execution of the 1860s and Nick Ut's horrifying record of the execution of a Vietcong prisoner over a hundred years later. Whatever you find in this aggregate, you can only look at these images *now*. You can see the 1850s simultaneously with the 1970s. In that sense, photography has not stopped time. It has obliterated time.

Just as André Malraux called the condition of contemporary arts a "Museum without Walls" because photography could reproduce any art object and present it in a book, so we might call our imaginary field overflowing with photographs "History without Time." For we are being overwhelmed by the simultaneity of photographic images from all decades and from all countries. We see everything and anything we want and see it *now*.

We may try to hold fast to our notions of *then* and *now*, but we can only look at an 1860s picture in the *now*. We cannot go back in time. We can scarcely go to another culture without losing ourselves. Superman cannot help us as we look at the mid-nineteenth century through late twentieth-century eyes and judge what we see only by what we ourselves, in the present, in the *now*, have learned to see. Even though pairs of photographs taken a century apart may urge us to think *then* and *now*, we are forced to acknowledge that we are looking at them in the *now*.

The poet-seer-artist William Blake believed that all time is present in each moment: "I see the Past, Present & Future existing all at once / Before me."[3] The psychologist Joost Meerloo agreed, for he said, "Every present contains the past, but also looks ahead to the future."[4] J. W. Dunne, in his *An Experiment with Time,* stated it unequivocally: "Past, present, and future exist simultaneously."[5] This may be a hard concept to grasp, even when propounded so directly by poet, psychologist, and scientist. It may be even harder to grasp when we turn to consider a statement ascribed to Albert Einstein: *The*

universe is an aggregate of nonsimultaneous and only partially overlapping events.[6]

Einstein was, of course, thinking about what we see when we look at the distant galaxies of the universe. It is old light, light emitted from the stars millions or even billions of years ago, arriving in our planet's neighborhood only after traversing mind-staggering spaces. George Kubler stressed this fact in his book *The Shape of Time*, reminding us that the light we see from the stars is, to put it mildly, ancient indeed.

Photographs, too, let us see old light, light captured a century and a half ago. That enormous pile of photographs we have imagined lying in chaotic dispersal across a wide field is quite similar to Einstein's universe. It, too, is an aggregate of nonsimultaneous and only partially overlapping events. Time has become relative in Einstein's world. It is impossible any longer to think of time as an absolute in Newton's terms. *Whose* time? *Which* time? *Where* time? When we say that photography *stops time,* does that phrase represent a misconception about the nature of time? As Martin Heidegger insisted, we do not live *in* time; rather, we *live time.* How can time therefore be "stopped"?

Henri Cartier-Bresson wrote and talked a good deal about what he called "the Decisive Moment." To me, his remarkable photograph of a man leaping a puddle behind a railway station in Paris is the quintessence of our problem. Cartier-Bresson wrote, "Photography implies the recognition of a rhythm in the world of real things,"[7] and "We work in unison with movement as though it were a presentiment of the way in which life unfolds. . . . But inside movement there is one moment at which the elements in motion are held in balance. Photography must seize upon this moment and hold immobile the equilibrium of it."[8]

If photography is supposed to stop time, it has always struck me as odd that Cartier-Bresson stressed rhythm, movement, elements of motion, immobility, equilibrium, and only twice uses the word *moment,* moment as an element of time. Here is this leaping fellow who in the rhythm of the world of real things was about to go kerplash into a major puddle. The photographer foresaw the consequences of the leap in the real world but chose to record the moment of high drama.

Obviously, what interested Cartier-Bresson more than the moment of time with its real consequences was the geometry of the moment, the perfect equilibrium of the man with his reflection in the puddle balancing his reality, and, just as important, the rhythm of the dancer in the posters behind him—a dancer in much the same pose and balanced by much the same type of reflection. Surely we know that in the immediate past the man executing this improbable jeté must have been hurrying to grab a taxi or catch a train, and in his immediate future there would have been a considerable wetness of the lower trousers and shoes. Past and future and present in the now.

12. Henri Cartier-Bresson. *Behind the Gare
St. Lazare, Paris,* 1932.

Or has Cartier-Bresson in his "decisive moment" somehow abstracted this
fellow from all time? Since, in the photograph, he can never move forward, is
he not in the now at all, but rather in what we call *eternity?* That idea requires
much thought.

The poet John Keats rhapsodized on the eternity of men and maidens cap-
tured in paint on a clay vessel, and wrote these lines in his "Ode on a Grecian
Urn": O Attic shape! Fair attitude! with brede / Of marble men and maidens
overwrought, / With forest branches and the trodden weed; / Thou, silent
form, dost tease us out of thought / As doth eternity" As that other
poet, William Blake, is said to have believed, "Eternity is not the endless du-
ration of time. It is the absence of time."[9] As an absence of time, eternity is a
concept that needs to be reckoned with in terms of photography. But first, per-
haps, we need to think about other aspects of time.

Visually, to understand that the past and future are implicit in the present, it
helps to look at sequential photographs of nature. The same scene in summer
and winter can remind us that the changing of the seasons has always been a
primary time teller relating us to the solar year. Few of us in the late twentieth
century doubt that spring will surely follow winter and that summer will fol-

low spring. In that sense, every landscape holds within it the now that enfolds past and future.

Of the many types of time, the one that photographs seem to excel at depicting is the before and after. Take, for example, a sequence of two photographs by Robert Doisneau: the picture on the left is of a wedding party arranged on raised platforms; the picture on the right is the same scene emptied of people. The presumption is that the wedding party posed first and the empty scene occurred afterward. The only trouble is that nothing in logic can persuade us that this sequence by Robert Doisneau is the only one possible. It would be just as easy to place the empty benches on the left and the full wedding group on the right. The primary reason we ''read'' this as ''before and after'' is that we read our written language from left to right, and therefore tend to read series of images in the same left-to-right sequence. Readers of Hebrew, for example, or any other language read from right to left, might easily see the empty bench as the ''before'' and the wedding group portrait as the ''after.'' Perceptions of time sequences in photographic images may be as culture-derived as our written languages.

Language itself speaks in many photographs. At one point in his photographic perambulations, Nathan Lyons came upon an irresistible billboard that read READY OR NOT . . . JESUS IS COMING! Lyons likes to photograph messages that embody past, present, and implications of the future. That particular message is a kind of threat of an immanent event whose precise time we cannot foretell. But clearly, the Jesus who is coming is that dire figure of Michelangelo's *Last Judgment,* else why threaten us, why warn us? The past contains our sins, our unreadiness; the present is the warning; and the future is heaven or hell. Quite a message!

In terms of the medium itself being the message, daguerreotypes and ambrotypes seem to carry time with them as part of the processes now seemingly abandoned forever. We tend to trust images recorded in these processes as representative not only of their technologies but of a certain time in the history of photography. Unfortunately, identifying process alone can no longer help us ascertain the time frame of a photograph. At Faneuil Hall in Boston, for example, you can yourself pose today for a daguerreotype. However, we do consider that photographs portray discrete moments of time that we can examine in the now as reliable guides to past information.

Not only the documentarians, but even the aesthetic pictorialists were interested in capturing the evanescent moments of reality. In a charming image by Pierre Dubreuil, a shuttlecock flies between two upper-class children bathed in the warm glow of orange-tinted gum bichromate as they play a game of badminton. Obviously, such depictions of suspended action were made possible by the increasing speed of light-sensitive emulsions as well as by camera shutters that could control the length of exposure. The two children in the Dubreuil

seem poised in eternity, brushed by the wings of their own time, yet removed from the world of cause and effect, removed from the terrors of onrushing time. Dubreuil has encapsulated them forever.

In another Dubreuil image, a puffing railroad engine roars on the tracks heading straight for us, but he photographed it in such a way that it seems suspended forever so that we might contemplate the formal geometry of the image. The train will never move forward. The steam will never dissipate. Even the most active subject can be deactivated by stress on formally beautiful composition. By this means, Dubreuil asked that we contemplate the symbolic meaning of the train, not its speed on the tracks nor its plunge forward. It is not the "decisive moment" we are asked to admire, but rather the long-term significance of an event. The "decisive moment" belongs to the photographer, not to the viewer. When we engage in contemplation, we are outside time, and we begin to be able to define eternity.

But when Dubreuil composes a picture in such a way as to imply ongoing motion, then we are forced to draw conclusions about past and future action. Even if we know intellectually that the tiny toy carousel horses in one of his pictures could never actually move, the gestural implication of those prancing hooves pushes us toward a nonverbal acceptance of the idea of motion. It takes only a few seconds for our eyes to travel from the top right corner to the bottom left and to rush back around again to the top, but those few seconds are enough to make us imagine swift movement on the part of the stationary creatures. Photographs are certainly *still* in the sense of being silent, but sometimes they are not at all still in the sense of being without movement. And movement takes place through our sense of time.

FROM MUYBRIDGE AND MAREY TO EDGERTON The need for stopping time in smaller and smaller increments has increased relentlessly since the experiments of Eadweard Muybridge in the 1870s. To capture the movement of racing horses, Muybridge set up a sequence of cameras rigged with electrically controlled shutters at about 1/1000th of a second, undoubtedly the fastest photographs taken up to that time. But a French contemporary of his, Étienne-Jules Marey, was dissatisfied because he wanted to show the continuity of motion rather than the separate movements Muybridge succeeded in capturing. Ingeniously, Marey devised ways of recording a sequence of motion on a single plate. A man wearing a black suit with a white strip painted on it was recorded as he ran past Marey's camera. Marey called his work chronophotography, literally the photography of time.

Marey also invented a single large photographic plate that was exposed to light only through the slits of a revolving wheel. The Marey wheel, as it came to be known, contained twelve slits through which fairly rapid exposures could be made. This wheel was a true stroboscope, a word meaning "whirling

13. Eadward Muybridge. *Dog, Galloping; Mastiff "Dread,"* 1886.

watcher,'' and was a forerunner of the astonishing accomplishments of Dr. Harold Edgerton at MIT in the 1930s. Edgerton, an electrical engineering professor, was at first interested primarily in studying the action of rotary engines. He soon discovered, however, that his invention of the electronic stroboscope and what we today know as electronic flash photography would alter forever how we see things.

Edgerton's strobe was used to capture the sequences of motions made by tennis players, girls skipping rope, dogs hurdling benches, and a wide variety of sports activities, including boxers and ice skaters, these usually at sixty multiflash exposures per second. Each moment of the action could be captured, yet Edgerton prefers to speak of ''events'' being stopped rather than time alone being stopped. A true son of the Einstein era, Edgerton does not separate time and space, but considers them together as an inseparable continuum.

Edgerton sought the perfect combination of timing and motion that would astonish viewers in pictures like *Milk-Drop Coronet* and *Shooting the Apple*. The visual surprise in the latter startling image is that entry of the supersonic bullet was as violent as its exit. A moment later the apple disintegrated, making it possible for Edgerton to title one of his lectures, ''How to Make Applesauce at M.I.T.'' Joke or not, a .30 caliber bullet traveling 2,800 feer per second required an exposure of less than 1/1,000,000th of a second to capture its passage. We might with justice call *this* stopping time.

TIMELY NEWS There is another sense of time being addressed when we talk of a picture being "timely." Newspaper publishers are rapaciously competitive about the timeliness of news photographs, and it became an urgent matter in the late nineteenth and early twentieth century to cut as much time as possible from the interval between taking the picture and seeing it in print. Photojournalists like Jimmy Hare became daredevils as they dodged bullets to capture battle scenes. Thanks to progress in rotogravure and other printing processes aided by photographic technologies, the cameramen of World War I had their photographs, including stills from motion pictures, published in millions of newspaper editions. Even the great gray lady, *The New York Times,* published special gravure sections and urged the public to collect them as specimens of "beautiful" photographs. What wonderful memories they were supposed to evoke is difficult to imagine, but it seems obvious that the newspapers marketed their pictures not just as excitements for the present, but as potential memories in an undefined future. Thus, what was timely was also expected to retain value over time.

Sometimes "before and after" news pictures yield most peculiar sensations. *Time* magazine, for example, published two photographs of the German city of Cologne, placing them side by side: the demolished city in 1945, after the heavy bombardments during the last days of World War II; then Cologne as it was in the 1980s, successfully revived and completely rebuilt. Looking at the picture of bustling Cologne, you may have an uncanny feeling as if certain things really had not happened. The time frame of any picture may be meaningless without an understanding and an acceptance of the context of the pictures.

MORTALITY AND TIME Yet another type of time recorded in photographs is the passage of time implicit in a single still subject. Was it Walker Evans or Minor White or Aaron Siskind who first began to record the destruction of painted surfaces and postered walls by the wrath of the elements over periods of time? Siskind, like Evans before him, saw in the deterioration of posters signs of mortality, the wreck left behind in time's wake. While he communicates far more than the simple passage of time as evinced by the tearing and layering of posters, he is clearly obsessed with their loss of solidity and longevity. Despite the fact that time seems embedded in Siskind's evocative fragments, we cannot tell which time is involved, how much time elapsed between the posting of a paper message on an outdoor wall and the last flapping piece of paper detritus. Siskind's imagery, therefore, is more a symbol of the *idea of time* rather than a specific time of any kind.

The idea of time and its inexorable passage finds eloquent embodiment in portraits, especially in Anne Noggle's records of her aging mother's face,

body, hands, taken through the last decade of Agnes's life. Who was it who said the human face is a clock? Discovering the human clock in his own visage, William Butler Yeats wanted to "spit into the face of Time / that has transfigured me." In a picture called *Artifact,* Noggle relentlessly recorded her mother's gnarled and furrowed hands holding in her lap nothing less than her upper dental plate. As Shakespeare put it, old age will deprive us of everything from hearing to sight, until at last we will be "*sans* teeth, *sans* everything." Noggle calls aging "the saga of the fallen flesh," but managed to endow her mother's last portraits with sublime dignity.

Time passes, bringing with it mortality. But *times* change, and sometimes bring improvements in social conditions. It seems to be difficult for still photographs to depict the changing of certain types of social conditions, and they may have to rely upon text to define their content. There may be no visual equivalent to verbal ideas about time, but anyone sensitive to changing mores would have to reject something like Bertrand Russell's epigrams on the "ages of man": "The child lives in the minute. / The boy in the day. / The instinctive man in the year. / The man imbued with history lives in the epoch. / The true philosopher lives in eternity."[10] Today such statements would be deemed sexist, since they seem to be excluding the female of the species. But even making Russell's statement about time less sexist does not necessarily make it possible for such abstractions to be photographed. Could we take photographic portraits of boy, man, or, for that matter, girl or woman, that could express the relationship of a person to a year, or an epoch? For expressing abstractions like "epoch," even a series of photographs may prove less accurate than language. Words best convey abstractions even if we interpret those abstractions according to our individual ideologies.

Photographic collages treat time uniquely, as the work of Vaughn Sills demonstrates. Sills has combined her own portrait with that of her mother, her grandmother, her early childhood. A comment by the psychologist Joost Meerloo may help to understand such an approach: "Temporality—awareness of the point of time—and duration—moving in time—are the keynotes in human self-awareness and existence, the beginning of comprehension. They involve an inner effort to go beyond the immediate data toward the continuity of the self."[11]

Sills felt very close to her grandmother and tried to express her feelings diaristically as well as photographically. In looking at her composites of images coalesced in the now but representing stages of her own development, I find an image history that has some relationship to cubism. At one point in that style's evolution, the painter Jean Metzinger observed that the cubists had abolished the rule that commanded painters "to remain motionless in front of the object, at a fixed distance. . . . They have allowed themselves to move around the object, in order to give . . . a concrete representation of it, made

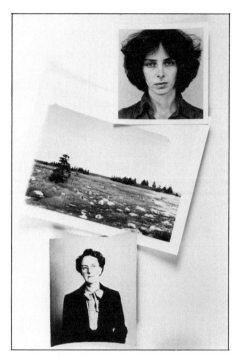

14. Vaughn Sills. *Self, Nova Scotia
Landscape, Grandmother*, 1985.

up of successive aspects. Formerly a picture took possession of space, now it
reigns also in time."[12] Stephen Kern's marvelous book, *The Culture of Time
and Space 1880–1918*, discloses many such observations. Rereading it helped
me conclude that, like her teacher Wendy Snyder MacNeil, Vaughn Sills does
not seek to make photography stop time. On the contrary, she wants to show
us many aspects of time in relation to each other.

MOVEMENTS OF TIME Like the portrait collage, the diptych or triptych
formats manage to display aspects of time in relation to each other. In Carl
Chiarenza's diptych of 1982 called *Menotomy,* he manipulated light to commu-
nicate the passage of time not in this world but in some mysterious universe
beyond our ken. Yet we do not know how much time or on what planet these
conditions might be operative. Chiarenza typically transforms fabrications
made to be photographed into poetic fantasies, and fantasies, as we all know,
must exist outside of commonsense time. Encounters with art tend to lift us
outside time; perhaps that is why Nietzsche said that art is what keeps you
from going crazy. In Chiarenza's art, his intense blacks and silvers proceed
like musical chords, a progression in time and rhythm that moves the soul.

 In music, we are expected to hear time moving. On television, we see time

moving: history passes before our eyes too rapidly to comprehend. Michael McKeen invented sequences culled from the evening news that he calls "Mock TV." He is convinced that we are going to smother in images that we are not permitted time to understand. The evening news consists of twenty-two minutes of "news" and eight minutes of advertising. The "news" sometimes consists of one sentence with a visual background to fill in the space around the anchorperson's head. The eight minutes of advertising is visually far more exciting than the news. Therefore newscasters attempt to liven up the news by speeding it up. What would take a leisurely column of explication in, say, *The New York Times,* flashes by in seconds on the tube. It has become impossible to tell the difference between newscasts and other forms of entertainment. We have become frenzied consumers of visual messages that speed by at what used to be intolerably quick rates for the human eye and brain. We may have become so accustomed to glancing at pictures that we rush by still photographs without granting them time for comprehension, enjoyment, or evaluation.

Human gestures, human actions, involve time. We move through time, we live time, we are creatures of time. Photography retrieves for us small shards of time, and we should relish our astonishment at this fact. Photography juggles time. Yet we can only know these shards and other simulacra of times gone by in the present, in the now. The longer we contemplate a photographic image, the longer we stay in the now. Staying in the now, instead of furiously rushing toward the future, has psychological advantages, and profound reverberations in our lives. As Ludwig Wittgenstein observed somewhere in the *Tractatus,* those of us who live in the present live in eternity. That is, we remain outside of time even while clocks tick their artificial minutes away. Perhaps the real measure of a photograph's greatness is that in its presence we experience a priceless relief from mortality, we engage in such intense thought that we have a sense of being outside ourselves, even for the eternity of a moment.

Based on a presentation at the University of Rochester's "Rochester Conference: *On Time,*" January 13, 1987. Previously unpublished.

Aesthetics and Photography

DIANA & NIKON: ESSAYS ON THE AESTHETIC OF
PHOTOGRAPHY

THE *NEW YORKER* IS one of the most sophisticated, civilized, and reliably perspicacious journals for the educated, upper-middle-class reader, a joy for the literate urbanite, unashamedly snobby in the chicness of its advertising, and generally shrewd in its political assessments. It is no accident that Janet Malcolm, the *New Yorker's* photography critic, shares many of its characteristics.

Malcolm is eminently intelligent, completely at ease in the contemporary scene, possessing both charm and acerbity, forthrightness and lucidity, and an expertise of surprising strength in the criticism of fashion photography. It has been remarked that she does not consider herself embedded in the photographic establishment—whatever that means—but it is unmistakable from these essays that she has a substantial background in literature and, most probably, art history.

The jacket illustration for *Diana & Nikon* is a photograph of a nude statue (by Saint-Gaudens) of the chaste goddess of the hunt. (Close examination reveals that Diana's bow, clumsily reinforced by what looks like piano wire, offers no arrow for the hunt.) It is an eye-catching jacket, but misleading. The Diana to which Malcolm refers is not out of mythology but out of a factory: a cheap little toy camera with a plastic lens noted for producing pastel-colored nostalgia and fascinating distortion. To compare the Diana with the Nikon—one of the best-known trade names for complex electronic precision in the 35mm line—is to establish the antipodes in both technology and artistic ideology. And that is Malcolm's intention.

It is one of her central propositions that there is a war between the unpretentious snapshot and the ambitious ''art'' photograph, with the snapshot winning battle after battle. Citing John Szarkowski's influential presentation in *The Photographer's Eye,* she reminds us that he equated the aesthetic value of ''fine-art'' photographs with ''the unselfconscious vernacular of commercial or news or amateur photography.'' This idea is rank heresy to those who believe that only the meticulously designed prints of, say, Edward Weston can be said to exist on the aesthetic plane. Malcolm wisely quotes Lisette Model on the

special delights of the vernacular photograph: "The picture isn't straight. It isn't done well. It isn't composed. It isn't thought out. And out of this not knowing, and out of this real innocence toward the medium comes an enormous vitality and the expression of life" (p. 69). It is presumably this combination of innocence with vitality that places the snapshot so high in the aesthetic hierarchy. Malcolm, unfortunately, sometimes seems to confuse the handsome accomplishments of many studio operators, who really knew how to pose and how to light, with this snapshot aesthetic.

As Malcolm notes, the professional photographers who have pursued the snapshot aesthetic—Garry Winogrand, Lee Friedlander, and Lisette Model herself—have succeeded in imitating the clutter, the seeming spontaneity, the accidents of pose and lighting, and all the hideous, hilarious, or simply homely aspects of the "candid." This is the dilemma dominating much of contemporary criticism. If an expert like Joel Meyerowitz can deliberately seek, and find, the richness of the accidental (if that is not a contradiction in terms, to seek the accidental) and if G. Botsford's or Nancy Rexroth's prints seem at first glance to be indistinguishable from the rank amateur's, then by what standards shall we ascertain the excellence of these new-style images? Can we delineate any difference between the excellence of one picture (professional) with the excellence of another (amateur)? If the images are indistinguishable from each other, and all are presumed to lack the traditional canon of balanced composition, rhythm of elements, harmony, and unity, are there any criteria by which we can judge these new images? And what on earth would justify our paying currently inflated prices for the established photographer of this school? Is anyone buying? Why are the traditional qualities of the pictorialists (the aesthetic photographers whose manipulated prints appeared so often in Stieglitz's commercial work) so valued on the market at the moment?

Since Janet Malcolm is offering us her *Aesthetic* in these essays reprinted, with one exception, from the *New Yorker,* we do not have to read far before we discover her major hypothesis: "If you scratch a great photograph you find two things: a painting *and* a photograph. It is the *photographic means* with which photography imitates painting that produce a photograph's uniqueness and aliveness." Now, this would seem not only to verge on tautology but to contradict everything else she has said. She offers as proof the work of Robert Frank, who, in his widely influential book, *The Americans,* seems to her to epitomize the "nakedly photographic." The nakedly photographic consists of "messy conjunctions of shape, the randomness of the framing, the disorderliness of the composition, the arbitrariness of gesture and expression, the blurriness and graininess of the printing."

The illustration of these characteristics that her book offers is Frank's picture called *Gallup, New Mexico* (1955–56), a tilted view of cowboys standing in a bar, the near distance obscured by two dark forms, one of them the close-

up of a man's back and his overcoat. There is nothing random about the framing of this content. As a matter of fact, the picture demonstrates many of the traits of the action paintings of the 1940s and 1950s and is constructed on the very ancient principle of one-third light to two-thirds dark. Furthermore, there is something in the picture, as in all Frank's work in *The Americans,* that derives not so much from the snapshot as from something that Malcolm misses entirely: the influence of what was called *film noir* in the same period. *Film noir* was characterized by severe contrasts of light and shadow, almost expressionist in derivation, with depressing, intimidating, or completely threatening decor. The camera tilts in Frank's work could as easily derive from Orson Welles's magnificent breakthrough in the cinematography used for *Citizen Kane* as from any unique pioneering instinct that Malcolm ascribes to Frank.

It was said of Welles that his use of the wide-angle lens and the tilted camera transformed space and movement in film. *Citizen Kane* is possibly the first major film in which the studio sets actually had to have ceilings, because the camera was tilted upward so often to give the actors monumental stature and tilted sideways to create tension and instability. In Frank's picture of *Gallup, New Mexico,* the upward tilt of the camera, the threatening darks, the seeming accident of composition, and the grungy realism of the scene resemble many realist films of the 1940s and 1950s. Frank, a European, was undoubtedly influenced by the *film noir* of France, especially by all those Jean Gabin films in which the actors are seen in fragmentary poses, bisected by scary shadows, depressed by human fate. He undoubtedly knew the moving, tilting camera used by Jean Renoir in *The Crime of M. Lange,* for example. Frank is a filmmaker, after all, and it seems highly unlikely that he could have avoided the influence of that cinematic fragmentation, a visual structure that Jean Renoir himself characterized as expressing as much the implications of the space around or implied by a particular frame as the fluid compositions within it.

Perhaps Malcolm should review the pervasive influence of Jean-Luc Godard's *Alphaville* (itself a take-off from the American *film noir*), which shares with Robert Frank's still photographs features like graininess, despair, tawdriness, dark anarchic shadows, depressing urban vistas, and a sense of paranoia. Perhaps further investigation of film would encourage Malcolm to abandon her theory that painting occupies the center of the photographer's world. Malcolm might argue, as she does in her discussion of color photography, that painting influenced the development of film art, as, for example, in the impressionism of *Elvira Madigan.* What she overlooks is that film, as the medium of motion, has pushed the aesthetic of the photograph toward the elusory, the ephemeral, away from the static and toward the shocking suddenness of the jump cut.

While Malcolm makes some surprisingly naive statements, especially in confusing Stieglitz's photo-secession with pictorialism itself—thereby denying at least twenty years of photographic history—her intelligence and capable in-

sights more than compensate. She is perhaps at her best in two essays on Richard Avedon, where she effectively documents her proposition that "the camera is equipped as no other medium is to show things in their worst possible aspect." In these essays, "Men without Props" and "A Series of Proposals," she comments astutely on the monstrously oversized and frightening portraits that Avedon took of his own aged father, as well as of priests, singers, madmen, psychiatrists, and even of Robert Frank himself. These essays are well worth the price of admission and will probably become classics of the academic classroom.

One of the definitions of an *aesthetic* is that it is "the science of cognition through the senses." Unlike the 1890s, which thought that aesthetics pertained solely to what Santayana called *The Sense of Beauty,* the 1980s recognize that any discussion of a medium as pervasive and powerful as photography must include not only the beautiful, but the moral, the social, the psychological. Malcolm makes us hope that she will elaborate further on her many provocative statements and produce something for which photographic criticism still awaits: a coherent field theory. What would be marvelous fun would be to somehow persuade Janet Malcolm, Susan Sontag, John Szarkowski, and Gisele Freund to sit down together and argue their various points of view. The possible permanent concussion we might all experience as a result of such a heady mix of Marxism and conventional criticism would be worth the risk.

The New Boston Review, November-December 1980.

The Subject Beautiful

A FEW WEEKS AGO, I WAS REMINDED of a familiar statement by Herman Melville, to the effect that if you want to write a great novel, you must choose a great subject. Like the well-trained, late twentieth-century aesthetician that I sometimes am, I brushed this away as having no possible relevance to the study of photography. After all, we know that the great subjects of, say, the American Civil War turned out to be Alexander Gardner's or Timothy O'Sullivan's aesthetic rearrangement of the dead soldiers at Gettysburg and Chancellorsville. Yes, yes; the presumed great documentarians had moved the poor corpses around to get a more interesting effect. It was only one example of thousands that indicate that, of course, it is what we do with a subject, rather than any intrinsic merit of the subject per se, that matters.

Unfortunately, like the well-trained, late twentieth-century information scientist and communications specialist that I sometimes am, I was not really satisfied with my swift dismissal of what was obviously not such a simple matter after all. What came to mind was the famous ''bulldog'' portrait that Yousuf Karsh had made of Winston Churchill. What if all those special effects of backlighting, pose, limited focus, and framing within the rectangle had been expended on, say, my own grandfather?

Would we then reproduce my grandfather's portrait in *Life* magazine and in a hundred photography manuals, not to mention the history books or Mr. Karsh's own publications? I doubt it. There seems to be a special aura of greatness about the photograph itself because its subject had been a great and important and well-recognized statesman, someone who had brought us through a great war with magnificent oratory and bulldog determination.

Obviously, some extraneous informational aspect of the photograph was impinging on the presumed aesthetic and formal characteristics we are expected to admire. Is it simply the anonymity of vernacular photographs that stands in the way of ''greatness''? Is it the generally unsuspected characteristics of photography as a mass medium—as ordinary and commonplace as everyday speech—that promote some special difficulties in the appreciation of the aesthetic qualities of photographs?

Think, if you will, of photographs. Billions of them. Lurking in closets, fading on bedroom walls, pressed into albums, worshipped on large mahogany desks of corporate executives—all those souvenirs of picnics, and the flotsam of hasty vacations.

Think of the millions and millions of color slides—of Greece, of Rome, of the Taj Mahal—millions of them stashed away in drawers and boxes. Some energetic statisticians have estimated that these millions of slides are looked at only once a year, if then, before the preliminary excitement dies, or during the first obligatory tourist slide show for the neighbors.

Salon photographs, art photographs, photographic postcards, pictures of Mars and the moons of Jupiter, galleries filled with photo murals, fashion models' portfolios, anthropologists' area files, photographic auctions and photographic fairs, not to mention the local amateur photography club. And reproductions of photographs in every book, in every journal, on the newsstands—ubiquitous, inescapable.

Think now not only of other people's photographs, but of your own—of those pictures you carry in your wallet—snapshots of loved ones nestled in those awkward acetate windows; snapshots of pets, both canine and feline, perhaps even equestrian; snaps of your grandmother's house before it became a parking lot.

And now think of cameras that focus automatically, cameras that deliver a colored square into your eager fingers instantly, cameras that beep if you don't have enough light, cameras that fire off three shots per second, cameras with manual override, twelve different viewing screens, twenty-two interchangeable lenses, and your choice of synchronized flash.

It has been estimated that, in thirty years, the world's supply of silver available for these photographic adventures will be permanently exhausted. And present color dyes may fade in five to eight years.

Are photographs an endangered species? If they are, nothing could please two critics of photography more. Wright Morris and Susan Sontag have warned us that photography is trivializing our existence, keeping us always at one remove from reality, forcing us to cannibalize our experiences, and transforming every authentic moment into an act of conspicuous consumption.

We need not be neo-Marxists to agree with such a general assessment. It is obvious, however, to any student of the history of media—whether of written language or satellite transponders—that all communication requires some codification of perception that places us at one or more removes from the phenomenological world. Is photography trivializing us, or are we trivializing photography?

Survey, if you will, the enormous publishing output of the nineteenth century: a stupefying array of penny sermons, shoddy novels, ladies' fashion magazines, quaint poetry albums illustrated with sentimental genre scenes,

advertising posters and catalogs, children's cautionary tales, ponderously pedantic treatises on etiquette and home decoration, Horatio Alger success stories, mawkish travelogs, gothic romances, and all the rest of that prodigious removal from reality that someone like Herman Melville towers above.

Of course, we do not—or should not—judge popular culture artifacts by rigid aesthetic formulae. Rather, we tend to examine trashy novels and Star Trek buttons in the frames of reference provided by cultural anthropology or sociology, looking for the relationships of the popular arts to the uses made of them in the fantasy life of specific audiences.

No matter how they vilify photography as a mass medium, neither Morris nor Sontag denies the aesthetic possibilities of photography as artistic expression. They do tend to leave the benighted word ''beautiful'' to writers in popular photography magazines, where, presumably, experts are offering amateurs hints on the prettifying or glamorizing of perfectly ordinary subjects.

I say ''presumably'' and ''ordinary'' because manuals, handbooks, and guides for amateur photographers are amazingly full of hints about a possible hierarchy of subjects.

We do, of course, trivialize photography, and sometimes it is in pursuit of the ''best'' subjects. Recently, I was browsing through a tour guide to the Caribbean (wishful thinking), and I was surprised to find as much attention paid to tips for photographs as to good hotels and appropriate evening wear. I was advised that each island had its own special set of views. I was told where I should stand, which views might require framing with a bit of bougainvillea or hibiscus. Particular subjects were stressed: soccer games, snack vans, cathedrals, yachts in the bay, the left side of the statue of Josephine in some villa yard, Spanish grillwork—why, this is almost as outrageous a list of academically acceptable subjects as those we find proposed in the discourses of Sir Joshua Reynolds, that eighteenth-century would-be dictator of what should or should not be painted.

Reynolds was determined that only the grand subjects deserved the name of ''art'': choice scenes from the classics, historical subjects on the high order of generals or governors, the Three Muses, and other grand themes. For he said, ''If deceiving the eye were the only business of art, there is little doubt, indeed, but that the minute painter would be more apt to succeed.'' (I cannot resist correcting that statement to read ''painter of minutiae,'' because it is too hilarious to think of a tiny painter you could pop out of your pocket.)

Furthermore, said Reynolds, ''The painters who have applied themselves more particularly to low and vulgar characters, and who express with precision the various shades of passion as they are exhibited by vulgar minds (such as we see in the works of William Hogarth), deserve great praise; but as genius has been employed in low and confined subjects, the praise which we must give must be as limited as its object.''

Stand, then, oh you eager travelers, cameras at the ready, checking off your lists of sublimely acceptable scenes, and if the ghost of Reynolds has forgotten his contempt for landscape, he may smile down on you from heaven.

When Reynolds was condemning low and confined subjects, what he was really talking about were the poor and downtrodden, the people tourists would see if they ventured forth from the sterile precincts of the safe hotels and visited the filthy hovels, the shameful groves of corruption and despair, of illness and savagery. Suddenly, the problem of what makes a pretty picture is obliterated by urgent messages of neglect and exploitation. And, suddenly, we talk no longer of beauty or the aesthetic emotion, but shift into other frames of reference: photo-journalism, -advocacy, -communication.

I would suggest that shifting the frame does not solve our problem, for Henri Cartier-Bresson, many of whose photographs have been called not only "great," but also "beautiful," insisted on being labeled "photo-journalist." He did this to escape what he thought were futile, sterile, counterproductive arguments over the word "art."

Photographers who pursue the beautiful with conscious, mystical fervor, like Ansel Adams and his romantic melodramas of the Far West, are often accused of neglecting the problems of society. Photographers who pursue the grossly disturbing visions, like Mary Ellen Mark and her images of mental patients or the prostitutes of Bombay, are accused of seeking shock for its own sake, or worse, of aestheticizing human suffering. The subject of the photograph seems to govern the response to the photograph as inevitably as Reynold's discourses led to a stultifying academicism.

John Szarkowski, the distinguished curator of photography at New York's Museum of Modern Art, has often remarked that photography is the only medium in which form and content are synonymous. Certainly, it is not difficult to observe that most of us, including that otherwise brilliant philosopher, Roland Barthes, tend to think of photography as a transparent window on reality, with nothing intervening between our eyes and a subject, whatever that might be. And since we come to photography hampered by this illusion, it seems inevitable that we expect that the subject of what we call a "beautiful" photograph must be either (1) beautiful, or (2) treated in a beautifying manner, the most notorious example of which would be Edward Weston's glorification of a green pepper with the sculptural monumentality of, say, a Henry Moore bronze.

How did the great photographers of the nineteenth century resolve this tension between subject and form?

The inventor of paper photography, that most ingenious gentleman, Sir Henry Fox Talbot, was stimulated to pursue his invention by his inability to draw. Unconsciously conditioned by the aesthetic tendencies of early romanticism, he equated the aims of photography with the goals of painting. In his

Pencil of Nature, the first book illustrated with photographs (in the form of mounted paper prints), he commented on a photograph from nature as if it were an artist's sketch. "A painter's eye will often be arrested where ordinary people see nothing remarkable. A casual gleam of sunshine, or a shadow thrown across his path, a time-withered oak, or a moss-covered stone may awaken a train of thoughts and feelings, and picturesque imaginings." This sounds as if it is straight out of William Gilpin's 1794 essay on the picturesque criteria for paintings.

One of Talbot's most famous pictures is called *The Open Door.* It displays nothing more remarkable than a straw broom resting against a stone doorjamb, with climbing vines and ivy on either side. This modest picture, photographed in 1843, was seized upon by critics who wished to enlist Talbot into the ranks of the documentarians. It was the amazing amount of detail that led these critics to ascribe to photography the mechanical role of a mere transmitter of information, and the very earliest delusions about photography included the notion that there was a strict isomorphic relationship between subject and recorded image. Later on, the term "documentary" became synonymous with images of brutal proletarian subjects.

As the nineteenth century wore on, the division between the "art" photograph and the "documentary" photograph became more and more pronounced until photographers discovered methods of transforming humble subjects into acceptable genre scenes.

Curiously enough, the so-called father of modern photography, Alfred Stieglitz, began his career with Barbizon scenes of German and Italian peasants, very much in the manner of the painter Max Liebermann, and it was not until Stieglitz had fallen under the influence of the French *fauves* and cubists, Arthur Dove, Wassily Kandinsky, and of his genius wife, Georgia O'Keefe, that he began to seek abstractions, shunning literal subject matter.

Like the good nineteenth-century artist that he was, Stieglitz became fixed on the idea that photography should be like music. You may recall Walter Pater's dictum that all art aspires to the condition of music. And what might that condition be? To be without subject—that is the common delusion. To make pure forms connect directly to an audience's emotions, without the hazardous, arduous manufacture of a physical artifact. (Stieglitz was exuberantly proud on at least two occasions: first, when his photograph *The Steerage* was likened to Pablo Picasso's cubism, and second, when one work in his series called *Songs of the Sky* was seen by the composer Ernest Bloch, who verified that, yes, indeed, the picture called to mind the sounds of clarinets and oboes.)

The French pictorialist, Robert Demachy, writing in the 1907 issue of Stieglitz's *Camera Work,* was also vehement on the notion of subject. "Take as an example a beautiful motive such as a sunset. Do you think William Turner's sunsets existed in nature such as he painted them? . . . Why, if the choice of a

beautiful motive was sufficient to make a work of art, ninety percent of the
graphic works in the world, paintings, drawings, photographs, and chromos
would be works of art.''

This was all nonsense, Demachy decided, indicating that the problem was
that two terms were then considered synonymous: ''the artistic'' and ''the
beautiful.'' It was ludicrous to seek the beautiful in nature when what was
wanted was the ability to manipulate photographs in a manner equal to any of
the other graphic arts. To do this, he introduced a number of new techniques,
including gum bichromate and bromoils. Like the American master pictorialist
F. Holland Day, Demachy became addicted to velvety platinum papers and the
soft-focus uncorrected lens.

Day did not believe that the creation of ''the artistic'' or ''the beautiful'' de-
pended merely on a technological manipulation of ordinary subjects. He was
smitten with the idea that photographers must study how the great painters like
Diego Velázquez and Peter Paul Rubens had achieved their emotional effects.
Not at all interested in prettiness, but rather in soaring flamboyant mysticism,
Day wanted to create images that reached the secret places of the soul. Like
William Morris, whose design ideals he helped to introduce into America, he
believed that beauty had transcendent moral force, and that the experience of
beauty could alter society for the better. Curiously enough, Day's archrival,
Stieglitz, believed in precisely the same idea, only Stieglitz was much less op-
timistic that the vulgar hordes would ever open their minds to the sublime and
elevating action of beauty.

Demachy's ideal of pictorial manipulation of ordinary subjects and Day's
adherence to the soft-focus lens and the emotionally charged subject were both
anathema to Paul Strand. Yet even Strand strongly defended the notion of
studying painting. ''For if photographers had really looked at painting, all of
painting, critically as a development, if they had not been content to stop with
the superficial aspects of James Whistler, Japanese prints, the inferior work of
the German and English landscape painters, Jean Corot, etc., they might have
discovered this—that the solidity of forms, the differentiation of texture, line,
and color are used as significant instruments in all the supreme achievements
of painting.'' As early as 1917, Strand was describing the formal means by
which his own profoundly beautiful and moving images were created.

In response to an interviewer's question about originality, the photographer
Minor White responded, ''Everything in the world has been photographed a
few million times, and it does not stop.'' He added, ''The material is out there
for anyone to use.'' Then the interviewer apparently made the sage angry, be-
cause he said most emphatically, ''The point is to make a photograph which
has the power of the original subject!'' (Bang! Exclamation point!) That
means, of course, that photographers must either (1) find the powerful subject,
or (2) empower the subject with formal means. Which sounds amazingly like

the previous comments on the beautiful photograph. But did White really mean that the point is to make a photograph that has the power of the original subject? How does one recognize a powerful subject?

Think, if you will, of the thousands and thousands of magnificent color plates in magazines like *National Geographic* or *Arizona Highways:* transparent windows on breathtaking scenes, overwhelming mountains, red sunsets flaming over desert wilderness, monumental redwood trees, vast gorges carved by roaring cataracts. It is probably impossible to decide what, exactly, we do when we look at such pictures. Are we exclaiming, "Oh, what a beautiful (and/or powerful) photograph!"? Or are we subliminally thinking, "Oh, what a fantastic view! What a fabulous place! Wish I could go there! Wonder what it costs? Of course I'll take my camera because look at all those marvelous subjects!"?

White, to the best of my knowledge, never took a color slide of a red sunset flaming over desert mountains. As you will recall, his photographs are intensely intimate poems about metaphysical aspects of nature and the transcendence achieved by the study of pure form.

One of the more interesting of the social interpreters of photography, Alan Trachtenberg, observed that "neither photographs nor the experience of them is an innocent act. A photographer never confronts an empty canvas, an abstract pictorial potentiality, but always a world already shaped, already understood." There are at least two interpretations of this statement that come readily to mind: (1) that the photographer is stuck with the phenomenological world that presents itself to his or her camera, and (2) that the photographer is stuck with his or her stereotypical understanding of what the world represents or signifies.

Communications theorists, sociologists of knowledge, and information scientists all agree that we tend to see only what we have already labeled or tagged and that, unfortunately, everything else drops through the sieve of inattention. That is, unless we have developed what Marshall McLuhan called "the antennae of the artist."

Trachtenberg fortunately continued. He began by saying, "A photographer never confronts an empty canvas, an abstract pictorial potentiality, but always a world already shaped, already understood." Then Trachtenberg points the way for us, "Reshaping, understanding anew in light of previously undetected concepts, is the most strenuous, most originating work of serious photography."

But how does one learn to escape convention, to reshape, to create new understanding? Sontag scathingly remarked, "In this century, the older generation of photographers described photography as a heroic effort of attention, an ascetic discipline, a mystic receptivity to the world which requires that the photographer pass through a cloud of unknowing." Then she quoted White:

" 'The state of mind of the photographer while creating is a blank . . . when looking for pictures. . . . The photographer projects himself into everything he sees, identifying himself with everything in order to know it and to feel it better.' " She also quoted Cartier-Bresson, who had once likened himself to a Zen archer who has to become the target in order to be able to hit it. " 'Thinking should be done beforehand and afterwards, never while actually taking a photograph.' " Sontag's complaint here is that these attitudes are presumably antirational and anti-intellectual, and she'd have none of it.

Alas, alas! Sontag was quoting out of context. White explained that his phrase about "keeping the mind blank" was simply his way of saying that the person should be totally sensitized to the visible world. He also suggested that if photographers (and I daresay anyone else) were to walk a single city block in that state of total sensitivity, they would be out of film in five minutes and completely drained of all emotion.

Perhaps Sontag's error here is believing that the process of thinking is purely verbal. Whether you call it the dominance of the right hemisphere of the brain—with its kinesthetic, tactile, spatial, rhythmic sensitivities—or choose to call it simply "nonverbal ability," the intelligence of people adept at visual expression and visual communication seems magical and intuitive and, therefore, to someone like Sontag, irrational and untrustworthy.

Certainly, without having experienced the charisma of a phenomenal teacher like White, who counseled Gurdjieffian exercises and deep meditation before undertaking to make even a single photograph, it may sound like some kind of hocus-pocus. The camera manufacturers are so skillful in making us all assume that we can take pictures effortlessly that we forget that all art requires discipline, practice, patience, dedication, receptivity, sensitivity, intelligence, wit, and serious thought. I am not talking about the making of pretty pictures. I am talking about creativity and intelligence.

Think again of those millions and millions of photographs. Think again of the almost compulsive need to see the world through a camera, as if one could no longer trust to memory or imagination. In the explosive tensions of our present society, where is the tranquillity required to contemplate *any* subject?

The word "beauty" has been in hiding since the 1890s, and probably for good reason. Today it seems more attached to Catherine Deneuve's seductive narcissism in those ads for Chanel No. 5 than to a contemplative activity, an activity that allows us to interact with nature as well as with artifacts. I suspect very few of us know how to spend time with a single photograph. That transparent window seems to render its subjects so effortlessly that we pass on, dismissing the life of forms that endows any great photograph with deepening significance and emotion, or we pass on, ignoring the urgent message beyond the aestheticized suffering, neglecting to ask what the photograph is asking of us.

Because I have barely scratched the surface of a complex aesthetic problem, let me close with these few observations. To erect a hierarchy of subjects, to propound a hierarchy of aesthetic values, as we all know, is to help erect the horrors of Soviet realism, neoclassic fascism, and an elitism that ultimately leads to suffocation. Even Herbert Marcuse agreed with that idea, because he recognized the politicizing of art (and photography is an art, of course, a method of investigating the universe) would not help to change society. In his critique of Marxist aesthetics, he voiced the novel idea that societal change comes first, and art follows.

If we do not recognize that every photograph, like any other aspect of the communicative arts, represents a conscious or unconscious ideology, and that photographs are *not* transparent windows but concretizations of ideas, we can never hope to solve the special dilemmas that photography presents. Whether it is the presumed greatness of a subject, or an idea of how to make an ordinary subject great, the aesthetic decision cannot be separated from the social and intellectual matrices out of which all art, all science, all philosophy, and all communication originate.

Originally published as ''Photography and Aesthetics'' in *The Simmons Review*, Winter 1982.

Quintessences
EDWARD WESTON'S SEARCH FOR MEANING

IF YOU GREATLY ADMIRE many of Edward Weston's photographs—as I do—and if you find them aesthetically majestic, recognize their substantial influence and their high status in contemporary criticism, you may turn to the photographer's writings in an effort to discover his intentions, his philosophies, perhaps even his secrets. Expect complexity.

As you begin to study Weston's prolific writings and his numerous statements about his own work, you quickly encounter the word *quintessence,* which he used to describe his primary goal in photography—to reach, with the aid of the piercing "honesty" of the camera, beyond superficialities to the quintessence of an object. A moment later, however, you read that he wants to make a rock *more* than a rock, a tree *more* than a tree, an apple *more* than an apple, a pepper *more* than a pepper. Continuing on, you will find that he vehemently opposes what he calls interpretation, but concedes that each person will have his or her own idiosyncratic reaction to both objects and photographs. If you are a photographer yourself, you may be unduly gratified by Edward Weston's insistence that "photography admits the possibility of considerable departure from factual recording,"[1] but wonder what he meant by saying that his goal was "direct presentation of THINGS in THEMSELVES."[2]

For how can you make a direct presentation of things in themselves, and yet depart considerably from factual recording? How can you reveal the quintessence of an object, yet make it more than it is? How can you avoid interpretation, yet remain yourself, with your own subjective reactions? Are these ideas contradictions in Edward Weston's thinking, or did he somehow find a way to reconcile seemingly disparate implications?

There was much to reconcile. In an early statement in 1922, Weston concluded in a lecture that his ideals of pure photography (he had only lately given up pictorialism) were much more difficult to live up to in the case of landscape, "for the obvious reason that nature—unadulterated and unimproved by man—is simply chaos. In fact, the camera proves that nature is crude and

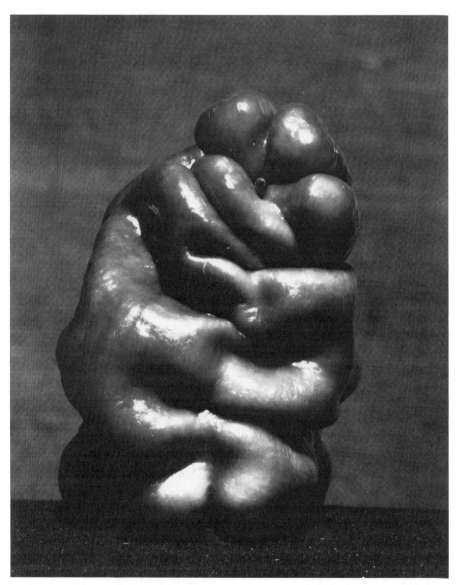

15. Edward Weston. *Pepper #14*, 1929.

lacking in arrangements. . . ."[3] Nine years later, in a 1931 statement, Weston declares:

> I am not trying to express myself through photography, impose *my* personality upon nature (any manifestation of life) but without prejudice or falsification to become identified with nature, to know things in their very essence, so that what I record is not an interpretation—*my* idea of what nature should be—but a *revelation* or a piercing of the smoke-screen artificially cast over life by irrelevant, humanly limited exigencies, into an absolute, impersonal recognition.[4]

Given the obvious fact that all of us change our opinions over time, and are entitled to do so, how did Weston travel philosophically from the idea of nature as chaos to a desire (and an ability) to become "identified" with nature? Did he notice the implication in his 1931 statement that *he* was capable of rising above "humanly limited exigencies" to an "absolute, impersonal recognition"? Later in that statement, Weston attempted to clarify his position by this declaration of his goal: "To present the *significance of facts*, so that they are transformed from things *seen* to things *known*."[5] He did not explain how he became endowed with what might be interpreted as godlike capacities.

Unfortunately for Weston's line of reasoning, the facility for recognizing the significance of facts varies considerably from human to human, since it is the idiosyncratic individual who assigns values to everything he or she encounters. The camera, of course, is a machine that cannot assign value, in the sense of significance. For all Weston's frequently iterated desire to achieve an absolute, impersonal recognition, he explained just as often that it was the intelligence of the human being behind the camera who directed it to its ultimate achievements. As for identifying with nature, one solution that worked for Edward Weston was to isolate fragments of nature. At the same time, however, he was able to deal magnificently with monumental aspects of nature—the dunes at Oceano, tomato fields polka-dotting toward the horizon, the poignant evanescence of tidal pools at Point Lobos, the plunging surf with the fog obliterating the Big Sur coast. Making selections out of the chaos of nature was precisely what photographers had been doing since the beginnings of the medium, for it was—and will always be—impossible to depict *all* of nature in one image.

In 1930, Weston wrote:

> . . . The camera for me is best in close-up, taking advantage of this lens power: recording with its one searching eye *the very quintessence of the thing itself* [emphasis added] rather than a mood of that thing—for instance, the object transformed for the moment by charming, unusual, even theatrical, but always transitory light effects.[6]

Since he would later insist that "reflected light is the photographic subject matter,"[7] the statement above is either mistaken, misleading, or self-deluding. Unless rigorously controlled by artificial means, *all* light effects are transitory.

The sun continues to move across the sky, clouds pass overhead, shadows come slanting down from houses, mountains, trees. As for the phrase "even theatrical," no one can deny that Edward Weston stage-managed his props exceedingly well, skillfully controlling lighting rather than light, although he would have insisted that just the opposite was true. The searching eye he attributes anthropomorphically to the camera lens is obviously the masterful eye of Weston himself, and this is demonstrated all too clearly in his 1939 article, "Light vs. Lighting," in which he describes the infinite pains he took with just one pepper.

> At the time I made it I was doing a great deal of still life work and my "studio" consisted of a porch open on three sides and screened at the top by an awning of cheese cloth. This particular pepper occupied me for several days. It seemed almost impossible to get all of its subtle contours outlined at once—I put it against every conceivable kind of background, light ones and dark ones; I put it on the ground in the shade, against the sky in the sunlight. I worked several days and made half a dozen negatives, but each time I knew I was wrong, I wasn't getting it. Then in a try-everything-once spirit I put it in a tin funnel and the moment I saw it there I knew my troubles were over. No direct light was needed.[8]

Was Weston struggling here with the quintessence of a pepper, or was he, like any photographer, simply seeking the best way to describe the physical forms of an object, to make an acceptable negative and, ultimately, a handsome, or at least interesting print?

What is this quintessence Weston keeps mentioning? Look at four pictures: *Pepper No. 14, 1929*; *Wrecked Car, Crescent Beach, 1939*; *Surf, Orick, 1937*; and *Knees, 1929*. When you look at these, are you struck by *essences*, or by the superlative composition of each picture? They are superlative in the modernistic sense, composed strikingly within the rectangle, relating negative and positive spaces, beautifully, contrasting mass and volume with emptiness, modeling flatness versus three-dimensionality; you can perhaps marvel at the equilibrium of various elements. This equilibrium is nowhere more conspicuous or satisfying than in the passages of light gray tones to darker tones that incorporate staccato stabs of still darker shapes as the eye travels along the various diagonals of *Wrecked Car, Crescent Beach*. Does one think, "This is the essence of wrecked car?" If so, Weston would have failed by his own account elsewhere, for he often stated harshly that photography had nothing to do with either illustration or literary allusions. Yet if you find yourself going beyond the dubious response of "this is the essence of wrecked car" to "so we must all of us come to dust—or rather, rust," you are allowing precisely the kind of vague sentiment that Weston claimed to despise. Weston would have insisted that he wanted us to look at the visual music of his picture for

16. Edward Weston. *Wrecked Car, Crescent Beach,* 1939.

the subtleties of pure form he had discovered and brilliantly arranged in his ground glass.

Weston was persuaded that his pepper, for example, was beyond any literary allusion or sentiment.

> It is classic, completely satisfying—a pepper—but more than a pepper; abstract, in that it is completely outside subject matter. It has no psychological attributes, no human emotions are aroused: this new pepper takes one beyond the world we know in the conscious mind. To be sure much of my work has this quality—many of my last year's peppers, but this one, and in fact all the new ones, take one into an inner reality—the absolute—with a clear understanding, a mystic revealment [sic]. This is the "significant presentation" that I mean, the presentation through one's intuitive self, seeing "through one's eyes, not with them," the visionary.[9]

One of his fervent admirers, nonetheless, wrote of this presumed absolute pepper, "fancy sees it as a human torso poised with grace and strength; another [pepper] might be a modernist conception of man's struggle to evolve from lower forms."[10] Others, as Weston admitted, saw in his absolute essence of pepper the female vulva, the male penis, sexual intercourse, men wrestling, and all manner of hated Freudian things. While Weston was congratulating

himself on having found a way to make peppers abstract and beyond subject matter, his audience was bemused (and often amused) by the presence of so many similes, analogies, and metaphors.

Weston confessed that few edibles excited him as much as a box of peppers down at the grocer's as he also admitted—he was in analysis at the time—the possibility of sexual eruptions from his own unconscious.[11] He defended his making perhaps fifty negatives of peppers "because of the endless variety in form manifestations, because of their extraordinary surface texture, because of the power, the force suggested in their amazing convolutions."[12] To be delighted by amazing convolutions is hardly equivalent to producing the vision, the essence, or the "mystic revealment" he mentioned above.

Was Weston only indulging in self-delusion, or were there influential ideologies that pushed him toward modernistic preoccupations with pure form? There had been profoundly mystical underpinnings to modernism, many of them linked to theosophical idealism. Derived from Swedenborg's notions of "correspondences" between the physical and spiritual worlds, the essential belief of theosophy was that a parallel universe exists in which all ultimate, pure, ideal forms dwell, free from nature's transitory appearances. The phenomenological world was illusion; truth existed only somewhere beyond our senses. Influential theosophists taught that human beings generate "thought forms" that are universal and emblematic of the spiritual world. When the abstract painter Wassily Kandinsky described these forms in *Concerning the Spiritual in Art* (1911), he influenced photographers like Stieglitz and, ultimately, Edward Weston.

Like so many modernistic photographers, Weston was intrigued by the possibility of a metaphysics of form, and fleetingly pondered the psychology of art. Once in a while, rather plaintively, Weston asked why it was that a combination of lines by Kandinsky or a sculpture by Brancusi—all abstractions—could evoke intense response even if the forms were unrelated to the phenomenological world. "Granted the eyes become excited, Why?"[13] Nineteenth-century artists and scientists had struggled to decipher and solve just such psychological and philosophical problems. What is innately recognizable? How and why do abstract forms stimulate our responses, and are these universal? The great semanticist Alfred Korzybski noted that it is merely language that links disparate forms, that we define "appleness," for example, by a set of characteristics that we assume belongs to all apples. Yet each individual apple is different from the next and is constantly in transition from one time-state to another, from one color and mass to ultimate dissolution. Korzybski might have said that Weston's preoccupation with revealing "quintessence" was as mystical as Weston admitted, and therefore totally unscientific.

Weston was persuaded that there is an underlying unity of life forms. In fact, despite his constant stress on quintessence, he saw a unifying force in all forms. In 1957, shortly before his death, he commented:

If there is symbolism in my work, it can only be the seeing of parts—frag-ments—as universal symbols. *All basic forms are so closely related as to be vis-ually equivalent* [emphasis added]. I have had a back (before close inspection) taken for a pear, knees for shell forms, a squash for a flower and rocks for everything imaginable![14]

As early as 1931, he had stated:

Life is a coherent whole: rocks, clouds, trees, shells, torsos, smokestacks, pep-pers, are interrelated, interdependent parts of the whole. Rhythm from one be-comes symbols of all. The creative force in man feels and records these rhythms, these forms, with the medium most suitable to him. . . .[15]

Now, it is really rather stunning to discover—despite Weston's search for the rock that is more than a rock and the tree that is more than a tree—that no outward form mattered at all. What mattered was the "life force," a Bergsoni-an idea that infected many artists in the 1920s. Weston's enthusiasm about the interchangeability of forms, and his acceptance of a squash being taken for a flower and knees for shell forms, simply contradict his continuing insistence that his search was for the squash *beyond* the squash. He was unable, or un-willing, to recognize that he was not reaching for essences at all, but for *ulti-mate essence*. Instead of seeking the soul of a pepper, the pepper beyond the pepper, the Platonic Ideal True Pepper, or the essence of pepperness, he was trying to photograph the life force itself, that ultimate essence of all of the ma-terial world.

One critic, who reacted with an apparent sense of outrage at Weston's 1975 retrospective exhibition at the Museum of Modern Art, wrote acerbically:

Straight photography—whatever it is—is hardly exemplified by peppers like clenched fists, thighs like shells, shells like vulvas, palm trees like industrial smoke stacks—forms that Weston saw because he had seen modern art.[16]

The critic—Janet Malcolm—was, furthermore, unpersuaded by Weston's fa-mous precision of detail. Modernistic art, she felt, was responsible for his achievements, but as for optical sharpness, it was "more an attribute of the buzzard's than of the human eye."

Stieglitz' blurry view of the Flatiron Building on a snowy day is surely more a literal rendering of "the thing itself" than Weston's razor-sharp close-up of a halved artichoke.[17]

What Malcolm was ignoring, of course, was the fact that Weston was not in-
terested in what he called seeing *with* the eyes, but seeing *through* them. Mal-
colm's example was poorly chosen, for Stieglitz's blurry view was
impressionism, or seeing with the eyes. Weston's idea was to want "the great-
er mystery of things revealed more clearly than the eyes see, at least more
than the layman, the casual observer notes. *I would have a microscope, shall
have one some day*" [emphasis added].[18]

The implication that the ultimate in seeing through to the greater mystery of
things would be made possible by a microscope has been largely overlooked in
writings about Weston. Why a microscope? A microscope permits you to view
what is truly beyond normal sight—the cellular structure of life. What if all of
Weston's talk about quintessences and essences and seeing through rather than
with the eyes was related, not to the greater mystery of things in a spiritual,
theosophical sense, but in a very literal sense, and a desperate sense at that?
For if you take Weston's desire for a microscope seriously and literally—and
there is no reason why you shouldn't—then you must admit the possibility that
one of the urges that drove Weston was something akin to a little boy's eager-
ness to learn about the mystery of life, or perhaps simply the mystery of birth,
in the way that a biologist or zoologist would pursue it.

Other photographers, Alvin Langdon Coburn being an excellent example,
sought to illuminate the mystery of life through religion and a variety of ar-
cane, non-Christian, non-Western philosophies. Weston, too, followed his
mysticism through similar creeds and ideologies, but there seemed always to
be a very literal sense in which he meant the act of "seeing." In 1940, writ-
ing for the *Encyclopaedia Britannica,* Weston set forth what might be consid-
ered his ultimate statement about his approach to photography. He began by
stating that the camera has an innate honesty.

> . . . It is that very quality which makes the camera expressly fitted for examin-
> ing deeply into *the meaning of things* [emphasis added]. The discriminating pho-
> tographer can direct its penetrating vision so as to present his subject—whatever
> it may be—in terms of its basic reality. He can reveal the essence of what lies
> before his lens with such clear insight that the beholder will find the recreated
> image more real and comprehensible than the actual object.[19]

Is Weston's "quintessence" to be equated with "the meaning of things"?
Can you ask, "What is the *meaning* of knees? Of a wrecked car on the beach?
Of peppers? Of surf pounding on the shore?" Is not "the meaning of things"
to be equated with his phrase "the significance of facts"? Did Weston intend
that we should look at the razor-sharp slice of artichoke and ask, "What does
an artichoke mean?" Did he simply want us to marvel at the geometric struc-

ture of nature as epitomized in the artichoke? Or did he want to light up the interior of an artichoke as he might have wanted to light up the very mystery of life?

Life is the ultimate mystery. It escapes even the electron microscope. The life force is another such ultimate mystery. If we can accept the idea of ultimate mysteries, and recognize that these were the goal of Weston's imagery, then his passionately insistent but often confusing statements about "quintessences" and other contradictions can be reconciled, or at least forgiven. It is in the nature of ultimate mysteries that human beings find them inexpressible.

From *EW 100*, (Carmel, Cal.: The Friends of Photography, 1986).

The Real Thing
MUSEUMS AND COMMUNICATIONS

IT IS PROBABLY ONE OF THE MOST widespread and unfortunately naive notions that communication is ''neutral''—that it is just a matter of taking information from over here, coding it onto a physical channel in some fashion, and conveying it over there—and *voila!* instant understanding. Unfortunately, communication is *not* neutral. Everyday words like ''mother,'' ''father,'' and even ''museum'' are loaded words. That is because we are not just passive receivers of messages but are actively selecting out of the message environment only those things that we find interesting, amusing, or necessary to survival.

If words threaten us, or don't match our self-image, or evoke some hostile reaction totally unintended by the sender of a message, we can blame what communications theorists call ''selective perception.'' All of us have had the experience at one time or another of words having just the opposite effect of what we had intended. It is not simply a matter of selective perception as some abstract concept. Put very simply, we have a stake, not only in what we say, but in what we actually hear or pay attention to.

None of the preceding observations can explain how we come, in the first place, to value something, how we come to determine, for example, that it is a worthwhile activity to serve, as I have, on the visiting committee for an important museum. It seems an honor to do so, secretly fanning the flames of our delicious and perfectly normal narcissism. But surely we must have determined to begin with that *a museum is a worthy cause*. I daresay that most of us have a difficult time communicating that belief without reaching for what are somewhat undependable clichés about ''education'' or ''culture,'' words that are, amazingly enough, buzz words to angry crowds of citizens who hear the word ''education'' and think of referenda to increase taxation or who hear the word ''culture'' and think of snobbism, elitism, and class warfare, depending on their ideological affiliations.

That we may all be making partial or incorrect assumptions about the idea of a museum is a matter of concern. Whether or not our various audiences understand what we mean by ''education,'' ''the preservation of human culture,'' and even the very word ''photography,'' demands serious investigation.

Photography is, first of all, not a thing but a method. Art, science, history, photography, none of these are things. And since photography is a method that can be applied to so many human experiences, it has come within the purview not only of photographic and art historians, but of social psychologists, anthropologists, psychologists, zoologists, and astronomers, to name only a few.

Photography, as a method and not as an object, is a direct tool of research, not only for recording the remote electronic scanning of the moons of Jupiter but also for establishing the very existence of particles of matter and energy. Museums of photography have an enormous range of interests and a staggering array of photographically produced objects to collect and protect.

As John Szarkowski once noted,

> Collectors of Roman coins or Impressionist paintings know the satisfaction and the despair that come with the realization that their tasks might, at least in theory, be finally completed, with each crucial specimen of a finished series nestled securely in its round niche of plush, or hung on its own proper and permanent wall. The collecting of photographs is a different and riskier sort of search, filled with mysteries and contradictions and unexpected adventures. Nineteenth-century masters are still being discovered—meanwhile, young photographers dispute the direction of their art's future, offering their best works as evidence of the correctness of their own intuitive understandings of the past.

That past described by John Szarkowski is the past of our culture as whole. Unfortunately, it is not everyone who respects either history or culture.

Somewhere during the first reel of Leni Riefenstahl's *Triumph of the Will*—a film of one of the first Nazi media events staged entirely for the camera—a Nazi gauleiter stands up before a vast political gathering waving his Luger pistol in his right hand. Sneering grotesquely, in a threatening manner that his audience thoroughly applauds, he proclaims, "When I hear the word *Culture,* I reach for my revolver!"

In the Futurist Manifesto of 1912, the artist Marinetti, soon to be one of Mussolini's most devoted followers, proclaimed, "Poets of futurism, I have taught you to loathe the libraries and the museums in order to cultivate in you *the hatred of intelligence.*"

Both these fanatics were seeking a New Order. I would ask you to ponder their proclamations before reading on.

In Chicago a few years ago, Beaumont Newhall was conducting a seminar for students at the Art Institute. They asked insistent questions about the history of photography. "What is the good of it?" "Why do you do it?" "What does it mean?" By his own admission, Newhall, a pioneering historian of photography, was dumbfounded, completely taken aback. While he recognized that the students were probably seeking his personal opinions rather than directly attacking the study of the history of photography, he was shaken be-

cause he could not present what he believed might be an adequate answer in that confrontational situation.

Why do I link Newhall's brief encounter with unexpected challenges with the two proclamations by Nazi and fascist zealots? Because it seems to me that those who despise culture and despise or fear intelligence do not have to explain or defend anything. They simply pick up their guns, either literally or figuratively, and do what they want when they want to. While the Holocaust proved more than adequately that even people who listen to Brahms and eat tasty strudels are capable of almost any atrocity, it also seems that people who respect human endeavor—in other words, culture—and who respect human intelligence take those things so much for granted that it never occurs to them that they may have to defend or explain their passions for art, science, logic, and history.

It probably never occurs to the astounding numbers of people who regularly visit museums that they will have to explain anything about this enjoyable activity. And, I suspect, it may rarely occur to the astounding numbers of loyal patrons and donors to museums that they, too, may have to explain anything about *their* activities. Most susceptible, perhaps, is the museum director, who, anxiously eyeing endowments (if he or she is lucky enough to have any), and worrying about inflation and the price of heating oil, has few weapons with which to persuade the unpersuadable. Museum directors, as we all know, do not carry a Luger pistol to their meetings with the trustees; all they have is the annual report, a weapon of somewhat dubious caliber (if you will forgive an atrocious pun).

The problem with annual reports, or circulation statistics, or turnstile figures, is that they are all acts of communication occurring in total psychosocial contexts of particular institutions and particular individuals, and they can prove to be amazingly *meaningless* even to well-intentioned readers.

Some time ago, I walked into the office of one of the deans at my college. It is an unstated obligation in academia that you must regularly indulge in a ritualized form of boasting for the sake of receiving promotions and salary increases. I was waving not a Luger, but a letter, and I said to this dean, rather smugly, "I've just been invited to participate in a symposium at the Museum of Fine Arts in Houston where I will have the considerable privilege of being one of five speakers who include Beaumont Newhall, John Szarkowski, Peter Bunnell, and Hollis Frampton." I paused, waiting for the grand effect to sink in. The dean's face remained friendly, but slightly perplexed. Suddenly the awful truth dawned on me, and I stammered out, " Do you *know* who Newhall, Szarkowski, Bunnell, and Frampton *are?*" He admitted, pleasantly, that he did not. Whereupon I told him *it was absolutely useless boasting to someone about anything if he doesn't know what you are talking about!*

Yes: it is absolutely useless boasting about your latest acquisitions, your triumphal parade of celebrity speakers, the books emanating from your collections, if your audience—the general public or the board of trustees—doesn't know what you are talking about.

I left the dean's office shaken, as startled as I am sure Beaumont Newhall had been in Chicago. I had taken something for granted and had discovered, to my great dismay, that there was almost no way that I could think of to explain just how important those four gentlemen were. To that dean, the history of photography and photographic criticism were subjects as arcane as the making of yogurt might be to me.

To what avail, then, to have a museum director report that, among the visiting scholars and researchers during the past year, the museum had accommodated persons like John Szarkowski, Beaumont Newhall, Weston Naef, Gail Buckland, when it is quite possible that repeating those names—even to friendly listeners—may mean absolutely nothing at all.

To have some sense of *why* an institution like the International Museum of Photography at George Eastman House, for example, is so remarkable, so important, so crucial in its field, it may be that you would have had to participate in some of its activities directly. You might even have had to learn something about the history of photography, pursue some topic in the technology of photography, seek out a magnificent print by Paul Strand or Alvin Langdon Coburn, or hold in your hand a unique nineteenth-century book stereoscope and have your breath catch with amazement.

Either that, or you will have to be a remarkably empathetic individual to understand how exciting it was that recently a young researcher from State College, Pennsylvania, valiantly drove six hours to make a 1:30 appointment in the archives of George Eastman House—an appointment, by the way, that the pressure of traffic in those archives had forced her to make many months ago. She came to see the unique Victor Hugo album in the museum's collection, only to have to turn around and valiantly drive six more hours back home. When the National Film Board of Canada, the Smithsonian Institution, the Manchester Polytechnic of England, the Niépce Museum in France, Time-Life books, television stations, and coeds from State College all find it necessary and valuable—no, *invaluable*—to seek information at George Eastman House, then you must feel some sense of excitement, some sense of pride, some sense that here is an institution that must be helped to survive.

But perhaps some of us are not certain of the definition of a museum? Or certain of its functions, its responsibilities, its mandates, its legal status. After musing on gauleiters, fascist poets who wanted to burn libraries and museums, and both Newhall's and my own sudden recognition that we can take nothing for granted, I have come to the reluctant conclusion that the idea of a museum

is not as simple as it sounds, nor are the implications of that idea easily delineated.

Given the necessary educational programs, traveling exhibitions, publications, seminars and symposia, visiting scholars and public attendance beyond anyone's fondest dreams for a contemporary museum, the essential idea of a museum may seem obscure. Let me review the fundamental attributes of a museum.

A museum has several essential functions. They are: to collect, organize, store and retrieve, preserve, display, and disseminate information about artifacts. In the case of the International Museum of Photography at George Eastman House, those artifacts happen to fall into two basic categories: (1) the instruments, or machines, of photography (and I include cinematography under the rubric), and (2) the products of those machines, namely, the photographic images or films themselves.

In other words, that museum is concerned with both technological and communicative artifacts.

If only the arduous imaginative and scientific labors of photographers and filmmakers could be inspected with the same direct enjoyment and relative simplicity that accompanies the inspection of machines! For it is an exceedingly complex act to understand the meanings—the very human meanings—embedded in paper or acetate images. Characteristically, it is relatively easy to put a price on a machine, difficult to put a price on a work of human imagination that imprints itself on a solitary sheet of, say, resin-coated paper.

But it is precisely for the sake of human imagination that museums exist. It is for the sake of the images that communicate to us, not only the idiosyncratic ecstasies of individual artists of the camera, but the idiosyncratic richness of individuals recorded for the camera; for photography, of all the arts, seems to speak most directly of what it means to be human.

The photographer Frederick Sommer once observed, "Life itself is not the reality. We are the ones who put life into stones and pebbles." Indeed, yes. It is human imagination that creates the world. We struggle all the while to secure some more perfect relationship between what we think, what we think we know, and what we think we see. Oscar Wilde put it much more flippantly, yet more accurately, when he said, "Nature imitates Art." We study images to learn how to look at nature. Some of us also study images to learn how to make our own images.

It used to be that if you asked about the use of history, you were told, "If you don't know history, you are condemned to repeat it." Does this matter outside of politics and ethical relationships? Curiously enough, for the breed of individuals known as photographers, it is really of prime economic importance to know the history of their profession. Since a photographer's contribution to

the profession will be judged largely on the basis of originality or uniqueness, a photographer may want to avoid any suggestion of doing what has already been done. On the other hand, the range of aesthetic options is immense if you know the older technologies. It is no accident that the old techniques like gum bichromate, platinum, Ozotype, and photogravure, have been revived. You may want to repeat history in the sense that you don't want to have to reinvent all of those processes. It really pays, on a gross level—meaning money—to know the history of photography.

What is most important to recognize is that there is no way you can learn about the qualities of an original print except by examining the real thing itself. You cannot judge much about processes and prints from reproductions in books. The museum is the conservator of artifacts as well as of the interpretation of those artifacts. *People must come to a museum.*

A museum is not a building, however. It is, rather, a process. Surely a museum, like a research library, is not merely a building, but is the dynamic process of education. Since many museums are supported by corporations and their executives, it is appropriate to ask this question: Can business managers, the people who run the largest corporations in the world, have tender and loving thoughts about educational and cultural institutions? The answer has been realized again and again: Yes. Despite their addiction to terms like *efficiency, cost-benefit,* or just plain *profit,* they do seem to recognize that even nonprofit institutions can be goal oriented and that to achieve their goals they require skilled personnel, dedicated professional staffs, and loyal and supportive trustees. But even nonprofit educational institutions have payrolls to meet and must offer competitive salaries and meet the ever-rising costs of maintaining and preserving the fragile objects in their care. A museum cannot fulfill its functions in a stable and reasonable way, contributing either to culture or to the expansion of human intelligence, if it must constantly play beggar.

John Szarkowski, a most quotable curator, has remarked: "It can be said with certainty only that photography has remained for a century and a quarter one of the most radical, instinctive, disruptive, influential, problematic, and astonishing phenomena of the modern epoch." Note the phrase, *It can be said with certainty*—but what certainty have we that potential supporters of any photographic museum will receive that communication with the same verve and enthusiasm with which Szarkowski presented it?

About fifteen years ago, the Smithsonian Institution held a conference on museums and education at the University of Vermont. A book came out of the proceedings of that conference. Not surprisingly, its title was *Museums and Education.* It offered a number of significant observations on the interrelationships between the two. One thought dominated all others. It was simply this: *A museum exists for the purpose of making it possible for people to look at*

things. That sounds childishly simple, does it not? Why, people go around looking at things all the time, don't they? *No. They don't.* Americans have been called the blindest of all nations, of all nations the most materialistic and simultaneously the least aware of their physical surroundings; the most nonmaterial, in fact. Watching television is not the same as looking at things or, if we must dignify the activity by a more jargony description, interfacing with the human significance of human-made objects.

A museum permits people to encounter the *itness* of things. In a museum like George Eastman House, people encounter the photographic prints themselves, with all their variety of textures, formats, sizes, contents, messages. Not reproductions, but the things themselves.

The eminent critic Susan Sontag participated in that Smithsonian conference on museums and education, and this is what she said: "A work of art encountered as a work of art is an experience, not a statement or an answer to a question. . . . Art is not *about* something; it *is* something. A work of art is a thing *in* the world, not just a text or commentary *on* the world. A work of art makes us see or comprehend something singular. . . ."

Rudolf Arnheim, a noted art historian and communications theorist, was also at that conference, and he observed, "Art is extremely hard to deal with in words, but almost everything else is too."

Robert Motherwell, the well-known painter, was at the Smithsonian conference, and he decided, "The ultimate value of what we're involved in is the degree to which the world of sensed feeling is extended, refined, internalized, and incorporated in every individual. . . . The capacity to compose images is really the capacity to give coherence to sensed experience."

But suppose that some of us, like our Nazi thug and our fascist poet mentioned earlier, simply despise intellectuals. Can't stand words like "sensed feeling," "refined," "internalized," "coherence," and especially "art." Can we appeal to such among us by quoting a cold, hard-nosed statement like this: "The massive collections of our museums represent a far longer and wider sequence of evidence (about human history) than exists in any other form and they are, in consequence, of fundamental . . . importance." In other words, museum collections are documents for "the story of life." I would respectfully observe, however, that each of us carries within us an ideological stance toward even so simple a term as "the story of life," some seeing it as oversimplification and condescension, others hearing it as a replica of hard knocks.

A museum nevertheless holds in trust for the public a story of life that has many versions, many, many differing approaches to "the" story of life. We need to collect those many differing approaches as civilization shifts and changes in its visual habits and in its life-styles. We need to preserve those stories for, as Cartier-Bresson reminded us, once they vanish they can never

be recreated. And we need to provide direct access to those objects communicating those stories, for secondhand stories (like reproductions) tend to degenerate into rumors and gossip.

Like the Coca-Cola jingles of a few years back, a museum represents *the real thing*.

So: to potential audiences of a photographic museum, we must communicate that these real things include images by Peter Henry Emerson, Lewis Hine, Eadweard Muybridge, Alexander Rodchenko, Alfred Stieglitz, Weed and Watkins, as well as contemporary prints by Lewis Baltz, Mark Cohen, Barbara Crane, Joe Deal, Elaine Mayes, Nicholas Nixon, Stephen Shore, Anne Noggle, Cindy Sherman, Barbara Kruger, Barbara Norfleet, to mention only a few. We must say to the potential audience: *Come and experience these images, for they cannot be communicated in words.*

These real things include dye transfers, photomicrographs, carbro prints, photographs on silk and ivory, gelatine silver prints, crystalotypes, Azochromes, Flexichromes photogravures, Kodachrome transparencies. *Come and explore these technologies, for they cannot be communicated in words.*

And if we collect instrumentations, every conceivable kind of camera from Daguerre's time and D. W. Griffith's era to the present, we should say: *Come and enjoy these machines, for they cannot be communicated in words.*

From Daguerre's time to the present is one hundred and fifty years, but it took almost one hundred and ten years for the establishment of the world's first photography museum, and that was not George Eastman House or the Bibliothèque Nationale or the Getty, but the modest institution of Dr. Louis Walton Sipley, who founded his own museum in Philadelphia after years of frustration with the established museums of art. One year after he founded that first photography museum, both Eastman House and Ansco came to his support. Not long ago, *Afterimage,* the publication of the Visual Studies Workshop in Rochester, published a comment on the International Museum of Photography's traveling exhibition of some of the Sipley Collection. In describing how Mrs. Alice Sipley failed to find anyone in the Philadelphia area to house the collection, and how the 3M Company had purchased it and donated it to George Eastman House, the reviewer commented, "I think a few people in Philadelphia are still pulling their hair out over that lack of foresight."

There is a lesson in there, somewhere, but I am much too discreet to point it out to anyone who doesn't already know it by heart.

Revised from an address to the Board of Trustees of the International Museum of Photography at George Eastman House, April 25, 1979.

Trashing the Media, Taking on the World

Some years ago, when I was on my way to visit a photographer in New York's bustling SoHo, I was walking down gritty Sixth Avenue, marveling at the intricate shapes of detritus decorating the sidewalks, breathing the delicious carbon monoxide with that thrill of recognition that only an exiled New Yorker can enjoy, and as I was wondering if the next careening taxicab would, in fact, jump the curb and smash me into a plate-glass window, I encountered—an artist.

I knew he was an artist because he was completely naked under a kind of wide-open fishnet overall on which he had managed to hang an astonishing variety of uncooked pasta. As he stood there motionless on the corner of Sixth Avenue and Meshuginah Street, posing himself with one arm held akimbo and the other draped backward across his linguinied **tusch,** I said to myself, not for the first time in my life, "What is art, and should I cook it?" It was the kind of moment that only a genius like Woody Allen could cope with, the kind of performance that only the director of the film *The Draughtsman's Contract* could exploit, the kind of exultant individualism that only Ayn Rand could digest. Here was a young man who obviously thought he was a baroque centerpiece, or maybe a spectre from a 1920s Beaux Arts Hall.

It was a moment that called for a photographer, but, as you all know, when you really need a photographer, you can't find one.

I retired hastily to the nearest café, there to sit with my nose pressed against the window, the better to observe this young man's performance. And I asked myself. What did he want from life? Pneumonia, perhaps, because it was late autumn and the wind was bone-cracking. There he stood in his filthy bare feet, his face and hair strung with pasta, and what did he want? A little recognition? A little applause? A nice note from his mother? A warm greeting from a policeman? Was he a walking advertisement for Ronzoni, although no name was attached to his multitudinous pasta appendages? Was he trying to express himself? Was he saying, "The macaroni, spaghettini, fettuccine, and rigatoni are pure forms, as pure as Cézanne's (forgive the pun) pasta-ulates concerning the cone, the cube, and the apple dumpling?" But no, performance art is not nec-

essarily interested in pure form, so what was the poor devil after? What did he want the passersby to think? To feel? To conceptualize? To pursue in terms of political action? Was it all just a metaphor for "You are what you eat?" Was he simply asking us to stop in our world-weary wending of our oblivious ways and think, really **think** about pasta, or about performance, or about getting your jollies out of being as original as possible, as outré as possible? Did he merit our attention for, so to speak, letting it all hang out?

Alas! I could not figure out what he was trying to communicate, if anything. Finally I came to the conclusion that the young man making a pasta spectacle of himself was presenting an autonomous work of art, art done for its own sake, and that, of course, placed our young man, willy-nilly, linquine or no linguine, squarely in the tradition of **modernism.** If that surprises you, you have forgotten not only your Alan Kaprow but your Kurt Schwitters and your Marinetti. Because if we think that postmodernism is the first period in which "Anything goes!" we have forgotten our history.

"Anything goes!" is not an ideology lacking in political import, although some of us seem to think so. Marguerite Yourcenar's new book, *The Dark Brain of Piranesi,* tells us that the symptoms of social decay are neither excessive violence nor sexual liberties, but rather, more fatally, intellectual incoherence. It is not that there is too much to think about, too many available varieties of experience, too much that is evanescent, impermanent, and faddish, but that we lack a value system that could permit us to make sense where there is nonsense, to divide what is **humane** from what is merely de facto human.

When there seems to be no order in art or society, totalitarians insist on a new order. You will forgive me if I blanch at the title of this conference (New Order/No Order) because to my generation the term New Order recalls nothing less than Hitler and genocide. Where there is a new order in the totalitarian style of dogmaticism, there must also be an underlying rebellion that speaks of a will to entropy and chaos once again. Intellectual coherence, unfortunately, like intellectual incoherence, may serve political ends. Each can be both cause and result of social evolution and the Hegelian swings of the pendulum.

Some time around the turn of the century, Anatole France wrote a delightful satire called *Penguin Island.* In it, a dazed old monk is set afloat in a miraculous stone vessel and pushed out to sea. Eventually, he arrives at one of the arctic regions, where he encounters what he believes to be a huge congregation of little people eager to hear the Gospel. In reality, they are a herd of peaceable penguins, but the nearly blind old monk doesn't recognize this fact.

Peering at them myopically from between his salt-encrusted eyelids, he preaches the blessings of baptism and the salvation of the soul to this crowd of presumed heathens, and then, for three days and three nights, he diligently and

compassionately baptizes them. Thousands and thousands of these quietly babbling little creatures does he baptize in his evangelical fervor.

Now, when news of this well-intentioned act reaches the celestial bureaucracy in heaven, there is great consternation. Terrific arguments erupt. Do penguins have souls, and if they do not, will baptizing them prove to be some kind of awesome sacrilege? If they do have souls, baptism would of course save them from automatic hell fire. But to baptize creatures without souls—it was potentially monstrous, unthinkable.

In desperation, then, it was decided to give the penguins souls, both male and female penguins, so that the baptism would not go to waste. And then, as might be expected from this kind of satire, the penguins evolve into human beings and begin a history as perversely racist, sexist, and bloodthirsty as our own. What went wrong, apparently, was that in giving the penguins souls, someone forgot to tell them what souls are for, namely, to be able to tell the difference between good and evil, and to care to make the choice.

To exculpate the poor old monk, it is necessary to recognize that he had done only what his training had prepared him to do. He possessed a dogma that insisted that all individuals had to be baptized. And he certainly did not need to worry about what to **teach** the penguins: that had already been decided by centuries of authority. When confronted by heathens, baptize—after carefully preaching the approved version of the Gospel, of course.

How terribly unnerving, how sad it is that we no longer have a dogma applicable to all untutored heathens! We no longer know, or cannot guarantee, whether our students will come to us already possessing souls. We no longer turn to them, with an assurance born of at least a century, and say, "Go, and let this MFA be your guide through life!" We can no longer pontificate, with the grand assurance of modernistic dogma, that it is only the abstract or formalist underpinnings of an image that give it the imprimatur of Art, with a capital A. It would be almost impossible today to read without considerable skepticism the following paragraph from a catalog for the Guggenheim Museum back in 1937:

> Non-objective art need not be understood or judged. It must be felt and will influence those who have eyes for the loveliness of forms and colors. Though we all enjoy sunshine, neither this joy nor the sun's shine have a meaning unless our intellect invents one. Neither a flower nor the moon can be criticized. They would never change themselves. The seed of the flower will continue to produce exactly the same kind despite criticism. It follows the intuitive order of creation. So does the non-objective masterpiece of art. It can be liked or disliked, but its existence is final and its perfection is beautiful.[1]

Douglas Davis said, "The Cambodia invasion of 1970 may have destroyed the realpolitik of formalism in the United States, by making it impossible to live with, morally speaking."[2]

Now, as never before, we feel impelled to criticize the flower and make the moon an accessory to genocide. When we take on the world, it is no longer to describe it, love it, caress it, but to label it, with great sincerity and determination, a hallucination of bourgeois decadence.

That catalog for the Guggenheim Museum was written by Hilla Rebay, and it continues as follows—(and just for the moment, please ignore the inherent genderism and sexism in this paragraph):

> The genius follows his conscience to his preordained destination, and does not need sensation. He develops his masterfulness to stronger power, greater simplicity, and superiority of technical expertise. By increasing accomplishment, the vision of further possibilities is enlarged. With cruel self-discipline a born master responds to a sensitive conscience by his unending devotion to the goal of perfection and beauty. All of his existence consists of hard work to reach beauty and increase spiritual wealth on earth. He foresees the necessity of new demands which humanity develops, and usually fulfills this demand long before it is made. Yet often for this reason [he] dies in obscure poverty.[3]

Cruel self-discipline! Hard work! Obscure poverty!

I have been trying to persuade a young photographer to pursue an MFA. Recently, she visited a photographer who lives in dire poverty in one of Boston's slums.

When she came back to tell me about this visit, she was visibly shaken. "But I don't want to live like that! I don't want to be poor!" I could see that she was frightened half out of her wits. "Fine," I said, "then you had better accept the fact that your photography may not support you. You may need some other means of earning a living. Otherwise, go to the garret at once!"[4]

The brochure for this SPE [Society for Photographic Education] conference indicated that a current worry here is that students are turning away from the liberal arts and are demanding education for employment today. Aside from the fact that education seems to be swinging back toward the liberal arts, let us look at the implications of demanding education for employment.

First, let me ask: Is the brochure implying that if students turn away from the liberal arts that they, like penguins, will have no souls?

May I remind you, most respectfully, that acquaintance with the masterpieces of the arts of the world doth not necessarily a soul produce—if by soul you mean someone with compassion and kindness?

Or are you simply saying that if students do not receive a liberal arts education that they will not meet the entrance requirements for the MFA? Since we all have a stake in our own survival, that seems like a sensible worry, but one that can easily be met by changing the entrance requirements.

But there are, if you will agree, much more important considerations here.

If you don't care about whether or not an artist has a soul, then it makes no difference what kind of education he or she receives.

I remember a book called *My Father's Library*. It was written by one of the original group of dadaists who managed to survive the Nazi Holocaust. In that book, the author talked despairingly of his own father, as an example of how cultured and cultivated the Germans were, and of course we all know that the Bitch of Belsen, Ilse Koch, listened to Bach, Beethoven, and Brahms while she stitched together her lampshades made of Jewish skin. *My Father's Library* makes it appallingly clear that loving music, enjoying paintings, or memorizing Shakespeare sonnets will not necessarily prevent a man from turning into Adolf Eichmann or a woman from metamorphizing into Ilse Koch.

Are you concerned that if students ask for education for employment today that this is tantamount to worshiping false gods, or selling one's soul for a mess of pottage, not to mention bean sprouts, tofu, and a bottle of white wine?

Modernism was imbued with idealism, with a confidence in the spiritual values of the arts, with the necessity of art as a fundamental and universal expression of human nature. I am always surprised to discover how many Marxist critics agreed. Here I quote from the Marxist critic, Ernst Fischer, from his book *The Necessity of Art:*

> The free decision of men communicates itself to objects. One of the great functions of art in an age of immense mechanical power is to show that free decision exists and that man is capable of creating the situations he wants and needs.[5]

I am assuming that in some other book Ernst Fischer contemplated the difficulties that **women** encounter when **they** want to be considered capable of creating the situations **they** want and need.

Modernism accepted the garret, the cruel self-discipline demanded by the need to create beauty and increase spiritual wealth on earth. In this, of course, modernism was the last gasp of the nineteenth century's romantic infatuation with the artist as self-sacrificing Messiah.

Yet even the moderns had a healthy regard for money-making, and I have yet to hear anyone accuse the abstract expressionists, for example, of rejecting suitably large emoluments for their labors. And I have yet to hear anyone accuse our most famous photographers of saying to a prospective collector, "No, thanks, keep your money. I'd much rather hang on to my cruel self-discipline and die in obscure poverty."

Frankly, the desire on the part of today's students to be taught something besides aesthetics and technique has a healthy ring to it. It speaks of a recognition, difficult for delayed adolescents to achieve, that unless you are very rich, art has practical outcomes, that it exists in a real world, and that even the most

pure aesthetic object is, of course, manufactured for the very real world of the galleries and museums, where it is part of the commodity nexus and often simply an adjunct to conspicuous consumption, the display of status, or perhaps a shrewd investment.

If the so-called pure aesthetic object is obviously aimed at an audience, and therefore a market—even if the artist protects his or her mental chastity by aiming at a posthumous market—then what possible difference is it to educate a student in the ways of other markets?

A highly respected colleague put down a rival institution with the deprecating remark that it is "more commercial in its orientation" than her own. Commercial in what sense?

Is there anyone today who is more of a cult figure than Diane Arbus? Did she not earn a living doing fashion and hustling media events? Is Joel Meyerowitz not admired for his recent color abstractions, and does he not earn his living as an advertising artist? Are Irving Penn and Richard Avedon, surely no slouches as photographers, not admired as much for their commercial work as for their work of self-expression, which in their cases would be hard to separate? Was Henri Cartier-Bresson not paid handsomely for his photojournalistic efforts? Does not every brave war photographer earn his or her keep? Isn't the history of the visual arts, in fact, chock full of geniuses who worked for a living and who produced "art" as a matter of course within that work?

Can we reject Michelangelo's Sistine Chapel because it was done on commission? or reject Peter Paul Rubens because he had an atelier and served as an ambassador as well? Can we reject our more recent god, Eugène Atget, who hoped to sell his photographs to artists and historians? or the FSA photographers who were on salary, for pete's sake?

What in heaven's name is intrinsically wrong with wanting to earn a living? Do not teachers earn their livings?

So it is not work for pay that we are objecting to; it is the kind of work for pay that raises the questions, the kind of work that says to us, "We have no souls and no value systems."

A recent issue of *People* magazine featured a story about a photographer in—I think—Laguna Beach or some such place in California, where everything is possible. This California photographer, a young man, is making money by posing housewives in salacious undress and in the costumes and attitudes of whores. The housewives are flocking to him because by having their pictures taken in tantalizing display they hope to give their husbands a reasonably cheap thrill. It is the same kind of sleazy seduction that was suggested by the woman who wrote a book chock full of advice about how to greet your husband when he arrives home dog-tired from a day's work: tog yourself out in nothing but transparent Cellophane.

Is the photographer to be blamed for catering to his client's wishes? Are he and the women to be blamed for living in a society where the mass media constantly, unremittingly, implacably equate being female with being a foxy tart? These all-too-willing housewives have been brainwashed into believing that it is crucial to imitate the heroines of such gratuitous dollops of nausea as the recent *Hollywood Wives,* or the ongoing fornications of *Knots Landing,* or the continuing parade of tits and asses on *T.J. Hooker,* and their husbands obviously approve.

The photographer of this Laguna Beach pseudobrothel is clearly following the successful styles of those magnificent classics of porn, *Hustler, Playboy, Penthouse,* and other mass media dispensers of masturbatory fantasies. Does he have to capitulate to these Lords of Cunt? If there is anyone here who will say, "Oh, the poor bastard, he has to make a living, after all," I will say to you, "Listen, **penguin,** it isn't your fault that you don't have a soul, but let us hope that someday you will." When I say it is important that students **know** they have to make a living, that society owes them nothing, it should be clear that I am not espousing the television game show called *Anything for Money.* But we might ask if there is such a great difference between our Laguna Beach hustler and someone like Helmut Newton. . . . Of course, you will instantly reply, "Oh, but Helmut Newton does it all with such style, such class, such panache, such technical perfection."

Yet the exploitation of women both in reality and in the mass media is only a symptom, not a cause. That is what is so hard to convey. We can swap around symptoms and pray that the removal of destructive stereotypes will change the nature of the beast, but the beast is still there, and the beast is something that Hans Enzenberger called "the industrialization of the mind." I'll come back to that in a moment.

In talking about the poet Baudelaire, Walter Benjamin remarked that the poet did not merely sell his wares, but actually managed to empathize with his commodity's consumption by city crowds.

As if his poems were surrogates for himself, Baudelaire talked of feeling the vicarious shocks of surrendering to the onslaught of the mob of buyers. Benjamin observed:

> The poet abandons himself, in holy prostitution of his soul, to the intoxication which he feels in having "stimulated" his potential mass of customers. As seller of himself, he has no personality or convictions, but assumes many masks—ragpicker, strolling flaneur, apache, and dandy are a few—while all the while preserving his incognito.[6]

Some of us know that passage by heart, since it is so often quoted, but do we apply it to those creatures we see every month in the gossip columns of

American Photographer? Do we not all long for the intoxication of stimulating a potential mass audience of customers? Isn't that what today's species of fame offers?

Carl Sandburg once said, somewhere, "Fame is worth a cup of warm spit."

Not many of us have the opportunity of finding out for ourselves whether or not that formulation has any truth to it, but we can look back at the poignant experience of Diane Arbus. After receiving the ultimate demonstration of her artistic worth as a photographer by being asked to participate in the big show at MOMA called *New Documentary,* Arbus discovered to her dismay that, despite fantastic media attention, she was receiving few assignments of the kind that pay the rent. Fewer, in fact, than before the show.

Of course, we should realize that art editors were put off by her newfound reputation as a photographer of freaks. The point is that she was not only confused and hurt, she was broke. Here she had done what the twentieth century seemed to be demanding of her as an artist: to establish a special identity as a unique individual, with specific types of images ready for sale, and the commercial world was frightened of her. O cruel self-discipline! O hard work! O obscure poverty! O the damned cold radiators of that godforsaken garret! Arbus thought she had no recourse but to turn entrepreneur. She set about preparing a portfolio to sell for a thousand dollars (doesn't that sound familiar!), issued it in limited quantities, and hustled around to sell it. As one plaintive "bunny" says to another "bunny" in Gloria Steinem's account of her days as a Playboy "bunny"—"Jeez, honey, if you can type, what do you want to do THIS for?"

From an article called "Postmodernism and Consumer Society," let me cull some insights from Frederic Jameson:

> The great modernisms were predicated on the invention of a personal, private style . . . that means that the modernist aesthetic is in some way organically linked to the conception of a unique self and private identity, a unique personality which can be expected to generate its own unique vision of the world and to forge its own unique, unmistakable style.[7]

Jameson suggested two positions we might take. The first suggests that during the time of competitive capitalism, when the bourgeoisie assumed hegemony over other classes, that there was such a thing as individualism. Today, however, in a corporate capitalistic state, with bureaucracies and the unprecedented population explosion, that old bourgeois individual subject exists no more. The second position, which Jameson called "Poststructuralist," denies that there ever was such a thing as an individual subject. It is a myth, something made up to persuade people that they were autonomous and actually possessed a unique identity.

Then Jameson brought up the essence of the problem:

Whichever position is correct, what we have to retain from all of this is rather an aesthetic dilemma: because if the experience and the ideology of the unique self, an experience and ideology which informed the stylistic practice of the classical modernism, is over and done with, then it is no longer clear what the artists and writers of the present day are supposed to be doing. What is clear is not merely that the older models—Picasso, Proust, T. S. Eliot—do not work anymore (or are positively harmful) since nobody has that kind of unique private world and style to express it any longer. . . .[8]

Surely this is a terrifying notion. The deconstructionist philosophers have put it even more directly. They tell us that we are born into a language system that preexists our birth and that, from the moment we are born, will supply us and indoctrinate us with all of its givens. We will be able to think only in the terms of that language system. Thus, if the word "woman" comes to us in a language system that places an intrinsically low value on it, by definition, then we will think of woman in low terms. If the word "artist" comes to us in a language system that places a specific and exclusive male gender within it, by definition, then we will think of the artist as male. If the word "cooperation" comes to us in a language system that automatically equates it with the word socialism, by definition, then we will think of cooperation as tainted and possibly baleful.

The dilemma we face is not simply the vulgarity of television shows, or the venality of someone like the Laguna Beach visual whoremaster, but a much more devastating imperative.

Hans Magnus Enzenberger, a German poet and philosopher writing in 1962, spoke of a historical circumstance that pushes us increasingly into regimented and conformist behavior while it exploits every susceptibility of the human mind:

All of us, no matter how irresolute we are, like to think that we reign supreme in our own awareness, that we are masters of what our minds accept or reject. Since the Soul is not mentioned any more, except by priests, poets, and pop musicians, the last refuge a man [or woman] can take from the catastrophic world at large seems to be his own mind. Where else can he expect to withstand the daily siege, if not within himself? Even under the conditions of totalitarian rule, where no one can fancy any more that his home is his castle, the mind of the individual is considered a kind of last citadel and hotly defended, though this imaginary fortress may have been long since taken over by an ingenious enemy.[9]

Enzenberger continued, "No illusion is more stubbornly upheld than the sovereignty of the mind." He then reminded us of a statement made more than a century ago, to the effect that "what is going on in our minds has always been, and will always be, a product of society."[10]

What is this insidious enemy that dominates our thinking without our being

aware of it? Enzenberger called it "the mind industry." The mind industry, surprisingly, is not primarily concerned with selling consumer goods. As Enzenberger saw it:

> Under state, public, or private management, within a capitalist or a socialist economy, on a profit or nonprofit basis . . . [t]he mind industry's main business and concern is not to sell its product: it is to "sell" the existing order, to perpetuate the prevailing system of man's domination over man, no matter who runs the society, and by what means. Its main task is to expand and train our consciousness—in order to exploit it.[11]

It is that concept, of the training of our consciousness by a self-perpetuating system, that makes perfect sense out of this statement, from Rozsika Parker and Griselda Pollock's *Old Mistresses:*

> Art is not a mirror. It mediates and represents social relations in a schema of signs which require a receptive and preconditioned reader in order to be meaningful. And it is at the level of what those signs connote, often unconsciously, that patriarchal ideology is reproduced.[12]

Can the artist become conscious of his or her preconditioning? If we take the deconstructionist philosophers too seriously, we would end by thinking that nothing can change. But it is precisely the artist who creates new vocabularies, even if these might remain somewhat burdened with unconscious value systems. Despite the fact that many teachers want nothing better than to reinvent themselves anew in each of their students, surely education has more to do with assisting in the creation of new vocabularies than in perpetuating the old? How this can be done is being addressed by other speakers at this conference.

Lest we think that it is only an embittered German poet like Enzenberger who can talk in such grim terms as the mind industry would apply, here is an Americanized theorist, George Gerbner, writing in his book called *Communication Technology and Social Policy:*

> The mass cultural presentations of many aspects of life and types of action teach lessons that serve institutionalized purposes. People do not have to accept these lessons but cannot escape having to deal with the social norms, the agenda of issues, and the calculus of life's chances implicit in them.[13]

Social norms, agenda of issues, calculus of life's chances . . .

Now of course sophisticated professionals know very well that there is a mind industry, know that consumerism is only one aspect of its activities, and have always suspected that mass media presentations are specifically aimed at serving institutional purposes. What we may be doing, however, is exempting our own image—making activities from acquiescence in these purposes. Because some of us may be convinced that art photography exists only for the sake of aesthetic appreciation and therefore only for its own sake, we may re-

ject the possibility that photography is a mass medium and, therefore, also presents social norms, an agenda of issues, a calculus of life's chances implicit in each picture. This would be true not only about pictures of Kampuchean massacres, for example, but also of pictures of flowers and moons.

We may accept the fact that photographers not only want to earn a living, want to achieve fame and individual recognition, but not be willing to recognize how inescapable is our contemporary destiny: that in order to earn any kind of living through our art, we must consort with the establishment that runs the mind industry, a mind industry that, by the way, perpetuates the seductive bourgeois infatuation with the market value of keeping the fine arts separated from the popular arts and as the possession of a privileged and exclusive elite.

We rail against the corporations, but we also write funding proposals to them, because whether we like it or not the modern corporation is our equivalent of the Medicis, patrons of the arts on the grand scale—just so long as the arts they support do not conspicuously challenge their existence in any way.

How can individuals survive even as self-deluding nonsubjects? Perhaps by becoming vastly more aware of the processes of communication and ourselves as communicators. As Carl Chiarenza put it at an SPE conference not many years ago, the question "Yes, but is it art?" is the wrong question for our own time. For whatever it was worth, we won that battle. Now that we've won it, many of us don't want it any more. Or maybe never wanted it. Currently there are more important questions, questions that deal with the **effects of art** rather than with some illusion of a permanent and intrinsic quality of an artifact. Not: "But is it art?"; the question is, "How does it affect an audience?"

George Gerbner defined communication as:

> . . . interaction through messages bearing man's notion of existence, priorities, values and relationships. Codes of symbolic significance conveyed through modes of expression form the currency of social relations. Institutions package, media compose, and technologies release message systems into the mainstream of common consciousness.[14]

Our notions of existence, priorities, values, and relationships.

What would happen if we were to advise our students that every professional decision we make depends directly on our notions of existence, priorities, values, and relationships? What if we were to ask each photography student to look at his or her pictures and ask what perspective on life and the world do they express and cultivate? Would they respond that art has no connection with the world? Would they resent an implied interference with their freedom to create whatever they wish? Would they insist that such a question would lead to an approach to art that is purely propagandistic?

And what about us? Would our refusing to ask such questions signify that
we have abandoned any pretense to a moral or ethical value system? Would
our refusing to ask such questions stamp us irrevocably as cynics and philis-
tines? Would our refusing to assign social relevance to even the most abstract
work of art signify that we are lacking in the most fundamental sense of social
responsibility? Can we possibly admit into our canon the flower and the moon,
and can they represent any kind of social responsibility?

I was quite surprised a few weeks ago when I was talking to a young pho-
tographer and he told me that none of his teachers had ever directly discussed
the question, "What is Art?" He was very troubled. He said that since he
could not define what is art, he did not know how to judge his own work. He
did not know if he could call his work "art" and how he would know if he
ever could produce art. So I suggested to him that there are more than a few
interpretations of the word "art" and that, as a preliminary step, he should
take a look at page 24 of the paperback edition of an interesting introduction
to the problem, Harold Osborne's *Aesthetics and Art History*.

Just for the heck of it, let me review very briefly some of the Western art
theories Osborne outlines. Under the rubric "Pragmatic interest: instrumental
theories of art," he listed:[15]

> 1. Art as manufacture. We might call that "Art as commodity." Notice that it is
> the very first one mentioned.
> 2. Art as an instrument of education or improvement.
> 3. Art as an instrument of religious or moral indoctrination.
> 4. Art as an instrument for the expression or communication of emotion.
> 5. Art as an instrument for the vicarious expansion of experience.

Before I continue with Osborne's other rubrics, let me comment on these.

It seems obvious that none of us can escape the necessity of considering art
a manufacture, not only in the Marxist commodity sense, but in the plain fact
that a work of art is precisely that: a work, a manipulation of some **thing,** a
putting together of some **thing,** for even so-called conceptual art wrote out its
instructions on pieces of paper and photographed the events, performances, or
odysseys.

The ideology of art as education not only fills the basements of large mu-
seums with art classes—teaching a general public about the making of im-
ages—but also supports the utilitarian liberal belief that education in art is
education in humane goals.

Art as an instrument of religious or moral indoctrination causes us all a
great deal of anguish in our totalitarian era, although we have few qualms
about teaching the history of art in which any fool can see that religion was
the focus of most of humanity's efforts in picture making, sculpture, and ar-
chitecture. But to use art as a means of moral indoctrination seems odious in a

day when we cannot decide what morality is, and when we have every reason to fear persons or groups who are absolutely convinced that they know, even if we don't.

We tend to stay safely with number 4, Art as an instrument for the expression or communication of emotion, that old cathartic notion of art that found its purest expression in romanticism. It found its staunchest supporter in Alfred Steiglitz, one of the great moderns of photography but clearly also a romantic idealist, a poet of the camera seeking the objective correlative for emotion just as surely as was T. S. Eliot. It is when we arrive at this theory of art that we also arrive at an art that demands "cruel self-discipline, hard work, and often obscure poverty." For what does an enormous technological society care about you wanting to express your emotions?

Go to the garret at once! Do not collect $200, do not collect rent on your Park Avenue hotels—but go to the garret at once!

You realize, of course, that none of these theories of art is mutually exclusive. You can be expressing your emotions even as you try to indoctrinate, educate, or sell a commodity.

Under a second rubric, Harold Osborne suggested other theories of art, primarily dealing with "Interest in art as a reflection or copy; naturalistic theories of art":

1. Realism: art as a reflection of the real.
2. Idealism: art as reflection of the ideal.
3. Fiction: art as reflecting imaginative actuality or the unachievable ideal.

In photography, these theories would give rise to the mirrors/windows argument, to the arguments about whether photography must always stick to the observable surfaces of reality, about the possibility of falsifying reality in pursuit of an ideal, which action often leads directly to propagandistic effects.

Finally, Osborne came to his third rubric: "The aesthetic interest: formalistic theories of art."

1. Art as autonomous creation.
2. Art as organic unity.

Under this last rubric, I would like to add:

3. Art as play.
4. Art as an object of contemplation or meditation.
5. Art as transcendence, art as spiritual experience.

We should remember, also, that Marcel Duchamp gave us one of the most intelligent of modern theories when he said, somewhere, "Art is whatever is looked at in an art context."

On closer examination, the Duchampian idea—which was intended to make

us recognize that the art experience (from the point of view of the audience as well as that of the maker) depends on what is called "framing," or placing an object within the framework of a discussion of an object in and for itself—this idea tends to lead to formalism.

No stubbornly inflexible Marxist will allow us to enjoy formalism, since in its extremes it led to the empty wastelands of minimalism, and to the occasionally dehumanized desert of idea art. Yet it is precisely in the play of forms that we humans seem to derive a great deal of pleasure, and pleasure is not allowed in certain circles of either criticism or manufacture.

Friedrich Nietzsche had a most interesting theory of art. He said, simply, somewhere, "Art is what keeps you from going crazy." Then, of course, he went mad himself, but that is another story.

Art is what keeps you from going crazy. Art therefore has a social function. It keeps us sane. It provides us not only with a method of expressing our frustrations, our rages, our passions, but it provides us with escape, with a respite from social responsibilities, with the value of an activity pursued for its own sake and only for its own sake. Art involves freedom of choice. As I mentioned earlier, even Marxist critics will allow this formulation.

Yet the moment you begin to investigate this notion, that art is what keeps you from going mad—so that any type of art will perform a fundamental social function—you come crashing up against what I call the Great Pascal-Montaigne Barrier Reef: the problem of whether or not it is acceptable to use art as an escape hatch.

To simplify it to its most fundamental premises, Pascal argued that we must not give in to easy distractions, but must work unceasingly for the salvation of our immortal souls. Montaigne, on the other hand, argued that life is so difficult, so wearying, that we deserve and need distraction, that entertainment was not only acceptable but necessary for psychological health. With Pascal crouched on our shoulders, we feel we must always be in the front lines, taking pictures of, say, the wretched victims of the Khmer Rouge, documenting the mistreatment of the elderly in nursing homes. With Montaigne tucked away in our undershirts, we feel we are allowed to take elegant pictures of flowers in Art Deco vases, or the moon coursing over a pristine wilderness.

Modern sociologists have begun to favor what is called the "uses and gratifications" theory of media since it turns away from the presumed intrinsic nature of art and questions like "What is Beauty?" to examining the ways in which people use the arts. Uses and gratifications theory attempts to deal with what sounds like a simple question: *Why do people look at photographs, watch television programs, read a book, or go to the movies?*

In a handy-dandy little book, *Media Analysis Techniques,* the media critic Arthur Asa Berger summarized potential uses and gratifications. Since he provided an extensive list but did not place them in any hierarchical order, I will

mention only a few: to be amused; to see authority figures exalted or deflated; to experience the beautiful (ah, but that's a whole other lecture!); to satisfy curiosity and be informed; to find distraction and diversion; to experience empathy; to experience, in a guilt-free situation, extreme emotions; to find role models to imitate; to believe in romantic love; to believe in magic, the marvelous, and the miraculous; to see order imposed on the world; to explore taboo subjects with impunity; to affirm moral, spiritual, and cultural values; to experience the ugly (ah, but that is yet another lecture!).[16]

I want to concentrate on just one of these uses and gratifications, and that is: **To experience empathy.** Without mentioning Aristotle's classic formulations of the catharsis of pity and terror through experience of tragedy, Berger elaborated on empathy:

> By this I mean being able to share the joys and sorrows of others and deriving, from this, psychological pleasure—often catharsis or "relief." Although we relate to the various characters we see in the media vicariously, we are still able to share in their emotional experiences and this enriches us greatly. It also helps us prepare ourselves emotionally for the difficulties we all face in real life at one time or another.[17]

It has always seemed to me that formalist theories of art founder on the shoals of tragedy. No formalist I have yet encountered has been successful in explaining either realism or expressionism in the visual arts. A recent review of the exhibition *German Expressionalist Sculpture* by Donald Kuspit, which appeared in *Art in America,* seems very much to the point. Much of German expressionism, produced between 1905 and 1925, was brutal, ugly, violent, with "an urgent insistence on the empathic and on pathos in art."[18] Apparently, as Stephanie Baron observed in her catalog for the exhibition, German expressionism dramatized the inner, psychological experiences of humanity through what she called an excess of feeling.

Kuspit found that the term "excess" is the clue: the expressionists went far beyond conventional life, disobeyed propriety, in order to arouse a repressed capacity for empathy. "The Expressionist point is that art that does *not* arouse empathy in the viewer is a failure. . . . Expression of feeling is *not* the issue in Expressionism; evocation of empathy is."[19] To emphathize with other human beings means to evoke a temporary identification with their sufferings and joys.

The modernist expectations about art as autonomous creation made it difficult to theorize about German expressionist sculpture, which Kuspit observed was primarily devoted to "an attempt to create an empathic milieu in a world which is hardly sympathetic to one's individual existence."[20]

But why is empathy so important? Martin Buber believed that the single most important lesson that each individual has to learn is the concept of the

"I-Thou," the ability to empathize with a separate Other. In its simplest
terms, it is not as important for the "I" to express itself as it is for the "I" to
recognize, respect, and even revere the difference and separateness of the Oth-
er. If the "I" can successfully emphathize with the "Thou," if the "I" can,
for example, emphathize with the pain that the "Thou" suffers, then the "I"
has attained personhood, maturity, and an ethical level of existence.

Do we chain women into the stereotypes of slave, bimbo, and whore? *Do*
we permit wars in which young men are sent to die in agony and terror? *Do*
we let black and Hispanic youth suffocate without jobs in the inner cities? The
"I-Thou" equation quickly escalates into political action, as it must.

But the "I-Thou" equation is somehow less malleable on the interpersonal
level. Since social Darwinism is the prevailing ideology of the mind industry
in this country, we may find that a man who empathizes with the sufferings of
starving Ethiopians may be unconcious of his effect on people around him. A
woman who empathizes with the social stigma of prostitution may nevertheless
photograph men and women in an exploitive, sensationalist way. We are en-
couraged to think that this is a tooth-and-claw existence and that we must
compete with each other tooth and claw. The "I-Thou" equation cannot be
taken for granted. We should encourage our students to examine each of their
actions to see what kind of world they are unconsciously fomenting.

It would seem that it is all too easy to forget to differentiate between mak-
ing art and encouraging barbarism.

June 1971. Where were we all in June 1971? Were we out on the streets
fighting to stop the Vietnam War? Were we too young to remember body
counts and government propaganda about the light at the end of the tunnel?
Patricia Bosworth's biography of Diane Arbus tells us where Arbus was, and it
is not a pretty scene. Arbus still wasn't receiving enough assignments to pay
the rent, so she would sometimes photograph media events for later sale. In
June 1971, she attended a press conference for Germaine Greer, who was pro-
moting her best-selling and controversy-provoking book, *The Female Eunuch.*
An imposing tall woman, over six feet in height and wearing buckskin, Greer
had created quite a sensation when she debated Norman Mailer at Town Hall
on the subject of female sexuality. She was a celebrity, with a cover of *Life*
and an invitation to emcee the Dick Cavett talk show. Bosworth reported:

> Today Greer says her first impression of Diane was of "a rose petal soft, deli-
> cate little girl. I couldn't guess how old she was, but she charmed me in her sa-
> fari jacket and shortcropped hair. She was carrying such an enormous bag of
> camera equipment I almost offered to carry it for her—she could barely lug it
> around. She hopped around photographing me—and when she said she'd like to
> have a proper photographic session alone with me, I agreed. I recognized her
> name and thought, "Why not!" "

"It was a hot muggy day. . . . I was staying at the Chelsea Hotel in a seedy room. Diane arrived and immediately asked me to lie down on my bed. I was tired. God knows I was tired—I'd been flogging my book like mad—so I did what she told me. Then all of a sudden she knelt on the bed and hung over me with this wide-angle lens staring me in the face and began clickclicking away."

"It developed into sort of a duel between us, because I *resisted* being photographed like that—close-up with all my pores and lines showing! She kept asking me all sorts of personal questions, and I became aware that she would only shoot me when my face was showing tension or concern or boredom or annoyance (and there was plenty of that, let me tell you), but because she was a woman I didn't tell her to fuck off. If she'd been a man, I'd have kicked her in the balls."

"It was tyranny. Really Tyranny. Diane Arbus ended up straddling me—this frail little person kneeling, keening over my face. I felt completely terrorized by the blasted lens. It was a helluva struggle. Finally, I decided 'Damn it, you're not going to do this to me, lady. I'm not going to be photographed like one of your grotesque freaks!'' So I stiffened my face like a mask. Diane went right on merrily photographing—clickclickclickclick—cajoling me, teasing me, flattering me. This frail rose petal creature kept at me like a laser beam, clickclickclick. She'd jump off the bed periodically to load the camera. Just as I was breathing a sigh of relief, she'd be on top of me again! It was a battle between us. Who won? It was a draw. After that afternoon I never saw her again. I never saw the photographs either."[21]

This bizarre scene occurred about one month before Diane Arbus killed herself.

This grotesque photographic rape of Germaine Greer by Diane Arbus has made me ask myself many questions with no sure answers. There are some obvious, funny questions, like why did the giant simply not punch out the pygmy? Greer claims it was because Arbus was a lady. Hell, she was no lady. She had become a brutal little savage. Unconsciously, Greer **does** equate the incident with rape, for she says that if Arbus had been a man, she would have kicked "him" in the balls—for that is what you are supposed to do if you are being raped by a man and think you can get away from him that way. But what was she supposed to kick with Diane Arbus?

Why did Germaine Greer simply lie there? She acknowledges that Arbus was flattering her, cajoling her. Did she need to be flattered? Or did she think, by the agenda of issues, social norms, and social expectations delivered daily by the mass media, that once you have said yes to a photographer you cannot ask him or her to leave and kindly shut the door on the way out?

And what of Arbus? Diane Arbus had not only done what the twentieth century expected of any artist—to make herself into a unique individual by what-

ever means—but she had also become a caricature of what the mind industry expected: first, that you will completely abandon yourself to the manufacture of saleable images no matter what the ethics of a situation and, second, that you will assume the aggressive, domineering, violent characteristics of what the nineteenth and twentieth century had demanded of the male artist, the male artist having become by that time the only true artist. Abdicating all pretense at compassionate, empathic behavior, she thought only of herself and some abstract ideology that the end justified the means.

If this is the kind of individualism we still cling to, I say to hell with it. If this is what makes for great photography—which I doubt—I say to hell with it. And if this is what we think is the only way to make "art," I say to hell with that, too. I do not think we need to play out the media fantasies of ourselves as celebrities that modern society seems to demand, to adulate, to worship. Germaine Greer was as culpable as Arbus. They were not in an "I-Thou" equation, but rather in an "It-It" situation of mutual exploitation.

The single most unexpected sentence in the best-selling book *Megatrends* is, "We must learn to balance the material wonders of technology with the spiritual demands of our human nature."[22] Our spiritual selves—that would mean the redevelopment of a humane system of values that excludes no one. Does that answer the pressing problems of how to get a job, how to conduct an interview, how to write a resume, how to break down the prejudices of museums and galleries, how to get published, and all the other practical problems of day-to-day survival? Possibly not, not in an immediate sense. But in the long view, unless we begin first to believe ourselves intrinsically worthy and then believe each other as deserving of the deepest respect, we will be living in a society not worth saving.

When James Joyce was asked how an artist could survive in **modern society,** he said that the artist needed to practice "silence, cunning, and exile." Those might have been appropriate behaviors in the 1920s, when the lost generation fled to Paris, there to live in cruel self-discipline, hard work, and to die, quite often, in obscure poverty. But in **postmodern** society, there is no longer any place where it is possible to achieve a peaceful exile in the company of other exiles. Silence has proved to be mute capitulation to the mind industry, which means to acquiesce in one's own destruction. But even in the postmodern society, we still can have cunning.

Cunning should not be looked upon as a Machiavellian evil, but rather as a combination of self-knowledge, awareness of change, flexibility to meet change, a knowledge of others, and an educated ability to make choices. Self-knowledge would demand that we face our talents, our delusions, our false expectations, our willingness or unwillingness to work within the system. Awareness of change would imply acceptance of the possibility, always present, of technological unemployment, since no technology of art or communication re-

mains static. Flexibility would encourage preparedness to meet technological challenges and new societal configurations. A knowledge of others prepares us to accept differences, to recognize what motivates and what persuades. And the educated ability to make choices requires a certain maturity, a wide acquaintance with the workings of professions and the psychology of small groups, and reflects back, always, on the continuing expansion of self-knowledge.

I do not think we need to be unduly pessimistic. On the contrary. If we keep in mind that, despite its early promise, **modernism** led to rigid dogmas about what was or was not art, about what men could do and women could not, about a hierarchy of aesthetic values that prohibited discussion about anything but a certain few fine arts—into which pantheon, let us remember, photography was **not** welcomed—dogmas that ultimately led to academies like the abstract expressionist gang, then to minimalist gang, all dominated by the tastes of a few museum curators and critics, then we should be grateful that we have moved on to a wilder, freer time in which, as C. Ray Smith put it, we have available: "accessibility, emotional expressivity and subjectivity, and qualities like irony, mystery, ambiguity, awkwardness, contrasting juxtapositions and conflict, perversity and paradox."[23] Smith was talking about postmodern architecture, but the same opportunities apply to photography; and we can include whimsy and humor, puns and witticisms, not merely the high seriousness of a monumental order. Smith also included in his list of new visual interests nudity, profanity, and scandalizing as well as the polite and decorous, but nowhere does he cite cruelty, subjugation, sadism, or rape.

As for advice? Trash the media by not adding your own trash; take on the world with affection, courage, respect, and even a sense of humor. Italo Calvino may have said it all in the following paragraph:

The inferno of the living is not something in the future: if there is a hell, it is what is already here, the inferno where we live every day, that we form by being together. There are two ways to escape suffering it. The first is easy for many accept the inferno and become such a part of it that you can no longer see it. The second is risky and demands constant vigilance and apprehension: **seek and learn to recognize who and what, in the midst of the inferno, are not inferno, then make them endure, give them space.**[24]

From the keynote address delivered at the 1985 National Conference of the Society for Photographic Education, Minneapolis.

Genres

Looking at Literati
THE WRITER'S IMAGE

IF WE ARE TO BELIEVE Jill Krementz's husband, Kurt Vonnegut—who obligingly provided a preface for this book of her portraits of famous writers, including many of Vonnegut himself—publishers have now recognized that a good portrait is "as crucial to selling a book as good copy." It is Krementz, apparently, who has convinced publishers that the face adorning the back flap of a colorful book jacket should be as enticing or marketable as the book itself. In fact, that face may be as significant as the logos and trademarks of huge corporations.

Obviously, a writer can succeed despite being shy, private, sullen, drunk, sophomoric, or even unphotogenic, but if we follow Vonnegut's observations to their logical end, it may be that soon publishers will be saying, "Great book, lousy face, Don't call us, we'll call you." If this has the ring of absurdity to it, read the recent series in the *New Yorker* on "The Blockbuster Complex." You will be persuaded that, thanks to conglomerate takeovers of publishing houses, movie and television tie-ins, and the huckstering of authors as video personalities on national talk shows, the author of a book must be as hot and salable a commodity as the book itself. In fact, more so. Given the ever increasing mania for celebrities, writers may soon need to hire surrogates, charismatic stand-ins who can offer a more attractive physical presence not only for the talk show, but the picture on the all-important book jacket.

The notion that a portrait can propel a person into a profitable limelight is not new nor confined to the age of television. Abraham Lincoln and Theodore Roosevelt both acknowledged their enormous debts to photographers and other visual artists. The twinkle-eyed, superbenign image of Dwight D. Eisenhower that greeted potential readers of the *Saturday Evening Post* back in the fifties was nothing more than a tricked-out photograph enhanced by Norman Rockwell. But with the possible exception of Norman Mailer, fiction writers do not run for the presidency of the United States. They may wish to be hailed as seers and prophets, but their ambitions are usually more oblique than directly political.

But what, exactly, do we hope to discover in their faces that makes literary

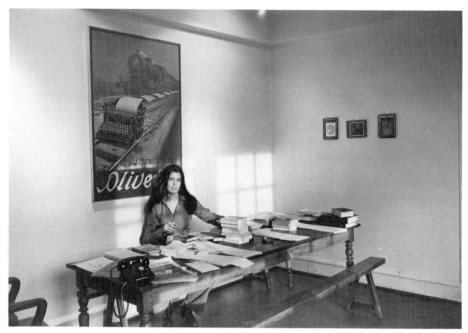

17. Jill Krementz. *Susan Sontag*, 1974.

portraits so magnetic? Are we still under the spell of the nineteenth-century be-
lief that the physiognomy of individuals reveals crucial mysteries of the soul?
Is it more simply that we want a visual tag as an information label for writers?
Or is it that we want to be able to recognize them as we shop for groceries or
go to the theater? If we think for a moment about the way actors are cast for
parts in movies, we can even imagine a kind of formula that would supply this
kind of face for that kind of book. Certainly we would never accept Groucho
Marx leering at us from the back flap of *War and Peace*.

With over a thousand portraits of writers to her credit, Jill Krementz has
demonstrated that writers can be photographed in a frequently interesting, pre-
sumably marketable, even intriguing manner. Essentially a documentary jour-
nalist, she has covered tough assignments in both Harlem and South Vietnam.
Her *Very Young* series has produced five books on extraordinary children.
Newsweek, Time, Life, People Magazine, and other journals regularly feature
her pictures, and her work has been collected by the Library of Congress and
the Museum of Modern Art. The portrait of her by Gordon Parks that deco-
rates *The Writer's Image* jacket flap presents her as an exceptionally striking
brunette, sophisticated, intelligent, and determined. She is so determined in the
pursuit of her profession that E. B. White called her "Jill, the Relentless," an
affectionate and accurate appellation reminiscent of the tender curses Alfred
Lord Tennyson accorded portrait sessions with Julia Margaret Cameron in the
1870s.

Krementz's pictures are often infectiously humorous. She props up Anaïs
Nin like a hieratic lily pad floating on Washington Square grass (from which
the debris has been scrupulously removed). Obviously horsing around for the
camera, Henry Miller and Lawrence Durrell mischievously grin at us from un-
der a blanket they share in Pacific Palisades. John Updike skips rope, hope-
lessly entangles himself, then flashes a big grin as he hastens down a Boston
street. Truman Capote mocks himself as a night-shirted odalisque very like his
earliest portraits, but a moment later dons a Mafia hat, hides his eyes behind
dark shades and his mouth behind surprisingly grubby fingers. Unconscious of
the humorous spectacle he presents, William F. Buckley, Jr., in the backseat
of his luxurious car, simultaneously chats on the telephone, balances eyeglass-
es and manuscripts, and ignores his insouciant dog.

Other writers seem less jovial, or more self-conscious, or too preoccupied
with their own thoughts to care about public impressions. Thus we find both
James Jones and Janet Flanner swathed protectively in rich billows of tobacco
smoke. Like a superannuated college boy in a checked jacket, lace-up boots,
and open shirt, Edward Albee squats glumly on his chaise. Dominated by a
large white telephone, Lillian Hellman, aloof and self-composed, seems to be
awaiting an important call. More chillingly, James Dickey broods under a
broad-brimmed hat, his ravaged face a testament of existential grief.

The more complex portraits pose questions as difficult as their subjects. Here, for example, is Susan Sontag at Sagaponack, Long Island, in 1974 seated at a comfortably large table that is littered with papers, books, and black telephone. In a rumpled shirt and slacks, her dark hair effectively framing her proud face, she is dominated by a huge poster of the 1930s that compares the fleet Italian express trains to the Olivetti typewriter here touted as *la rapidissima*. The words *la rapidissima* are directly over Sontag's head. Surely this is no accident, nor is it an accident that the issue of the *New York Review of Books* containing an early Sontag essay on photography is deliberately turned for us to read its title.

Krementz does something similar with Katherine Anne Porter, posing her in 1972 in a rococo bed heaped with newspapers and books, the most conspicuous of which is Porter's own *Ship of Fools*. Even more strikingly self-reflexive is her 1974 double portrait of Joseph Heller. Graying, long-haired, modishly casual, he sits leaning against a piano on which stands a copy of *Catch-22*, the book that established his reputation. The back cover portrait of the author of *Catch-22* reveals a crewcut, ambitious young man. The next step would entail taking an identically posed picture of Heller holding the 1974 portrait, which includes the 1960s portrait: we would then have a spectacular visual metaphor for growth, change, and the problem of identity.

Indeed, the problem of identity is the crux of the matter. Which of the four protraits of E. B. White here reproduced can be said to represent the complex personality of that gifted man? White sprawled in his sailboat? White feeding his terrier Pepperidge Farm Goldfish crackers, which he is munching with an afternoon highball? The loving double portrait of Katherine and E. B. White? Or the best photograph of the lot, E. B. White in his starkly empty Maine studio? It is this last portrait that was selected for the front jacket cover, and an excellent choice it was. White is seated at his typewriter, a barrel beside him for rejected prose and an open window through which little but an empty sea can be observed. It is a classic portrayal of the writer's eternally lonely diligence, repeated by Krementz in portraits of Eudora Welty and Isaac Bashevis Singer.

Even if the image of the writer at his or her typewriter has become a visual cliché for the arduous mental and physical work of writing, it is a useful stereotype. Writing is a kind of invisible profession for which there is no uniform. The butcher has his apron and straw hat, the chambermaid her cap and duster, a policeman his badge and stick, and the journalistic photographer her camera and flash. Of course there is another valuable cliché: the identification of the writer with the literary project of published books. Here is Ionesco, smiling cloyingly under his towering book collection, and John MacDonald parades his published paperbacks, while Alberto Moravia and John Updike pose

with both books and typewriters. How else would we know who these people
are or what they do if we did not read the verbal caption?

If we consider that Alfred Stieglitz took over five hundred portraits of Geor-
gia O'Keeffe in a determined effort to capture her magnificent variety, it be-
comes apparent that only the smallest glimpses are afforded here by
Krementz's pictures. We know that she must have exposed roll after roll of
film for each portrait, yet the limitations of still photography are perhaps never
more obvious than in portraiture. Even Edward Steichen, himself no mean im-
ager of the famous and artistic, recognized very early that no mere aggregate
of still portraits could succeed: "It has sometimes been said of the work of
certain portrait painters that, by prolonged study and work with the model,
they were able to produce a synthesis of the sitter's complete personality. But
here we must remember that it took great writers like Balzac or Proust vol-
umes to bring us a living portrait of a person. To imagine that a visual artist in
any medium could condense a complete portrait into one picture is putting a
strain on logic."

According to Vonnegut, "Every portrait Jill takes . . . is of a person tricked
out of his or her shell by a sweetly surprising, unthreatening, and momentarily
entertaining social situation." Her approach resembles that of an actor or "a
highly intelligent clown" who knows how to persuade subjects to reveal their
inner selves "by entertaining them as children." If Krementz dances around at
the moment of shooting to distract the anxious subject, we can safely doubt
that she does anything to threaten the stability of the camera. Still, she seems
totally unlike someone like Yousuf Karsh, who insists that a photographer's
greatest asset is a knowledge of human psychology. Karsh, of course, has
often been accused of producing stiff, predictable portraits embalmed in wax;
yet that embalming has given us the extraordinary portraits of Winston
Churchill and Ernest Hemingway. Obviously, a useful portrait of a famous
person cannot escape two demands: the first is that it must be a fascinating
photograph, the second is that it provide clues to the subject's "true" person-
ality or character.

Krementz may be limited by her technology. She uses the 35mm camera ex-
clusively, an instrument that sometimes tempts the user into the grab shot rath-
er than the presentational pose. If she is capable of both the candid and the
conceptual, many of her portraits suffer by comparison with masters like Ar-
nold Newman, Richard Avedon, or Cecil Beaton. For example: in Ben Mad-
dow's survey, *Faces* (New York Graphic Society, 1976), we encounter
Beaton's *Gertrude Stein and Alice B. Toklas,* with Stein dominating the fore-
ground and Alice suppressed into the far background, commenting on their re-
lationship as well as their relative importance in literature. Beaton's *Aldous
Huxley* appears partly revealed through a torn semitransparent stage scrim,

with backlighting that makes him cast a shadow larger than himself, once again a correctly perceived metaphor for the writer's influence being greater than his own person. Avedon's portrait of Isak Dinesen presents her as a tiny wrinkled head atop a huge fur coat, photographed from below to make her larger than life, as indeed her stories are written from a perspective far above the trivia of so-called realism. In other words, neither Beaton nor Avedon are afraid of the symbolic, whereas Krementz often seems limited by her journalistic approach to a more naturalistic, therefore more ephemeral product. She is limited as well by the task she has set for herself and for which publishers pay her: not to make the ultimate artistic statement about individuals who happen to be famous writers, but to produce attractive pictures specifically related to the selling of books. It is therefore hard to imagine that she will ever match what may be the greatest portrait of any writer, Henri Cartier-Bresson's study of Ezra Pound when that monumental spirit was nearly insane, nearly dead, his wrinkled face pierced with hating eyes, his equally wrinkled sweater and his clenched hands all reverberating with barely repressed anger and despair.

In trying to separate these portraits from their original purpose, and in assessing Krementz as a photographer, is it a problem that Krementz occasionally shows up aspects of writers we do not care to examine? That too many of these pictures are of grinning faces? Or that too many reek of comfortable success and not of the agony of creation and the hard work of thought? Two group portraits epitomize this last difficulty. On a manicured lawn in East Hampton, Long Island, Kurt Vonnegut with cigarette and beer can, E. L. Doctorow dressed for tennis, Joseph Heller grinning and seductively *contraposto*, George Plimpton at his most Ivy League, and a stiffly posturing Wilfred Sheed, are gathered together for the camera. Nothing in the picture (or the text) explains this gathering, and while it displays a certain relaxed charm, it is basically insignificant, as useless a clue to creativity as the showy glop in journals like *People*. A second portrait offers John Knowles, Willie Morris, James Jones, and Truman Capote, again in the fashionable Hamptons. Accompanied by a prone German shepherd dog, they are seated around a glass-topped summer table laughing. Again, there is not a single clue to the meaning of the laughter or of the gathering itself. These groups confide nothing; they are like the private meanings of an unidentified family album you pick up at a flea market.

As a physical artifact, *The Writer's Image* makes a handsome first impression. Yet there are minor distractions. The black borders around most of the pictures were undoubtedly conceived as frames to strengthen images too light to offer contrast with the white paper. Unfortunately, these substantial black borders have the effect of making obituary items out of still-living writers or of promoting the effect of the snapshot. The bleed pages are much more effective. After all, since the portrait often pretends to be a window on personal

realities, it is perhaps better not to interfere with the illusion that the photographer is present only as recording instrument of the utmost objectivity. The moment that the photographer attempts to impose an almost inevitable "artistic" design, to make the almost unavoidable subjective statement, then the viewer is no longer experiencing the illusion of reality, but is actively interested in the photography as an art object. It is only the greatest of portrait photographers who can perform both miracles at once.

Writers often used to supply their publishers with slovenly and haphazard snapshots that resembled photo booth productions. Krementz has the reasonably virtuous goal of replacing such eyesores with decent portraits. In *The Writer's Image,* she provides at least a dozen memorable images, among them the Anaïs Nin preciosity and the heartier delights of Studs Terkel, who, bare feet on coffee table, lower lip ajar with talk, gray hair askew, in a room scattered with books, seems the very essence of the tough-minded writer. It would be interesting to learn if Krementz ever yearns to be free of the marketplace, but it would be unfair to ask of *The Writer's Image* that it be judged outside of that commercial context.

The New Boston Review, March-April 1981.

18. Starr Ockenga. Untitled, 1980.

Starr Ockenga's Nudes
SOME NOTES ON THE GENRE

WHEN THE NUDE FAMILY HERE REPRODUCED was displayed in a Boston gallery, Photoworks, a woman came in off the street to suggest, rather sternly, that curtains be hung across the gallery windows. She had a seven-year-old daughter who had to pass that way to school. The daughter would be horrified by what she saw. Naked people, after all, are not acceptable in a decent, civilized world. Ockenga's nudes, male and female, were large prints and in vivid flesh color, compounding the issue. They had to be covered up in some way, even if it meant screening the photographs behind little skirts of window chintz.

What was so surprising about this reaction was that the images seemed so completely lacking any taint of pornographic or exploitive interest. In groupings Ockenga calls "the intimate circle," they are simply photographs of mothers with children, sisters together, a young boy hoisted naked on his older brother's torso. The fine line between blatant eroticism and straightforward presentation of the unclothed state of various humans had been scrupulously observed. Other adventurous gallery visitors who wandered in from Newbury Street had remarked on the relaxed trust that the models clearly offered the photographer. "They look so natural," one older woman opined, shedding a warm smile on the flesh tones, as if she felt she could be patronizingly sweet about the difficult task of representing naked humans without prurient seduction or, to use Sir Kenneth Clark's delightful phrase, "lubricious excitation." But several younger students from art schools and photography classes who visited the gallery complained of being confused. "What is she trying to do?" and "I can't tell how she expects me to react."

Much of Kenneth Clark's exquisite but decidedly old-fashioned study of the genre of nude art is devoted to the explication of reaction cues presented to the viewer. At first he seems to be stating the obvious: *naked* simply means being without clothes, a condition implying a normal, almost universal embarrassment depending, one presumes, on the context. The term *nude,* on the other hand, since it does not arouse any suspicion of vulnerability or defenselessness, connotes "a balanced, prosperous, and confident body."[1] Clark's com-

19. Starr Ockenga. *Bev and Cliffie and Jan and Dereck*, 1981.

patriot, John Berger, has a much more modern and feminist approach.[2] For him, *naked* means being yourself; *nude* is the objectifying of a human being into a thing, an abstraction. Both critics agree that it was the nineteenth century that established the genre of the nude as primarily involving the female body. Berger would say that the bovine lumps of attractive flesh that present themselves in paintings from the realism of Courbet to the idealism of Renoir are the product of capitalist attitudes toward women. A purely Marxist view, however, tends to overlook the long history of the female nude as object, even excepting the ancient goddesses (for they were equalled by male nudes of Apollo). For Kenneth Clark, the nude is an art form invented by Greek sculptors of the Golden Age, just as opera is an art form devised by baroque period Italians. He avoids the potential connections between the development of representational optics and perspective as they connect with the Renaissance money nexus, and does not pursue the objectifying of the natural world itself by the scientific method. The apparent genetic disposition of males to gain pleasure from sheer looking—an activity that reveals itself par excellence in the male photography clubs and their endless preoccupation with voyeuristic peering through the camera at naked women—is, at best, a psychobiological hypothesis as yet unproved. In any event, Thorstein Veblen's *Theory of the Leisure Class* makes ample comment about the consumerist attitude toward women.

Kenneth Clark insists that ''the nude is not the subject of art, but a form of art.'' The nude is to be considered one of the several genres of the visual arts: landscapes, still life, abstraction, portraiture, marinescapes, cityscapes, and so on. It seems curious, therefore, that he insists ''no nude, however abstract, should fail to arouse in the spectator some vestige of erotic feeling, even though it be only the faintest shadow. . . .'' It would follow then, that a landscape should evoke a desire to own land? To plow fields?—to use a sexual metaphor. To cut down trees?—to use a sadomasochistic analogy. And still life? What should that genre arouse? The desire to eat?—if the picture presents a superabundance of fruits, meats, and vintage wines. The desire to rearrange table tops? Portraiture, we imagine, exists to arouse the passion to know another human being. The latter idea at least makes sense. But if no nude, however abstract, should fail to arouse erotic feeling, then, despite Clark's protestations, the subject of the nude *is* the naked body, and the implication is that the naked body inevitably arouses desire. The photographer Duane Michals agrees: ''As far as the sexual aspect of the nude is concerned, there is no such thing as an innocent nude, even in a photograph of a 97-year-old person, the viewer still responds out of sexual curiosity.''[3]

Clark is quick to protect himself from such an extreme position. The subtitle to his book *The Nude*, is, after all, *A Study in Ideal Form*. It would be only the ideal form that arouses, or should arouse, desire, not the pathetic, exhaust-

ed, aged form, nor the grotesque. In other words, it is the beautiful that arouses desire. But "beautiful" is a relative term, and we all recognize that what is beautiful in one culture may be hideous in another. Helmut Newton, that purveyor of chic sadomasochistic fantasies, claims he never photographs a body he considers ugly. What he finds beautiful is the fashion mannequin, that bony, half-starved, essentially sexless artifice.

What Starr Ockenga finds beautiful is the ordinary human body. She talks about the problem of "beauty" this way: "When I look at the most ordinary human body, I see it as beautiful. Whether a body is or is not classically beautiful or beautiful according to current standards or by any other standards is not a judgment I make. The given for me is that the human body, in whatever form, at whatever age, *is* beautiful. My job, as I see it, is simply to make pictures that document that mortal beauty." What may confuse this message is that she tends to photograph young women and children of spectacular perfection of both form and texture even as she claims to be pursuing the body in its natural state, undisguised by cosmetics, unfettered by clothing. According to Ockenga, this fact is pure accident. "I'll photograph anyone who comes my way and who wants to be photographed. I don't select my subjects very often. Frequently, in the case of models, when they arrive at my studio ready to be photographed, I have never even seen them before."

The nude may be a form of art, but nudity equates with nakedness. Clark has trouble keeping the terms separate. In a charming discussion of Titian's painting called *Sacred and Profane Love,* in which a brocade-gowned woman and a seminaked woman seem to be conversing on the nature of love, Clark remarks on their context: it is an Arcadian vista in which they personify human essences, with the human being seen as part of nature. For Clark, these graceful, thoughtful, composed women represent the ancient habit of anthropomorphizing "the essence of every pleasant thing in nature—springs, flowers, rivers, trees, even the elusive echo—. . . as having the shape of a beautiful girl." Unfortunately, this idea of permitting naked beauty to be "a natural feature of the landscape" could not last. "Titian's employers were not averse to naked women, but they wanted them in their proper place, and there follows a series of nude figures reclining on beds and couches."

Note the erosion of his previously precise use of the term "nude." His statement about "a series of *nude* figures reclining," really signifies "a series of *naked* figures." Note, too, the unstated palace pornography, the power and control over the woman's body. The female of the species was considered a utility available in a specific context only: bed. No wonder the audience for Ockenga's nude photographs was sometimes confused. Lacking conventional clues for responding, the younger students may have been expecting to be told how to use the images. Ockenga is firm on this score: "My pictures are not intended to provoke 'bed thoughts.' Most of my subjects in single portraits

stand. With no props, nothing to recline on or against. It is only when I make pictures about the nude as a kind of bodyscape or landscape that I let them lie or move like the land does. Lolling about on beds or reclining in languid postures suggests too much leisure. I want a stronger and more serious, a less easy confrontation between subject and viewer.'' In the Photoworks exhibition, Ockenga made it a matter of aesthetic principle to provide no conventional clues.

Kenneth Clark offers another instance of the proffered clue: Manet's *Olympia,* the controversial portrait of a naked courtesan attended by a black woman holding a bouquet and by a startled black kitten. The courtesan stares directly into the spectator's eyes with disconcerting frankness. Clark comments: ''The *Olympia* is a portrait of an individual, whose interesting but sharply characteristic body is placed exactly where one would expect to find it.'' That is, in bed. He continues, ''Amateurs were thus suddenly reminded of the circumstances under which actual nudity was familiar to them, and their embarrassment is understandable.''

For all his desire to make the nude not the subject of but a form of art, Clark keeps stumbling over the hidden agenda—and an anxious one, at that— of most aestheticians in the twentieth century: the reconciliation of the presumed separation of form and content, which has disquieting reverberations of the mind-body separation. The problem surfaces most painfully in discussions of photography, and perhaps what makes Clark stumble is precisely the photographic quality of Manet's *Olympia:* it is specific, direct, and intimate. But while the model for the *Olympia* is placed witin a context of bed, servant, animal, Ockenga's refusal to provide context is a deliberate attempt to force us to respond directly to the human body itself. She explains, ''When I made these pictures, I thought of props and environment as excuses. I wanted the viewer to have no distractions. I wanted viewers to confront the nakedness. Most photographs or paintings of the naked body offer relief from this confrontation. I wanted to try to force the viewer to be responsible for his or her response. There is simply nothing else to look at but the flesh and the person to whom it belongs. This demand I make can be very upsetting. I am taking the risk of disturbing and thus alienating my audience. What I am hoping is that prolonged viewing will remove the fright or difficulty or anger. That there may be, after all, a gentle pleasure in looking at the body.''

Daughter of a highly regarded upper-class minister of a large Boston Evangelical-Congregational church, Starr Ockenga was brought up in the strictest and narrowest conception of personal modesty. Less amiable souls might call it prudery. One was not unclothed beyond the bathtub, nor did one reveal one's naked body to one's husband. While her self-sacrificing, self-denying painter mother finally informed her, just before Ockenga's first, short-lived marriage, that sex (and all that went on in the bedroom) was perfectly acceptable, sexuality per se was never discussed. Since such attitudes are the result of

centuries of Christian dogma castigating the evils of the flesh, it might be useful to recall the origins of the taboo against nudity in Western civilizations.

It all began with Eve. And Adam. The original story goes something like this. Eve and Adam "were both naked, the man and his wife, and were not ashamed."[4] After the serpent seduced Eve into eating the fruit of the tree of the knowledge of good and evil, "The eyes of them both were opened, and they knew that they were naked; and they sewed fig leaves together, and made themselves aprons." The Lord then discovers them cowering in terror among the trees of the Garden, and calls to them. Adam responds, "I heard thy voice in the garden, and I was afraid, because I was naked; and I hid myself." And the Lord astutely surmises the truth. "Who told thee that thou wast naked?" Hast thou eaten of the tree, whereof I commanded thee that thou shouldest not eat?" Adam promptly scapegoats Eve, and for this act of disobedience, the Lord punishes her kind forever, dooming all women to bring forth children in sorrow and pain, and making them subservient to their husbands, who, in turn, are cast as the unwilling breadwinners and toilers. All of this is well known, but a minor consequence is worth noting. After cursing these two creatures of his, the symptom of whose sin of disobedience was their nakedness, "Unto Adam also and to his wife did the Lord God make coats of skin, and clothed them." The Lord God, Jahweh, was the first tailor? The first clothing manufacturer? The first couturier?

Anyone familiar with the ways of folklore will recognize that the entire episode in the Garden of Eden is a tale of origins: it relates not only the origin of women's travail in childbirth, but the origin of man's sweating in the fields; in addition, rather delightfully, but not at all as a side issue, it relates the origin of clothing.

The Book of Genesis makes it clear that the evidence of disobedience and sin is nakedness. Nakedness is therefore evil. No explanation is offered for this damnation of a natural state, except that its cause is associated with the ability to tell the difference between good and evil. To be clothed was good. Unclothed, evil. The point was buttressed by the association of nakedness with the ultimate punishment for disobedience: death. A serious matter indeed. One disobeys the command not to eat of the fruit of the tree of knowledge of good and evil, and the punishment—obviously, the *knowledge* itself is the punishment—is mortality. In another sense, since the fruit of knowledge is the knowledge of one's nakedness and knowledge is equated with death, the knowledge of one's own mortality derives directly from one's knowledge of one's own body. By covering, clothing, disguising the body, one covers and hides one's sense of mortality. At the same time, paradoxically, the naked body has also been considered a display of one's sexuality; obviously, sexuality has been required for the perpetuation of the race or immortal life through the passing on of one's genes to future generations.

In his *Letters from the Earth,* Mark Twain excoriated the primal scene in the Garden of Eden. "Adam and Eve entered the world naked and unashamed—naked and pure-minded; and no descendant of theirs has ever entered it otherwise. All have entered it modest. They had to acquire immodesty and the soiled mind. . . . A Christian mother's first duty is to soil her child's mind, and she does not neglect it."[5]

Ockenga has no animus toward her strict parents, but she does acknowledge that it took a long time to rid herself of ideas she thought as a child had come from the Devil. Ultimately, the taboo against the naked body seemed so pointless. It was the birth of her son that first began the liberation. Her delight in the softness and sweetness of his tiny body seemed entirely natural. In her responses to his early growth, she associated gestures and poses she discovered in their relationship with the paintings of Mary Cassatt, long a favorite of her own mother. But the *japonisme* of Cassatt did not interfere with the distinctions of assignable roles: mother, child. In her recent nudes, Ockenga recognizes that it is the lack of assignable roles that so conspicuously confuses or disorients her audience. In the fractionated image of two nude sisters, where there is no sign stating "these are sisters in a comfortable, intimate relationship,"[6] and where flesh presses upon flesh, she believes it might help viewers to relax with the image if they were even to imagine it to be of two lesbians. Despite the seeming conflict with conventional morality, she believes that the demand for role cues or relationship clues is so strong that any ascription is preferable to ambiguity.

Why, then, refuse to provide cues of any sort?

"Because what interests me more than it ever did is form." In Starr Ockenga's first book, *Mirror after Mirror,* she had provided many cues, but she now believes that having the models pose in their own houses made it difficult for her to control lighting and detail. At that time, she wanted the women to be in a context, and to have a history represented by their possessions. With the current nudes, she decided to remove her subjects from all the trappings.

I remind her that the people in her recent pictures are not merely naked, they are exposed. She agrees, although she had been using the word "vulnerable" to describe her models without the meaning of defenselessness. There are two meanings to the word "exposed." A photographer "exposes" film. A person "exposes" his or her private skin. And, of course, the photographer herself is "exposed" in the act of choosing to produce these specific images. How do these various exposures interact?

"It's an abstract kind of relationship, almost as if I am photographing trees. I'm looking at line and form and gesture. I'm fascinated by the eloquence of simple gestures." She ponders the fact that she herself is always clothed during the modeling sessions. "That is my defense, I suppose. It keeps the session absolutely professional and abstract. It makes for distance. But it

sometimes makes me feel like a voyeur. I do wonder about the unequalness of
the situation.''

Is she ever aware of becoming physically excited during the act of photo-
graphing nudes? ''No. It's purely a visual excitement. I say, 'Wow, this is ter-
rific!' but I'm talking about the pose. I'm not turned on, if that's what you
mean.''

Starr Ockenga finds ordinary bodies beautiful. While most of her models do
not seem to think much about their bodies, some of them do become quite in-
terested in the process of being photographed naked. For some reason, they
are willing to do anything she asks. It is she who decides if a particular pose
becomes overly explicit, suggestive of the direct physical act of sex, some-
thing she wants to avoid at all costs, especially in pictures involving children.

Is she a female Lewis Carroll, intoxicated with the prepubescent child?
''No, because in his own time, Lewis Carroll would have been thought border-
ing on the sexually suggestive. I have prints that I won't let the public see for
another twenty years, because by then we may all have accepted the natural-
ness of being naked.''

Did she not use the word ''vulnerable''? And then suggest that ''exposed''
was a better word for what happens to her models in front of her camera? Did
her conception of ''exposed'' have any relation to the idea of the ''exposé''?
''None whatsoever. I simply ask my models to undress and place themselves
on the large seamless white sheets of paper all photographers use. There they
have no props. They are alone with their bodies. The atmosphere is warm,
loving, comfortable. They know I will not make them ugly or exploit them.
They trust me absolutely.''

Do the models ever feel threatened? ''No. When we use the word 'vulnera-
ble,' we tend to think people are open to attack. All that I mean is that they
are human. Nothing threatens them while they are being photographed. And
the white paper background lets you discover their flesh colors.''

Without social cues, without defensive props, with nothing but their own
mortality embedded in their own flesh, her models seem extraordinarily trust-
ing. On further thought, however, I suggest to her that this is a kind of theatri-
cal situation, uncovering the body and placing it against a pure white
background. She responds, ''White is the color of truth, purity, virginity.
Draw your own conclusions. And yes, it is a kind of theater.''

Magazine publishers frequently call Ockenga for permission to reproduce
her nudes. They are summarily dismissed if they are sexually exploitive.
Time-Life was also refused at least once, because the picture of the young girl
they wanted might have made the model feel uncomfortable if it were repro-
duced in a mass medium. ''When she grows up, perhaps then I'll publish it.''

What constitutes an exploitive context? Are there any parts of the body that

are not beautiful? "Spreading a woman's legs wide open so that the genitalia are exposed usually implies sexual invitation, therefore exploitation." But isn't a man's penis always on view when he's naked and facing the camera? "Yes, but I take care never to use any part of a person's body in what I consider as a provocation. If somebody is going to be excited by my pictures, I can't help it. I know that what I see as provocation and what someone else sees may be different. I have to remain true to my own standards." She laughs. "If they buy a print and take it home so they can masturbate in front of it, I can just hope it is a warm kind of experience."

What is her ultimate goal in producing these nudes? "To show how beautiful the human body is. To show how beautiful ordinary people are. To show simple, straightforward relationships that are intimate. I always ask my models to bring along a friend or a sister. I enjoy photographing intimacy, relaxed intimacy. I just wish I could find more older women to photograph, and more children." She grieves that all of her friends' offspring have grown up, and her son, too, is an increasingly private late adolescent unwilling to pose.

Ockenga confesses an early fascination with E. J. Bellocq's pictures of prostitutes. Why? "Because he respected them so much as people."

She studied with Harry Callahan and Aaron Siskind at the the Rhode Island School of Design and then one summer took a course with the visiting Robert Heinecken at Harvard. He had the reputation of being an exceptionally fine teacher. After her first showing of prints at a weekly critique, he took her aside and said bluntly, "I can't teach you anything about technique. But your morality is getting in the way of your work." She perceived this as such a challenge that she went home, undressed, shot an entire roll of film of herself naked, developed it, printed it, and took the pictures into the next critique without explanation. She remembers this act as a last push toward freedom; she even felt somehow purified, as if she had gone through some kind of initiation rite.

Does she realize that Robert Heinecken is one of the two photographers most despised by radical feminists?[7] "Yes, but there are two issues here. The first is his teaching. He really is a fine teacher, and many different kinds of directions result from his classes. He encourages individuality of vision. The second is that I don't feel my own imagery has been substantially influenced by him in anyway. He influenced me more as a teacher than as an artist."

And Les Krims, who plants naked women in sardonic tableaux fantasies of murder? "I can't stand most of Krims's work. I am offended by it, particularly where women seem abused, threatened, or exploited."

Does she consider that her work has any kind of feminist message? "I've never marched in parades. I'm not a placard carrier. I don't seem to operate that way. But I am totally in sympathy with feminist causes, and I will fight

for any one in my immediate circle whom I feel has been damaged by preju-
dice. I would hope that my work speaks for itself, that it carries a message
about being human and about being equal.''

One picture that served as the poster for her Photoworks show proved to be
particularly disturbing to viewers. It is a startling image: a young woman
whose face we do not see is holding up the curved body of another female, a
slim child of ten. The arc of the child's body, like a thickening new moon's
crescent, is repeated in the ovals of bracelets and breasts. There is a kind of
saltimbanque abandon in the pose, with the slender asexual freedom reminis-
cent of Picasso's rose period acrobats. The tension between the supporting fig-
ure (the child's sister), straining with the pressure of her burden's weight, and
the lithe collapse of the figure poised in air creates an odd kinesthetic re-
sponse. It has the simultaneity of closure/opening that some dancers can
achieve. Kenneth Clark offers some assistance with a discussion of nudes in
ecstasy: they are essentially ''unstable, and if they do not collapse it is not
through conscious control, but through the precarious equilibrium of enthusi-
asm.'' The body in ecstasy also ''provides a store of perfect decorative materi-
al. It pleases the eye, it is symmetrical, and it has been reduced to a simple,
memorable form almost as a condition of its survival.''

This curious balancing act of the two female figures arouses another re-
sponse. I decided that it was a picture of sacramental reverence, a kind of sac-
rificial offering. Ockenga gave this suggestion some quiet thought. ''Yes, I
suppose it is a female version of the story of Abraham and Isaac. It is a sacri-
fice. It is an offering. But it is also a symbol of trust. The child being lifted
feels the freedom to arch her body. She knows she will not fall.''

In another time, obviously the mid-nineteenth century, such an offering
would have been dressed up as a tableau. There would have been no ambigui-
ty. All the appropriate props would have been in evidence: wigs, togas, san-
dals, the sacrificial knife. It is not easy to look at pictures without cues,
without context, pictures that attempt to communicate through primarily formal
relationships.

Why, if she had not been influenced by Robert Heinecken's imagery, had
she fractionated two women's bodies in a long horizontal picture? ''In photog-
raphy, we are always photographing the peak moment. That is what photogra-
phy is usually about. The peak moment. I wanted to see if you could slow
down the peak moment, make it into many peaks, stretch it out across time
like a Japanese screen.''

There remained unanswered, because unasked, the serious question of how
it is possible to create purely formal experiences while conveying a message
about being human. After the interview,[6] Ockenga offered the following obser-
vation: ''In my simple way, I'd like to observe the beauty of form while al-
ways acknowledging that each person is unique. The title of each image in that

exhibition of nudes is the subject's first name—an effort to remind the viewer that the pictures are not only about the flow of form, but equally about the person who in his or her body owns and displays that particular grace of form.'' That response raises even more questions.

The nude is possibly the most difficult of all the visual genres. Clichéd, overworked, exploitive in the worst of hands, magnificent in the best, the nude body offers the experiences of tactility, texture, geometric form, the interlacings (so splendidly demonstrated by Henry Moore's sculptures) of negative and positive spaces. But the nude body can probably never be entirely divested of significance as it can be of clothing. Whether we look at nudes for titillation or for some presumably purer form of visual pleasure, it is always with the knowledge that we are looking at the representation of flesh. Flesh is mortal. The nude, therefore, is perhaps the most poignant of all the genres.

The Massachusetts Review, Spring 1983.

The Ethnocentric Icon

THERE IS A MEXICAN PROVERB to the effect that if you want to be happy, never leave your native land. That sentiment emerges in many societies, reflecting the folk wisdom that the intricate and subtle web of place, language, climate, and culture is sundered only at great hazard to the individual. But while we easily recognize the deprivation facing a writer exiled from the "motherland"—denied the "mother tongue"—it seems more difficult to define the equivalent experience for the visual artist. After all, the nineteenth-century romantic painters roamed the globe seeking the spectacular and the exotic: Delacroix delighted in the colorful eroticism of North Africa; Gauguin developed his decorative cloisonné symbolism in peasant Brittany and pagan South Pacific; Turner's swirling cataclysms stormed at him from the high Alps and the sunsets of Venice. In nineteenth-century photography, we think immediately of Maxime Du Camp recording the majesty of Egypt and Syria, John Thomson sailing off to China, William Bradford working his giant wet plates in the freezing Arctic, and Eadweard Muybridge, far from his native England, in the sublime wilderness of the Yosemite.

Is there nothing, then, that resembles the "mother tongue" for photographers? Does the specific landscape into which one is born make no permanent impact on one's vision? Can photographers, unlike writers, leave their native land with impunity? Is photography, as was suggested by exhibitions like Steichen's *Family of Man,* a universal language, tied to no syntactical conventions of a specific culture, freed from ethnocentric habits of mind, shackled by no visual preconceptions? In the search for subject, for content that offers the artist an objective correlative for a concept, a mood, a deep emotion, what risk does the photographer take in abandoning an authentic relationship between visual phenomena and their symbolic resonances in his or her specific culture?

A recent exhibition at the Creative Photography Laboratory of the Massachusetts Institute of Technology featured images by Dublin-born Alen MacWeeney and the masterful Mexican photographer, Manuel Alvarez Bravo. Together they offered a fascinating juxtaposition of two strongly identifiable places and two markedly different ethnic types. But Bravo had stayed firmly

20. Alen MacWeeney. *White Horse, Donegal, Ireland*, 1965–66.

planted in his native land, whereas MacWeeney uprooted himself from Dublin for a New York apprenticeship with Richard Avedon when he was barely twenty-one. Now MacWeeney continues to live in New York and revisits his home country as frequently as possible. As he told another interviewer (see Valerie Moolman's "Alen MacWeeney: An Irish Odyssey," *Aperture,* no. 82), "I feel an affinity with the Irish. . . . I really love the countryside, and I love the quality of light. And I just know what's ticking when I see the Irish people—I know what's going on." There is more than the lilt of an Irish brogue involved here: obviously, the familiar light, the facial expressions and body language he learned in childhood, and the social-psychological set in which he feels completely at home, all speak to him.

MacWeeney's Irish Odyssey is a series on the tinkers, a group of itinerants generally regarded as social outcasts. Inspired at first by the poetry of Yeats to seek them out, MacWeeney divulged that he had a documentarian ideal as well: he wanted to record the folkways of the tinkers before they vanish like the smoke of their campfires. This urge to be a recording angel has a long history among photographers as well as among filmmakers like Flaherty and Grierson. In cold print, however, it sounds like the slick, multicolor credo of the *National Geographic* magazine. Even relatively sophisticated viewers might be fooled by MacWeeney's slightly exotic subject into thinking he was merely conducting a black-and-white travelogue, with the camera finding nothing but folkways and picturesque scenery. A look at his striking prints of a great white gelding turning its head away, a young girl staring at us through peekaboo Cellophane, a boy astride a mottled pony trotting through a debris-strewn meadow, a curly-haired teenager tensely holding her bicycle, the smudged faces of two urchins playing somberly on an abandoned auto, a rainbow reflection unexpectedly curving between a pensive woman and a sorrowful man drinking in a pub, a landscape heavy with mist and dark trees—all these would persuade the viewer that much more is happening than mere surface record.

MacWeeney confesses readily to having been most strongly influenced by another ex-European, Robert Frank, whose cinematic, seemingly spontaneous, pseudosnapshot technique used in creating his famous and gloomy portrait of America erupts in MacWeeney's work only in off-center, differentially focused compositions. Unlike Frank, MacWeeney has no ideological axe to grind. In describing his artistic intentions, MacWeeney used an unusual phrase: he wants his pictures to be "deceptively ordinary." He would be much happier if he could produce images with his mind rather than with a mechanical contrivance, for what he wants is "to capture what is there." He agreed, when I asked him, that what he craved was a kind of transparency of effect, as if the camera did not intervene between himself and his subject. Unfortunately, it is

a notorious paradox that photography cannot be trusted as a ''messenger-boy of reality,'' as Walter Benjamin astutely remarked.

Why does MacWeeney need to return to Ireland to find compatible subjects? Why should it be so difficult, as he admits, to find inspiration in hard-edged, tumultuous New York City, when it comes so easily in mist-drenched, smokey Ireland? If, indeed, he seeks only transparency, only to ''capture what is there,'' why does he need the emotional support that being among his home-land's inhabitants, even of a different social class, offers his art? (In actuality, it took him several months to acclimate himself to the tinkers' folkways.) Is it not always a matter of what resonates within oneself, of what speaks to the heart and the brain in signals that have the deepest, most intuitive meanings? In Manhattan, apparently, MacWeeney is still searching for the resonating chords to move his poetic soul, a soul obviously imbued with the visual mean-ings and character of his homeland.

Even if we were able to induce that ineffable transparency of experience wherein the desired image simply implants itself on the desired surface, would we then record a more complete reality? Since the content of any single photo-graph is related necessarily to what has been left out of the frame, this window effect—much noted by critics of painting—means our vision of a presumed to-tality is limited. That is why what the photographer selects from that totality is so crucial. Those who regard photography as a communications medium quin-tessentially suited to the transmission of fact and nothing else fail to under-stand how implacably tenuous a visual fact can be. A visual fact depends almost entirely on its context, and while a single still photograph may resound with meaning, it can encompass only so much and no more of any given world. Even sequences of photographs are severely limited by their essential characteristics: moment/place in time/space . . . moment/place in time/space . . . ad infinitum. Elusive reality slips by even while the fastest motorized camera speeds in its pursuit.

The miracle is that some photographers manage to capture the significance of these fragmented moments and spaces by an intuitive magic of design and metaphor. In his *Landscape into Art,* Sir Kenneth Clark noted that ''the less an artifact interests our eye as imitation, the more it must delight our eye as pattern, and an art of symbols always evolves a language of decoration.'' From MacWeeney to Alvarez Bravo is a giant step not only from misty moors to dusty mountains but from cinematic spontaneity to a greater formalism oc-casioned by a vastly different culture and slower camera techniques. At first glance, it is the decorative power of Bravo's prints that captures the attention with bold design: the girl watching birds against a background of breast-shaped mullions, the window on the agaves as handsome as any Paul Strand, *Mr. Municipal President* condensing the history of revolutionary Mexico into one slightly overwhelmed peasant, laughing mannequins reminiscent of the

Paris scenes of Eugène Atget, landscapes of cactus and sown agaves and pine trees rippling out strong chords of rhythmic structure.

Then the eye explores surrealist images: a half-naked girl lying on a broken skylight, a woman standing amid white sheets hiding her face with black fabric, and one of Bravo's most enigmatic pictures, *La buena fama durmiendo* ("Good reputation sleeping"). Near a textured, darkened wall lies a naked young woman on a striped blanket. Around her hips and ankles have been wound broad strips of hospital gauze, although no accident has occurred. Close to her vulnerable flesh lie four spiney cactus pods. She is serene, sunning herself, eyes closed, one leg crossed over the other. The longer one gazes at this odd, self-absorbed scene, the more hypnotized one becomes.

In her recently republished book (*M. Alvarez Bravo,* Boston: David R. Godine), Jane Livingston—Associate Curator of the Corcoran Gallery—commented that Bravo is "entirely aware of the elusive iconologies of his images." She noted that "poetic images and concrete symbols in Mexican life, as in its art, seem to lodge in universally familiar syntax. The horse, the dog, the pair of hands at work, drapery on clotheslines, the mask, the skull, the serpent—such objects have mythological significance understood by every Latin American." For MacWeeney's tinkers, the list might include the white horse, swans, cats, caravans, tents, dogs, magic stones, trees, unholy night places, symbols he had to learn but that were closely related to general Irish folklore.

When we think of a photographer's identification with a place, perhaps we summon up Edward Weston at Point Lobos, Harry Callahan's Chicago, André Kertész and Washington Square. Obviously, *place* is not simply landscape, but a configuration of people, a kind of light governed by moisture or dryness, the symbols a particular culture originates as it evolves in a physical setting, and, perhaps, a willingness by the photographer to interact with these factors at least partially on their own terms. I say at least partially because there is never any escaping the idiosyncrasies of personality, no matter how objective the camera pretends to be, or how transparently uninterfering the photographer hopes to be. In Alvarez Bravo's case, some of his images are veiled, their meanings hidden from us not only by the special languages of his cultural mythos, or by the secretive, proud, even haughtily self-contained Latin personality, but also by a unique vision extracting its own meaning from its environment. Of course, he has had plenty of time in which to develop this vision; he is seventy-eight years old and has spent all but one of those years in Mexico. MacWeeney, forty-one, left Ireland in 1961, yet feels compelled to return again and again. We can never know what might have happened if Bravo had been uprooted and MacWeeney had never left home.

When Starr Ockenga, Director of the Creative Photography Laboratory, decided to mount the MacWeeney-Bravo joint exhibition, the publicity releases announced that "this two-person/two-country show will offer a metaphorical

representation'' of their two distinctly different homelands. Ockenga, herself a talented photgrapher and Associate Professor in the M.I.T. program for Visual Studies, explained that she had found certain affinities between their subjects and their approaches. What were these affinities? We agreed that both photographers describe relatively homogenous, nonbourgeois cultures that seem equally foreign to most Americans. More important, Ockenga finds that both artists have a passion missing from many contemporary photographers, even though Bravo is somewhat distanced from the viewer and MacWeeney more involved. Neither fears confronting an individual; both find people fascinating, and disdain the current trend toward depersonalization. Or was it also that white horses rear up so conspicuously in each man's work as symbols of supernatural forces? Alvarez Bravo's wooden carousel horses are famous for their compressed evocations of terror. Alen MacWeeney's white steeds are more uncanny: real animals, they nevertheless glow with unearthly radiance.

The difference between them is perhaps in a sense of time: Bravo seems intent on carving his people out of eternity; MacWeeney's tinkers are already on their way to the next place, whistling down the wind.

The New Boston Review, January-February 1981.

Icons or Ideology
STIEGLITZ AND HINE

ALFRED STIEGLITZ AND LEWIS HINE: the maker of icons and the apostle of social reform. Their careers ran closely parallel in time, but seem completely antithetical in every respect. Stieglitz became the Messiah of the avant-garde in both photography and painting; Hine languished as a documentarian, overlooked and ignored by the practitioners of purism, who were themselves rejected by the academy and the people whom H. L. Mencken called "the booboisie."

Stieglitz was repelled by the masses, believing them incapable of an educated response to "beauty." Hine sought out the working class, finding in them an eternal human spirit surviving even under despicable oppression, and that was his "truth." Stieglitz was a disciple of Nietzsche, viewing the task of the artist as a Promethean commitment to uplifting mankind by heroic deeds, by standing upright and awesome on the mountaintop, far above the squalid materialism of the late nineteenth and early twentieth centuries, keeping alive the flame of idealism and perfectionism by a strength of will and purpose to which the common man, destroyed by meaningless labor and abased by the sordid ignorance of the slums, could not possibly aspire. Hine was unassumingly non-heroic, but a fighter who believed that God's grace was the birthright of every American, that nobility lay in work, that the masses, despite their ignorance and their lack of taste for the "finer things," were intrinsically worthy.

The ardor of Stieglitz was expended in the struggle to have photography accepted as a peer of the other fine arts. The passion of Hine was devoted to the use of photography as a tool for social reform. Stieglitz seemed nonpolitical, an idealist whose implied optimism about the ability of an individual to change and uplift the world was unshakable. Hine seemed political, a realist whose implied pessimism about an individual's capability for changing society was the result of a Marxist-derived interpretation of the world as class struggle, group organization, communal effort. Stieglitz was an optimist about individuals, a pessimist about changing society. He withdrew into solitary effort. Hine was just the opposite, pessimistic about the individual as social reformer—

even though he himself was one—and optimistic that society could achieve change. He entered the fray.

Stieglitz seems to represent the final outcome of the inexorable progress of the nineteenth century's art-for-art's-sake formalist ideology. Hine seems to represent the spirit of what used to be called "social consciousness," of art for society's sake. In other words, we seem to have here the perfect models to represent the present debate as formulated by the editors of this issue of *The Massachusetts Review:* Should photography be regarded as a "detached, symbolic, and formalistic art" or should the photographer see his or her purpose as "necessarily mediating between the objective world and a particular, humanistic, and engaged vision of it?"

How can these extreme positions be reconciled or should they be considered eternally in conflict? In one corner: *Beauty,* art for art's sake, the pursuit of bold experimentation without regard for easy comprehensibility; in the other corner: *Truth,* art for society's sake, the pursuit of revelations in which human beings would be made to feel empathy for each other's sufferings. The elite versus the hoi polloi. Is this a true logical dichotomy? Must we profess allegiance to one and not the other? Is this the ultimate *Either/Or?*

The debate is as modern as photography itself, and as ancient as Plato's *Republic.* In fact, the question as to whether or not photography must pursue a particular ideological stand—whether this is called "beauty" or "truth," "art" or "human concern"—has a long history and is as saturated with political implications as were Platonic aesthetics. Furthermore, a philosopher might indicate to us, with considerable justice, that we are being asked to choose, perhaps arbitrarily, between aesthetics and ethics. It is as if the question were whether individual photographers should be considered immoral, unethical, and irresponsible if they pursue the play of formal elements so beloved of modern painters like Picasso and Kandinsky. It is as if individual photographers are to be judged antihumanist if they are not somehow politically *engagé.*

But how, precisely, are we to identify, with perfect surety, this humanism that the formalist is denied? To push that question to its extreme: Is formalism necessarily against humanity and against concern? We might even ask, Does an interest in aesthetics necessarily obstruct, obliterate, or simply overwhelm an ethical commitment? We know the answer that Soviet "socialist realism" supplies; we can perhaps recall the answer that Nazi "Aryan art" supplied: in both these political situations, the arts were, and are, circumscribed in content, approach, subjectivity, comprehensibility. Every reader will recognize the dangers implicit in too extreme a response to the present debate.

What the debate revives, once again, are old and unresolved problems dealing with the functions and purposes of the arts, the uses of art by audiences,

the intention of the artist as opposed to the actual psychological effects of the work of art, not to mention the huge complexities of whether or not exposure to works of art makes for any changes whatsoever in individuals or in societies, and by what means these changes are precipitated.

Alfred Stieglitz obviously considered the arts as a spiritual connection between humanity and nature. Lewis Hine, just as obviously, considered photographs as some sort of direct communications, bearers of messages that would call for specific responses from an audience. The difficulty arises not in reading about these two photographers in their biographies or in critical essays, but in confronting the photographs themselves out of the context in which they were produced, long after the peculiar metaphysics of Stieglitz and the specific political situation of Hine have disappeared, have become meaningless, or seem incomprehensible to those among us who will live to see the year 2001. How do we judge, today, now, in 1978, whether or not Stieglitz was being "humanistic" when he photographed the chilled workman and the steaming horses of *The Terminal* (1892), or whether he should be considered arcane and unconcerned about humanity's fate when he pictured cloud forms in his famous series *Songs of the Sky* (1922 on)? Are we automatically forced to consider Lewis Hine the more moral and responsible photographer because he bravely climbed the Empire State Building during its construction to photograph noble steelworkers grinning among the girders? And are we automatically forced to consider Hine less the artist because he seemed to be pursuing "facts"? Can we really separate the heroism of the steelworkers from the way in which Hine meticulously posed them, and can we really differentiate their heroism from the kind of ennoblement that enshrined tractor drivers and women farmers in Soviet posters of the 1930s? Do the seemingly cold abstractions of Stieglitz's cityscapes of this same decade make no human comment or have no human concern simply because we see none of the proletariat? Is the chill of those Stieglitz cityscapes—with their frozen shadows and harsh lights—the chill of an aging, possibly embittered artist, or is it the chill of the ultimate dehumanization, the desperate anomie of the megalopolis? Is making a pictorial statement to the effect that fragile humanity seems to be excluded from the monoliths of capital enterprise (Stieglitz) any less "humanistic" or less "concerned" than making a pictorial statement to the effect that steelworkers were enjoying building what was to become the very symbol of capitalist success (Hine)? At the very least, we should admit a paradox or two.

Why is there this deep-rooted suspicion of the formal elements of the visual arts by all those who profess engagement? Is there, in fact, no redeeming humanism in the play of symbolic forms even if they can be viewed as having connection with deep human needs, needs that can be discovered evolving throughout all we know of human history? Would it be unthinkable, a jolt to

our psyches, if we suddenly confronted the possibility that, in their own way, symbolic formalists might also be "necessarily mediating between the objective world and a particular humanistic and engaged vision of it"?

I suggest that among the origins of the modern dilemma are serious confusions about the meaning of "art for art's sake," the functions of the arts in the lives of individuals, the nature of the social contract, the freedom of the individual to choose nonconforming values and to seek pleasure, as well as seriously rigid interpretations concerning the notions of what ends humanity must struggle to achieve both individually and collectively. If Susan Sontag's latest opus is any indication, we are witnessing a powerful swing of the philosophical pendulum away from the question of aesthetics to the question of ethics. The swing has taken almost two centuries, from the eighteenth century's creation of the very term "aesthetics" to increasingly somber moralities that request of the arts that they once again assume the didactic, political, quasi-totalitarian functions that they have so often served. It was the nineteenth century that was quite literally a battleground for these conflicting positions, yet the origins of these essentially political arguments begin in that same eighteenth century that gave us the obsession with "beauty."

One of the ideals, first of the Enlightenment and then of the American Revolution, was that individuals are free to exercise choice, free to enjoy not only life and liberty but something called "the pursuit of happiness." By contrast, the French Revolutionists, busy with class warfare, did not prattle about individual "happiness." Yet the most influential exponent of class warfare, Karl Marx, was at first interested in the restoration of the whole human being, restored to a sense of harmony, community, and selfhood from which the Industrial Revolution had cast him out into a brutalizing and brutalized alienation. That Americans should have talked about the pursuit of happiness given their masochistic, tortured, and self-denying Puritan origins, should be regarded as something of a miracle. That the French should have almost immediately instituted a tyranny more despotic and cruel than its royal antecedents—including a centralized censorship of the arts—is surely amazing in view of their contributions to the idea of individual freedoms as articulated by Rousseau. That Marx wanted precisely to see individuals being granted the right to pursue full and happy lives, without persecution and starvation, free to enjoy the fruits of their labors and to experience life with a measure of control and satisfaction is perhaps the most astonishing in the light of subsequent developments.

In the midst of this turbulent philosophizing and the wretchedly failed revolutions of the nineteenth century, while the self-perpetuating engines of capitalist power continued to increase their dominance over every aspect of life, the *artist* was discovered to be the sole survivor of industrialism, for it was the artist who combined that sense of love of one's own work, dedication to serious creation, and a passion for individual freedom that epitomized the utopian

view of the ideal person. The artist became invested with a mythology of free-
dom and independence that had characterized the intellectual and political
events of the eighteenth century, and in the nineteenth century we hear George
Sand sighing:

> To be an artist! Yes, I wanted to be one, not only to escape from the material
> jail where property, large or small, imprisons us in a circle of odious little
> preoccupations, but to isolate myself from the control of opinion . . . to live
> away from the prejudices of the world.[1]

That could be Stieglitz speaking, and Stieglitz was the child of the nineteenth
century's notion that it was in the very practice of art that a contribution could
be made to the progress of humanity, without reference to any edification
through moral subjects. As Geraldine Pelles observed, it was "through the ac-
tivity of art itself"[2] that artists believed a healing influence could be brought
to bear on dehumanized, corrupt, and materialist society. The problem for
moralists became the fact that artists turned from didacticism to aesthetics.

At the time of the infancy of photography, during the 1830s and 1840s, the
idea of "art for art's sake" began to be promulgated by a growing corpus of
philosophical thought about the nature of the aesthetic experience, about
"beauty" and whether or not it was a condition of objects or a subjective re-
sponse to a stimulus. It is an overlooked but nevertheless remarkable fact that
the history of photography and the history of a clashing antithesis between
"beauty" and "truth," between aesthetics and ethics/politics, should have
been so closely linked. By no means are Stieglitz and Hine the first to repre-
sent this clash. By 1850, when Talbot released his patents for paper photogra-
phy, the various processes of photography were all embedded in a series of
violent disputes concerning "the proper end of art." The disputes were made
even more violent because documentary photography seemed to have the ca-
pacity, unique among the graphic media, to provide direct access to "truth."

European photographers were at first unable to resolve the dilemma of
"art" versus "truth" because their thinking was almost completely subjugated
by the prevalent views concerning the goals and values of painting. In Ameri-
ca, however, photography seemed simply to be a mechanism for transmitting
information about people and places. Until Stieglitz, then, there was relatively
little thought about the artist-photographer as a paradigm of individual free-
dom, a hero who represented the last vestige of selfhood. Art for art's sake
was a comparatively distant and exotic notion, remote from everyday practical
affairs.

As the century wore on, and as photographers like Rejlander and Robinson
began to imitate the moral tales and spiritual uplift of paintings, the art-for-
art's-sake struggle—which had already burgeoned into a full-scale replica of

the war between the European aristocracy and the masses—erupted with particular bitterness. Socialist utopian critics like Proudhon and his followers vowed that art was the moral conscience of society, not a pleasurable act of free will or free response. The excoriations were polemic and violent:

> *Art for Art,* as it has been called, not having its lawfullness [sic] in itself, and resting on nothing *is* nothing. It is a debauch of the heart and dissolution of the mind. Separated from right and duty, cultivated and sought after as the highest thought of the soul and the supreme manifestation of humanity, art, or the ideal, shorn of the best part of itself, reduced to nothing more than an excitement of fancy and the senses, *is the principle of sin, the origin of slavery, the poisoned source whence flow, according to the Bible, all the fornications and abominations of the earth.* From this point of view the pursuit of letters and of the arts has been so often marked by historians and moralists as the cause of the corruption of manners and the decadence of states. . . .[3]

This vitriolic paragraph was quoted by Philip Gilbert Hamerton, an influential English critic, graphic artist, and frequent commentator on things photographic, who made a mild and polite reply:

> Let us examine for one moment what the principle of Art for Art really is. It simply maintains that works of art, as such, are to be estimated purely by their artistic qualities, not by qualities lying outside of art.[4]

That was precisely Proudhon's bone of contention, of course, that art that was judged purely for its internal qualities had divested itself of its most sacred functions. For Proudhon, like other social reformers, considered art to have primary responsibilities in the political arena. It was to be used as a force for Good, with a definite hierarchy of approvable subjects; it was not to be allowed to become a focus for mere Pleasure, especially since the pleasures seem to be becoming more and more perverse.

Proudhon's jeremiads were not destined to stop the progression of the visual arts from purely sensory delights—the impressionists—to arcane, remote allegories embodied in the works of the symbolists, whose worst and most decadent tendencies were considered to be most evident in the paintings of Moreau or Fernand Khnopff, and in the photographs of, for example, the American F. Holland Day and certain European aristocrats who delighted in sunstruck pictures of nubile young boys in pseudo-classical poses. Like the preciosities of the earlier mannerists, the so-called decadents, who included Aubrey Beardsley and Arnold Böcklin, were the outcome of an historical development:

> . . . a relatively unified culture, which transcended national boundaries, and which was directed by an elite determined to emphasize the distance which lay between itself and the mob. Both put forward the proposition that the arts were a closed, special world with its own rules and its own languages. . . .[5]

We can see now why humanitarians and revolutionists were outraged, and why Alfred Stieglitz was to bear the stigma of this kind of elitism even if he did not share, in any possible way, the goals of the decadents. To political critics, however, it was seen that now the elite not only held a monopoly on the means of production but were extending that monopoly to the arts. Access to the pleasures of the fine arts would lie in the hands of the high priests of culture who understood the obscure symbols of classical antiquity or of modern poetry; the common folk were severed not only from satisfactions with daily work but from the comforts and simple pleasures of homey art.

It was to demolish the artists who painted Salomés, chimeras, sphinxes, ghosts with severed heads, and other such vanities, and, simultaneously, to excoriate the elite who supported such artists, that Count Leo Tolstoy wrote *What Is Art?* "one of the most vigorous attacks upon formalism and the doctrine of art for art's sake ever written."[6] Published in English translation in 1898, the book evinced little differentiation between one aspect of modernism and another; that is, Tolstoy blasted impressionists and decadent symbolists with equal relish. In an exceptional survey of the history of aesthetics (see his Chapter 4), Tolstoy condemned any art that could not be easily comprehended by "the people." The idea that any art should require the study of some special grammars of form or of symbolism was anathema to him, as this presented the parasitic and despotic dominance of the elites over the common folk who could not easily understand allegorical references or nonrepresentational art. Deciding what was to be considered "good" or "bad" in the subject matter of a painting was simple:

> Art, like speech, is a means of communication, and therefore of progress, i.e., of the movement of humanity forward to perfection. . . . And as the evolution of knowledge proceeds by truer and more necessary knowledge, displacing and replacing what is mistaken and unnecessary, so the evolution of feeling proceeds through art—feelings less kind and less needful for the well-being of mankind are replaced by others kinder and more needful for that end.[7]

Feeling: this was the crucial word; feeling was to be all-important in this evolutionary progress that placed art alongside science in the onward and upward betterment of mankind. In a truly Wordsworthian sentence, Tolstoy sums up what was for the great author of *War and Peace* the true means by which human beings could be united with one another in spirit—amazingly, it was to be through art.

> To evoke in oneself a feeling one has once experienced, and having evoked it in oneself, then, by means of movements, lines, colors, sounds, or forms expressed in words, so to transmit that feeling that others may experience the same feeling—this is the activity of art.[8]

But that could be Stieglitz speaking; at least that was the way in which he was perceived by his critics in *America & Alfred Stieglitz*. It would be particularly in the *Equivalents*, first shown in 1925, that his ideals would match those of Tolstoy.

> The prints included pictures of natural objects, clouds, a poplar tree, its leaves shimmering in wind and sunlight, which were recognized as portraits. The translation of experience through photography, the storing up of energy, feeling, memory, impulse, will, which could find release through subject matter later presenting itself to the photographer, were thus made evident. This should have ended for all time the silly and unthinking talk to the effect that the photographer was limited to a literal transcript of what was before him.[9]

Tolstoy had been dead since 1910, but it is not too difficult to imagine his approving not only of such expression of feeling and its transmission through suitable "movements, lines, colors, sounds" but further, of Stieglitz's fight against the crassness of artistic exploitation, in his role as gallery owner and art dealer:

> For it was not mere economic sustenance that the Intimate Gallery was standing for, it was the relationship of the divinity in men and women as represented by the creative artist, with the entire nation and the life of the world.[10]

The nineteenth-century notion that the creative artist was invested with mythic powers, that artists were representing both the last anarchic independence of individuals and some kind of divine metaphysical beneficence, had by no means expired. Indeed, it was not class warfare that would bring down the exploiters, but some inexorable process within history:

> The civilization that could neglect or refuse its best, yield its choicest spirits to ostracism, exclusion, starvation, and extinction, was in that degree signing its own death warrant.[11]

The artist, the best and choicest spirit, was obviously paying a heavy price for his special status as redeemer of the world. The fact was that the artist had been split off from society in much the same way and at much the same time as the split between the worker and his work, between the moral function of art and the formal aspects of art.

There is one more bit of history that should be considered in any attempt to understand what Stieglitz represents, and whether or not he stands for some kind of empty-headed creation of artistic icons or for a humane concern. This was the advent of abstractionism and the influence of Wassily Kandinsky. It was only one year after Tolstoy died that his compatriot Kandinsky published a manifesto called *Concerning the Spiritual in Art,* in which Tolstoy would have had great difficulty discerning the evolution of his own ideas. Kandinsky here would sever the last connection between the visual arts and any represen-

tational forms, with the aim of creating a formal grammar of means that would permit artists to express their "inner need." This inner need was composed of three mystical elements:

> (1) Every artist, as a creator, has something in him which calls for expression (this is the element of personality). (2) Every artist, as child of his age, is impelled to express the spirit of his age (this is the element of style). . . . (3) Every artist, as a servant of art, has to help the cause of art (this is the element of pure artistry, which is constant in all ages and among all nationalities). . . .[12]

Furthermore, every artist was free to invent whatever forms would make possible the expression of his inner need. Kandinsky did not invent abstraction, although he may be said to have been the first to carry abstraction to a complete severing with the representational in art. Actually, many of his ideas about a formal grammar that would have universal meaning come out of a movement that had already influenced Stieglitz through the work of Maurice Maeterlinck. This was Theosophy, a movement much too complex to be here discussed in any detail. Suffice it that the followers of Madame Blavatsky believed in Platonic ideas concerning the nature of reality: that somewhere there was an ultimate ideal that the real world represented rather poorly. These thought forms were shapes that corresponded to ideas, and Stieglitz, Kandinsky, Arthur Dove, Georgia O'Keeffe, and other moderns were transcendentalists who are best explained, perhaps, in the words of their fellow traveler, Paul Klee: "We are striving for the essence that hides behind the fortuitous."[13] If one reads the many statements of Alfred Stieglitz, it is not the word "Beauty" that appears, but the word "Truth."

The simple fact would seem to be that Stieglitz was seeking a universal and metaphysical "truth" that did not match the political expectations, needs, desires, and fantasies of many of his contemporaries. In other words, his "truth" and the "truth" of a photographer like Lewis Hine were completely different. Yet they were both "truths." The problem then continues to be the one in which we must decide whether or not one truth or one pursuit is necessarily more moral, more authentically human, and more expressive of humane concern than any other truth or pursuit. I call on the philosopher and art historian, Sir Herbert Read, to see if he can help us:

> I believe that we have reached a certain crisis in the development of our civilization in which the real nature of art is in danger of being obscured; and art itself is dying of misuse. It is not altogether a question of indifference. . . . It is rather a question of forcing art into moral issues; of confusing art, which is an intuitive faculty, with various modes of intellectual judgement; of making art subordinate, not merely to political doctrines, but also to philosophical points of view. But art, I shall maintain, is an autonomous activity, influenced like all our activities

by the material conditions of existence, but as a mode of knowledge at once its own reality and its own end. It has necessary relations with politics, with religion, and with all other modes of reacting to our human destiny. But as a mode of reaction it is distinct and contributes in its own right to that process of integration which we call a civilization or a culture.[14]

Is Sir Herbert Read a victim of the nineteenth-century fallacy concerning the unique attributes of art? He wrote the above paragraph in 1945, at a time in history when it had become impossible to remain detached: the Nazi Holocaust had demanded a choosing of sides. It may therefore be somewhat surprising to hear Herbert Read proclaiming that art must remain autonomous, outside political activity, apart from "false moral issues." Read apparently believed that there were intuitive, spiritual, instinctual levels of human experience that could become suppressed if the rational moralizing aspects of our personalities were always overseeing our activities. It is not necessarily a frivolous act of play but a grander game of metaphysical communion with being ourselves, being human, and of a universal civilizing spirit.

The debate as it was formulated implied that photographers who concerned themselves with symbolic forms rather than with some unspecified but still "necessary" humane concern were somehow less moral, less ethical, and less committed to humanistic efforts. I believe that this mistaken idea comes out of the past century of struggle between competing ideologies concerning the arts as they reflected the political realities and ethical ideals of a particular time. Stieglitz apparently believed, in good faith, that he was upholding the very foundations of civilization, by seeking universal "truths." Hine was serving the best tradition of those who believed that photography, like any other "art," should be used to foment social reform. Stieglitz was expressing what Kandinsky called the "inner need." Hine was communicating what he thought was the "social need." But Karl Marx had already identified the ultimate *social* need: it was precisely the *inner* need, the needs of individuals to pursue free and meaningful lives. One way in which we might solve this apparent contradiction is to pursue the hierarchy of needs proposed by the social psychologist, Abraham Maslow, who suggested that survival needs like food and shelter precede more advanced needs having to do with the development of selfhood and the expansion of personal competence.

This sounds like a fine solution until we encounter the response of someone like Lewis Mumford:

The materialist creed by which a large part of humanity has sought to live during the last few centuries confused the needs of survival with the needs of fulfillment; whereas man's life requires both. . . . In terms of life-fulfillment, however, this ascending scale of needs, from bare physical life to social stimulus and

personal growth, must be reversed. The most important needs from the standpoint of life-fulfillment are those that foster spiritual activity and promote spiritual growth: the needs for order, continuity, meaning, value, purpose and design— needs out of which language and poesy and music and science and art and religion have grown.[15]

Mumford, of course, had spent his entire career tracing the complex interconnections between modes of production and the development of societies— see his *Technics and Civilization* and *The Pentagon of Power*—also he cannot be called naive or a neophyte in the history of the relationship of culture to the lives of individuals. He is surprisingly insistent that both the inner need and the social need require satisfaction or what is specifically human about us will shrivel and die:

> . . . For even the humblest person, a day spent without the sight or sound of beauty, the contemplation of mystery, or the search for truth and perfection is a poverty-stricken day; and a succession of such days is fatal to human life.[16]

For Mumford, the human spirit requires humanizing nourishment, of a kind that deepens and intensifies responses, increasing the human potential for cooperation and true communion.

How, then, do we balance the satisfaction of the inner need with the responsibilities of the social need? How much individual freedom and how much social responsibility? I believe that Northrop Frye put the matter very well:

> The myths of concern and of freedom are ultimately inseparable, and the genuine individual can exist only where they join. When a myth of concern has everything its own way, it becomes the most squalid of tyrannies, with no moral principles except those of its own tactics, and a hatred of all human life that escapes from its particular obsessions. When a myth of freedom has everything its own way, it becomes a lazy and selfish parasite on a power-structure.[17]

To achieve a genuine humane commitment, the photographer as artist, as person, as member of a social organism, may need to seek this balance between the myth of freedom—the ''inner need''—and the myth of concern—the ''social need''—with a conscientious effort; as do we all.

The Massachusetts Review, Winter 1978.

Propaganda and Persuasion

In reality, to distinguish exactly between propaganda and information is impossible. JACQUES ELLUL

IT IS CURIOUS that the literature of photography contains far more about the chronological history of "documentary" than about how documentary photography succeeds in persuading, how the photographs manage to influence public opinion. Beaumont Newhall has observed that a photographer engaged in the documentary strategy "seeks to do more than convey information. . . . His aim is to persuade and convince."[1] Yet, outside the labyrinths of semiotics, we find few writers who pursue the processes by which photographs can persuade, if indeed they do.

Such processes of persuasion clearly involve not only the psychology of individuals and the social psychology of groups, but the mass psychology of entire cultures and societies. It is the study of the *audience* and the context of its response that has been most neglected. Even in his exemplary introduction to the logic of "documentary," *Documentary Expression and Thirties America,* William Stott seems more concerned with establishing the definitions of certain subgenres than in investigating the peculiar workings of public opinion, although he makes it adequately clear, "Almost all social utterances involve propaganda because almost all seek to influence opinion."[2] He would agree absolutely with Beaumont Newhall that it is not information that the documentary photograph supplies, but an inescapably biased form of communication that is equally present in all forms of exposition. In their simplest terms, Stott's hypotheses rest upon the recognition that the so-called information in documentary photography is always biased.

Communication is intended to alter behavior, even if only the behavior of believing. "Information" is never neutral, since it is always received and interpreted by individuals according to their idiosyncratic beliefs, tempered by the massive conditioning that their sociocultural environment provides. We have only to recollect that when Americans went to India to bring enlightened birth control methods to an overpopulated, hungry society, they were greeted as genocidal fanatics intent on destroying the children needed to support their aging parents. Information that we believed would alleviate the desperation of poverty was interpreted as depriving families of their fundamental economic

structure, not only endangering the safety and authority of elders, but subverting the foundation of Indian society.

So much for the presumed neutrality of information. It is clear that, rather than through the logic of the message, individuals receive and process information through the screen of their personal stakes in a given behavior, or through the cracked mirror of prejudice, and always by emotional responses that require the most subtle manipulation to achieve a desired effect.

The task of photography in persuasion would seem, then, to be extremely difficult, if not impossible. Can the single still photograph persuade? If so, how, if not, why not? William Stott claimed that "the heart of documentary is not form or style or medium, but always content."[3] He offered specific parameters of that content:

> Documentary treats the actual unimagined [i.e., non-fictive] experiences of individuals belonging to a group generally of low economic and social standing in the society (lower than the audience for whom the report is made) and treats this experience in such a way as to render it vivid, "human" and—most often— poignant to the audience.[4]

A photograph that seems to satisfy Stott's description is Russell Lee's *Instruction at Home; Transylvania, Louisiana* (1939). A young black woman, handkerchief on her head, wearing an ill-fitting, worn sweater over a flowered print dress, and dusty shoes, points with a stick toward a homemade "blackboard." This piece of linoleum supports chalk writing: "The rain are fallin," then a row of numbers and the alphabet. Seated on two hardbacked chairs are two attentive young black boys who are learning how to read and count. The environment, a newspaper-lined shack, includes a calendar, various domestic appliances such as an oil lamp, a water pitcher, a chest of drawers, matches, spools of sewing thread and irons; the fireplace has been stuffed with rags around its perimeter to keep out drafts, and the floor boards are clean. Lee's photograph is vivid, "human," and poignant—but to whom?

From a liberal viewer, the following response might be elicited. "Blacks in the South were not allowed to learn how to read or write, and their education continued to be rudimentary long after the Emancipation Proclamation; rural blacks lived in demeaning conditions of desperate poverty, but managed courageously to teach each other the most important skills for an increasingly technological society; blacks who could not read or write were easily denied the vote, and so this photograph by Russell Lee has captured the essence of the black condition before the civil rights struggle of the sixties." That response is predicated, of course, on the liberal viewer knowing something of the extensive history of black deprivation in the deep South. A liberal who also happened to know something about what is called "Black English" would see the

phrase "The rain are fallin" and recall that African languages occasionally attach plural verb forms to singular nouns.

Now the same photograph in the hands of a viewer from the far right might elicit an entirely different response. "Blacks are a threat to white America; they are disgusting; they are stupid—look at that sentence 'The rain are fallin'—any white child of six knows better than that; teach them to read and write and they'll only vote in their own kind, like the black mayor of Chicago; then they will want our jobs; blacks must be kept out of white schools because they will lower the general educational level; they're probably on food stamps or welfare and they are just a burden to whites."

One photograph verifies two entirely opposing ideologies. That would seem to be inevitable, since what communications theorists call cognitive dissonance is always operative. Cognitive dissonance is the process by which individuals reject information that does not support attitudes already held or decisions already made. A belief system or ideology represents a series of decisions to be made: namely, to believe or not to believe what the communications environment provides. It has been discovered that people tend to read only what will verify or support their opinions, since new thinking requires change and change is always painful or threatening.

Instruction at Home was produced by Russell Lee as part of his ongoing work for the Farm Security Administration (FSA) photography division under Roy Stryker, who considered Lee to be one of the best documentarians in that program. But showing the Lee photograph to someone who held views antithetical to the progress of poor blacks in America would do little to change opinion. As Einstein observed, "Theory precedes seeing." Theory is not altered by "seeing" if the seeing is skewed by strongly held opinions tied to emotional responses. It is extremely doubtful that we would call Lee's documentary photography a document capable of persuasion *by itself*.

Stott's paragraph, quoted above, refers to documentary as treating individuals of low economic and social standing relative to the audiences for whom the report, the photograph, was produced. Does this rule out Weegee's sardonic "documents" of the very rich, say, entering an opera house bedecked in diamonds and furs? Does the presence of a bedraggled onlooker in that famous picture automatically make the group suitable for the documentary category? If there is in documentary only the presentation of the lower socioeconomic classes, what is expected of the viewer? Is it only, as Stott's paragraph suggests, that the viewer should have a "vivid, 'human,' and poignant" experience? Is no action expected to follow? Or is this supportive, verifying experience simply bolstering the liberal point of view with no specific action to be taken? Is it only the wealthier individual at the top of the social status index who can look at Lee's photograph with superior knowledge and sympa-

thy because—presumably—it is only the wealthy who are better educated and who are in the power position to right the wrongs depicted? If so, then action is definitely anticipated, and it is for action on the political and economic level that the photograph was, in fact, expected to fulfill its function, whatever its actual effect or result.

According to Jacques Ellul, author of a provocative work on propaganda, the idea of stimulating action as a result of persuasion is a relatively new one. The Victorians generally conceived of persuasion as having the aim of manipulating the change of ideas and opinions, "whereas the aim of modern propaganda is no longer to modify ideas, but to provoke action. It [the aim] is no longer adherence to a doctrine, but to make the individual cling irrationally to a process of action."[5]

The popular notion of this process of action can be found in some of the legends of landscape photography, although landscape photographs are probably not thought to be propagandistic. There is the story to the effect that Ansel Adams's photographs for his book *Sierra Nevada: The John Muir Trail* so impressed the then secretary of the interior, Harold Ickes, that he promptly brought the book to the attention of President Franklin Roosevelt. The result was that Congress established the half-million-acre Kings Canyon region as a national park in 1939. This story satisfies an outdated conception of how communication works—a picture presented to the right person at the right time galvanizes swift action, delivering a desired result in a simple cause-and-effect fashion.

But let us imagine showing the same Ansel Adams book to the first secretary of the interior under President Ronald Reagan, with the assumption that James Watt would so enthuse over the pictures that he would pressure the president to urge the Congress to legislate another national park. The idea is patently absurd. Anyone who followed the career of Mr. Watt would know that pictures of magnificent forests would trigger his thoughts of the timber industries, while photographs of glorious mountains and "empty" natural vistas would inspire greed for coal and natural gas exploration. Photographs by themselves resemble Holy Writ, which the Devil has been known to quote to his own advantage.

It has been customary to think of propagandistic landscape photographs as belonging primarily to the catastrophe genre. Dorothea Lange's often reproduced *Tractored Out* belongs to that category. As William Stott described it, the picture (he called it "noble") is of "an abandoned tenant shack floating in a sea of tractor furrows that rise even to the porch."[6] To William Stott, the picture offered a completely self-contained explanation of the absence of humans and the cause of their having been evicted. Lange herself believed that her brief captions would tell the story. On the contrary, it is entirely possible to look at the picture, read its caption, and nevertheless devise completely ir-

relevant scenarios: the owners of the property had been greedy and overplowed their land; perhaps a death in the family had occasioned their hasty removal from the farm. The established facts of the dust bowl era are that huge agribusinesses, taking advantage of the Great Depression, were buying up small farms to create uninterrupted tracts of land susceptible to being farmed by the new agricultural machines. Despite Stott's opinion of Lange's dust bowl pictures as being "noble," *Tractored Out* does not function as propaganda, even with its explanatory caption, without the viewer's having a knowledge of the context of its imagery. Without context—the context of other photographs, the context of the economic and political realities of the time, plus *the context in verbal terms* of how the image related to those realities—there can be little chance that a single picture can convey not only its intended meaning but also a persuasive message that could motivate action.

It may come as a surprise that Marion Post Wolcott's photograph of a harvest scene—a landscape cliché if ever there was one—was *intended* as propaganda. This is an example of the legerdemain that Roy Stryker performed when World War II broke out in 1939. Forced to shift abruptly from the social reform pictures produced for the FSA to direct support for the war effort, he called on documentary photographers, who had previously been engaged in depicting the sorrows of the Great Depression and the exhausted land of the dust bowl, to produce overt propaganda proclaiming the might and abundance of the American earth. His instinct was perfectly on target, since few threats can arouse emotion faster than the implied destruction of your homeland. Using imagery associated with Thanksgiving and that season's cornucopia of good food, Wolcott's display of cornfield harvest abundance undoubtedly was intended to promote feelings of security, to remind us of the great productive capacity of the American nation, and to arouse the identification with a bountiful land on which all patriotism may depend. The documentarians (if such they could be called in their new roles) were giving the "common man" something positive in which to believe, something to love and to fight for, using the same realistic technique but an entirely new content. The new content, according to Stott's definition, would remove these wartime pictures from the realm of pure documentary and place them in the category of pure propaganda.

Since neither the Russell Lee photograph nor the Marion Post Wolcott landscape could operate effectively without prior consent to their underlying assumptions, their utility as propaganda would depend on what Tony Schwartz, a master of public opinion, called "the responsive chord."[7] In the absence of communication that resonates with what is already in the hearts and minds of the audience, propaganda cannot arouse emotion and subsequent action. But Ellul argued that propaganda is a two-stage process, not a simple one-to-one, cause-and-effect event. Ellul suggested that *pre-propaganda* is required to mobilize psychological responses by replacing the established conditioned reflexes

partly by the repetition of new slogans. Pre-propaganda creates feelings or in-
stills stereotypes useful when the time for action comes. But even pre-propa-
ganda fails unless there is a deep consonance, resembling Schwartz's
resonating chord, between the emotionally tainted social beliefs and any new
ideologies being promulgated. Propaganda itself plays on the already present
assumptions and unconscious motivations of individuals and groups, relying on
the universal mythologies of specific societies.

How, then, can public opinion be changed? How can a photograph operate
as effective propaganda? Probably as pre-propaganda, for Ellul asserted that an
informed opinion is vital to the subsequent galvanizing force of direct propa-
ganda for immediate action. It is one of his most startling conclusions that,
contrary to popular illusion, it is the *best* informed who are most susceptible to
propaganda, not the least informed. Something cannot be created out of noth-
ing. When sufficient numbers of individual Americans, for example, had ab-
sorbed the ongoing information supplied by the mass media, once the media
had ceased simply forwarding government propaganda, the Vietnam War was
no longer supportable. The change in opinion was slow and hardly complete.
Photographs of atrocities, coupled with the live television coverage, helped by
providing the incontrovertible evidence that the war was neither simple nor
one-sided nor without horrible fatalities to innocent civilians. Photographs of
dead American soldiers returning home in body bags were certainly documents
of an inescapable reality if individuals could stand the painful emotion of look-
ing at them.

Susan Sontag has written that the photographs of Auschwitz had a searing
effect on her. People do not ordinarily enjoy painful spectacles, and such im-
ages turn people away, literally and physically. It is easier to repress or deny
knowledge of horrors than to accept the guilt and powerlessness that accompa-
ny revelations of brutal inhumanities. Educators may prate about photographic
literacy, but what is needed is an understanding of how any picture could mi-
raculously transform painful information into coherent social action. For the
obvious truth is that a single photograph, unaccompanied by verbal messages,
cannot simultaneously contain both the image of the problem *and* the solution
to the problem. A photograph, therefore, would seem to be able to pose the
question, to imply a situation for which some other medium might be needed
to provide the answer.

The inability of a single photograph to function as propaganda in modern
terms leads to the potential conclusion that film (the motion picture) can oper-
ate on a higher level simply because it can incorporate aural messages, and be-
cause it is photography extended through time. This is perhaps why Béla
Balázs, a noted film theorist, observed that it was only montage that could
turn single images into truths or falsehoods.[8] Montage, or editing, provides a

juxtaposition of materials—what Sergey Eisenstein called the collision of ideas—that permits an audience to draw complex conclusions, to grasp implications, or to be effectively jolted out of complacency and readied for new beliefs. In the case of positive propaganda like Marion Post Wolcott's harvest picture, cinematic editing may add little. Flashing iconic telegrams to the brain may be sufficient to resonate with stereotypical responses of patriotic variety. But to transform knee-jerk patriotism into patriotism based on humanitarianism requires not only long exposure to both words and images but words and images that can be accepted by individuals on an unconscious level, down in the depths of the psyche, where, as Freud said, absolute contradictions exist side by side.

Jacques Ellul believed that "propaganda can work only in the face of profound *immediacy*."[9] That is why photojournalists have always been identified with propagandistic efforts; they are identified with the relative instantaneity of the mass media. Photojournalists, then, are considered to rely upon propaganda's mass contagion, sometimes called the crowd effect, plus the fluctuating tensions associated with political decisions. In addition, their work implies a participation in group actions of large organizations like political parties or labor unions, where peers not only have the opportunity for interchanges of opinion but where opinion leaders can play their all-important roles.

This kind of relationship between photojournalism and politics is typified by the Nixon dirty tricks campaign during the 1972 election, when Edward Muskie, a front-running candidate for the presidency, was captured in a journalistic photograph as a grown man crying. Whatever the cause (exhaustion, attacks on his wife, false rumors, etc.), the immediate effect of an image of a grown man crying was astonishing. There was no doubt that a weeping male face was unacceptable to audiences of the 1960s, when the macho image of American presidents was still superordinate in this nation's psyche. Muskie's "crying face" was immediately distributed through the mass media, including newspapers and magazines, at perhaps the very moment when he was beginning to have some impact on potential voters. So deeply ingrained were the social beliefs that the myth of masculine imperviousness to emotion that it is extremely doubtful that a new series of published photographs or even a television program demonstrating Muskie's undeniable manliness could have prevented his failure in the campaign. There was simply not enough time to reverse an image that had struck such a responsive chord in the mass audience.

Whatever the medium, film or photography, television or newspaper, all images are interpreted within the context of social beliefs. Since all photographs represent a paradoxical mix of information and persuasion, a condemnation of propaganda as being intrinsically evil is based on a misunderstanding of the nature of communication. Photographers dedicated to social reform or political

change must recognize that they may only be able to contribute to the pre-propaganda phases. The political process is a sluggish behemoth; and once it turns in a direction and gains momentum, it requires a stupendous effort to change its direction toward the achievement of humane goals. Unfortunately, it is all too easy for a single photograph of the "grown man crying" variety to play the responsible chord in the context of immediate political decisions. But long-term goals undoubtedly require continuous exposure of social wrongs and a vocabulary of change that can provide the basis of a new ideology. In that struggle, photography undoubtedly has much to contribute—if the photographer can develop not only patience but an uncanny sense of timing for the influential image.

From *Observations* (Carmel, Cal.: The Friends of Photography, 1984).

From the Studio to the Snapshot
AN IMMIGRANT PHOTOGRAPHER
OF THE 1920s

INTRODUCTION In his justly famous work, *Looking at Photographs,* John Szarkowski remarked[1] that "Photography has learned about its nature not only from the great masters, but also from the simple and radical works of photographers of modest aspiration and small renown. . . ." It is thanks to critics like Szarkowski that we are encouraged to view photographs on their own terms, instead of always having to compare them to the rigid aesthetic hierarchies of *Hochkunst.*

Since photography struggled for so long to be recognized as a fine art, it is all the more admirable that we are now free to turn and look at photographs as part of popular culture, as having a social history, and, yes, even having a personal and psychological history. On those terms, even the career of a photographer of "modest aspiration and small renown" permits us to explore not only the human interest implicit in the workings of a portrait studio of the 1920s, but some of the connections between that modest career and its larger social setting, as well as general aspects of the nature of photography: specifically, aspects of photographic development in the genre of portraiture from the studio to the snapshot.

Portraiture is a special branch of the continually enlarging history and aesthetic of photography. We are beginning to recognize its special problems. Confronted with those millions of anonymous ancestor portraits of the past, it is difficult to assign aesthetic value to images so fraught with the revelations of human nature. What is it that we look at in the early daguerreotype portraits? Is it social history, psychological verities, the mirror glint of metal, or an aesthetic icon? Szarkowski himself, in describing a "Mother and Daughter" daguerreotype of 1850, seems to be stressing the revelation of human nature far more than any intrinsic aesthetic worth. "Who would not feel better," he asks, "for having two women as handsome, strong and proud as these in his past?"[2] As he noted in *The Photographer's Eye,* "For the first time in history, even the poor man knew what his ancestors had looked like."[3] Yet, are we always interested in the ancestors of *strangers* unless some special virtue

21. Borris Jussim. *Manya Aaronovna*, 1916.

resides in the photograph itself? And, if there *is* any special virtue, what might that be?

If we attempt to glean some insights from the reproductions that Beaumont Newhall selected for his *History of Photography,* we find rather diverse clues. In the *Portrait of Mme. Sabatier-Blot,* we might assume that what appealed to the historian was a certain strength of character expressed through an almost menacing black compactness of form, while in his choice of a *Daguerreotype by unknown American photographer,* we find a lovely lady who exudes personal beauty, elegance of costume, gracefulness, and charm. In his choice of *Mrs. Anne Rigby and her daughter Elizabeth (later Lady Eastlake),* clearly the historian's interest is primarily in the fact that the double portrait is not only a superb example of calotype work by the famous team of Hill & Adamson, but also that it illuminates a mother-daughter relationship and the psychological nuances thereof.[4] In any number of studio group portraits available at George Eastman House, we can find visual statements that seem to focus on the psychological power of the dominant male, the head of subservient families, real documents of social roles at a particular moment in history.

Again: if Newhall had not known that the subject of a portrait by Etienne Carjat was Charles Baudelaire, or that a portrait by Hessler was of Abraham Lincoln, would he necessarily have selected these as examples of *any* aspect of the history of photography? For the physiognomies of the heroes of politics and art are of interest in themselves, but often barely justify any other consideration. To be sure, from another point of view, that ramrod portrait of Lincoln is typical of the posed studio photograph, with its classical column on a painted backdrop, augmenting the importance of the man with the strength of the marble column, much as the painters Copley and Gainsborough augmented their bourgeois subjects with similar classical appendages. And, again, from another point of view that disregards the aesthetic, we can see in the Carjat portrait of Baudelaire that aspect of photography that enables us to inspect him as one inspects a dead shark in the laboratory.

If there seems to be no aesthetic common denominator in the portraits we have been discussing, does this lack indicate a lack of critical vocabulary or the obvious possibility that we approach each photograph as we do any artifact, on its own terms? If either of these possibilities is fact, we seem to be left without any criterion by which to judge the excellence or poverty of any specific studio portrait. Yet, after all, there may be some way to establish a criterion for judgment that places the portrait not in the tradition of the fine arts, but in the category of the document of social or psychological fact. In that case, we are forced to approach the evaluation of a studio portrait as the archaeologist approaches the suddenly uncovered artifact, which, standing by itself in the detritus of eons, demands the total excavation of the site in order to decipher its meaning.

In the case of our photographer of ''modest aspiration and small renown,'' we will approach his studio portraits in that spirit, but we will also seek out any common denominator that might help us formulate a productive generalization concerning the nature of portrait photography.

THE ''IMMIGRANT'' AS PHOTOGRAPHIC SUBJECT Most of the Russian Jews who were ultimately to emigrate to the United States by the hundreds of thousands between 1890 and 1914 came from large families who lived in what was called the Pale of Settlement, a ''territory within the borders of Czarist Russia wherein the residence of Jews was legally authorized.''[5] The life of even urban Jews was hemmed about with so many restrictions that only a life of limited commerce was permitted them. The threat of pogroms arranged by *agents provocateurs,* featuring drunken Cossacks, was a fearful and ongoing reality. It was hardly surprising that, as the czar's bureaucracy became increasingly corrupt, individuals whom the *Encyclopedia Judaica* calls ''pauperized Jews''[6]—impoverished through no fault of their own—were driven to seek escape from a suffocating economic and political tyranny. Scattered throughout the world in the attempt to secure a livelihood, they kept alive memories by exchanging small portraits through the mails.

Among the few hundred personal documents remaining in the family collection of our subject, there are several of these small portraits made by unknown photographers from the south of Russia in about 1910. In one of these, a mustachioed young man seems unconscious of the slovenly provincial backdrop before which he is posing, ignorant of the rips and sags in the canvas, overlooking, perhaps, the worn carpet askew on a rough floor. He had obviously spent his kopeks on a postcard portrait to send to his relatives and friends in America. Clearly hoping that people will think him handsome, but not sure that they will do so, he seems ill at ease. In another portrait, a young woman with a broad hat and a simple dress stands brooding over a chair, rapt in some fantasy that the posing has evoked—probably, that the portrait will make her seem romantic and mysterious. We can examine such anonymous pictures either as examples of provincial Russian hackwork or as the records of individuals who were ultimately wrenched from their homeland, who became transmogrified into ''immigrants.''

A portrait of the family Glusker, taken in 1907 at the Tschereshkin Studio in Moghilev, White Russia, was to commemorate the last time this vast brood would be together. Ultimately, almost all of these intense, handsome individuals, with their trace of pride and sombre vanity, were destined to become ''immigrants,'' some of them arriving in the United States only after long years in places like Harbin, Manchuria, or Shanghai. We can admire them *as individuals* in this ordinary studio portrait, with its painted backdrop of pseudomirror and pseudoflowers. Yet when they board ship at Riga or Hamburg to make

their immigration voyage to New York, their individuality vanishes. Even—or perhaps especially—in Stieglitz's famous picture, *The Steerage,* where aesthetic perfection dominates our interest, these individuals vanish. What were a moment ago somehow memorable people—a striking, dashing young man, proud with his wife between his parents, with his sisters ranged symmetrically on the outside of the group—all of these will vanish, to become totally submerged in our national melting pot fantasy of the "wretched of the earth" and "the huddled masses."[7] All of those early twentieth-century steerage pictures commit a savage rape on the identities of the immigrants. Crammed into stinking holds, these ruptured families knew that if you were poor, you were an "immigrant." If you were rich, you were an "emigré." That attitude had a deep psychological impact on many steerage passengers, including those who were very young.

Certainly, in the eyes of the social historian of the day, if you landed penniless at Ellis Island and then were crowded into the unbearable slums of the 1890s and 1900s on the Lower East Side, you had lost all your prior identity. Many *New York Times* articles[8] would portray you as the worst of degraded, degenerate criminal animals. Jacob Riis would try to save you. Lewis Hine would try to dignify you. In either case, you *had* lost your identity, and it may be that the studio photographic portrait was one way to recapture it.

It is against this image of the seething chaos of the immigrant slum, with the "huddled masses" of enterprising Russian Jews, Poles, Italians, Ukrainians, and Germans who had had the strength, foresight, ambition, and courage, not to mention sheer luck, to get themselves out of Europe, that we should view our specific subject. He was an immigrant Russian Jew, but anyone who expects his work to reveal any obsession with crude hovels and suffering humanity, will be disappointed. In the case of our photographer of "modest aspiration and small renown," there was only one calling and one demand from his clientele: to beautify, to idealize. Catering precisely to the aspirations of these submerged peoples in the teeming ghetto of New York's Lower East Side, his was a craft devoted to a romanticized enhancement of his subject's egos. Looking at his photographs, it is almost impossible to judge that they were pictures of what we tend to confuse by the epithet: "immigrant."

But let us seek him first in Russia, within the Pale.

THE RUSSIAN BACKGROUND Our photographer of "modest aspiration," Boris Ossipovich Jussim, was born on 3 January 1890, in Bratzlaw, a Ukrainian village midway between Kiev to the north and Odessa to the south, the oldest son of a former cantor turned *rebbe* who supported his family of four sons and a daughter by teaching Hebrew and Russian in his own home.

Boris Ossipovich was an enterprising lover of literature and had organized his own lending library by the time he was thirteen. He was one of a tiny

number of Jewish students admitted for study at the Russian school. A year before he was to graduate, his father died unexpectedly. Somehow, the family managed to scrape by until he received his diploma, but this was a futile exercise. In the town of 4,000 there was such fierce competition for the few trades that the government allowed Jews to pursue that there was not a single job available. With a sense of desperation, he turned to distant relatives, and fortunately, an uncle in Odessa, one of the largest cities within the Pale, invited him to try his luck in the great port on the Black Sea.

Two features of modern Odessa have changed not at all since the day that Boris Ossipovich arrived there in 1907: the famed Opera House, and the steps immortalized by Sergey Eisenstein in *Battleship Potemkin,* a film depicting the rebellion and massacre that had occurred only two years before, in 1905. Between these two landmarks lay the Richelievskaya Ulyetsa, a long boulevard lined with trees and shops, among them quite a number of photography studios.

After trying first the grocery business and then tinsmithing, young Boris was apprenticed to a photographer, for whom he mounted prints, rather unhappily. Most trades at that time required a four-year apprenticeship. With justifiable impatience, Boris hoped for better and found a widow who was willing, for heaven only knows what reason, to cut this photographic apprenticeship to one and a half years, without salary, as was the custom. All the studios on the Richelievskaya Ulyetsa operated on sharply divided hierarchies. At the bottom, the apprentice mounter, then came the apprentice printer, then the salaried positive retoucher, then the negative retoucher. At the top, the sublime manager-operator, the only person who was allowed to enter the studio (or the operating room, as it was called) and who did all of the camera work and all of the developing himself. These, of course, were closely guarded trade secrets. The staff worked six days a week, from 9 A.M. to 5 P.M. in unionized shops where conditions were reasonably good.

Boris was placed under the supervision of a salaried young woman to learn positive retouching, which consisted of pencil work on paper prints. She taught him little, but, even so, after three months the manager fired her and gave all of her work to Boris, who still received no wages. After that, not unsurprisingly, no one seemed particularly anxious to help the young apprentice to advance. But he was nothing if not enterprising. Arriving at 7:30 A.M. each day, he practiced the high art of negative retouching. One morning, inevitably, the manager caught him, but instead of firing him for violating the hierarchy, he decided to move him up and to give him a tiny wage. Boris was ecstatic until he realized that he had still never seen a studio camera and had no idea of how the glass negatives were developed, how the printing-out papers were handled, or why they were gold-toned. Indeed, he noted later, at this point in

his life photography was a complete mystery; furthermore, there was small likelihood that he would ever be initiated into its inner secrets.

It was perhaps for this reason that he became interested in the labor movement. Following the encouragement of an attractive older woman at the studio, he joined a group of unionists in the spring of 1909. Three months later, he bravely attended a forbidden political meeting at a union local. No sooner had the meeting opened when the czar's police arrived. About three hundred young men were arrested, released, and rearrested one week later. Young Boris was thrown into jail, and only the fact that this was his first offence saved him from Siberia. Escorted by two soldiers, he was rushed back to his hometown and forbidden to reenter any large cities under threat of banishment to the steppes.

How to support himself? Casting about for work as a teacher of languages, he became acquainted with the only photographer in a neighboring small town. He was hired on the spot when the man heard that Boris was an expert retoucher. Later, when business slowed, his boss supplied Boris with equipment, a few modest lessons in camera work, a few roubles for expenses, and sent him out on the road as a traveling portrait maker. Very quickly, Boris realized that if he could only afford to buy his own equipment, he could go into business for himself, and begged his hardworking mother for help. Astonishingly enough, his mother wrote to him with the good news that an Army officer was willing to sell a portable photography outfit, worth about 150 to 200 roubles, for a quick 50 roubles to cover a gambling debt. By this gratuitous stroke of fortune, Boris was now enabled to take up the trade of itinerant photographer.

With a portable backdrop hastily painted up for him by a friend, a modest 5 × 7 inch studio camera, lenses, trays, drying and printing frames, and only the barest knowledge about studio practice, he hired a peasant to take himself and his equipment to a town where he had a poor relation, who helped him find a room suitable for photography and who let the community know of his existence by word of mouth. To have a resident photographer, apparently, was a species of miracle. Boris wrote, "A lot of Jewish families had fathers in the U.S.A. and they could not send any pictures of themselves. I was a Godsend."[9]

We should pause for a moment to recall that the profession of photographer was something of an anomaly for a Jew, even a nonconformist like Boris Ossipovich. His hometown, Bratzlaw, supported only one photographer who eked out a precarious living from passport photos and other bureaucratic niceties. To Orthodox Jews of this era, however, photography was still anathema. *Deuteronomy* IV, 17–18, leaves little room for ambiguity: "Thou shalt not make unto thee a graven image . . . the likeness of male or female . . ." and so on. Although the tides of iconoclasm had risen and fallen, with paintings of Jews

quite common in the sixteenth and seventeenth centuries, by the nineteenth century in Russia, "persons of particular piety"[10] declined to have their likeness taken. Only unusually liberated elders would permit it. Later, during the 1920s in New York City, Boris would be called out in the middle of the night, with flash powder and camera, to photograph some dying Jewish elder whose relatives wanted a keepsake, although it was only the deathbed that prevented the old man or woman from rising to smite such a blasphemer.

The reason that Boris could be a "Godsend" to small-town Orthodox Jews back in the first decade of this century was that something unexpected was happening even in provincial Russia. This was the arrival of photographic postcards from the United States, where such artifacts were cheaply and easily produced. Boris noted: "Photography came in from the outside. The immigrants who had gone away were sending home their portraits,"[11] and this caused an increasing abandonment of the ancient prescriptions against images. It also created a market in the old country for the production of photographic mementos to be forwarded to the land of opportunity. There was actually a lively photographic exchange across the Atlantic, at least until World War I ruptured connections.

World War I threatened for several years before the actual conflict. If you did not have the standard 600-rouble bribe for the czar's draft officials, you could be conscripted in your early teens and be forced to spend twenty-five years of your life in the army, a notoriously anti-Semitic institution. When a good friend of his went AWOL, and offered to lend Boris passage money to America if they could both leave immediately, Boris accepted. Their escape was through a well-organized, if hazardous "underground," which bribed Russian and German border officials and required considerable freezing, starving, hiding, and anxiety. Finally, crammed into a creaking vessel out of Hamburg, they entered into that disassociating process called "immigration." The voyage was a nightmare not only because of stormy seas, but because the captain of the ship was a sadist who locked the latrines each night at six and kept them locked until eight o'clock next morning. They were treated like animals until their arrival at Ellis Island.

A NEW YORK CITY IMMIGRANT PHOTOGRAPHER Boris Ossipovich began his new life in November of 1912. He wrote, "New York was a colossus, overwhelming, and I was without a penny in my pocket."[12] With a little preliminary help from the beneficent Hebrew Immigrant Aid Society (HIAS), he found a first job in Brooklyn and then did piecework retouching for small studios. He noted, "Most retouchers in those days were Russian Jews, and I had no difficulties in adjusting."[13] In only one year, he worked his way up to a job as top negative retoucher for White Studios, one of the largest commercial portrait houses in Manhattan. With branches all over the country, they not

only produced stage pictures of musical comedy stars, but all the yearbook photographs for West Point, Annapolis, and the Ivy League colleges. All the work was mailed to New York City, where it was retouched, printed, mounted, and mailed back. As Boris recalled it, the shop was a huge five-story factory, with about twenty-five camera operators and forty-five retouchers.

It was while he was working at White Studios that Boris began seriously courting his future wife, whose beauty had so smitten him at first encounter that he decided instantly that he would marry her. She was Manya Aaronovna Glusker, a lively, intelligent, and ambitious young immigrant who had arrived in 1912, aged sixteen, from Mogilev a city in White Russia, In New York, she discovered that, alas! the streets were not paved with gold, but rather strewn with sweatshops and noisy with labor disputes. In these disputes, perhaps not unpredictably, her fiancé Boris was soon embroiled.

Shortly before they married in 1916, Boris joined a strike for higher wages against White Studios. Not only did he lose his job, but he was blacklisted and was unable to find work at the better houses. It was Manya Aaronovna who persuaded him to open his own studio, in which she proposed to share the work. And so she became not only his wife, but his business partner. On their wedding night, they and a group of singing relatives and friends walked across the Williamsburg Bridge from Brooklyn to Manhattan to their newly opened studio at 95 Avenue A, near Sixth Street. Manya wrote, "We only had two hours of sleep that night because we had to prepare for many wedding appointments (with portraits to be taken next day)."[14] Thus, they spent their honeymoon photographing other couples.

The studio was a wild gamble. For all that he had been an itinerant photographer, Boris still knew nothing about large studio cameras or studio business practice. The prior owner rushed them through three days of instruction before he left for California. Then Boris and Manya were on their own in a competitive field of thirty or forty Lower East Side studios. For their $600 outlay for their studio, they had bought a Century 8 × 10 inch view camera, some chemicals and trays, the glass negatives of his predecessor's customers, some poorly painted backdrops, and "Good Will." One of the first things he did was to order several new backgrounds from a local painter, each costing about $50. New York had a long tradition of producing painted backdrops, going back to Seavey in the 1880s.[15] And New York was well serviced by Kodak salesmen, who were more than willing to help a young greenhorn improve his photography. Boris learned quickly, with the help of his Kodak representative, a pleasant man who soon encouraged him to exchange a poor lens for a better one. That, and subscribing to *Studio Light,* was all the outside help he ever had. Later on, he could swap ideas with friends in the New York Photographic Club, which he joined.

Many of Boris Ossipovich's first pictures were "glamour" portraits of his

wife and her sisters, who all had a dramatic flair, which lent itself nicely to romantic poses. They had a lively group of friends, immigrants like themselves, all loving music, especially the Metropolitan Opera House, where Caruso and Galli-Curci were singing, and where standing room tickets were not prohibitively expensive. The group went frequently on weekend visits to the Brooklyn Museum, on boating excursions up the Hudson River, to Central Park band concerts; they swam in Bear Mountain Lake, strolled through the Bronx Park Zoo, or went bicycling in Prospect Park. Their great pleasure was conversation, disputations over politics, spouting Pushkin or Tolstoy or the Jewish writers at each other.

Then the United States entered the war. It was a serious time, not only because their friends and relatives were being called off to fight in the Europe they had so recently escaped, but because chemicals were in short supply, papers and lenses and other German manufactures were almost impossible to obtain. Their first child was born in 1917, at a time when, despite the shortages, business was improving since everyone wanted photographs of sweethearts going off to war. When the decimating swine flu epidemic of 1918 struck, Boris was kept busy around the clock, rushing off to take pictures of the dying until he himself, and then his wife, became seriously ill. Surviving by good fortune and some excellent nursing by relatives, they became optimistic about their prospects. Selling the first studio, they purchased another at 7 Avenue A, between First and Second streets, on a block where two other portrait studios were already located, and only a short distance from the most hectic of the slum shopping ravines, Orchard Street.

The new studio cost them all of $4,000, a substantial sum in those days, and paying if off was a heavy burden. But it was a vast improvement over the first, with two large floors, the first one consisting of one large reception room and four rooms for living quarters. Upstairs was the gallery, which extended the full length and width of the building (75 ft. × 25 ft.) and which included three dressing rooms on one end, with the darkroom at the other. Across the street was a famous restaurant, Garfein's, and anyone who went there for a ball or a wedding reception or an engagement supper could easily see the large display photographs in the upstairs windows and in a free-standing glass case on the sidewalk outside the studio.

Boris set to work to learn his trade in earnest, while Manya became the business woman. It was she who took the orders, made appointments, and amused the customers with her lively jokes. It was Manya who helped customers select from their proofs, which were printed on paper that would rapidly darken in sunlight. It was she who offered all the special trade inducements, for example, portrait medallions on metal. It was Manya who straightened out the costumes and smoothed out the wrinkles, kept the couples patient in the waiting room, or assisted them in the dressing rooms. Often she was assisted

in this series of chores by any relatives who might be handy. But it was Boris who was the camera operator, who manipulated the lights, and who helped his subjects assume attractive poses.

He was quick to capitalize on the new Cooper-Hewitt lamps, although he preferred daylight, then somewhat more plentiful in New York City than in today's hopelessly gray smog. Often, if a couple or a group came too late in the day to be shot in what he considered to be the most flattering light, he would simply pretend to take their pictures; then he would say that the negatives had been accidentally damaged, and make them come back at a better time. This practice changed, of course, when electric lights became acceptable and standardized in studio practice.

When he was not rushed, which was rare, he particularly enjoyed manipulating lights and exploring the expressive subtleties of his subjects. He constructed his own banks of lights because, as he remarked at the age of 86, "Light was what appealed to me. But my customers didn't want good photography. They didn't know anything about good photography. They only wanted me to make them and their clothes look beautiful."[16] Often, his customers' demands went from the sublime to the ridiculous. A customer would arrive with many different outfits and spend hours in the dressing rooms with a dozen changes, and these were not rich customers but people from the neighborhood. It was quite customary to pose would-be Mack Sennett bathing beauties in the studio. It was also customary to pose clients fully clothed in winter overcoats, and, as the gallery was heated in winter by only one coal stove in the corner, it may have been a practical idea at that.

Suddenly it was the 1920s, and the immigrants of before the War were transformed into Prohibition flappers and pomaded dandies. The upward bubble of American optimism about personal fortune was beginning its crazed ascent. Glamour was not simply for the movie stars who were beginning to attain notoriety, but for every woman. Movie stars were fast becoming role models for makeup, stance, gesture, and coiffeur. Notwithstanding the many temptations to mimic Hollywood, Boris made serious wedding portraits that contained profound statements about personal relationships. In his double portraits, it can be observed that women were not always subservient to men. A portrait of Boris's brother and sister-in-law, especially, has an iconic ambiguity with psychological implications: the couple seems to have only one arm apiece, placed in such a way that the woman seems to have acquired both of them.

By the mid-twenties, Boris was completely immersed in the routine of the studio trade. A dream he had entertained on arriving in America, a dream of continuing his education and progressing on into a "real" profession, was, of necessity, thrust aside while the busy work of the studio consumed his energies. Photography offered much of interest, even occasional personal achieve-

ment, yet it was a business like any other, where success demanded total commitment. Since he had taken on the responsibility of bringing over all of his and Manya's relatives after the chaos of the Russian Revolution had subsided, pursuing a private ideal of excellence became more and more subservient to crass financial worries of a sort unsuited to his romanticizing temperament.

Business flourished. They were particularly gratified when customers, who included friends, of course, returned again and again to commemorate this or that family event at Jussim Studios. Entire families were difficult to pose, especially if there were active children. Boris usually rose to the occasion, while Manya exercised her most winning persuasive powers on the paterfamilias to buy the profitable extras. Persuasion was a needed adjunct, for competition was fierce. Enter the photographic agent, who shall remain nameless and faceless. He was the gladhander who rushed after each affianced couple to congratulate them, and, incidentally, to sell them on a grand package for the wedding. For a handsome fee, and tyrannous cutbacks from his clients, this jovial and conniving chap arranged everything, from the purchase or rental of wedding gowns and tuxedos to the wedding itself, to the limousines from the church to the reception at a restaurant, and, finally, to the group portraits at the photographers. The 30 percent he extracted made profits small, and often he would quietly pocket the entire sum and pretend he had not been paid himself. Boris admitted, regretfully, that without the agent, at least for wedding pictures, they might not have prospered and possibly would not have survived.

Actually, Boris hated wedding pictures. Even if they were simple and unpretentious as couples occasionally permitted, they were, as he put it, "Nothing but a big bore."[17] The groups were wild and raucous, and Manya was rushed to distraction, especially as it was she who had to learn enough Polish, Italian, Ukrainian, and German to conduct business discussions. What was particularly difficult, she recalled, and required great tact, was to help pregnant brides conceal their misadventure with a little discreet adjustment of billowing bridal gowns. Great care had to be taken, in any event, for even if many of the gowns were rented, the brides wanted to look as if they owned them.

The wedding trade was, of course, the basic core of the business, and it was nothing unusual for Boris to keep shooting away from 7 A.M. to 7 P.M. on Sundays, often unable to stop to eat.[18] Wedding groups sometimes came in so hard on each other's heels that they had to be given bakery style numbers to keep them in order.

The studio work was divided as follows: Saturday and Sunday, wedding appointments. Monday was for developing, washing, and drying. Tuesday the proofs were printed by sunlight on the roof. Wednesday and Thursday, retouching. Friday, printing and washing and drying, often until 2 to 3 A.M. Sat-

urday morning, spotting prints and pasting them on cardboards. Enlargements were sent out to Columbia Enlarging down on the Bowery. Boris himself, now the master, did his own developing and negative retouching, while an assistant looked after the proofing and printing.

Naturally, the studios did not prosper on weddings alone, but did a healthy business in child portraits. Boris liked children and they seemed to pose easily for him. The children went through the same costume gyrations as did the parents. The sailor outfit was *de rigeur,* as was the "little executive" look. And they also went from the sublime to the ridiculous, posing as George Washington or other great Americans who were all taken very seriously by little immigrant boys. The little girls were glamorized with netting and soft lights, and posed on the chaise longue or a park bench, or any one of the studio accessories, which were augmented by baroque pedestals, a polar bear rug for infants, plastic flowers, gold fish bowls. A frequent technique was to take a double portrait of children in a strong silhouette pose, have the print mounted on wood at a special shop, and jigsawed away before being given a small easel backing. This mounted cutout effect was expensive, but it was one of the many popular services that the studio was expected to provide.

On rare vacations, a 5 × 7 inch Century view camera would be hauled along and Manya was often made to pose like a water nymph in a black and freezing mountain stream. There was nothing accidental or improvised about Boris's outdoor portraits of either his wife or his children. His approach to portraits with a view camera was to establish a stable composition, strongly sidelighted, and only the subject's frown of concentration or impish grin might be uncontrollable.

THE PHOTOGRAPHERS' AMERICAN DREAM On 10 June 1926, Boris and Manya celebrated their tenth anniversary. The week after, while she went off to the mountains with the children, Boris escaped on what can only be called the quintessential American adventure fantasy: the pursuit of gold. The Roaring Twenties were not only boom years, they were a time when finding a gold mine, either figuratively or literally, had begun to seem like the national birthright of every American, and even more so to the immigrants. By now, of course, Boris and his family could no longer be called "immigrants." They were citizens of the United States, they spoke English, and they had taken out a subscription to the American Dream, hoping that a combination of hard work and luck would make them millionaires.

Boris's trusted Century 5 × 7 inch view camera recorded this gold mine expedition. In one photograph we find Mr. Brown (foreground) and Mr. Friedman (background), two who helped to organize the venture. Brown was one of two miners who had just opened a mining corporation called Four Nations, operating staked parcels in Ontario, Canada. A photographer named either

Lunfeld or Lunenfeld, depending on whether Boris or Manya did the remembering, happened to be vacationing in Canada when he became acquainted with Brown. Friedman was a photographic supplies manufacturer specializing in easels and mats, and the "Swede," as he was called, used Friedman to spread the good word among his customers. Using his contacts, Friedman rounded up about twenty-five New York City photographers and photographic specialties makers who had some free cash to invest. And so there was founded an unlikely gold mine company composed almost entirely of studio photographers from Manhattan. Together they went up to Canada, up into the wilds, to inspect the property and test the progress of the mine. Boris noted that in the midst of a literally trackless forest, reached by motor launch on a narrow river, they were "met by clouds of large mosquitoes who were very glad to see new faces and they tried their best to show us what they could do."[19]

It was perhaps the most relaxed and happy time of Boris's life. He posed for his own portrait, holding on high a sledgehammer that seemed the new emblem of his good fortune. For two weeks, the New Yorkers, all of them immigrants of ten and fifteen years before, frolicked and played at being gold miners, sure that they were making a splendid investment.

During the next year, 1927, Boris consolidated his business. Then an unforeseen onslaught of urban renewal created havoc and near panic. Looking now at what remains of his pictures, in the few boxes owned by his family, it is impossible to tell that the tenements around his studio were the most fearful slums. We have to recall Jacob Riis in order to empathize with the situation of six families living on one floor of a tenement, sharing one toilet, each family bathing in the kitchen tub. Roaches, rats, and lice were frequent accompaniments to daily living, even as they are now in the poorer slums of all major cities. When the city fathers decided to eradicate the slum warrens, it was to be a near catastrophe for the photographers of the neighborhood.

What is important to our understanding of his career is the fact that Boris Ossipovich never, not once, took a single picture of the human misery surrounding him, except for those brief moments when he was called into the tenements for deathbed memorials. It was not because he could ignore this misery. After all, he and his family, his wife and her family, had all been brought over to the United States and had passed through the slums with the others. It was not because he was callous. He and his wife were helping to support many of the new immigrants. But it was as if he made no connection between the magic power of the camera to record his surroundings and those surroundings themselves. Photography had become little more than a business, a craft at which he had some talent, but he never seemed to connect that talent with the amelioration of social wrongs. That is not to criticize him, but simply to observe. Trapped by domestic responsibilities and a trade that demanded all of his time, he made the best of it by refusing to see any implications of the

camera. His métier was the portrait, his love was for the play of light to model flesh and cloth, and the drama of the posing, and it was as if he refused to see the people around him as part of any vast sociological phenomenon. He saw people as they wished to be seen, as unique individuals who had somehow reconstructed a life in a new country. He saw them as he undoubtedly saw himself, not in the real world, but in a world transfigured by an immigrant's dreams.

In 1927, a long block of tenements was razed between Avenue A and Third Avenue in conjunction with an ambitious project to build a street park from First Street all the way to the Manhattan Bridge. About one thousand storekeepers lost their livelihoods, and about twenty thousand people were displaced, many of them Boris and Manya's customers. He wrote, "There came such a plague of rats that you could not believe it."[20] Business came to a standstill. No one frequented the famous restaurant across the street. Boris himself was bitten severely on the hand as he slept. He feared for his family, and finally decided that they would have to seek a studio elsewhere. Now that much of his savings were tied up in the gold mine venture, the best he could afford was a run-down studio in Jersey City in a predominately Italian neighborhood. Despite the fact that Manya had just given birth to their third child, she bustled over, cleaned up, painted, and supervised the establishment of the new studio. Soon they were dividing up the workweek, rushing back and forth on the ferry across the Hudson, slaving beside several assistants and praying that the Lower East Side's rodent plague would stop. By some miracle, the rat population resettled itself, customers began to trickle in once again, and the New York studio returned to a moderate level of business. For two years, then, they returned to their normal trade: babies, weddings, graduations, anniversary portraits. By the early 1930s, Boris had even added a new and dramatic backdrop, to his stock, in the best art deco style. The painterliness of the previous backgrounds, all Gainsborough and bravura, gave way to a modernistic hard edge. He was keeping up with the times, hard times indeed, for he had just lost his shirt. The Great Crash of 1929 had come down on them like a sword, severing millions of Americans from their dreams of materialistic success.

At one blow, the gold mine was lost to the Ontario government for nonpayment of taxes. And suddenly it was the thirties, and the times reveal themselves in portraits taken of Boris by his assistant and of his wife by himself. There is a perplexed awareness in Boris Ossipovich's face. A rueful smile tinges the saddened face of Manya Aaronovna. In 1932, they were forced to sell the Jersey City studio. In 1933, the New York studio. They were part of the almost total demise of the Lower East Side studio business. No conniving agents could revive it. Studio photography was now a hopelessly expensive luxury. Even more important, the former immigrants discovered, or thought

they had discovered, that they did not really need the studio photographer any longer. A technological invention that had been gathering momentum since the 1880s, now came into its own. "You Press the Button—We Do the Rest" had conquered the world, and out of this conquest was to come a new aesthetic, that of the snapshot. With the collapse of the old studio aesthetic came the disintegration not only of Boris Ossipovich's business, but of himself as a photographer, for the snapshot aesthetic was like a new country to which he no longer had the energy and the motivation to immigrate.

FROM THE STUDIO TO THE SNAPSHOT Paul Strand has asked, "When is a snapshot not a snapshot? When is a photograph not a snapshot?"[21] He firmly attested, "No matter what lens you use, no matter what the speed of the film is, no matter how you develop it, no matter how you print it, you cannot say more than you see."[22]

In perceptual theory, Strand's comment can be interpreted to mean that what we see (or do, for that matter) depends on what we can conceptualize, or imagine. Boris Ossipovich could not "see" except through his own romanticizing imagination, an attribute of his personality that fortunately matched the expectations of his clientele. Yet, there are other crucial aspects to "seeing," among them what the available technology will permit a photographer to conceptualize.

Strand remarked, "The snapshot has nothing at all to do with amateurism or casual photography." Unfortunately, when he was confronted with snapshot technology, Boris lost his professional expertise and behaved like the rankest amateur. He could not shift his aesthetic vision from the controlled stillness of the posed portrait to the spontaneity demanded by swift movement or accidental circumstances. He had become so habituated to the limitations of a specific studio technology that his visual goals had become synonymous with formal composition.

Let us recall that his first studio camera was a Century 8 × 10 inch view camera, which sat on a mobile stand. Equipped with tilts and swings, a variety of lenses on individual mounts, this camera had no shutter. The time of exposure was determined by removing a lens cap, counting two or three seconds, and returning the cap. It was a camera for which subjects *had* to pose and *had* to stand still. The photographer put his head under a black hood, composed his subjects meticulously in all details, usually against a diffuse background, viewing these subjects upside down and reversed. The glass plates were carefully developed, retouched on the emulsion side by applying a dope made of resin and turpentine. With fine pencils, all blemishes on the negatives were removed. Contact prints were made, sepia-toned for greater warmth. Then the prints were mounted, cardboard framed, and easelled.

Boris's second camera was a Century Model 47 view camera, one that went

with him on all trips. Although technically a portable 5 × 7 inch, he never used it without a tripod. It could focus no closer than 7 feet. With this camera he had the option of composing either on ground glass or through a tiny viewfinder—and every time he used the viewfinder alone he composed poorly. The prints were often unretouched contacts, not mounted, but passed around as "souvenirs of experience," as Steven Halpern called them.[24]

The villain of the piece is a camera not yet mentioned, Boris's first folding camera, a Kodak No. 1 Kodamatic, a type of camera ironically introduced in the year of his birth, 1890, a camera so useful and inexpensive that it became a mass medium. It was this kind of camera, which he himself had bought as a kind of toy, he later claimed had ruined his business. It was so foreign to his general aesthetic that he could not learn how to use it. With some luck, he could bring off a mildly interesting snapshot, often either under- or overexposed. The contrast with the exquisite studio control he loved is obvious in his family album. With the 5 × 7 inch view camera, he could try to compose as he had with the larger studio equipment, but often with foregrounds inevitably overemphasized. Twenty years after he left the studio, he still had not learned how to use a small camera.

A comparison between his own studio portraits and portrait "snapshots" from his family album, either taken by Boris or by members of his family, reveals some aspects of what we have gained and what we have lost in portrait photography's journey from the professional studio to the amateur snapshot. Only a very few examples can be included here, but even these few may indicate that we have gained *and* lost many things. Imagine: Manya Aaronovna as a "Gainsborough" in 1916; Manya Aaronovna as a shopkeeper's tired wife, 1940. A bride and groom of 1917, posing for eternity; their daughter and son-in-law overwhelmed by hotel decor. The formal presentation of selves in 1907; the informal moment, delightedly losing self in 1950. Boris and Manya with their infant son, establishing a radiant triad in 1917; their daughter Matty, her husband and young son halted during a park stroll, 1949.

And finally, when Boris attempted to take candid shots of his wife in the late 1960s during a trip to California, he didn't do very well. In fact, one cannot tell who she is, or why she is being photographed, nor does one care.

Once out of the studio, Boris Ossipovich, and so many like him, disappear from photography altogether. The amateur snapshot, with its candid inadvertencies, its transient buffooneries, its marvelous spontaneity, its casual nonchalance, its amazing capturings of hilarious moments in time, has become the ubiquitous replica of the world. And if these aspects of the snapshot aesthetic revolutionized our ways of seeing, once they were incorporated into the work of creative professionals (or a genius like Lartigue), and if they have provided us with a tremendous new scope to photography, they have also robbed us of a sense of personality, personality and character enduring in time, strong and un-

22. Boris Jussim. *Snapshot of Manya in California,* ca. 1960.

changing. Our photographer of "modest aspiration and small renown" primarily saw the world as stasis. The snapshot sees it in flux. It is that old, old battle between *the ideal* and *the real.* For whatever reasons, perhaps given the turbulence of his background in the oppressive tyranny of Russia or the uncontrollable economic havoc wreaked on him, our photographer took refuge in the ideal; perhaps, on the other hand, he had a painter's imagination that viewed photography as an art of classical possibilities.

Perhaps what makes us look back to the studio portrait with nostalgia and longing (and it is being revived) is that we seem to have lost forever any sense of hope for the ideal. It is said that each epoch gets the art form that matches its implicit ideologies. If that is true, then it is *not* the snapshot that has revolutionized our ways of thinking, but, on the contrary, the loss of the *ideal* that has revolutionized photography, for ours is a disillusioned and cynical epoch that sneers at any notion of permanence or of greatness. It is as if we are being asked by all the paparazzi of the world to dwell only on Ozymandias's fate: to be dust in the desert, to be corrupt, to be weak, to be nothing in the end. The amateur snapshot is clearly a shard of the whole personality, a frag-

ment that frustrates reconstruction, an accidental recording of a gesture, but not of the soul.

The paradox is that while the snapshot claims to *stop time,* it is the very essence of the *transitory* that is being recorded. The good old studio portraits slowly gathered up the kinetic presence of individuals and forced us to confront, if not permanence, at least the idea of an enduring, idealized self, a self carefully chosen for public display. As Erving Goffman, the eminent psychologist, put it, the *self* is a *performed character,* not an organic thing that has a specific biological location and "whose fundamental fate is to be born, to mature, and to die."[25] On the contrary, the self is "a dramatic effect arising diffusely from a *scene* that is presented."[26] I suggest that the studio photographer had as his task the establishment of a suitable stage upon which the self could act out its delusional systems, its ideal. It would seem that one of the things that we look for in portraits is, specifically, exactly how well the photographer has succeeded in his task of establishing a suitable stage for the self. I believe that our photographer of "modest aspiration and small renown," Boris Ossipovich, and his helpmate and partner, Manya Aaronovna, excelled at establishing a suitable stage for the particular selves of their milieu, and if that is even partly true, I believe these two people will be remembered as they *wish* to be remembered, in other words, *as they chose to present themselves,* as two individuals who believed themselves capable of surviving any exigency.

History of Photography, vol. 1, no. 3, July 1977.

The Heart of the Ineffable

MOTHERS AND DAUGHTERS! Are there any fantasies or ideal images left to us in this tough-minded age of psychological realism? Do we still yearn (without admitting it) for the imagined paradise of lost Mother-Daughter delights that some of us have never known? Psychologists tell us that *Mother* is that all-giving, all-dominating, all-powerful figure from our fairy-tale infancies, the giant in the nursery. She is transmuted into the evil stepmother of those tales, yet simultaneously she is also the life-enhancing, sweetly tender goddess whose beauty, goodness, and self-sacrifice we could never hope to equal. Ultimately, she seems to contain all the mysteries of adulthood.

Daughter, on the other hand, simply connotes a biological relationship, a social role of no great consequence, and (depending on the culture into which a daughter is born) an expensive liability requiring dowries and protection. A society that devalues women in general may decide that the birth of a daughter is an unaffordable luxury, since she cannot become a warrior, a hunter, or a chief. Fortunately, most human groups no longer dispose of their daughters on the nearest hilltop. But, as we look at the pictures in this collection, we should keep a firm grasp on our history, for even in the relatively few decades we have enjoyed photography, the changing iconography that inevitably accompanies changing social attitudes is conspicuous and tangible.

It has been widely recognized that even the greatest portrait can capture only so much of an individual's personality and character, not all of that person's physical attributes, and certainly not a permanently ascribable mood. An attempt by a photographer to convey not only one but two persons and their relationship might seem to be exceedingly difficult, if not impossible. To portray two persons defined as mother and daughter is to define a relationship fraught with cultural and emotional overtones. Such intensity of meaning would seem to demand skillful decoding. Perhaps, also, it requires a grasp of visual language that not all of us possess. Even if we did possess such a visual language, it might prove to be so ethnocentric and tempocentric as to defy our desires for significant universal meanings. This collection makes no pretense of offering more than an intelligent sifting of contemporary imagery, which,

23. Sally Mann. *Jenny and Her Mother*, 1984.

upon examination, can reveal much about contemporary life and our implicit ideologies concerning motherhood.

Wynn Bullock once observed that photographs peer at life and attempt to record it truthfully, but can only transcribe two of the four of life's dimensions. Reduced to the plane of two dimensions on a flat piece of paper, constrained (usually) within the four straight edges of a rectangle, photographs lack two crucial factors: the sense of ongoing time in the three physical dimensions, and the unseen (because unseeable) fourth dimension Bullock called "spirit."

Even if they could encompass all the dimensions experienced by living human beings, photographs offer complexities of meanings, not single, precisely definable and verifiable meanings. Like value of any kind, meaning is ascribed by the viewer, the person examining the image in his or her own specific moment of time. We decode a picture the only way we can: through our visual enculturation, interpreting images by means of our idiosyncratic backgrounds as well, including socioeconomic class, political bias, educational level, religious affiliation or spiritual inclination, competence with symbolism and other aspects of iconography, and a multitude of other vital influences. Of these, perhaps none is more important than how we relate to our own status and history in the hierarchy of family relationships.

What is remarkable, then, is that creative photographers manage to convey a great deal about reality, about life, about the spirit of human beings, and about superordinate realities sometimes called the *Zeitgeist,* or the Soul of an Era. Photographs, which always require close study and attention before their various potential meanings can reveal themselves, can and do provide a substantial number of clues about relationships. We simply have to be tuned in to those clues and to have both patience and humility in assigning their significance. While verbal information often proves crucially useful in this enterprise, it is not always as helpful as we might suspect.

Perhaps surprisingly, the most explicit caption may fail to explain the specifics of either a relationship or a situation depicted in a single photograph. Consider, for example, the Mathew Brady albumen print that the Library of Congress identified as *Rose O'Neal Greenhow with her daughter in the courtyard of the Old Capitol Prison, Washington, D.C.* The caption for this picture seems explicit enough, yet it tells us nothing about the fact that Rose Greenhow was a Confederate spy captured by Union forces. That fact explains why she was photographed in the courtyard of a prison, but does not explain the presence of her daughter, who clutches her tight-lipped mother with a strong, protective embrace. Are they about to be separated? Is the mother about to be hanged? How did Rose Greenhow manage to maintain her elegant costume, her dainty gloves, her air of nobility? Without a considerable amount of biographical research, we may never know what, exactly, is being depicted here.

Yet perhaps we can manage to decipher the mood of strained affection and taint of sorrow. We can do this because we tend to believe that emotions reveal themselves through the face, body posture, gestures of hands, just as we interpret the historical moment and social class of persons through their apparel.

American audiences and American photographers of the mid-nineteenth century cared much more for facts than for the melodrama of an "art" picture by the British photographer Henry Peach Robinson. *Fading Away* is obviously a fiction, a tableau, so we do not expect realistic documentation, but try to interpret the symbols provided by this 1858 concoction. Watched over by an older sister (or perhaps a good friend), a young woman fades away to die amid the mawkish trappings of a scene that could have come straight out of Dickens. The bonneted mother seems resigned to her child's fate; she holds a book, undoubtedly moral teachings about accepting death. Compiled from a number of separate negatives, *Fading Away,* with its powerful symmetry, artificial poses, and distraught male figure (the father? a husband?) bids us all too dramatically to weep. The bright sky, however, offers hope of heaven: the daughter will soon be among the angels. Too reminiscent of theater to be taken seriously today, the picture tells little about the grief of the mother. From a knowledge of Victorian conventions, we know that the mother was taught Christian resignation, and to express grief most genteelly, without the rending of clothes, wailing, and uncontrollable anguish that might emanate from other ethnic groups. We should also take note that it was all too common in the mid-nineteenth century for mothers to lose their daughters (and sons) to the ravages of tuberculosis, pneumonia, or typhoid fever.

America's greatest portrayer of the mother-daughter relationship in the late nineteenth and early twentieth centuries was indisputably Gertrude Käsebier. In her justly famous photograph, *Blessed Art Thou Among Women,* an elegant mother seems to be urging her adored daughter to cross the threshold, a metaphor for entering adult life, and to pass confidently from one state of being to another. The lovely formal aspects of this 1899 gum platinum print were the result of Käsebier's expert posterization, a technique that emanated from both the teachings of Arthur Wesley Dow and *japonisme* in artistic posters themselves. The decorative darks concentrated in the figure of the daughter, with her precise contour, are enhanced by contrast to the wraithlike whiteness of the mother, a woman who by her overtly loving connection with the daughter epitomized what mothers were supposed to be. It was, as the author and critic Ann Dally has remarked, the era that "invented motherhood" as a relationship of an almost suffocating closeness between the maternal figure and the offspring. Yet Käsebier displayed that intimacy not as suffocating, but as sublimely supportive.

Nothing here presages the imminent death of this beautiful child. These

were real people, not the stagey characters of *Fading Away.* The pair were
Käsebier's friend, Frances Lee, and her daughter. In a later Käsebier photo-
graph of 1900, called *The Heritage of Motherhood,* Frances Lee was trans-
figured into a universal symbol of grieving motherhood, with her agony
undiminished by the false piety and repressed resignation of the Robinson pas-
tiche. Käsebier took her subject seriously. She was one of the first photogra-
phers who rendered the mother-daughter relationship without tear-jerking
sentimentality. She granted both female roles respect and admiration, a re-
markable accomplishment at a time when to be considered ''blessed among
women'' because one had a daughter was possibly a rare proposition in an
American culture that worshiped male progeny. (If women were still on a ped-
estal in 1900, it was because in that rather awkward position they were hardly
able to compete with men for power or even the dignity of the vote.)

The poet Adrienne Rich encapsulated the problem: *how we dwelt in two
worlds / the daughters and the mothers / in the kingdom of the sons.* Icono-
graphically, the worship of a son rather than a daughter has been one of the
most enduring and influential images in Western art since the establishment of
the Virgin Mary as a primary figure of worship. In our unconscious responses
to images of mothers with children, it would be difficult to ignore the residue
of all the thousands of reproductions we have seen of paintings showing the
Virgin Mother and her God-son. That is perhaps why Lewis Hine's *Ellis Is-
land Madonna* seems strained and falsely titled. The immigrant mother's ado-
ration is appropriate for the traditional idea of a Madonna, but the daughter
she holds so firmly gazes upward with a most peculiar stare, and not at the
mother, who is behind the child. Taken with the explosive light of flash pow-
der, the picture surprises because the child did not wince. Flash powder was
fast, but tended to make nervous wrecks out of unsuspecting subjects. That a
mother was holding a child seems an insufficient excuse to dignify this picture
with the resonance of one of the greatest themes of Christian art. Besides, it
should have been obvious to Hine that no Madonna had ever worshiped God
immanent in a girl-child.

Social class as well as physical presence are two clues to the beauty and
charm of James Van Der Zee's portrait of a mother with two daughters.
Against a typical studio backdrop of the 1930s, the trio radiates a quiet beauty.
The grace and poise of these female members of the black bourgeoisie were
heightened by the self-aware prettiness of the little girl who has wrapped her
mother in two arms. Not quite so adorable, the other daughter is more relaxed.
The mother could easily have posed for Raphael, and the group is the visual
antithesis of the farm wife with children so typical of the work of Michael
Disfarmer.

In a frontal pose that bluntly presents an enraged daughter and a gently re-
signed mother, this Disfarmer studio portrait is completely bare of environ-

mental or fictional ambience, a technique that Richard Avedon adopted for its ability to concentrate total attention on the participants in a photograph. The mother's willingness to be recorded in her gaudy cheap dress and anklets with sandals indicates not a lack of aesthetic taste but of education, and deep poverty. The mother restrains her glaring daughter with a protective hand that has known labor. For the sake of historical accuracy, it should be noted that it is sometimes impossible to distinguish very young girls from boys because in many areas it was customary for both to wear dresses in infancy. But this sturdy youngster seems unquestionably a girl.

In another Disfarmer double portrait, one that features a wonderful rhythm of diagonally placed forearms and vertical legs, a rural mother perches with her teenage daughter in a affectionate and casual pose. The young girl is comfortable, relaxed, and intelligent, and her mother, looking away from the camera, seems as solid and strong as our stereotype of farm wives and pioneer women would have us believe. No resignation, no anger here; these are straightforward people, so real one feels able to strike up a conversation as soon as they stop posing. If farm life was hard in the thirties and forties, nothing in this Disfarmer image reminds us of the terrifying Great Depression that echoes so implacably in the work of Dorothea Lange.

Migrant Mother, Nipomo, California. 1936 is Lange's most famous picture, one that is almost an embarrassment to reproduce any more, as the concerned mother survived the dust bowl agony to tell the world that she had never received a penny for the thousands of times this picture has been printed. Certainly, she was immortalized as the very essence of the infinite cares of motherhood. How to feed, clean, clothe these daughters in the midst of social disintegration? How to summon the strength to go on working as a grossly underpaid pea picker in the hell of a California migrant camp? How to maintain the unity of this desperate family? What would be the future of these starving daughters without the opportunity of an education? Would the father be able to find work? The Lange image, so sculptural and sure in its details, makes a direct impact on the emotions, reminding us of the anguish of extreme poverty before it invites us to ask questions about the fate of individuals confronted by social disaster.

While the Farm Security Administration photographers were out scouting for pictures that they hoped would arouse the sympathy of an America distracted by nationwide unemployment, even more dangerous threats were brewing in Europe and the Far East. World War II—that last "good" war where the alternatives to defeating Hitler's Germany were nonexistent—hurled destruction on millions of innocent civilians. After the war, Americans turned to "togetherness" and family life with considerable enthusiasm. In Eve Arnold's interior scene, we find a sailor home on leave, his wife continuing the middle-class niceties of white gloves for the dainty blonde daughter. The youngest plays hap-

pily with the Sunday funnies, oblivious both to the socialization process being inflicted on her sister and to the meaning of her father's uniform. Perhaps the older daughter is being readied for Sunday school, or the family has just returned from an early visit to church (the clock reads 10:55 and the light indicates that this is morning). The history of the movies tells us that the dolled-up child has been coiffed and dressed in imitation of that great culture icon of the 1930s, Shirley Temple, whose singing, dancing, and unbridled cuteness won the hearts of many a mother. The artless *accoutrements* of the room include an early television set (television did not become ubiquitous until the 1950s), which, marvelously, mirrors back the daughter who is already the mirror of a cultural ideal. That the mother should be the transmitter of this ideal is obvious; less obvious, perhaps, is that the daughter is without the power to choose an alternative vision of female childhood. Meanwhile, the young father buries himself in "man's work," reading the sports pages or the political news. Ordinary women were not expected to be interested in politics.

One of the most poignant mother-daughter images of the late 1940s was taken by Jerome Liebling at a Jewish wedding in Brooklyn. Here, side by side, viewed with Liebling's characteristic combination of brutal honesty and compassion, are two generations. It has been said that a man can tell the future of his intended bride by looking at the face and figure of his intended mother-in-law. Will this sensual daughter indeed grow to resemble the monumental mother? Together, they offer a visual contrast as stark as that between the delicacy of a Tanagra figurine and the baroque extravagance of late Hellenistic sculpture.

In the diary of Anaïs Nin, that author describes her mother in terms that illuminate Liebling's portrait: "She was secretive about sex, yet florid, natural, warm, fond of eating, earthy in other ways. But she became a Mother, sexless, all maternity, a devouring maternity enveloping us; heroic, yes, battling for her children, working, sacrificing." This concept, of the Mother becoming somehow sexless, has been challanged by some writers, including Nancy Friday. Yet many daughters would prefer the stalwart Liebling mother to the mod mother portrayed by Linda Brooks in her 1981 picture entitled *Mom at 55, me nearing 30*. "Mom" is flirting with the camera, offering herself as strong competition to her daughter. "Mom" is also a social butterfly: can we ignore the butterfly motif on plants and in petit point? The Linda Brooks picture, like so many others in this collection, can be read as a painful reminder of the perils inherent in the mother-daughter relationship. If "Mom" is always out-charming the daughter, constantly demonstrating how youthful she is, how much prettier she is, then she cannot be used as a role model. She becomes the devouring Gorgon of a daughter's nightmares, the enemy who is always victorious, the diminisher of one's hopes, the inflicter of a permanently damaged self-respect.

How different is the reverse of the problem! In Joel Meyerowitz's splendid portrait of an upper-class mother and daughter seen in the pastel light of an early evening on Cape Cod, it is the daughter rather than the mother who flirts with the photographer. What are the clues to their social class? It seems that it is only lower middle-class women and the jet set who bother to create fantastic bouffant coiffures. Intellectuals and old money disguise themselves or simply do not care. Then there are the rings on the mother's hands, the casual but stunning white trousers, the Wasp features, her stance. The daughter, who seems accustomed to being admired, is carefully making a display of herself as elegant as any Botticelli. This is no candid shot taken with a 35 mm autofocus, but a deliberate posing for an 8 × 10 view camera. These are two women who are presenting their personae more as individuals than as connected in a relationship: the mother's arm crosses behind the girl, but by no stretch of the imagination can this be considered an embrace.

Sexuality haunts all mother-daughter relationships. Daughters may be wonderful creatures, but their chastity must be protected. They must be safely married off. In a surreal moment captured by Sage Sohier at a Utah picnic, the sexuality of the daughter is overwhelming. *Zaftig* in her tight shorts, her blonde hair askew as if it were mirroring an inner wish for freedom from constraint, she holds—yes!—an apple to her mouth. Was there a satanic serpent in that tree? Eve: the eternal seductress, the first sinner, our first mother (unless you count Mother Earth, Lilith, or Pandora), who was called "The Mother of All Living Things," has also been defended by skillful exegesis of the book of Genesis, where, curiously enough, there are two versions of her creation. In the first, God creates male and female as equals; in the second, Eve is notoriously Adam's Rib. Apple to mouth, Sohier's young woman is a pictorial equivalent to that Eve who ate the fruit out of primordial disobedience, and who thereupon brought the knowledge of sexuality into the world. In that act, too, she cast herself not only into demeaning bondage to the male, but was cursed with having to bring forth children in dire pain. This story of the origins of male/female relationships and of the presence of evil has powerfully influenced attitudes even today and still surfaces in the iconography of women.

Sexuality does indeed haunt all family relationships, even when the sexuality of the parents has been channeled into reproduction, as we see in Sally Mann's *Jenny and Her Mother*. An adolescent daughter clings to her pregnant mother, who leans against one of the symbols of womanhood: the washing machine. Why such sorrow in the daughter's face? Thirteen, perhaps, she is all too conscious of the genesis of that baby-to-be. Needy still, as are all adolescents who perch so precariously between the safety of childhood and the perils of young adulthood, she intertwines her body with her mother's. It is as if the daughter is drowning and is hanging on for dear life, while the mother, accustomed to the emotional demands of the child, strives to keep her head

up, as if she is afraid of being sucked down by the child. Any excessively symbiotic relationship between mothers and daughters is threatening to each, for each needs to preserve her own identity and separateness. The Mann portrait is a marvelous display of the passion of the quintessential female-to-female arc.

Mothers are our first teachers, and it is they who decide what shall be our first lessons. Todd Merrill's *Susan and Blaze* brings us into a contemporary middle-class kitchen. A young, attractive mother, her waist bound with a short red apron, is introducing her gap-toothed daughter to the single most important function of women in any family: the provision of food. The girl is happy, excited; the mother pulls her daughter's head close, in a gesture that could smother the child. Together they make pizza. The girl is learning how to prepare the appetizing food that Daddy will enjoy with them when he comes home. It can be noted that most food advertising on television and in the popular magazines tends to equate food with love, with mother love in particular, as well as with sensuous pleasure. Mother, of course, cannot escape being equated with food: she *is* food, was our first food. As every marketing consultant for food companies knows, Mother is not only the vessel in which the fetus grows but also the vessel out of which food miraculously appears for the infant.

Some mothers do not necessarily concentrate on teaching their daughters how to cook or even how to become motherly. Some, as in Susan Copen-Oken's devastating photograph called *Coach,* are preparing their daughters to perform, to compete, perhaps for Miss America, perhaps for the musical comedy stage. Only someone who has ambitions to be on the stage herself would be able to teach her daughter how to mimic the desired gestures and poses. It seems natural enough for a parent to want to create a child in his or her own image. In *Mommie Dearest,* the scalding autobiography of Joan Crawford's daughter, Christina, there is a photograph of them together when Christina was perhaps four years old. They are dressed exactly alike, in an awfully folksy item, probably of the forties, dirndle jumpers over puffed-sleeve white blouses. Mother Joan, then a famous actress and glamour girl, obviously outshines the grinning tot. There is a hypothesis that women who create these performances of dressing alike were probably extremely frustrated in their relationships with their own mothers and seek a close relationship with their daughters as compensation, also believing they will gain in youthfulness by such tactics as dressing their daughters in miniature versions of their own clothes.

Dressing alike may seem like fun to some daughters, but others want to keep their mothers from imitating their activities. Such a pair can be studied in Margaret Randall's *Mother and Daughter Riding.* It is impossible to guess whether it was the daughter or the mother who initiated this biking form of togetherness, yet the clue of the daughter's expression indicates that she would

just as soon not be compared with her mother or to share the fun with the old-
er woman, who seems to be having such a grand time. Each generation needs
to find itself through generationally exclusive activities, language, clothing,
and hair styles. To be too closely identified with the mother is viewed as not
being "cool." Besides, the point of generationally exclusive behavior is to
make separation from the parent possible—being a pal is not the same as
being a mom.

Sometimes a photographer has the good fortune to encapsulate the entire
history of a relationship in a single picture. Carla Weber's acerbic *Donna and
Diane* reveals much more than the typical middle-class delight in portraiture.
The pictures of daughter Diane, growing up blonde and once quite pretty,
guard both sides of a mirror in which today's realities can be seen. The mother
is forceful, with the beady eyes and jutting-forward gesture of her chin that
make her resemble a bird of prey. The daughter seems repressed, subdued,
even close to depression. It is possible to read a failed life in the daughter's
expression, and a wariness like a caged animal. These two are overwhelmed
by the objects in the mother's house. One longs to say to these women: at
least hold hands, look at each other, relate to each other, let the mother give
the daughter the assurance that she need not live up to those banal portraits be-
hind her.

After the airless claustrophobia of the Carla Weber portrait, turning to Mil-
ton Rogovin's dual image of an Appalachian woman and her daughter is a re-
lief. Here is a woman who has had the courage to enter what has been
traditionally a man's job: mining. Recent history tells us that she will have
undergone a painful initiation, including rejection by her male co-workers,
then perhaps a grudging respect. This woman is earning far more at a danger-
ous, grimy job than she might as a clerk in a local department store. Despite
having entered a masculine province, when she washes up and sits in her liv-
ing room embracing her reluctant daughter, she clearly retains her femininity.
She even stresses the conventionality of her femaleness, if you accept as a clue
the customary southern-belle doll atop the radio. Visible pride is here, and a
comfortable affection for the child, but unfortunately the photographer can tell
us little about the child except her recalcitrance at being photographed. We can
guess that she may be one of those children who hates being hugged by her
parents in front of strangers.

Paul Fusco's *Cocopah Indian Family* is a revelation of another kind. The
pain of poverty seems to have been overcome by a strongly loving connection.
In what was apparently a grab shot, Fusco recorded a lively truth: the boys
will be independent of their mother's affections far sooner than the girl will
be. How very easy they are with each other, this mother and her pretty daugh-
ter; the boys, meanwhile, are roughhousing, learning how to be men as they

might understand the meaning of that role. When a photographer has been completely accepted by a family, when they become oblivious to his or her presence, forgetting the clicking of the shutter, wonderfully truthful and intimate insights can be gleaned.

One of the great masters of this kind of insight, Garry Winogrand, gives us a glimpse of an eternal verity with his picture of a young mother with one child in a shoulder carrier and her daughter embracing her hand with an expression of total adoration. Watching her step on the often potholed pavements of Manhattan's Fifth Avenue, the mother seems somewhat abstracted, yet she is not aloof. She holds the girl's hand firmly, protectively. It is easy to imagine this mother and this daughter sharing a story over milk and cookies or reading aloud together from a book before the girl goes to sleep. So many photographs of mothers and daughters, from the time of Gertrude Käsebier to the present, display them in this storybook relationship. Alice Walker, author of *The Color Purple,* wrote about her own mother's stories as the most precious cargo of her soul. It was not only that she would retell them, but that she believed her mother was a writer manqué. What was more important, claimed Walker, was the fact that she absorbed the cadences of her mother's voice until they became part of her own art. Even though the Winogrand photograph does not show a mother reading to a child, something about the daughter's almost convulsive gesture of love bespeaks a close, articulate friendship between the two.

Perhaps the most joyous photograph in the entire collection is Bea Nettles's *Rachel and the Bananaquit.* Bea has undoubtedly been telling her merry daughter about a fantastic bird, a story that Rachel will remember and can recall as long as this picture survives. Here is the mother-daughter combination before the pressures of growing up intervene, before competition emerges, before sexuality threatens, before illness or separation or divorce or social disaster can overpower this captivating *joie de vivre*. It is perhaps the single picture in the collection that is a genuine Adoration, with the daughter even raising her chubby little hand as if in benediction. It is an incredibly rich image despite its pictorial directness and simplicity.

Could the Nettles's picture have had the same effect in black and white? No. An immediate loss would be the warm interaction between flesh tones, fantasy creature, and tropical landscape. Yet many photographers contend that nothing but black and white can express concepts. Robert Frank, for one, once insisted that black and white were the only possible colors for photographs. He wrote that they symbolized the antipodes of hope and despair to which humanity was forever doomed. His was a tragic vision, yet not all photographers choose to see the world in such radically opposed values. Even Frank admitted, ''There is one thing the photograph must contain, the humanity of the mo-

ment.'' If several of the photographs in this collection hint at despair, many of them, like the Nettles picture, do indeed reverberate with the humanity of the moment, humanity here meaning not simply people, but their humaneness, their tenderness, their loving, their fragilities, their strengths.

Since our humanity can be expressed in both verbal and visual languages, it can be said that *Mother* is a verb, while *Daughter* can be nothing but a noun. *To mother* is to nurture, to cherish, to nurse, to care for, to encourage, to provide sustenance for, to educate: those are the good attributes of our verb. The less admirable attributes are still verbs: to dominate, to squelch, to crush, to compete, to smother—yet these are not ordinarily considered the exclusive behaviors of the role of Mother, but merely the unsavory behaviors of human beings, male or female. *To daughter* does not exist as a verb; one cannot ''daughter'' someone else, whereas one can ''mother'' even if you are male.

This difference in the syntactical definitions of their roles accounts for the absence of some types of interactions from this collection. We do not, for example, see many older daughters caring for their invalid mothers. We do not see—and how to represent it?—mature women taking on the reversed roles of mothering the mother in her old age. We do, however, see glimpses of the generations of great-grandmother, grandmother, mother, and daughter, with the daughter sometimes bearing in her arms the succeeding generation. This chain of being, female to female, has been the inspiration for much contemporary literature and poetry, and, to judge by these photographs, has become the focus of attention for many visual artists as well. The struggle is to convey through concrete physical appearance the ineffable, the indescribable subtleties of a primary female relationship.

That relationship between mothers and daughters has undergone many changes. While every mother in the past was perforce also a daughter, today's options ensure that not every daughter may choose to be a mother. It was perhaps inevitable that sophisticated technology, birth control methods that are relatively safe, a complete alteration in the nature of work and other socioeconomic factors of the postindustrial world, would impinge on the structure of the family. It was inevitable that the division of labor eminently suited to the cave-hunter stage of society—with women safely indoors bearing and rearing children, and men outdoors hunting the woolly mammoth for food—would alter not only with the advent of agriculture and the domestication of animals but also with the long history of a shift from production to service. The complexities of cities, the long commutes to work, the recent struggle for the father to share the responsibilities of parenthood, the ever-rising rate of divorce and the subsequent abandonment of women to poverty-stricken single parenthood—all these factors will impact on what might otherwise seem to be the

most natural and fundamental of all relationships, that of mother to child.
Even the privilege of educating the daughters may be shifted elsewhere.

Photographers will need to be able to communicate these subtleties without
reviving traditional stereotypes. So much is invisible in any relationship that it
requires great feats of the imagination to conjure up significant meanings that
we can share. We are still learning about the varieties of mother-daughter in-
teractions, just as we are beginning to learn about many other aspects of what
it means to be human. These pictures demonstrate that there is no single moth-
er-daughter relationship, but almost as many differences as there are individu-
als.

From *Mothers and Daughters* (New York: Aperture, 1986).

Bio-History

F. Holland Day

RECENTLY, WHEN A FRAMED SET of F. Holland Day's exceedingly rare series. *The Seven Last Words of Christ,* was rescued from a basement in Philadelphia (see *American Photographer,* June 1980), it was estimated that the prints would sell for $25,000 at the very least. The amazed discoverer admitted that he had not been sure if the pictures were trash or art, though he suspected the latter. Such are the humiliations that fate bestows upon the once-famous. Such are the ironies—and there were many of them—that accompanied the career of one of America's first and most successful proponents of photography as "Art."

Due to the rarity of his prints and the general ignorance of the more admirable aspects of his career, F. Holland Day himself has been badly in need of rescuing from near oblivion. In the 1890s, after only a few years of work with the camera, Day was considered not only the equal of Alfred Stieglitz, but the leader of the pictorialists long before Stieglitz ever thought of photo-secession. Critics swiftly acknowledged Day's primacy in subtlety of composition, suggestiveness of detail, daring use of light (especially in extremes of contrast), and sensitive portraiture of female subjects. Joseph Keiley, an influential pictorialist, wrote that Day had many imitators but few equals, and even Sadakichi Hartmann, sometimes crankily ambivalent about Day, described his work as "an art full of delicacy, refinement, and subtlety, an art full of deep thought and charm, full of dreamy fascination."

The first of many controversies that would stalk Day's career began when the adulation and celebrity status he had begun to enjoy were transformed into satire and notoriety. At the Philadelphia Salon of 1898, a furor erupted over Day's sacred subjects. Cries of "Blasphemy!" greeted his tableaux of crucifixions—with and without saints—entombments, and pietàs with weeping Magdalenes. The painted wounds and grotesque realism of some of these images garnered the condemnation of the important American art critic Charles Caffin as "clap-trap" and "a divagation from good taste." Only the final versions of *The Seven Last Words of Christ* received international acclaim, and then mainly because Day had turned to gum bichromate and glycerine manipulations to achieve more decorative effects. For his female portraits and pagan nudes,

24. F. Holland Day, *An Ethiopian Chief*, 1897.

however, Day continued to be widely respected, imitated, admired, and re-
garded as a leader.

Unfortunately, in 1904, at the height of his international reputation, a cata-
strophic fire razed his Boston studio, destroying 2,000 glass negatives,
hundreds of platinum and gum prints, as well as his collection of drawings by
Aubrey Beardsley and Oriental artifacts. The prevailing belief was that Day's
career ended in the ashes. The American public did not learn that he produced
many of his most delightful images after the fire, undoubtedly because he rare-
ly exhibited them. What remained of his reputation were rumors of homoeroti-
cism, the sensationalism of his having posed as Christ, and his exoticisms of
costume and manner—the trappings of an eccentric, but hardly those of a seri-
ous artist.

Day's nonconformity took many shapes, none more obvious than his collec-
tion of Arab finery. Clients and models visiting his Beacon Hill studio could
expect to be greeted by Day in North African regalia, and turned-up Turkish
slippers, or blue silk shirts from China. He smoked a water pipe, and expen-
sive Russian cigarettes, and was suspected of an addiction to opium. As an
avant-garde publisher—a career he pursued simultaneously with photography
from 1893 to 1899—he scandalized Boston by importing Oscar Wilde's play
Salomé, illustrated by Beardsley at his most mocking and perverse. His studio
was described as "Beardsley-esque," and at least one outraged British critic
called him "the leader of the Oscar Wilde school of photography."

That label was a reference neither to sexual practice nor to subject matter,
since Day was entirely private in his sexual behavior and his known photo-
graphic subjects numbered far many more beautiful women than tantalizing
male nudes. What it signified was Day's absolute adherence to the Cult of
Beauty, a doctrine vigorously espoused by Oscar Wilde but born of Théophile
Gautier, John Keats, the Pre-Raphaelites, Walter Pater, and William Morris. It
became the central doctrine of the pictorialist photographers.

The term "Beauty" had special meaning in the late nineteenth century.
Beauty was considered to have moral force. Beauty was the ultimate good.
Beauty uplifted and transformed; it was the source of spiritual regeneration and
inspiration. Long considered an exclusive property of the fine arts, Beauty was
presumably beyond the powers of the mechanical camera. Day came to pho-
tography just as Peter Henry Emerson, among others, affirmed that photogra-
phy could rival painting. This heretical notion was promulgated by the
London-based Brotherhood of the Linked Ring (1892–1910), a high-minded
international society of art photographers for whom beauty was the ultimate
goal; the means included abandoning shiny silver processes in favor of the sof-
ter qualities of platinum. When Day was in London in 1894, dedicating a me-
morial to his idol John Keats, he showed a portfolio of his striking female por-
traits to George Davison, one of the founders of the Links. In 1895, before he

had any public exhibition and only one year after Alfred Stieglitz himself had
been elected, F. Holland Day became the third American member of that pres-
tigious brotherhood.

It is customary today to regard Alfred Stieglitz and F. Holland Day as repre-
senting the antipodes of that photographic ideology that Cartier-Bresson in our
day characterized as "discovery" and "invention." During the 1890s Stieglitz
and Day shared similar perceptions and admired each other's work without res-
ervation. Elitists both, they desired to elevate taste through the appreciation of
great art. They were convinced that love of beauty could transform the crass
industrial scene and cure the barbarisms of machine civilization.

Unlike Stieglitz, Day was entirely self-educated in photography. Born in
1864, just six months after Stieglitz, Day was the son of a wealthy Norwood
leather merchant who thought college was an unnecessary luxury for a future
businessman. Although Boston's Chauncy Hall School gave Day a fine liberal
arts education, Day began to feel the sting of being a self-made man when he
found himself almost constantly in the company of Harvard graduates. He
compensated by establishing several literary clubs, becoming a fanatical biblio-
phile with a collection of first editions and rare books that was the envy of
Boston. But if Day regretted having missed the advantages of Harvard, he
never envied the intensive technical training in photography that Stieglitz had
received in Berlin. In Day's view, fine photography was promoted by the
study of beauty and its manifestations in great art, and not the study of chem-
istry and physics.

Stieglitz proudly introduced Day to American readers in the first issues of
Camera Notes, beginning with Day's Nubian series of 1897: *An Ethiopian
Chief, Ebony and Ivory, The Smoker,* and a mysterious nude now known only
in reproduction and called, simply, *America.* These images presented to a
largely racist America one of the earliest and boldest statements of the idea
that "Black is beautiful." The prints were sublimely difficult, with close har-
monies and dark shadows contrasted with bright white statuettes, and to do
them justice Stieglitz obligingly turned to photogravure, the finest printing me-
dium of the decade.

Day's first Boston successes had been a series of dramatic and glamorizing
portraits of women, many of them his close friends. With his fine eye for the
decorative, he was drawn to strong, individualistic women and exotic ethnic
types dressed in his North African costumes. Typical journalistic gush of the
time described his portrait of the actress Mrs. Potter as possessing such exquis-
ite softness and generous grace that it suggested "A love-illuminated, love-
glorified face seen in a strange and anxious dream."

After the 1904 fire, Day established a summer studio at Five Islands,
Maine, to commune with his muse in more conducive surroundings. Contrary
to rumor, he did not confine himself there to posing pubescent homoerotic

male nudes. He pursued a new series of decorative portraits of women, including dreamily composed studies of mothers with sucking infants, young girls in sweet and innocent poses, and old women affectionately recorded. That these sympathetic and lovely portraits of women were contemporaneous with the frankly sensual and evocative idealizations of male nudes is a revelation of Day's broad humanity. His closest friends among photographers—Clarence White, Gertrude Käsebier, Frederick Evans, and Edward Steichen—recognized and admired Day's personal generosity and respect for others that bordered on the fanatical. With the exception of White and his family. Day's friends were granted few hints of the profound psychological conflicts that led ultimately to a 16-year seclusion from a world he found hostile to his nature, his ambitions, and his gentlemanly manners.

White and Käsebier visited Day's chalet in Maine, even before all three worked together in White's influential Seguinland photography school. In 1905, Day and White even shared similar subjects: youths as archers, naked boys (the White children among them) wrestling on craggy boulders, wreathed ephebes embracing a marble herm of Pan that Day had installed in the nearby woods. Such pagan themes were quite popular with photographers who, like the academic painters, still needed an excuse for nudity. Day began a pagan series as early as the mid-1890s, of which his *Marble Faun* was the most widely reproduced. The later series, dominated by a sultry Italian youth from the slums of Chelsea, transformed ordinary mortals into demigods of woods and shore through the magic of an uncorrected Dallmeyer lens.

This lens, brought home from London in 1900, became Day's favorite tool, and was soon copied for him by the Boston optical firm of Pinkham & Smith and shared with other pictorialists. The soft veiling of harsh realities by the diffusing lens was a paradigm of the transformations of urban ugliness so desired by Day and his colleagues. Unfortunately, as both Day and Stieglitz discovered, beauty remained a preoccupation of the idle rich, whose taste was suspect at best, and photography as art held little attraction for literal-minded hucksters, traveling salesmen, and sentimental housewives. Although he was admired by the photographic elite, the critics recognized that Day held little appeal for the masses. As Sadakichi Hartmann put it, Day appealed primarily "to the intellectual and the refined; to those, in a word, who can understand and feel." To Hartmann, Day was unique, and "he had probably done more to the creating of the 'new school' than any other individual photographer."

The "new school" to which Hartmann referred was pictorialism, of course, but it was also literally "The New School of American Photography," which Day exhibited in London in 1900 despite the underhanded efforts Stieglitz made to discredit him. Stieglitz accused Day of having made an unrepresentative collection and of exhibiting poor prints. This was vehemently denied by both Edward Steichen and Alvin Langdon Coburn, who verified that the prints

were of excellent quality, and the overall selection included every established
American pictorialist (with the notable exception of Stieglitz, who had refused
to participate) and some newcomers of great promise, including Coburn and
Steichen themselves.

Day never forgave Stieglitz's attacks, and his justifiable anger unfortunately
progressed to a stubborn intransigence that proved to have tragic conse-
quences. When Stieglitz tried to make amends in 1902 by inviting Day to be
reproduced extensively in the very first issue of his new journal, *Camera
Work,* Day refused the honor. He could not have foreseen that *Camera Work*
would become the single most influential, documented, studied, and coveted
journal in the history of photography. (Ironically, Day did make a single ap-
pearance in *Camera Work.* A portrait of him by Edward Steichen, titled *Soli-
tude* but otherwise unidentified, was published in April 1906.)

Admitting privately that a major exhibition without F. Holland Day would
be, in his own words, "a scandal," Stieglitz asked him to participate in their
1910 Buffalo Exhibition. Day again refused. Furthermore, he explicitly for-
bade Stieglitz to exhibit his early works, outstanding examples of which were
in Stieglitz's own collection. Stieglitz ignored this prohibition, and it was the
last straw. Day withdrew even further from the photographic community, and
he permitted only two photographers to see his later work with any regularity:
Frederick Evans in London and Robert Demachy in Paris.

Only once more in his lifetime did Day receive major critical acclaim when
he finally made a public appearance. His triptych, *The Prodigal,* posed on the
Maine shore in 1909 and reminiscent of Puvis de Chavannes's murals, was re-
produced in *Photograms* and exhibited at the London Salon in the fall of 1910.
E. O. Hoppé, regretting Day's long absence from the exhibition scene, de-
scribed *The Prodigal* as belonging to Day's "older, religious, semi-mystical
style, and should be dwelt with for a while, to realize fully the grey depths of
gloom and self-condemnation of the spirit, once proud and wayward, now bro-
ken. . . ."

The Prodigal was undoubtedly the epitome of the spiritual expression for
which Day had been striving in the ill-fated sacred subjects of 1898, and it is
with some understanding of Day's sources and motivations that we should
reexamine the religious pictures, failures though many of them were.

Day's eccentricities, his flamboyant costumes, and his aestheticism obscured
his serious intentions during his lifetime. His presentation of himself as the
crucified Messiah was the outcome of mystical preoccupations that consumed
artists and writers as disparate as Paul Gauguin, Puvis de Chavannes, James
Ensor, Odilon Redon, Rémy de Goncourt, and William Butler Yeats. Seeking
the spiritual in an age that denied it, believing in suffering as redemption,
viewing the artist as a priest of the imagination, many artists of the 1890s
were members of arcane secret cults whose rituals demanded an identification

with Christ's suffering and whose attraction was a synthesis of longings for transcendent experience. It was not sensationalism, but transcendence, that Day was seeking in the *Seven Last Words*.

In striving to elevate photography to the status of a fine art, Day was briefly deluded into believing that he could achieve that goal by attempting the sacred subjects, the one theme that had dominated Western painting since the Middle Ages. Their complex etiology included Day's fascination with the dramatic potential of religious tableaux, his severe depression following the early death of Aubrey Beardsley in 1897, and a mixture of profound psychological needs and secret mystical affiliations. Obviously, posing himself as Christ was also a symbol of Day's desire for expiatory suffering. But it was an error of judgment, and the sacred subjects displayed a fundamental misapprehension of photography as medium.

To judge from the estimated auction value of *The Seven Last Words of Christ*, however, it would seem that collectors and historians of photography are now ready to forgive that misapprehension and restore F. Holland Day to his rightful place as a major figure in the American aesthetic movement.

American Photographer, October 1981.

The Photographs of Jerome Liebling

A PERSONAL VIEW

IT IS ENOUGH to have been human. This is a refrain we hear and see in al-
most any contact with Jerry Liebling: a reverence for humanity that has all the
earmarks of a Judaic obsession with life, an acceptance of both the living and
the dead that borders on the reverential, a pervasive secular sorrow. This sor-
row suffuses his images with a sense of loss of any personal god who could
somehow be held accountable for all the searing horrors of the twentieth centu-
ry.

To have been human enough: no one need seek significance beyond that.
No one need seek redemption beyond his own humanity. It is an attitude that
helps us deal with the unspeakable guilts of the Holocaust, with the slaughter
of the innocents throughout human history. It is an attitude that genuinely en-
dows us with heroism in the face of unconscionable torture, which permits the
victims of ghetto servitude—of whatever race, time, or nationality—to hold up
their heads with Socratic fortitude. *I am human and nothing you do to me can
ever efface the nobility of that essence.*

This reverential attitude is far beyond politics in the ordinary sense, yet it
carries with it implications of a political sensibility, or perhaps more impor-
tantly, of a profound sense of social commitment. To confront and endure the
shock of his cadavers, to discover the piercing chiaroscuro of Spain, and the
even crueler extremes of Mexico, to identify the stunning metaphors of the
slaughterhouse sequences, to recover from all this *angst* in the presence of a
single leaf thrusting out of darkness into the light of vulnerability, and then,
suddenly, to open the door on the sophisticated clarity and bombshell satire of
his political portraits is to know that Liebling is not purely, or even simply,
reverential. Nor is he as naive as he sometimes pretends to be. For if one as-
pect of Liebling resembles his namesake, St. Jerome, on his knees before the
awesome suffering of humankind, another is not Jerome at all, but thundering
Jeremiah, the Old Testament prophet.

Liebling readily confesses that he is a preacher, but there is nothing in his
preaching that resembles the stereotypes of either the pompous, sleek Sunday-
school moralist or the fulminating, hell-fire country Bible thumper. If any-

26. Jerome Liebling. *Handball Player, Miami Beach, Florida*, 1977.

thing, it is the kind of preaching that many photographers have pursued, from Thomas Annan to Lewis Hine: *The truth shall make ye free*. In this respect, Liebling is an impassioned documentarian, a recorder of the pleasures and trials of the flesh, of starkly ravaged urban environments, of sharply revealing moments of political-convention charades. He indicates that he strives for a kind of scientific precision in his pursuit of politicians on the stump and at televised conferences, listening to each other's honest convictions and self-engrossed hypocrisies. None of his pictures smacks of the easy exaggerations of a Weegee, although he was influenced by that master journalist. More evident is the influence of another master, Henri Cartier-Bresson, whose range is more classical than Weegee's and whose sense of exquisite timing still remains the standard by which other photographers are measured. Yet while Liebling professes the cult of the documentarian, he recognizes his own romanticism, his idealism, his formalism. To understand Liebling's pictures, perhaps you have to imagine how it would be possible to mix Cartier-Bresson with the Bauhaus, one of the strongest stylistic influences he will acknowledge.

For all its trumpeting of pure form, logical enterprise, and scientific analysis, the Bauhaus school was essentially metaphysical, spiritualistic, and transcendental. The proof of this lies in the statement by the very apostle of purism, Mies van der Rohe, who said, "God dwells in the details." The Bauhaus was a group devoted to the exploration of the material basis of form, and it was through the so-called third phase of the Bauhaus that constructivism was brought to America in the person of László Moholy-Nagy. In 1932, when Hitler's henchmen ordered the Bauhaus closed down as a potential "breeding ground of cultural Bolshevism," the great masters—including Mies, Walter Gropius, Herbert Bayer, Marcel Breuer, Moholy-Nagy, and Josef Albers—fled to America. Here Moholy-Nagy established the New Bauhaus in Chicago, and from his circle of Lyonel Feininger, Gyorgy Kepes, and Serge Chamayeff emanated an enormous design influence. It was Chamayeff, as chairman of the Design Department at Brooklyn College, who established a pervasive Bauhaus environment in which Liebling encountered and absorbed the influence of Kepes, Ad Reinhardt, Burgoyne Diller, and other avant-garde artists during the 1940s.

At Brooklyn College, Liebling also experienced the personal encouragement of the photographer Walter Rosenblum, a former president of the famous Photo League. To understand why Liebling joined the Photo League at a relatively young age may require a look at his milieu. He characterizes himself as a "boy from Brooklyn" with a public high school education, the son of immigrant parents; but he knows how little that explains. His mother had come from a small *shtetl* near Warsaw; his father from some anonymous town in the fluid Austro-Hungarian Empire. They were poor. Of his two brothers, the eldest died when Jerry was nine years old; it was his brother Stanley who gave

him his first subscription to *Popular Photography* for his sixteenth birthday. The first camera, a Super Ikonta-B, was his father's gift.

Liebling had wanted to be a photographer for as long as he could remember, and it was from the very beginning that his camera was the symbol of *Truth*. His father was what was called "a good immigrant," that is, one who defended everything about his adopted country, even if he was a strong unionist among his fellow restaurant workers. Wanting to prove that his father was being naively idealistic about America, young Jerry would take pictures of old clothes men and other exemplars of dire poverty and abased alienation. These pictures would be brought to his father as "evidence," precipitating heavy political arguments. His father believed, very simply, that if you worked hard, you could make a living. That was enough. For young Jerry, it was not enough, not so long as everyone did not enjoy the same justice and opportunities.

Photography, then, was to be Liebling's weapon in the war against injustice. It was probably inevitable that he would seek out the Photo League, as the League shared his documentary and social intentions. Besides, the League had attracted many major talents of the late 1930s and 1940s, among them Berenice Abbott, Leo Hurwitz, Aaron Siskind, Paul Strand, and Dan Weiner, all of whom believed that persuasive social documents were required by the times. Considered in the light of Great Depression politics, when the United States and Europe were suffering catastrophic and dislocating unemployment, and when the racist pronouncements of Hitler Germany were loudly prophesying the imminent bloodbath in which millions would be slaughtered, the idea that photography should make some contribution to arousing public opinion seems an appropriate doctrine. But how, and whether or not, the Photo League—in its short life between 1936 and 1951—actually made any contribution would require difficult research in the sociology of knowledge, in the psychology of persuasion and of communications interactions. What is propaganda to one generation often becomes either revealed truths or totally incomprehensible statements to another. Even such devastating events as the Great Depression or the Nazi Holocaust have to be reinterpreted to new generations.

Both the Great Depression and the Holocaust shaped Liebling's attitudes and are very much evident in his subject matter, even if indirectly. He was eighteen in 1942, when, after a brief semester at college, he volunteered for the army. Opting for the Signal Corps with the hope of serving as a photographer, he was instead trained as a telephone lineman with the 82nd Airborne. He talks of encountering evidence of atrocities as they joined in the battles to liberate Sicily, Africa, Italy, France, and, finally, Germany. For three long years he survived and survived again, but it was a physical survival. If whatever makes us human can be called a "soul," then Liebling's soul can be said to have been flayed, leaving the permanent lacerations that all of us of that gen-

eration bear. Indeed, the pain and suffering that we find in Liebling's pictures may be the result of his soul's wounds not having sufficiently healed. It is as if the wounds he experienced are still pulsatingly raw, sensitive to the end, shivering afresh with each new vision of the hell into which humanity flings itself from time to time.

The GI Bill sent Liebling back to college at the close of the war, still unaware of the Photo League. He had become interested in design, and was about to go to Mexico, to Sterling Dickinson's Institute in San Miguel Allende. His father's death in 1946, however, changed his plans and kept him in New York. When finally he met Walter Rosenblum, who was teaching photography at Brooklyn, Liebling says, ''I was immediately able to take pictures.'' And immediately he was able to take the delightful series of *Ruthie Schwartz,* whose family signals to us, even in the jaded 1970s, the innocent joys of the lower-middle-class wedding. Of Weegee, he knew nothing at this moment, at the age of twenty-two; but, he says, ''I knew what I wanted.'' What he wanted was to find some way to accommodate the seemingly academic aspects of design—line, tone, composition—within the documentary photograph. In other words, there came the discovery that he had strong aesthetic inclinations that would have to be reconciled with his equally strong social preoccupations. The tension between these two inclinations reveal themselves superbly in his study of a little black boy, in the pictures of Coney Island, and in those of Manhattan's famous Union Square.

Manhattan was beginning to be an exciting environment for filmmakers as well as still photographers in the late 1940s. The Museum of Modern Art was exhibiting Cartier-Bresson; it was also showing great foreign and American films. Paul Strand's films were being shown at the League, and Hans Richter was teaching film at CCNY. Then came the momentous opening of The Film Workshop, an offshoot of Erwin Piscator's Dramatic Workshop, offering one of this country's earliest full-time film courses. By this time, in 1948, Liebling had become seriously interested in film. He was, in fact, one of the Workshop's first film students, and he studied there with Lewis Jacobs, Leo Hurwitz, and Raymond Spottiswoode. This film experience probably encouraged and enhanced his ability to seize on the perfect moment—the objective correlative grasped as an instant in time—in his still photography.

When he went to Spain many years later, he sat in a small café with his still camera, shooting through the glass at the passersby as they framed themselves against a baroque thrust of building in the background. He speaks of these shots as ''the opening frames of a film.'' This is tremendously revealing of not only his intention but his technique: he remarked that he is not one of those photographers who sees a perfect opportunity for one picture, takes it, puts the camera away. Not at all. He regards his still pictures as parts of sequences, even if the sequences, in some cases, have taken ten years in the making. He

dances around subjects; he clicks away; he wants to encompass all of it, letting nothing escape. Then he wants the viewer to experience this same intensity, this same series of blows to the viscera or to the intellect; he demands that the viewer dance into the subject with him, touch it, fondle it, examine it, breathe with it. He is, absolutely, a photographer who cannot be understood or experienced in one picture. While his prints can stand alone in formal strength and power of focus on a subject, they are overwhelming seen in a series.

At the age of twenty-five, Liebling was hired by the University of Minnesota as a teacher of photography rather than as a filmmaker, but he was soon to begin making films. This was a brand-new art department headed by H. Harvard Arnason, an art historian who strenuously and imaginatively built up the studio faculty. Liebling believes his art education was strengthened and vastly expanded by the stimulating artistic and intellectual interactions of the large university, but the most immediate outcome of his joining the university was his meeting with Allen Downs, who was teaching photography and design. Downs and Liebling began a highly productive relationship, out of which would later come the well-known and prize-winning films *Pow-Wow, The Tree Is Dead, The Old Man,* and *89 Years.* In *Pow-Wow,* a hilarious 1960 short whose subject is the tremendous seriousness with which midwesterners pursue band practice, even in downpours, Liebling reveals an extraordinarily practiced eye for the touching foibles of humanity. The entire film is, once again, a kind of "evidence" wherein Liebling expresses not humanity's inhumanity, but its tremulous vulnerability and delicious silliness, captured by telephoto lenses. In the remarkable reverse zoom of the film's last few seconds, Liebling is unquestionably commenting, once again, on the unique and almost magical ability of the camera to provide access to the most intimate human rites.

Rather than to humor, however, Liebling's continuing commitment is to showing us the dark side of our natures. In 1951, he discovered the slaughterhouses of South St. Paul, and began to shoot unforgettable scenes: bespattered walls, severed animal heads, the faces of the slaughterers—men who were simply earning a living at butchery—and everywhere the blood of a sacrifice robbed of its ritual meanings, denied expiation through having been kept hidden. To Liebling, who recalls seeing Franju's overwhelming film *The Blood of the Beasts* at about this time, these abattoirs permitted him to create a complex metaphor of the Holocaust. But Franju's vision was here intermingled with the insights of Siegfried Giedion's *Mechanization Takes Command,* which details the impact of technology on social behavior, especially in the area of factory assembly-line labor. The metaphors of the slaughterhouse series are thus richly and densely intertwined, with the Holocaust's death camps signifying the "logical" outcome of a dehumanizing mechanization of human endeavor. Crushed, hacked into pieces, humanity, like these pitiful animals slaughtered

for our carnivorous demands, seeks to find some meaning in existence, and can find it only in the sacredness of that existence alone.

Blood, flesh, guilt, desire: Liebling talks frequently of his interest in "physicality," in the way arthritic hands lie twisted, in the tautness of a young woman's neck, in the tactility of blond down texturizing a woman's back. As Mies put it, "God is in the details." Liebling forces these details on us, whether in the ferocious, yet touching, cadaver series, or in the crisp voile of a child's communion dress. Photography, after all, must find some way to express inexpressible, nonverbal thought through the selection of significant detail. Liebling is a master of synecdoche, the use of the part to stand for the whole or to evoke an emotion, something that the old master, Stieglitz, would have heartily approved. The difference might be said to be that Stieglitz framed the detail in an "artistic," abstract-art manner; Liebling crops so closely that the content of the detail is thrust upon you, with much less immediate awareness on the part of the viewer of the overall design. Liebling is saying, "Touch!" because he wants you to feel deeply. He wants to mesmerize the viewer by close contact, even if that close contact is almost too much to bear.

I ask him, "Jerry, now that you have shown your audience this pain, this suffering, this agony, what is it that you want them to do with it?"

He leaps upon the word *agony* and cries out that the Greek *agon* is very much what he seeks, a method of catharsis of the tragic emotions.

"Is it political, this pain and suffering? What is it for?"

At first, he denies knowledge of his own goals; then, as he thinks it over for a while, he says forcefully, "Yes, I *do* know. I want people to feel their own humanity."

No, this is not politics. I believe there has been a metamorphosis from a view he once held of photography as a call to political action. How can there be a call to action against *death? Et in Arcadia ego:* even in paradise, death lurks and lies in wait for us. Liebling has gone far beyond politics in any ordinary sense of that word.

Back in the 1950s, however, his political photographs did help to establish his reputation. He knew Walter Mondale and Orville Freeman, and he was paid to do the pictures for the *Minnesota Blue Books,* and the *Medical World News.* Yes, he made money as a stringer. He captured Hubert Humphrey seated behind Eugene McCarthy at a rally, Humphrey's smile under a broad hat, McCarthy's sad face. They are a marvelous contrast, a successful piece of photojournalism, a genre with which Liebling has no hesitation in identifying himself. He agrees that great photography can be anonymous, that preoccupation with style, unique, individual style instantly recognized as belonging to this or that great master, can sometimes interfere with the necessity of making

certain kinds of pictures that are just as important as the "art" pictures. He is unafraid of documenting a place; here, too, is his sense of series, of filming, of ongoing processes. When his Spanish washerwoman of the 1966–67 series happens to receive a fortuitous halo, Liebling is unabashedly charmed by it.

When he talks about the people he likes, the names of A. C. Vroman, August Sander, and Walker Evans predominate. When he goes off into an animated discourse on what photography is all about, the phrases come cascading out: "the force of life," "serious import," "the diversity of what life is all about," "trying to define what life is," "I won't say that you need catharsis but you need to get involved," "You've got to force yourself to use anything you've got." What I sense he detests are fads, fashions, and the phony, and he is uncomfortable with the current pressure to make photography into a manipulated graphic art with stylistic chic. More phrases, more ideas: "We are being devoured" and "Yes, it is a sense of awe, of people going beyond themselves." This last, in response to my questions about the *Blind House* series of 1963. Yes, even in casual conversation, we can hear and see that Liebling is awed by what people in adversity can do; again, *It is enough to have been human.* Look at the poignancy of a situation, feel it, think it, try to be as clinical as possible, learn from Rembrandt's *The Anatomy Lesson.* "The world as organized now is giving off the pain." Is this last merely an echo of the old politics? I do not believe so; it is a sense of human injustice that goes far beyond any specific political system.

Far beyond the conventional meaning of politics, and much closer to a sense of religious devotion to humanity, are those remarkable handball players, those half-naked septuagenarians who stride toward us with such nobility and dignity that they are the equals of classic Greek statues. Here I experience that same sense of awe and admiration when I first saw Pablo Picasso, through the eyes of David Duncan, as an incredible old man whose strength and virility remained until death. Although Liebling has much work ahead of him, I suspect these handball players of his will stand as his most consistently noble achievement. He has managed, by some telling combination of light, form, stopped motion, significant shadow, to make heroic figures out of retired salesmen, clothiers, and waiters. This heroism is not the poster-style heroics of the last works of Lewis Hine in his *Men and Machines.* Liebling is not enshrining his handball players. He simply loves them.

Love and rage: these shine together in the most recent series on the South Bronx slums, for which he was supported by a Guggenheim fellowship. Not only love and rage supporting each other as they reveal to us the devastation of an urban environment as horrifying as the bombed-out ruins of Dresden, but the formal sense reinforcing the choice of object. Now he groans: he feels guilty because he made some of these pictures "too pretty." It is true that

they are handsome pictures despite their subjects. One view of the side of an apartment house around which everything else has been torn down is as handsome as any Maxime Du Camp picture of Egyptian monuments during the mid-nineteenth century. The Bauhaus sense of structure and design has never left him; in fact, it has been reinforced over the years by an increasing sureness of vision. He knows just when to snap the shutter, cares no longer if buildings tilt, looks for the impact of shape with shape. But he feels guilty, guilty because his conscience, shaped in the Great Depression years, scarred in the war years, prods him relentlessly to fulfill his sense of social mission. It is a Judaic, puritanical conscience shuddering away inside a sensual, materialistic artist.

Again, this glimpse of the biblical prophet Jeremiah, who cries, in the words of the Vulgate, *O vos omnes qui transitis per viam* . . . "Is it of no concern to you who pass by?" Are we to stand aside and permit a people to be herded like animals into the slaughterhouse of poverty and humiliation? Stare now into the eyes of a young man, arms outflung and hands pressed against door jambs, his body taut with repressed power, and give your answer; dare, if you will, to turn away, saying, "It is of no concern." And the Vulgate also gives us Ezekiel, that other major prophet, saying, *Et dabo vobis cor novum.* . . . "I will give you a new heart and put a new spirit within you." I think that is what Liebling is trying to do, to give us that new heart of compassion and that new spirit of humane understanding, which is as new as the Gospels and as old as any definition of what it means to be human. It is Ezekiel who intoned, "These bones shall rise again," and it is Liebling who miraculously manages to invoke a spirit of resurrection and the resurrection of the spirit even in the grisly cadavers.

It is this desire for the new spirit that perhaps forces Liebling to admit being outside of contemporary photographic allegiances, outside obeisance to "the art of photography," and certainly outside—with his back turned—to the whole discussion of semiotics, structural grammars, and other recent photocritical concerns. As Ortega y Gasset remarked, "We possess of reality, strictly speaking, nothing but the ideas we have succeeded in forming about it." For Jerome Liebling, photographer, teacher, filmmaker, organizer and leader of photographic associations, survivor of battles, survivor of personal struggles and defeats outside the province of this essay, reality is the human reality. Reality is to be seen unencumbered by the intellectualisms about it, concretely revealing itself through the flesh. Whether or not he is conscious of having reified himself in the role of "tough teller of truths," or, perhaps, "fearless warrior against injustice," cannot matter as much as the outcome of these roles portrayed in his photographs. They are among the strongest statements we can encounter today, statements of human worth and significance, of the sacrament

of living. There is perhaps no greater gift that an artist can make to his publics than to have endured the suffering out of which he has created an ideology averring, *I am human and that is enough to make me significant and worthy.*

What is contradictory about this kind of ideology is, of course, that it is the nobility that Jeremiah offered his audiences: through suffering and oppression you will become even more human and more deserving. The murderers, the creators of holocausts, which we all fear may yet come, must not be identified as human or share in this saving grace. It is a romantic's view of the possibilities of the world, to rise up out of sorrow and find some sweet saving remnant of pride.

In that transcendence that Liebling offers us we can find no concrete villain, no simple creator of evil. He has pushed still photography to its absolute limits as a message system; he has wrenched from paper images the utmost which they, as a visual communication medium, can deliver. There may be a point beyond which the still photograph cannot go, when we must turn to words as more capable transmitters of complex abstractions, as perhaps more economical communicators of causal connections, as more precise descriptors of context. For Liebling, the *context* of his work is so important as to almost demand explanation. Yet the *themes* of his work are so universal that they defy the restrictions of specific denotation.

Without question, Jerry Liebling is a photographer of considerable formal means, with a superb ability to make us feel, whose conscience offers a gripping testament of faith in humanity. His many unforgettable images demand, and reward, close and patient study.

From *Jerome Liebling: Photographs 1947–1977* (Carmel, Cal.: The Friends of Photography, 1978).

Imagination, Phototechnics, and Chance

THE WORK OF BARBARA CRANE

HER ACHIEVEMENT IS SUBSTANTIAL, her productivity amazing, her prints—from the intriguing *Petites Choses* to the large-scale industrial murals—demonstrate an integrity and continuity of vision coupled with an impressive technical excellence. Her work is not casual, delicately charming, or as demure as her petite physical presence might lead you to expect. She is complex, cerebral yet sensual in a direct, unabashed way. With an intelligent consciousness of what she is pursuing, she commits herself to the photographic event with boldness and passion. What is so delightful about her work is that it encompasses both high seriousness and a formal playfulness, a sensitivity to the microcosm of found objects transformed into monumental conception, and a rigorous sense of purpose enlightened by devotion to chance and instinct.

Crane is an influential educator, recently elevated to the rank of full professor at the distinguished School of the Art Institute of Chicago, where she has been teaching photography since 1967. Whether as visiting artist or workshop leader, she has attracted students and audiences all over the country—at the Ansel Adams Yosemite Workshop, the School of the Museum of Fine Arts in Boston, the Massachusetts Institute of Technology, the Victor School in Colorado, the Friends of Photography in California, the Philadelphia College of Art, and the International Center of Photography in New York.

She has had one-woman shows at the Museum of Science and Industry in Chicago, the Davis Gallery of Stephens College in Columbia, Missouri, the University of Iowa Museum, the Worcester Museum in Massachusetts, and the Vision Gallery in Boston. Forty-five group exhibitions have included her prints, which have been purchased by George Eastman House, the Library of Congress, the Art Institute of Chicago, the Pasedena Art Museum, Polaroid Corporation, Sam Wagstaff, Arnold Crane (no relation), Rouald Bostrum, David C. Ruttenberg, and other public and private collections.

This retrospective of Barbara Crane's work should be considered only an introduction to selected aspects of an accomplishment that is unusual in its versatility. As editors and curators know all too well, it is a brave and difficult act to cull from an artist's production of thousands of prints only a certain

27. Barbara Crane. *Bus People*, 1975.

few. It is almost impossible and probably not even desirable to try to designate "the best" out of the context of hundreds of related images. Barbara Crane is one of those many artists of the camera whose work is cumulative, not only in conception but in effect. Included here is a representative selection of some— by no means all—of Crane's major preoccupations, an introduction to only a few of the challenges pursued and conquered, of projects initiated and completed. It is a clear invitation to pursue her work in greater depth.

Barbara Crane conceptualizes in all formats, shapes, and sizes and is now making an extensive exploration of color, an activity for which her Guggenheim Fellowship was awarded in 1979. This is by no means the first time that she has given herself wholeheartedly to a project that requires mastering a new technology. In fact, despite her claim to dislike hardware, it is at the core of her self-knowledge to have recognized exactly how "any given piece of equipment strongly influences image concept." Typically, she rejoices in the opportunities and challenges of new phototechnics and will modify, experiment with, and push to its extremes any instrument or material that has excited her imagination. The origins of such energy, commitment, and daring are surely embedded in a unique psychodrama, the outlines of which can only be tentatively sketched here.

Born Barbara Dell Bachmann in Chicago on March 19, 1928, she was brought up to be safely bland and taught to survive a rigidly anti-Semitic neighborhood by her upper-middle-class, German-Jewish parents. At stiffly upper-crust New Trier High School, she was encouraged by her peers to masquerade as just another emotionless "nice girl." Ruled by a formidable Teutonic discipline in a competitive family situation not noted for its calm, she developed perhaps too many internal restraints. Typically, it was only in her photography that the cap could come off the bottled-up emotions, and that release would take years to accomplish.

Her earliest memories of photography are of her father in his amateur darkroom, printing his negatives of family and friends. Crane was then a teenager, and it was a magical experience watching her father make a great game out of the mysteries of printing. Each time a print developed in its chemical bath, it seemed a victory for light and definition over emptiness and obscurity. She thoroughly enjoyed these quiet, good-humored moments.

After the war ended in 1945, she went off to Mills College in Oakland, California. "It was the best thing that could have happened to me," she observes. Mills was not only a superb liberal arts school, it was a women's college. Up to that point, she conformed to the societal pressure that had been teaching her, "All women are dabblers and dilettantes." That was her first real challenge: not to be a dabbler. It was depressing enough that her family thought art was an extravagance and marriage the only career for a woman. At Mills College, she found her first female role models of a more encouraging kind,

among them the great American photographer Imogen Cunningham. Later, Crane and Cunningham became friends, maintaining contact until Cunningham's death in 1978. Of her, Crane says, "She gave me such hope; she gave me the sense that one could survive."

Majoring in art history, she had a project that required photocopying paintings. Her first camera was a 1947 twin-lens Kodak Reflex, which she traded in three years later for a Rolleiflex. A design instructor obligingly provided about six hours of practice in developing and printing. More important, he put into her hands the works of Gyorgy Kepes and László Moholy-Nagy, then the guiding geniuses of the Institute of Design in Chicago. Moholy-Nagy had been a leader of the European Bauhaus and had transplanted to Chicago the ideals and methods of the avant-garde formalists and modern functionalists. Kepes had recently published his influential *Language of Vision* (1944), in which he prosletyzed an art based on "the shaping of sensory impressions into unified organic wholes."[1] This was to be an art of discovery, an art of experimentation with materials and form, rather than the copying of nature. The goal of the modern artist was to pursue "the closest connection between art, science, and technology."[2] Early exposure to these Bauhaus ideas of the connection between technics and aesthetics undoubtedly laid some of the foundations of Crane's later approach to her art.

Photography swiftly became an obsession, but as she tells it now, it was 1948, a time when "you lost your boyfriend if you wielded a camera, so photography had to be a very private affair." She was coming of age in a generation that taught women to be submissive, self-effacing, and "feminine"— meaning totally consumed by maternity, *Good Housekeeping* ads, husband, home, and "togetherness"—one of the slogans of the time. In 1948, before she could finish at Mills, she was hurried into marrying Alan Crane, who promptly moved his new wife to New York City. There, with her husband's approval, she worked at Bloomingdale's in the portrait studio, her first professional experience in photography.

Manhattan was stupendous. She haunted the Museum of Modern Art, overwhelmed by Mondrian, Matisse, Klee, and photographs of architecture. In 1950 she completed her B.A. at New York University with a senior project comparing three New York churches with their European counterparts. Architecture has remained a perennial interest, but there were many other attractions in New York. She recalls that the Guggenheim Museum was still in a brownstone when she avidly pursued their programs of abstract and experimental films. Often she went alone to the dance performances of Ruth St. Denis and José Limón, continuing an interest encouraged by many friends at Mills who had been dancers and musicians. She was beginning to be tantalized by the notion that there were connections between serial music and visual art. A memorable class in oriental art, taught by a Metropolitan Museum of Art curator,

introduced her to the triptychs, folding screens, scrolls, and calligraphy, which embody many of the nonrepresentational, formal aspects admired in Kepes's *Language of Vision.*

In 1952 the Cranes moved back to Chicago, and in the process of moving, "The enlarger was packed up," and it stayed packed until 1960. She had been programmed to be a good mother: for eight years she denied herself photography while she devoted herself exclusively to her three young children. But once the youngest was safely in prekindergarten, out came the camera, the enlarger, and the trays, and daughter Beth's bedroom became a darkroom. For a few years, she free-lanced as a photographer of other people's children. Then, by a stroke of good luck, one of her subject's parents directly intervened. His public relations firm wanted someone to take portraits of the corporate giants who ran Chicago's newest industrial park, and he enthusiastically recommended Crane for the project.

In the early 1960s businessmen apparently found it unusual for a woman to be taking industrial portraits. Petite and seemingly fragile, Crane was careful always to dress in conservative, tailored suits and to smile at patronizing remarks. As a model for independence, she kept Ayn Rand's architect hero of *The Fountainhead* very much in mind. But even if she was also reading Betty Friedan by then, she still imagined that she was fighting only Barbara Crane's battles, not experiencing a typical woman-in-business situation. The recognition that it was perfectly legitimate for a woman to seek employment that would help her realize her own worth as a person slowly emerged.

By this time, she knew that her marriage was in serious trouble because of a fundamental clash of temperaments. Despite valiant efforts, the marriage lasted only until 1965. Its dissolution, however painful, completed an artistic liberation that had been evolving since 1960.

In January of 1964 she brought a portfolio of her prints to Aaron Siskind, then teaching at the Institute of Design at the Illinois Institute of Technology, the former home of her earlier idols, Kepes and Moholy-Nagy. Siskind was an inevitable choice. He seemed the only photographer in Chicago who would understand and sympathize with her preoccupations with experiment and form. She was desperate to find other photographers who were on the same frequency, who wanted to create images of consequence and monumentality. Siskind was generous with his time and frank with his opinion: she had to go back to school, this time into studio classes. That seemed an impossible idea, yet she called him the very next day to ask how she could register for courses with him. She then put herself through the graduate program at the Institute of Design with portrait commissions. Six months after enrolling in the program, she landed a job teaching photography at her old alma mater, New Trier High School.

The Institute proved anything but easy. She was self-conscious about being

both suburban and a mother. The divorce had granted her custody of three children who still needed her. Since their care precluded having the freedom to take street pictures, she paid her children thirty-five cents an hour to model for her—not the first time a woman photographer has had to make a similar compromise. They were often posed on the basement Ping-Pong table, and they complained they did not want to be recognized in her pictures. The solution was to find ingenious ways of making compositions without including their faces. For her Institute thesis, a production of ninety images of the human form, she did occasionally manage to hire professional models in addition to her children. For inspiration for some of these, she turned to Modigliani's nudes and Matisse's sinuous line, wanting, as she says, "to see if I could produce something like a contour drawing in clean black lines having the energy of a sketch and the sensuality and ambiguity of a Matisse calligraphic ink drawing."

Between 1964 and 1967, Crane taught at New Trier, where she initiated a dynamic program. In 1967 she presented a slide lecture on her students' work at the annual meeting of the Society for Photographic Education. Immediately, Kenneth Josephson, Harold Allen, and Frank Barsotti all invited her to teach at the School of the Art Institute of Chicago. But other well-known photographic instructors were not so pleased by her presentation. They were offended and upset that she did not consider good composition as merely the underlying structure of a social message but rather as a formal examination of relationships for their own sake. The documentarians and adherents of "straight" photography were unhappy, while the poets of the camera, like Todd Walker, were so impressed that they borrowed her slides to show at their own institutions.

If she had been a pioneering teacher at the secondary school level, she now found herself enmeshed in the politics of photography. That politics rises out of allegiances as arbitrary as our national two-party system, and the most recent articulation of the ideological issues was John Szarkowski's exhibition, *Mirrors and Windows: American Photography since 1960,* at the Museum of Modern Art, 1978. Szarkowski is undeniably one of the greatest critics of photography, yet the dichotomy perpetuated by that exhibition has only served to exacerbate the ideological excesses of both sides. While Szarkowski modified his original conception by claiming that his intention was not to divide photography into two parts, but rather "to suggest a continuum, a single axis with two poles"[3] and that all photographs were part of a "single, complex plastic tradition,"[4] it was obvious that he did make a distinction between two notions of what a photograph might be: "Is it a mirror, reflecting a portrait of the artist who made it, or a window, through which one might better know the world?"[5]

To understand Barbara Crane's position within photographic politics, we

should recognize that her work falls into both of Szarkowski's arbitrary categories. But an implicit value judgment is laid against the "mirror" artist. Szarkowski implies that "window" artists help us *better* to know the world. Yet Immanuel Kant demonstrated that we can never know the world apart from the inherent limitations of the human brain and the strictures of preestablished mental and cultural concepts. Advanced scientists admit that complete objectivity is a glorified myth. Intuition and poetic metaphor teach us as surely as Comte's formidable statistics, only they may teach us about different events. I cannot imagine that Szarkowski meant to deny the human insights of diarists like Virginia Woolf, Jean-Jacques Rousseau, or James Boswell, nor the subtle psychological portraits by the great novelists. The more we are forced to pretend that we are investigating the phenomenological world without benefit of emotion, the more we approximate the stereotype of the "mad scientist." The "mad scientist" is mad because he has lost his sense of human values. It is not at all a question of "mirrors" or "windows" but rather the much more perplexing issue of what we plan to do with our knowledge, acquired by whatever means. The "mirror" artist is often trying to move us to action; the "window" artist may simply be offering vacuous description.

To a surprising extent, approaches in photographic criticism, journalistic enterprises, even entire schools of the art, are mired in a century-old argument over whether photography is (or should be) a science or an art, or whether manipulated photography is as legitimate as "straight." Some curators, educators, and critics of photography contend that photography cannot be abstract, must not be formalist, dare not be "decorative"—that now fashionable word, which was all too recently a term of execration. Yet Aaron Siskind, Paul Caponigro, Imogen Cunningham, Minor White, Kenneth Josephson, Barbara Crane, and a host of other photographers have created an imposing body of work no less respectable than that of Robert Frank, Garry Winogrand, Tod Papageorge, Diane Arbus, Lee Friedlander, and William Eggleston, to mention only a few.

What is particularly interesting about the career of Barbara Crane is that she has always felt the pull of these antipodes on a personal level. She has deliberately alternated between intensive explorations of visual phenomena structured into complex designs and an approach that relies on chance as connection with unpredictable humanity. At times she has found the immersion in purely formal and impersonal visual stimuli so exhausting that she has had to pull back to a more simple relationship with strangers interacting in relatively chaotic environments like beaches and parks. To give chance its opportunity is her personal ideal, even in her more structured work. For the structured work she often manipulates found objects or chance juxtapositions, subjects she has accidentally discovered have the same kind of visual vibration, something she likens to the tensions in futurist paintings.

"To give chance its opportunity": late in the 1950s, Crane became a devotee of John Cage and Merce Cunningham, the composer and choreographer whose aleatory theater and music compositions were so controversial at the time. Yvonne Rainer has called their improvisational, yet structured, work "spontaneous determination."[6] The method of aleatory art in any medium is to select several formal motives, place them in sequence without predetermining their combinations, and then perform them in a spirit of spontaneous discovery within the limits of a given time and/or space.

Crane's sequences, like the *People of the North Portal* series, are deliberate explorations of combinations of motives, carefully predetermined. As she has explained, "Chance extends the boundaries of my imagination. I try to set up a framework to allow this to happen: I choose where I stand; I determine the tonalities; I select the forms; I look for the right light. Then I give chance a little room to perform for me."

This delight in chance led, for example, to the series of pigeon pictures that Crane used as part of the collage in the enormous bank mural called *Chicago Epic*. Crane was flat on her back on the ground, with the camera pointing directly to the sky. Her assistant then poured pigeon feed all around her, stepped back until the pigeons came in to feed, and then rushed in to scatter them in a flapping of blurred wings. Crane shot three exposures per scattering. The interplay between seed, feeding, rushing, scattering, and snapping must have been amusing to spectators, many of whom may have thought Crane was completely mad. But Barbara has never been afraid of risking public disapproval for the sake of capturing new and difficult images. She has trudged through the streets of Chicago pulling a golf cart burdened with a 5 × 7 camera, tripod, film holders, lenses, and other materials. She has placed herself forthrightly with her heavy press camera in the midst of hectic beach scenes. With good humor, she recognizes that she was many times in danger of being trampled, perhaps most especially during her shooting of *Commuter Discourse* and the *North Portal* series.

While chance has always been given its opportunity, Crane has invariably selected the motives for the performance. In one of the earliest series of multiples, *Neon*, she was using double exposure. The film already had on it the reflected lights of giant electric signs. The patterning of light bulbs perforates the superimposed faces with a "do not fold, spindle, or mutilate" effect. The delightful *Neon Cowboy*, with its luminescent outlines vibrating against a background of nudes, was the forerunner of experiments with combining different sizes into one print. An impetus toward this kind of combination image was the purchase of an old 8 × 10 enlarger that offered the potential of printing two 4 × 5s side by side in a dialogue between two images. This, in turn, led to the notion of creating one 8 × 10 print from whole rolls of 35mm film and of playing with combinations of sizes and shapes printed together. She had

long before calmly sawed sections out of the wooden slides of her Deardorff camera to permit multiple exposures on one negative.

In the *Wrightsville Beach* series, Crane says she began to think of the implications of the space beyond the edges of a particular image format. She wanted to encourage the viewer to see the rows of similar yet different houses as a kind of infinite progression. The houses were so ubiquitously alike as to preclude the notion of individuality. Yet within this Mondrianesque beat, the unique individuals who inhabit these beach houses or who work in this repetitious environment staunchly display their stubborn idiosyncracies. Crane provides an enjoyable tension between anonymity and personality.

The *Whole Roll* series begins with a shocker pulsing with an obscene rhythm. It is as if a disease of pornographic amoeba was about to explode from the paper. The circular shapes are not Frank Mouris-like fantasies, however, but simply variations on intertwined human forms. The round pictures were obtained by using a lens shade too small for the lens surface. The rowboats in the *Whole Roll* series share with *Neon Cowboy* an iridescence and sparkle determined by sharp contrasts of light and dark. Like the op art of the 1960s that helped give birth to these repeats, the rowboats seem first to be structured in an overall pattern; then they seem less like boats and more like flat bullet-shaped cutouts turning on rows of wires, and finally they vibrate like the crazy gaudy streamers at secondhand auto dealers.

I find distinct correlations between several aspects of Crane's work and the paintings of op art. As Cyril Barrett observes, optical effects created by the repetition of anonymous forms were the essence of the 1960s op art movement, in which Victor Vasarely, Bridget Riley, Josef Albers—another Bauhaus leader transplanted to the United States—Dieter Hacker, and Francois Morellet figure prominently. The fact that Albers can be placed within the op art tradition as well as in the Bauhaus ideology is confirmation of the connections between the two movements and suggests a similar development within Crane's photography.

Op artists rejoiced in aleatoric combinations as well as in the spontaneous determinism that marked Cage's and Cunningham's dance pieces. Like these two performers, Crane has always been fascinated by the element of time as an aspect of picture making. Barrett believes that op art was the first conscious manipulation of the element of time within pictures. "Instead of building up a set of relationships between elements which can be apprehended more or less simultaneously, it permits the artist to relate visual experiences in a temporal sequence. It has the added advantage that he can work with simple elements; the richness and complexity lies in the possibilities for development rather than their structure at any given time. . . . This in turn permits the element of indeterminacy and randomness."[7]

The *Whole Roll* series and her large murals share with op art the reliance

upon abstraction, hard-edged geometry, a keen sense of scale, and the manipulation of anonymous forms creating a vivid optical effect.

In her *Combines,* Crane utilizes the principle of synecdoche, the part for the whole: an exploding center image is explicated by the repetition of similar tree gestures below. Analogous shapes dominate this series. A found pigeon's wing and a discovered tree are seen in the eerie light of negative printing: the frame on each side of the parade of tree forms is cut through the middle, so the left frame reveals the right side of the tree and the right frame reveals the left. These tensions create two diagonal pulls through the fan shape of the feathers.

Crane has been collecting found objects for more than ten years. They have stimulated concepts dealing with recycling, randomness, open-endedness, and infinity. In *Phantom Image #1* (20″ × 24″) a found object like the shadow of a blurred animal races through an overall pattern of dappled light, an assemblage of thirty frames carefully selected. The illusion is uncannily like looking down at the fleeting shape as if the viewer were on horseback. The stone blocks of *Phantom Image #2,* a montage of thirty-six frames, some of them cropped along the outer edges of the composition, support the shredded branch shapes to create an ancient graffiti on an implacable wall. One of her comments about this series is that she was showing big prints when the fashion was for small, but this pioneering in the large print paid off handsomely in her first major industrial commission in 1975–1976.

Her monumental prints, with their combines, repeats, optical effects, and analogous shapes, found their perfect expression in the sumptuous mural series for the Baxter/Travenol Laboratories Corporate Headquarters in Deerfield, Illinois. Her commission was to execute twenty-four murals utilizing Baxter's medical products as subjects. They were stunned by what they received: gigantic, heraldic combines in which medical paraphernalia were structured into striking decorative patterns. Within some formal patterns was a large centerpiece containing recognizable and often humorous human actions. *Just Married, Bus People, Victorian Assembly, Suspended Boardwalk,* and *Bicentennial Polka* can probably only be appreciated *in situ.* They lose much of their tremendous decorative impact reduced to book-size. In fact, much of Crane's work suffers more than most from loss of scale of the original in reproduction.

Yet even in reproduction, one can feel the vigor of Crane's imagination through photographs of the murals on site and in scale with walls and furniture. The Baxter murals rely heavily upon analogy or what she calls "similar sensibilities" in differing subjects. *Bicentennial Polka* makes the most obvious use of the similarities of diagonals. Crane picks up the rhythm of the sailors' movements forward, the spaces between them, the shapes of their legs, and the intricate triangles produced by their gestures, and ricochets these off the

march of the test tubes. It is heraldic, humorous, and human. *Suspended Boardwalk* floats on a grid of four black verticals, suspended like a billboard sign on a writhing floral decoration composed of dialysis cables. The energy of these repeated units propels two vacationers through their tilting landscape.

In the ingenious superimposition of *Just Married,* the cloud shapes form Rorschach patterns, while the doubling of the Baxter water tower, by inversion, converts it into a repeated surreal hourglass. The frontal plane of the mural seems carved and emblazoned like a mannerist bas-relief in which the absurd one-point perspective of the cars, the scrawled ''Just Married,'' and the floating real sky clouds produce a marvelous visual ambivalence. *Victorian Assembly* is the most optically misleading of all: the abstractions of the repeated isosceles triangles prove to be women seated at infinitely retreating assembly lines. This of all the Baxter murals is the most quiltlike and reminds us that women have long been noted for their outstanding contributions to the arts of weaving and textile decoration.

Indeed, in one of the murals her fascination with the *trompe l'oeil* possibilities of scale and distance creates from granite boulders and waterfall sequences a striking overall pattern rather like a modern tapestry; yet, in close-up, each image reveals all the expected reality textures of the landscapes photographed. The duality of this activity is one of the visual excitements of Crane's work in this style. Another *trompe l'oeil* mural contains matched inverted sets of abstractions created by the serpentine curves of under and overpasses on a highway. Out of these dark and light contrasts evolves an overall gyration of giant butterfly shapes. With the people at the top and the sight-seeing bus at the bottom, *Bus People* offers simultaneously a dynamic design of intrinsic visual interest and a metaphor of road travel.

In all these murals, she creates movement without copying movement, just as op artists do, and as they do, she delights in altering scale. Paul Vanderbilt once gave her a tiny bit of lace: this ribbon finds itself enlarged to the size of a Toltec snake crawling across a surface of lacelike analogies. *Tar Findings* is yet another example of Crane's obsession with shape, form, and texture translated into large-scale icons. Here the push-pull of the micro and macro worlds creates a tension not unlike the surreal floating forms of Yves Tanguy and Joan Miró. Viewed up close, these ''findings''—some of them originally the size of a small fingernail—have the odd texture of elephant skin. They resemble not so much minute drippings of roof tar but peculiar creatures floating in a microscopic slide. In mural size, the tar drippings have much more than visual impact. The textures and shapes are so compelling that we are forced to ''touch'' them with our eyes.

In the Albanian soccer players combine, with its very precise selection of inverted images conning the eye into thinking of reflections, we can find a re-

semblance to the all-over perspective of Eskimo carvings. The Eskimo do not hesitate to carve in all directions, as the Innuit view of reality is nonlinear and interpenetrating. Crane asks us to share this view.

The *Petites Choses* series crashes down from the monumentality of the Baxter murals to the intimacy of images smaller than one's hand. With these repetitions you may begin to ask, "What if yet another one or two units of the design were added, would the effect be substantially altered?" Yes. The units are strictly calculated as to number. But, in fact, not all the *Petites Choses* are exact repeats. With the marvelous close-ups of the eye of a steer, we enter a much more ambivalent realm. Like many of Crane's early experiments with human form, the ambiguity here is deliberate and shocking.

The next group, *Repeats,* offers a Swiss Alps sequence labeled *Crust,* and here the ambiguity ranges from the inversion of forms to metaphors about crustiness resembling good French bread or the jaggedness of a snake shedding its skin. *Dan Ryan Expressway II* slices reality into an hypnotic pattern, which creates out of still pictures the surprising reminder of those interrupted and often unintelligible glimpses we see out of the windows of speeding buses or trucks. Of the *Repeats,* the most sensual and surreal is the series of the boy's hand being licked by a steer's tongue. It has an overtone of unexpected perverseness. The visual oddity depends on the contrast of black background with white arm: it is an arm removed from the person, acting independently and therefore vulnerable. *Zag Zig* is also hypnotic. Lace, fire-escapes, and calligraphic graffiti all join in a syncopation of wiry forms, greatly reminiscent of the notes and pen squiggles Crane makes at concerts.

The *People of the North Portal* series was over a year in the making and should be considered an aggregate of images rather than single pictures to be judged by those arbitrary standards of composition or content traditionally applied. In 1970 and 1971, Crane decided to attempt "a documentary out of which people can draw their own facts," a continuous investigation of visual cues about strangers in a specific setting. The North Portal, a doorway on the north side of the Museum of Science and Industry in Chicago, was to serve as a stage and as a visual constant. Using aleatory principles, she selected the combinations of phototechnics and environmental motives she would use. Changing lenses from day to day, she concentrated now on edges, now on close-ups; on some days she opened the two doors, on others she left one door open or shut them both, so that the people exiting from the museum would have a variety of options for pushing, moving, or walking. For the close-ups, Barbara walked through the doors each time, passing her subjects with the camera focused at twenty-one inches. Here she notes an advantage to being short: the men looked down into the camera and the kids were at her eye-level.

The difference between the near/far images results from her use of lenses of

various focal lengths while standing braced against a column about twelve feet from the doorway. Eliminating the coldest of the winter months, during which Chicago is blasted with icy winds or knee-deep in snow, Crane shot a minimum of twenty-five 4 × 5s each day, with a total of 1,500 shots in this series. She wanted a kind of *Comédie Humaine*. At first she rejected the clowns who hammed it up for her, but later she realized that these actions were as valid a part of her scenario as those oblivious to the presence of the photographer.

The *North Portal* series has been her most controversial work. Angry critics have suggested that she could have simply put an automatic camera in front of the portal and left it there to take pictures at set intervals. But Crane protests that every picture represents deliberate choice: in the placement of the subject, in the options of open/half-open/shut doors, where she was focused regardless of the length of the lens so that she always knew where a subject would land, and so on. Each day offered a choice between potential interactions of people, since she would give one day to shooting only couples, then foursomes, then only women together. She was always relating the activity at the edges of the picture with the central activity and always sought the same kind of "layering" effect with people as she would shortly use with architecture. She harnessed the unexpected, made distinct editing choices. She did decide to border these pictures in black, perhaps the least successful aspect of these otherwise striking images. Generally, one suspects that the virulence of some critics' objections really arose from their ideological rejection of chance as an element of art, making Crane by no means a unique object of misunderstanding and rejection. We must remember that even so great a master of the "chance witness" photograph as Garry Winogrand has been excoriated for his approach to picture making.

In that respect, it is surely surprising that one of the most respected camera workers of our era, Ansel Adams, himself the very model of artistic choice and precise preparation for compositional perfection—in other words, the antithesis of the aleatory artist—has proved one of Barbara Crane's staunchest suppporters. Not only has he purchased her work, but he has invited her repeatedly to teach at his own workshop at Yosemite. Adams has encouraged Crane since their first meeting in 1968, and has commented most appreciatively on her vitality and the excitement she brings to students. Ansel Adams is the rare example of a photographer who has risen above arbitrary and limited ideologies of photography, and Crane has greatly benefited from his friendship and constancy.

Between 1972 and 1979, Crane worked for the Chicago Commission on Historic and Architectural Landmarks as a part-time photographer with a yearly contract. She had long been proficient in straight black-and-white photography, and the director of the project was seeking someone who would be compatible. Crane remarks, "This is true of all photographic jobs. It isn't just

what you are as a photographer, but whether people feel they can get along with you.'' No prima donna, Crane's relation with the commission ended only when she felt she could learn no more from continuing that kind of work. But perhaps it was inevitable that the architectural commission would now lead into a new, much freer experimentation with form.

The city walls series, now called *Chicago Loop* series, came after she produced a giant mural for the Chicago Bank of Commerce in the Standard Oil Building. In this twenty-six foot mural printed from a film collage of images of the renowned Chicago landmarks, we find the leaven of the scattering pigeons—eternal proof of the survival of urban fauna. As a reaction to the complexity and hard physical labor of the mural, Crane began to believe she had reached a point where she could only fabricate pictures. To prove to herself that she could still conceptualize and carry out a project of large single-image contact-printed pictures, she gave herself the task of making ''design'' pictures of city walls, with a center division or midhorizon line as unifying aesthetic conditions. In these pictures, the skyscrapers loom in militaristic hubris, as Vincent Scully puts it so well, yet they are always compressed by Crane into obedient patterns through which the urban energy emerges. Audaciously, she crops a serpentine front so that the edges of the curving building fool the eye into thinking the print itself is curved. She waits for the decisive moment when just so many window blinds will be open or shut, and wonders what human agency has performed this mystery within a totally anonymous structure. She wonders; but perhaps these photographs do not invite us to do the same. The mind is too rapt in a Chicago Boogie-Woogie.

As the people rush with the buses toward unstated destinations, they are eclipsed by bridges and buildings. The sky thrusting down between the giant edifices resembles a sharply clipped hole in a dense cloth. The cross-bars of new construction offer no promises of rosy urban futures, but of more and more congestion, blocking movement, inviting defensive actions like putting your arms in front of your face to protect yourself. It is an odd relief to come to the bizarre fabric rendered by wrecking ball, a facade crumbling as if in an earthquake, with no implication of sorrow or loss. It is a relief that we ourselves can destroy what has begun to resemble an impenetrable concrete prison. In a street scene, two clumsy pylons, one in shadow, one in light, mirror each other but foretell different destinies. They are two blind sentinels brooding over the oblivious pedestrians and the drivers who must obey no-left-turn signs and other imperious dicta. The strong central vertical, so popular with many contemporary photographers, here seems a logical outcome of Crane's continuous experimentation with dualities, especially with half-frame and split images.

Crane insists on a personal and artistic balance between more formalistic en-

terprises and projects that bring her closer to casual humanity, choreographing the latter according to the laws of chance. Naked flesh, the sunburned leg, the greased arm, the innocent pleasures of dancing to music by portable radio, the beach snapshots, the outlandish outfits, the park pictures radiating a late afternoon self-awareness epitomized by one strong-minded old woman asserting her territory with basketball, picnic jug, purse, shoes, and striped kerchief: but these pictures are not meant to be viewed individually. For Crane, they represent parts of a whole pursued for six years, between 1972 and 1978. The sum was to be greater than the individual pictures, and that expectation raises specific critical problems.

How are we to judge the *Chicago Beaches and Parks* series? Or any series like it, by any photographer? Are they pure storytelling? Conscientious social documentary? *Just* chance? Romanticizing invasions of private lives? Take, for example, the image of the glassy-eyed blonde with long hair who sits on the park grass, legs outstretched, arms forming a strong V over her knees. Beside her are two children looking off in the opposite direction. On the next plane, an elderly couple seems tied to the earth by long shadows, which also cool their resting dog. Beyond, another couple walks out of the picture carrying picnic paraphernalia, and still other couples and singles dot the remote landscape. *La Grande Jatte* by Seurat, with a dash of Cartier-Bresson? A can of Coca-Cola juts up beside the blonde. It holds the picture together like a beacon: a symbol of popular culture or simply a strong chunk of verticality exactly where it was needed? This is perhaps the best of the park pictures; it has all the solidity and serenity of a Courbet.

These pictures at beaches and parks were accomplished through the social prestige of the press camera. It somehow persuaded her potential subjects that she was no Peeping Tom, no intruder, but a legitimate newspaper or city photographer recording Sunday activities. As we all know, the press camera viewfinder is hardly a precise instrument. Crane finds this an advantage, another opportunity for chance to keep the picture "loose and lively." This feeling of spontaneity, she believed, would help achieve a positive, life-affirming mood.

When Crane cuts in close to her beach figures, she achieves a welcome note of intimacy, an antidote to her urban *angst* of the skyscrapers. Her two dancing Hispanics interlock their negative/positive shapes with the precision of a jig-saw puzzle, but with beautiful tactility. The naked belly exudes both energy and relaxed pleasure. Most poignant of these pictures is an evocative Hispanic trio, mother squashed within the father's embrace, while their long-haired child plays with pebbles on a bleak wall. Far off looms the ghostly silhouette of a harbor beacon on a triangular support, obscured by haze. The painful isolation of this trio is both social and emotional.

One or two of these beach and park pictures verge on sociological cliché, as

in the shaved-headed black man with the mod glasses staring at a white woman's white bikini. The cliché is of subject, not of formal expressiveness. And the harshness of this scene is offset by the tender interplay of another black man serenading his sweetheart on his guitar while she suns her naked white back.

Headless, garish, a monumental, one-armed kitsch goddess in a satin black bathing suit concludes this series. Who sculpted this cropped ruin of a body? And is the descending hand hers or a return of the omnipotent hand descending from the top of the opening frames in Maya Deren's *Meshes of the Afternoon?* Even as Crane seeks intimacy here at the beaches, relief from preoccupation with form, her formal sense is so powerful that it sometimes creates surreal monsters. If you stare too long at the black arches of the bathing suit as it carves out the woman's legs, then at the super-reality of the hand's nail polish and bulging veins, you may feel as if this kitsch goddess is ominous and eternal, an antique anomaly erected on the beach by reincarnated pagans.

Now the slight photographer plants herself boldly in the midst of the commuter rush in late afternoon, permitting her super-angulon lens—a 21mm on a 35mm camera—to fill the frame with the crush of the on-coming hordes. She is too short to be able to photograph both the shadows on the ground and their faces. What she seeks is some revelation in this surge, and she rapidly discovers that she needs adjoining frames and half-frames to communicate this sunburst energy. Once again, it is not the individual pictures she desires, but an aggregate, almost a sociological compilation. Sociology might be the best analogy here, for these pictures of the *Commuter Discourse* deal with the faceless masses and statistics, which are quite different from the social psychological interests of, say, the *People of the North Portal*. It was the unpremeditated purchase of the lens that inspired the series: she needed a subject that could take maximum advantage of the sun-burst effect, a subject that would give her edge-to-edge forms and sufficient complexity to warrant such great depth of field.

To go from Chicago to Tucson requires considerable readjustment. Not to the new environment of heat and dust. What requires the adjustment is that now Crane is working in a new medium, Polacolor, and she has had a year of support from the Guggenheim Foundation to investigate this color process. She is bold as usual: 8 × 10 Polacolor II is an indoor medium; Crane proposes to use it outdoors. Her first efforts present us with indefinably repulsive shapes, the found objects of her new environment, saguaro ''boots,'' parts of huge cactuses hollowed out by desert birds. The saguaro boots are like cadavers with desiccated flesh, an effect obtained by deliberately overexposing the film to bleach out its normal intensity. Someone gives her a rabbit; it dies, a taxi-

dermist treats it, Crane forces us to see its crucified remains. She is using an ordinary cross-wired fence to hang these objects, automatically assuring herself a decorative unity with both cruel and indifferent connotations. A burnt tree limb, glowing with tar, rests on the fence, a gruesome paleolithic club. Something about the new environment is causing her to see only angry images at first, images unfortunately not illustrated here.

Then she gains mastery of the medium and the color work becomes astonishing. Tucson's searing sun has not obliterated her fascination with found objects. But now these become opportunities not only for formal ideas but for very personal biographical notations. For the first time, perhaps under the influence of the casual southwestern ambience, Crane is permitting herself pure biography. She photographs her own notes to lovers; she worships a flamboyant leather vest. She rises at dawn, however, to pursue the formal exercises of a series of funerary crosses, seeking the pink-rosy colors to match the fading paper flowers.

Another series demonstrates how she has conquered the small Polacolor format. Seen from the back, people move through a country fair, flashing brilliant suspenders, clutching stiff blue overalls and red shirts. The choreography of intimate gestures seems so much more sure and joyous now that she has color to articulate form and rhythm. It is an unusually sure leap from one medium to the next, but of course Crane has been using phototechnics to her advantage all of her career.

In the small Polacolors, she explores touch: hands crossing, a boy's fingers affectionately and possessively tucked into the back pocket of his girlfriend's jeans. A marching band struts away into perfect one-point perspective under a gale of flags. In larger formats, she turns from spontaneous gestures to more formally organized diptychs and triptychs, seeking the pulsing energy that imbued so much of her previous work. She finds her way into the mysteries of nopal and organ-pipe cactus and makes of them both icon and totem. One nopal pod fills the frame, dazzling us with the conversion of its needles into gold or silver dots.

These new experiments with color only verify Barbara Crane's immense versatility, her energy and boldness, her inventive imagination, and her professional expertise, her playfulness, and her visual wit. Surprisingly, these attributes have not always served her well in the marketplace, where artists forever discover they are expected to produce only *one* immediately identifiable product. Not surprisingly to those who know Chicago, it has not served her well to be specifically a Chicago artist. For Chicago has the misfortune to be located in a totally imaginary prairie limbo between chic East and mod West, a presumed vacuum where few art critics venture and where a regional paranoia about national neglect is understandably raging. It is a paradox almost beyond

comprehension that a glittering metropolis, offering even the most casual visitor stupendous vistas and breathtaking architecture, not to mention several of the world's most significant intellectual and artistic centers, should nevertheless suffer from a gigantic inferiority complex. It appears that wealthy Chicagoans tend to rush to New York or Los Angeles for their patronage of the visual arts, cavalierly ignoring their own immense regional talent.

The term *regionalism* is one of those red flags of criticism that tend to obscure more useful issues. To be sure, there was Chicago jazz and New Orleans jazz and New York jazz, but the similarity of these regional musical styles is far greater than their dissimilarity, particularly from the distance of several decades of other, completely different forms like swing, progressive jazz, and rock, So, too, in the visual arts there are certain similarities of coloration, selection of formal elements, and even energies that can be allocated to different regions. Chicago artists can be accused of sharing the same motives of skyscraper and lake, commuter and shopper, city walls and street bustle. They can even be accused of sharing the pervasive influence of the Institute of Design, which not only attracted artists of similar sensibilities but subjected them to the same rigorous training, an education that left its mark on all its adherents. The question of regionalism inevitably raises artificial issues about who did what first, always creating the false assumption that the artists who inhabit a specific region are looking only to each other for inspiration.

Arguments about precedence are impossible to resolve in any case, yet this is an appropriate moment to consider what the aesthetician Morse Peckham calls "cultural convergence."[8] At certain times in history, similar ideas emerge almost simultaneously from different individuals who know nothing of each other's work but who have been exposed to similar intellectual, scientific, technological, and artistic currents. Famous examples are Darwin's theory of evolution, Bell's invention of the telephone, and art movements like romanticism, impressionism, and dadaism. Since there may be no reliable method for distinguishing unconscious influence, educational affinities, or conscious imitation from cultural convergence, the important issue becomes the significance of the images produced, no matter where or by whom.

Certainly, artists cannot be forced to deny their own time and place—even if this were humanly possible. Even Shakespeare can be found to have been embedded in a very Elizabethan theatrical milieu relying upon previous writers for subject matter and dallying with typically sixteenth-century dramatic conventions. It is the significance of Shakespeare's accomplishments that we judge him by, not by unrealistic notions of total originality. To apply the misnomer of "Chicago artist" to Barbara Crane, in the sense that this implies regionalist limitations, would be a serious condemnation of the politics of

photography. As George Kubler observed in his dazzling tour-de-force, *The Shape of Time: Remarks on the History of Things,* "Every important work of art can be regarded both as a historical event and as a hard-won solution to some problem. It is irrelevant now whether the event was original or conventional, accidental or willed. . . ."[9]

Crane's ceaselessly experimenting imagination has seized every available means—original or conventional, accidental or willed—to achieve complex, haunting images. Yet, as Kubler also remarks, "history is unfinished business."[10] Her creative and personal history are surely Barbara Crane's "unfinished business," with much still to be performed and much yet to be discovered.

From *Barbara Crane Photographs 1948–1980* (Tucson: Center for Creative Photography, 1981).

The Optical Fantasies of Barbara Kasten

The rhythmic law of constructive counterpoint, contained in a creative masterpiece, sets into motion life itself, through a rhythm displayed between harmonies and the contrast of color and form. WASSILY KANDINSKY

THEY ARE THEATER, SCULPTURE, painting, light play—all masquerading as photographs. They are obsessively perfect, complex, imaginative yet completely controlled. They interweave colors saturated with light and light creating color on mirrored scaffoldings—illusory, sometimes perverse, unpredictable, requiring a visual response as intense as her own, demanding a clearing of the spectator's mind prior to surrender to her majestic polyphonies; yet they are instantly pleasurable. They are everything Wassily Kandinsky swore was the science of art and László Moholy-Nagy speculated was the future of color photography. They are marvelous, visually stunning ordered universes tinged with a brooding metaphysic that claims mystery and fascination as ultimate goals.

Barbara Kasten has mastered many media, in the true tradition of the Bauhaus ideology that viewed every material and each medium as artistically potent. She fabricates, or has constructed for her, all the objects in her photographs: painted black rods, half-moon mirrors, elongated pyramids, cones and spheres, cut-paper forms serving as light modulators. Occasionally she adds a found object, an architectural unit—a white column, part of a balustrade, a magical black object that might have been an ornate chair leg. With these she creates a mood of contemplative nostalgia not unlike that created by Giorgio De Chirico's juxtapositions of the antique with the modern.

For all her obsession with constructivist organization of fundamental shapes, it is photography that makes the ultimate image not only effective but possible. Staged on seamless white, the constructions themselves resemble the photographs only in so far as they present the elements to the camera, much as a proscenium presents the actors to the audience. Lens and film together coalesce Kasten's optical fantasies into an artifact. *Fabricated to be photographed* is the essence of her current preoccupations, but the fabrications are as important to her as their final record on film. Deeply attracted to constructivist theater—we recall that Moholy-Nagy was a consumate stage designer—Kasten frequently exhibits her constructions and sculptural environments to be enjoyed for their own sake. She masterminds these displays with the awesome preci-

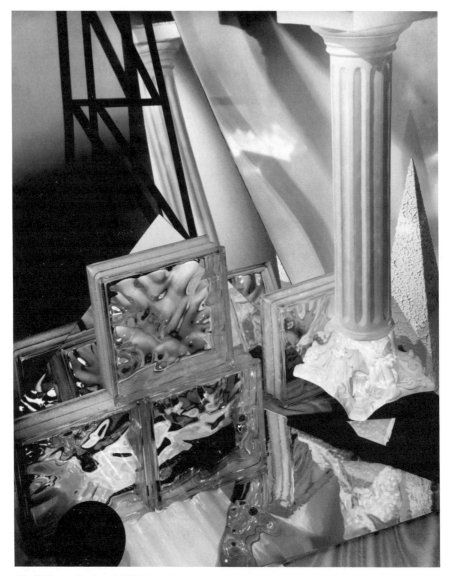

28. Barbara Kasten. METAPHASE 1, 1986.

sion of a theatrical director. Eventually she wants to work with dancers in a setting of her own invention, much as Isamu Noguchi worked with Martha Graham.

Kasten has not always been interested in photography, although she knew as a child, after she had lessons at the Art Institute of Chicago, that she wanted to be some kind of visual artist. She began as a painter, with a B.F.A. from the University of Arizona at Tucson, where her family moved when she was eighteen. Subsequently, she worked in fabric and fiber, with soft sculptures blossoming out of bentwood chairs; one humorous example transformed a red chair into the ankle straps of a bulbous, open-toed shoe.

In 1968 she began graduate work at the California College of Arts and Crafts in Oakland. There she studied with Trude Guermonprez, a master weaver. Guermonprez was also a dedicated Bauhaus disciple, and Kasten had already recognized that the Bauhaus approach to artistic creation, in which experimentation with materials constituted a kind of transition from painting to architecture, matched her own interests. After teaching a semester at UCLA, her work with soft materials culminated in a Fulbright-Hays Fellowship in 1971–72; she used it to study in Poland with the fiber artist Magdalena Abakanowicz.

When she met and married Leland Rice, a California photographer and teacher, her fascination with Bauhaus photography crystallized. Together they collected outstanding Bauhaus prints, and Leland curated an exhibition of Moholy-Nagy photographs at Pomona College. Moholy-Nagy, the founder of the ''New'' Bauhaus—the Institute of Design in Chicago—was becoming a significant influence on Kasten, especially in his revolutionary concepts about light: it was no longer to be considered, as Moholy put it, ''an auxiliary medium to indicate material existence'' through chiaroscuro. ''The aim is to produce pictorial space from the elemental material of optical creation, from direct light.'' He demonstrated the artistic potential of direct light in his many ingenious photograms—cameraless prints produced by placing various three-dimensional objects directly on light-sensitive papers.

Kasten's first experiments with photography were with photograms created with blueprints, fabrics, and finally photosensitive canvas. As she explained in a 1982 interview with Constance W. Glenn on the occasion of her *Installation/ Photographs* exhibition at California State University, she constructed settings to photograph and used ''4 × 5 Polaroid negatives to project geometric images.'' At that point she was interested in the ''rigid geometric content of the work of Al Held, Sol LeWitt, Sylvia Mangold, and Dorothea Rockburne.'' Then her involvement in actually working with the materials, the space, and especially the illusion of space created for the camera made a dynamic change in her approach to her work. She had never actually used a camera until she

began to record her constructions using an 8 × 10 camera and Polaroid Pola-
color ER Land Film Type 809. Now the camera was to become the primary
factor in her thinking about her constructions.

Kasten then began to make large-format images with the Polaroid 20 × 24
camera, ultimately using the 8 × 10 as a preliminary stage for the production
of Cibachrome prints. She finds the physicality of the surface of Polaroid
prints "luscious" and is delighted with the kind of "etched line the layered
emulsion gives you." Kasten feels Polaroid materials permit her "a working
dialogue with the sculpture," adding "the color of the 20 × 24 prints is gor-
geous." With her intense need for perfection of geometric form and color, she
depends on the instant feedback to make adjustments in the illusionistic stage
settings.

Kasten's method of working with color is probably unique. Using colored
gels over tungsten lighting, she carefully arranges scrims and light modulators.
She does not make multiple exposures; instead, she opens the camera shutter
and then shuts off the lights in a predetermined pattern, achieving simulta-
neously control of the overflow of colored light and "intensity of color and
balance." Each color is given different exposure lengths, with red demanding
as much as ninety seconds. Over the past decade, she has acquired a formida-
ble knowledge of the characteristics of light, pursuing research both directly
and through extensive reading. She has likened her mastery of strobes, gels,
and sequential exposure to the activity of painting. When she mixes light to
create a specific effect, she feels that she is actually painting with light. Cer-
tainly her most recent prints are saturated with color, radiating combinations of
light that are far more intense than any oil or watercolor painting could pro-
vide. The fact that most of the objects in her constructs are essentially gray
makes the final result all the more exceptional and astonishing.

There are many critical issues implicit in any evaluation of Barbara Kasten's
photographs. The fact that her constructions are fabricated to be photographed
is at odds with a prevailing strain of purism in photographic ideology that in-
sists only natural realities—landscape, people, street activities—rather than
imagined and conceptual realities are the appropriate subjects for the camera.
One critic even went so far as to describe Kasten's images as "specifically
anti-humanist in their concentration on the stagecraft of geometric form." Kas-
ten, to the contrary, considers her abstractions to be profoundly humanistic in
their play of forms.

It is true that she would seem to be following the prescription offered by
Moholy-Nagy in *The New Vision,* where he claimed. "Not the representation
of an object, or even of a feeling, is the real problem here, but the sovereign
organization of relationships of volume of material, of mass, of shape, direc-
tion, position and light. Thus a new reality emerges." What has to be remem-

bered is that this new reality was endowed with a Neoplatonic and Pythagorean ancestry in which the divine presence in the world is revealed through two languages of abstraction: geometry and mathematics. That number and proportion, rhythm and repetition (which have numerical analogies) are among the fundamentals of aesthetic experience has long been recognized by visual artists in all media, as well as by composers and performers. Indeed, the poet-critic Baudelaire insisted that "*All* is number. . . . Ecstasy is a number!"

To counter objections to abstraction, Moholy-Nagy mocked what seemed to the moderns to be the visually exhausted tradition of narrative representationalism, saying, "The 'spiritual' factor lies no longer in the reproduction of outlines filled with 'life,' but in the effect of the relationship of elements." Like Kandinsky, who wrote passionately of the emotional effects of color as well as of the presumed psychological effects of geometric forms (and who, by the way, was as profoundly mystical and idealistic as any of his Bauhaus colleagues), Moholy-Nagy believed that art is intrinsic to human life, art is in the service of life; abstract art, arising out of the marriage of art, science, and technology in the early twentieth century, sustained and invigorated life. Abstraction, devoid of clichéd subjects reeking of literary content, was the pure path to transcendental, spiritual experience, the highest value of human life.

Kasten admits to having fought the idea that "my work might be beautiful," for beauty seemed antithetical to her primary purpose: to enhance perception, to open new visual avenues of exploration to the viewer. While accepting, finally, that people who enjoy her photographs might exclaim about their "beauty," she continues to view her approach to art as "research." She has by no means pursued a hermetic artistic career. Her grants include a Fulbright-Hays Fellowship, a Guggenheim Fellowship, and a National Endowment for the Arts grant for a 1980–81 project to produce videotape documentaries of senior women photographers. Her interest in video is not new, and as she is fascinated by movement as well as by stasis, she has experimented with filmmaking. Her project with women photographers—among them Florence Henri, Louise Dahl-Wolfe, and Lisette Model—involved her with questions of her own growth, an experience for which she remains grateful. With massive amounts of unedited tape waiting for the time and funding to complete the video program, Kasten remains hopeful that the finished project will help other women to grow and understand themselves as individuals as well as artists.

When I visited Barbara Kasten in her current New York studio, I was struck by the contrast between the outward environment of Canal Street on the fringes of SoHo with the studio itself. The street was visual chaos: smeared cardboard, orange peels in the gutters, worn and greasy cobblestones, cartons

crammed with refuse from nearby manufacturing lofts, junk littering the side-
walks. Her studio was a haven of order: clean, neat, light, quiet. The street
wallowed in urban desperation; the studio offered a welcome optimism. It was
a Bauhaus kind of optimism, an approach to life that did more than suggest: it
demanded reordering priorities, redesigning environments. It was an optimism
some say emanates today from sunny southern California, where Barbara Kas-
ten lived for more than a decade. Now, however, she says she wants to think
about working on a larger and larger scale, in total theater, on stages where
her optical fantasies can be realized in monumental form. Her intense pursuit
of perfection, coupled with an ever-expanding sense of visual drama, will un-
doubtedly require such an ultimate display.

From *Constructs: Barbara Kasten* (New York: New York Graphic Society and the Polaroid Cor-
poration, 1985).

Mysteries and Transformations
THE ART OF CARL CHIARENZA

IF YOU COULD LOOK into a kaleidoscope that revealed the major facets of Carl Chiarenza's career, you would find recurring motifs and transformations. Music would metamorphose into photography. Spiritual search would coalesce into image making. Dark nights of the soul would shift into exuberant joy. Chance and discovery would intermingle with formal certainties. All these, however, would be dominated by the enigmatic and mysterious landscapes he expresses in the chords of blacks, grays, and reflected whites of his superb prints. For Carl Chiarenza is obsessed by the changing landscape, the poignant transformation of nature into urban and technological environments.

There are many other facets of his distinguished career. He is an art historian who has contributed significant publications on the theory of photographic images and their relationship to painting. He is a much revered teacher of the history of photography and visual art. His prints adorn the collections of major museums and private connoisseurs. As one of a group including Paul Caponigro, Walter Chappell, and Nicholas Dean, he was among the first to test the artistic potential of new Polaroid films. Chiarenza's critical essays, reviews, and reprints of his lectures are widely read and anthologized. In short, the present American scene in photography and education in the visual arts probably would not be the same without him. This first substantial monograph on his work has been long overdue.

BEGINNINGS Born in Rochester, New York, on September 5, 1935, Chiarenza is a first-generation American of Sicilian parentage. In his childhood, the Sicilian population of Rochester suffered the usual fate of recent immigrants. Carl recalls being made to feel like a second-class citizen. His father, Charles, earned his living as a cabinetmaker. His mother, Mary, was a gifted seamstress employed by a fine men's clothier. Mary was also a strict Roman Catholic, with an obsessive concern for the health and safety of her four sons. Her husband was a loner, an artist manqué who painted nudes, propagandistic urbanscapes, and mythical subjects after Dante. An idealist and utopian socialist, he hated priests and all organized religion. Carl went through all the ap-

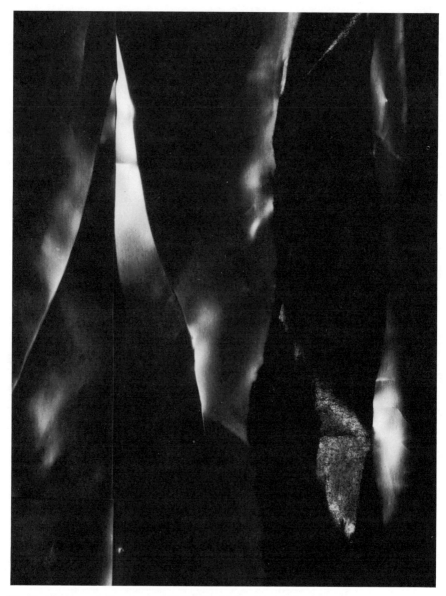

29. Carl Chiarenza. *Noumenon 247* (detail of triptych), 1984–5.

propriate rites of Catholicism, including confirmation, but he was thoroughly disillusioned by the discovery that priests were only human.

Carl recalls two seemingly trivial incidents. Visiting the rectory one day, he discovered the priests eating meat on a Friday at a time when church dogma insisted that only fish could be consumed. Having quit religious instruction, he was pursued home by a priest who wanted to inquire why he was continually absent. Noting several of his father's paintings of nudes hanging in the living room, the scandalized priest commented on the deleterious influence the parent was obviously having on the son. Whereupon his father threw the priest bodily out the front door. To Carl, these incidents symbolized a loss of a comforting faith. That loss has haunted him. Much of his subsequent life has been spent in a search for a meaningful spirituality. Certainly, if his father's secularism seemed a healthy balance to his mother's insistent religiosity, the young boy was left with the difficulty, often unconscious, of having to reconcile two powerful and contradictory ideologies.

Despite constant squabbling between the parents, the Chiarenza family was united by a passion for music. It was perhaps the only religion they shared, as each Saturday afternoon they would gather to listen reverently to the Texaco broadcasts from the Metropolitan Opera. Father Chiarenza played the mandolin and guitar with gusto; Mother and all the boys sang. (One brother had such a good voice that he was about to depart for an audition with Beniamino Gigli, a famous Metropolitan Opera star, when he was drafted into the army.) By the time he was eight, Carl was taking lessons on the clarinet and added the saxophone later in high school.

Not only did all the Chiarenzas love music, play instruments, and worship opera, but they also painted, drew, and designed. It was an intensely artistic family, yet the father was adamantly against his sons pursuing any career in the arts. He knew all too well the practical problems of supporting oneself as an artist. There were strenuous arguments about careers. Typically for immigrant parents of that generation, the emphasis was on careers that would make substantial amounts of money. Torn by a desire to please his father, young Carl nevertheless rejected any notion of becoming a doctor or lawyer. He was persuaded that his own calling was music. The constant turmoil of the family drama laid the groundwork for Carl's temperament to be forged into a passionate and despairing cynicism, an attitude he later enjoyed in the writings of H. L. Mencken, a journalist and essayist of a singularly acerbic disposition. It has been said that only an unabashed idealist and romantic can become a cynic. Idealist and romantic that Carl was, the defensive shell he erected against the harsh realities and disappointments of living never managed to obscure his essential sweetness, gentleness, and spirituality.

Carl was active in grammar school and high school bands and orchestras. Later, he managed to pay his way through the Rochester Institute of Technolo-

gy playing jazz for college dances. He worked in small combos as well as in big bands, in the Stan Kenton style of the 1950s. At the same time, through an accident of destiny understandable for anyone born in Rochester—home of the enormous Kodak enterprises—he was also becoming more and more intrigued with photography. In his eighth year, Carl had the curious fortune of receiving both a clarinet and a camera. The director of a playground he frequented encouraged his photography when he put together a darkroom for the neighborhood kids. His father's brother, Anthony, a painter, illustrator, and decorator, gave him an excellent lens for a Speed Graphic camera that Carl had purchased secondhand, and introduced him to the more complex rituals of darkroom practice. He even helped Carl build his own enlarger. Then, in high school, he took a photography course. Soon he was the newspaper and yearbook photographer. He wrote for the newspaper, too, took the advanced English writing course, and began to recognize his love of words and ideas. For all its raptures, music, which remained supremely important to him, did not offer a life-style he was willing to pursue. He envisioned a future as a writer, artist, and photographer.

Since he was keenly interested in image making, and since he knew he would shortly have to earn his own living, Carl decided that the practical courses at the Rochester Institute of Technology would satisfy both needs. Over the initial objections of his parents, he applied to RIT, was accepted, and embarked on what he thought would be an uneventful two-year associate degree program in applied science.

UNEXPECTED ENCOUNTERS In 1953, all RIT students had to take the same fundamental courses whether they wanted eventually to pursue careers in science, optics, portraiture, illustration, or photochemistry. During his first two years, Carl studied sensitometry, lighting, dye transfer and other color techniques, advertising setups—all subjects intended to give him a firm ground in professional practice. What he had not anticipated was that the institute was in the process of formulating a new curriculum program that would lead to the bachelor of fine arts in photography.

Initiated by Ralph Hattersley, an inspired teacher with decidedly unconventional methods and goals, the program managed to acquire the influential presence of the photographer Minor White, who had arrived at George Eastman House only the year before. White's charismatic personality offered an approach to artistic image making that went straight back to Alfred Stieglitz and the early Paul Strand. The essence of the approach was that the photograph was an independent entity free of simple representational values. Like his personal god, the awesome Edward Weston, Minor promulgated the belief that photographs were to be looked at not for what they were, but for what else they might be. Stieglitz had established the Equivalent, a concept about the

metaphoric content of a picture, and White expended much energy in trying to illuminate what the idea of Equivalence might include. If he did not entirely succeed in this ambition, he firmly demonstrated that photography could engage in symbolism, metaphor, and mystical resonances. His images, mysterious and enigmatic as they were, always connected to nature, a nature viewed as Mallarmé expressed it in his theory of correspondences taken from Swedenborgianism. As Jonathan Green, a noted photographer and historian, put it, "every fact of visible reality corresponds to a fact of mental or spiritual consciousness."

Minor was still exploring the potential of the teaching methods that later made him such a controversial figure. At the same time, he was searching for a spiritual center to his own life. He was demanding, sometimes irascible, profoundly moving, difficult. Unlike many of his classmates, who found Minor's exercises in "reading" photographs irritating and exhausting, Chiarenza often enjoyed being forced to study a single photograph for two hours at a time. One of Minor White's aphorisms, set down as early as 1955, made a permanent impact on him: "Photographing is the transforming art of the photographer." Carl was making his own discoveries along these lines, to the effect that it is in the very nature of the medium of photography to be transformative. The phenomenological world is transformed into the artifact; nature is transformed into picture. Chiarenza would later devote much of his intellectual energy into investigating the implications of such transformations.

In his own way, Ralph Hattersley was far more innovative than Minor White, although, like White, he was intent on shattering his students' stereotypical responses to photography. As Carl reports, Hattersley once hired a nude model and, among other strange settings, wrapped her in ropes for the students to photograph. At other times, he could counter White's insistence on the straight, beautiful print, insisting that they deliberately try to make muddy images just to see what would happen to form and value. Hattersley took groups of students on exciting field trips, to New York City, to meet famous *Life* photographers and fashion greats like Irving Penn, Richard Avedon, and Alexey Brodovitch, later Diane Arbus's mentor. The students even went to Chicago's Institute of Design, where the Bauhaus influence of Moholy-Nagy had created a center of modernist art.

Many students in the program felt like guinea pigs as they were bounced back and forth between Minor's fervently mystical sessions and Ralph's surprises. Yet Hattersley was nothing if not a mystic himself. Later, in Minor White's publication called *Octave of Prayer* (1972), he wrote, "A great many people are aware that in some mysterious way photography is a kind of religion for them. They would not express themselves in such words, of course, nor would they equate photography with say, Christianity, Buddhism, or Vedanta. Nevertheless, photography has come closer to being a religion than any-

thing else they've ever had.'' For all that Chiarenza occasionally found Minor's emphasis on the spiritual somewhat excessive—"we were trying to figure out how to make a living"—it seems inescapable that he found Minor's approach and the observations of Hattersley very close to his own soul. One could even venture to say that of all of Minor's famous students who were at RIT when Carl was there—Kenneth Josephson, Jerry Uelsmann, Bruce Davidson—it is Carl who, consciously or unconsciously, remained the foremost exponent of Minor's philosophy in his own images, without incorporating any of Minor's life-style, his need to be a guru, or his imposition of his opinions on others. Looking at Carl's images, it would seem that he has tried always to answer some of the questions Minor posed: "How far can camera work go toward making manifest the invisible? That is its work, but how far can it go? How much can camera bring to others of my own experiences of light and darkness, Christ or Lucifer?"

Both Minor White and Ralph Hattersley made lasting impressions. But they were not the only influences on Chiarenza. In fact, he claims that Robert Koch, a professor of English and American literatures and creative writing, may have made as profound an impact. Koch, a warm and sympathetic individual, had long discussions with his classes on the nature of both written and visual languages. He inspired Carl to investigate the relationships between these two forms of expression. Minor, of course, was also interested in such relationships, especially in the way that what he called ''Sequences'' reflected a similar structure to narrative form and poetic phrasing.

Carl was also much impressed with what W. Eugene Smith was doing with his photo essays in *Life,* with a style of photojournalism that was not only different from what appeared in the daily newspapers but that often reached profound emotional effect. It was particularly Smith's use of black as color, evoking both mystery and dramatic mood, that Chiarenza sought to emulate. Later, when he came to do his master's thesis at Boston University, Carl produced an essay, ''City Hospital,'' which revealed his burgeoning love of richly complex images based on black. He still reveres Gene Smith.

Beaumont Newhall, then director of George Eastman House, came over to RIT to teach a course in the history of photography, which Carl attended with interest. Beaumont's wife, Nancy, had written an article called ''The Caption,'' which appeared in the first issue of the journal *Aperture,* begun in 1952, and edited by Minor White. With Minor's approval and under his supervision, Carl produced his RIT thesis as a direct response to Nancy Newhall's article. His thesis was called *Interaction: Verbal/Visual;* its visual subject was aspects of railroads. Relying heavily on synecdoche, Carl created a series of poetic images of parts of wheels, railroad cars, and the technological detritus that accompanies rail transport. ''I loved the railroad and I loved sequencing,''

Carl comments. The thesis was a handmade and hand-bound book; it exists in three copies, one of which is at George Eastman House.

Minor was clearly impressed with Carl. For many years afterward, Carl's photographs were reproduced either within the pages of *Aperture* or as a feature of its back cover. Carl's writing also appeared in *Aperture*. One early essay, "Stereotypes: Barriers to the Experience of Photographs," however, proved to be a turning point in their relationship. Minor accepted the essay with enthusiasm, yet when it appeared Carl discovered that more than half of it had been cut without Minor's having consulted him. He still recalls the incident with bitterness. It seemed more urgent than ever to remove himself entirely from Minor's overwhelming influence and to find his own way. Minor had been such a force in his students' lives that many continued for the rest of their careers, and the rest of his life, to be intimately connected with the guru. But while Carl and Minor continued to have cordial relations, the younger man was determined to achieve artistic and personal independence.

"It is impossible to isolate exactly what Minor did for me," Carl has commented. "But two things seem clear: he provided support for a belief in the photograph as an object worthy of intense effort in the making, and in the photograph as an object in and of itself, apart from anything else in the world, that could be as expressive as music, poetry, or painting in relating the individual to the world." Purely on formal grounds, any study of Chiarenza's brooding prints reveals not only mysteries that Minor White could have approved, but transformations that are not dissimilar to several of Minor's ideologies and pictorial strategies.

If one were to construct a litany of transformations evident in Chiarenza's work and developed with content far different from Minor White's, that litany might be:

Transforming the accidental and chance into composition and formal structure
Transforming the biomorphic and geomorphic into passionate visual music
Transforming the horizontal reality into vertical pattern
Transforming the jagged, brutalizing detritus of a technological civilization into negative/positive spaces of a beauty reminiscent of Oriental painting
Transforming texture, reflection, shape, modulations of three-dimensions, into mystery and enigma

Where Carl's transformations differ most radically from his early mentor's are in their commentary on urban landscapes, rather than on what Carl calls the "unmolested landscape" of the countryside. His most recent works, of the past five years especially, have become more and more different from anyone's else's, richer, more symphonic, with a confidence in his own personal visual language.

NEW CONNECTIONS In 1957, Carl Chiarenza had his B.F.A., a circle of friends he had met in Rochester, and no job prospects. Offered a fellowship as a teaching assistant, with a stipend, in the photo lab at Boston University, he accepted with alacrity. A master's degree in journalism seemed a reasonable route to gainful employment, something he could pursue without compromising his creative work. Unfortunately, the program deeply disappointed him. It seemed hardly the environment for a would-be Mencken, Ambrose Bierce, or W. Eugene Smith. Yet during the two years he was in the journalism program, Chiarenza found himself involved with more activities than he can remember. Photography, friends, photojournalism, working on occasional assignments for a commercial photography company, and making his presence known in the Boston community kept him busy.

His first major step was to establish a gallery in the basement of the photo lab. Called Image Study, the gallery helped to bring the visual ideologies of the Rochester group to Boston, as Chiarenza exhibited Minor White, Paul Caponigro, and Nathan Lyons, an innovative artist and educator who would soon capture national attention. A recent article in *Boston* magazine called Chiarenza's activities at this time nothing less than the beginning of "the modern saga of Boston photography." Certainly, he was one of the prime catalysts in the invigoration of Boston photography, along with talented photographers like Walter Chappell, Nicholas Dean, Paul Caponigro, Irene Schwachman, Steven Trefonides, John Brook, and the dealer Carl Siembab.

What histories of the 1950s photography scene do not stress sufficiently is the strong connection between Boston and Rochester. Chiarenza, Caponigro, and Chappell would think nothing of driving back and forth between the two cities, an eight-hour drive each way. The Rochester group found a willing listener in the person of the Boston dealer, Carl Siembab, who had been exhibiting photographs along with paintings, sculpture, and graphic arts prints. Urged on by Irene Schwachman, other Boston photographers, and the newcomers, Siembab began to exhibit the prints of Edward Weston, Paul Strand, and other modern masters, as well as the work of younger unknowns. The Siembab Gallery became the site for weekly gatherings, and later for Minor White's workshops even before Minor moved to Boston permanently in the 1960s, when he became the controversial guru for a new program at the Massachusetts Institute of Technology. Siembab organized a one-man show for Aaron Siskind and was for many years the East Coast dealer for Ansel Adams.

There was another crucial supporter for photographic innovation in the Boston area. This was Polaroid Corporation, based in Cambridge, where forward-looking executives had recognized the urgency of involving creative photographers in the testing of its new instant materials. Ansel Adams was serving as a consultant and would publish his detailed handbook on the Polaroid processes in 1963. During the early sixties, Chiarenza, Caponigro, Nicholas Dean,

among others, were invited to experiment with both positive and negative/positive films. Chiarenza's Polaroid-based abstractions began to appear on the back covers of *Aperture,* even as his poems were being published in its pages. It was the beginning of a long and productive association with Polaroid. More important, it was the start of Chiarenza's infatuation with the unusually rich blacks and silver tones of the Polaroid prints and of prints he made from Polaroid negatives. The instant feedback of the Polaroid process served him well as a kind of sketching dynamic that helped him make moment-to-moment transformations in his compositions and exposures. The exceptional versatility of the Polaroid medium has been the basis of his pictorial strategies since then.

Paul Caponigro, who had been studying privately with Minor White, met Carl during the period when Chiarenza was ostensibly pursuing his journalism degree. Both Italian in origin, they felt an immediate empathy, chummed around, went on photography jaunts together to Maine, Ipswich, Gloucester, and through the Northeast, becoming fast friends. Paul had also felt the need for some kind of spiritual center in his life. There was a Gurdjieff group in Boston, which Paul and the printmaker George Lockwood persuaded Carl to join for a few months. Their meetings were held at Impressions Workshop, an important artists' space run by Lockwood. The group had no connection to the Gurdjieffians sanctioned by Minor White, but followed the same essential teachings: that human beings should recognize their interdependence with the universe; that they contemplate their lives to find their place within Creation; and that they follow certain procedures—dance, meditation, strenuous labor—to achieve freedom of psyche. Carl found himself unprepared for what he swiftly decided was not a route to salvation for himself.

He also discovered fairly soon that the life of a photojournalist was not for him. Assigned by the Sickles Photo Company, for whom he had been writing as well as photographing, to record the newly shingled roof of a local high school, Carl was asked to climb into the lift bucket of a fire truck. There was no other way to see the shingles. But there was also no earthly way that Carl could or would oblige. A long-time sufferer from vertigo, it was looking at that bucket that convinced Carl he did not care for commercial photography. Besides, the idea of photographing shingles was excruciatingly boring.

In a manner of speaking, he was saved by being drafted into the infantry no sooner than he had received his master's degree. From late 1959 to late 1961, Carl endured both the hell of an accidentally prolonged basic training and the joys of an unexpected shift into a new area of interest: he began to read art history. During his tour of duty, he was courting the daughter of Howard Thurman, then a dean at Boston University. He was fortunate to be sent eventually to Fort Devens in Massachusetts, within commuting distance to his future wife's apartment.

Chiarenza had met Anne Spencer Thurman on the steps of the Boston Uni-

versity chapel sometime in 1958. In 1961, they married. Anne had finished law school and later worked for Eliot Richardson and other notables as a speech writer. In 1967, they adopted a five-month-old baby girl, Suzanne Mari. Unfortunately, the marriage deteriorated. In 1972, they underwent a painful divorce exacerbated by Carl's new academic commitments.

Just before Carl had been drafted, Boston University invited him to teach photography in the School of Journalism. The army interrupted that opportunity. He was about to complete his tour of duty when the Berlin crisis exploded, with President John Kennedy immediately imposing an extension on all armed forces commitments. Chiarenza was able to escape this unwanted extension by a curious circumstance. There was a law that provided inductees with release from an extension of time in the armed forces if they were offered a scholarship they would lose if they could not take it immediately. It was a tremendous relief to Carl when he was offered such a scholarship back to Boston University. This time it was to take courses in art history while he continued his photographic activities.

In 1963, a group consisting of Paul Caponigro, Walter Chappell, William Clift, Marie Cosindas, Carl Chiarenza, Nicholas Dean, and Paul Petricone formed the Society of Heliographers, with the intention of making their talents known to the international art market in New York City. The group attracted much public notice with a major exhibition at Lever House. They had also formed a cooperative gallery. Unfortunately, there was contention over several members not abiding by the bylaws of the Heliographers, and questions of financial management coupled with the distance from the gallery prompted the withdrawal of the Boston group after one year. It was an important adventure for like-minded artists of the camera, but in terms of the fickle photography market, it was undoubtedly before its time. Ultimately, although the Heliographers continued for some years, the original group scattered, with Clift and Caponigro later migrating to Santa Fe and Nick Dean moving to Maine. Chiarenza, Cosindas, and Petricone remained in Boston.

It was in 1964 also that Chiarenza, who was keenly devoted to the betterment of the photographic community, became an active leader in the Society for Photographic Education, a national organization founded by Nathan Lyons a year earlier. In 1963, Carl was asked by the Department of Fine Arts at Boston University to teach some basic courses. In 1964, he was officially appointed instructor. Two years later, when he came up for renewal of contract, the dean of the college advised him that if he wanted to continue teaching there, he would need a Ph.D. He was so well respected that the dean not only granted him an extended leave, but nominated him for a Danforth teaching fellowship so that he could attend Harvard University.

As Carl describes it, Harvard was an almost unendurable experience. Finish-

ing his residence and course work in 1968, he wanted to proceed with a doctoral dissertation on a contemporary photographer. No: the department envisioned a book about the relationship between painting and photography. As it happened, Aaron Scharf chose that moment to publish his own major book on that subject. Carl then proposed to his original thesis adviser, who shall remain nameless, that he write a biography of the highly respected photographer Aaron Siskind. Siskind was, without question, one of the most important living artists working in the photography medium. With a mixture of incredulity and anger, barely diminished over the years, Carl reports that he received a letter from his adviser, then in London, to the effect that "I can't become excited about a living artist."

With heroic persistence, Carl managed to overcome the objections of the traditional art historians and was finally permitted to begin his thesis on Siskind. Between 1969 and 1972, Chiarenza flew back and forth between Boston and Chicago, where Siskind was an influential professor at the Institute of Design, and made many side trips to New York to talk with painters considered to be abstract expressionists, to whose work Siskind's image had often been likened. Carl was increasingly intrigued by his subject, with whom he began to identify in terms of both being abstractionists—although of a very different order—both being first-generation Americans, both from persecuted minorities, both having difficulties with marriages. Although Siskind was much older and already an established world figure in photography, and although he was generally temperamental and impatient, the two became good friends. It was a relationship that would have both vitalizing and discouraging aspects.

The critic Thomas Hess wrote a description of Aaron Siskind's pictures, which have included found graffiti, the ambiguous residues of torn and disintegrating posters, and patterns in nature, as their subjects. "It's in a formalist area that Siskind's particular genius obtains—his ability to make photography a matter of transcendent aesthetic import. The finished prints should be considered as pure phenomena, matters of inter-relationships, of parts to a whole, the whole to the medium, the medium to its particular state of technological and philosophical awareness at the moment in art-historical time." Hess emphasized that Siskind "talks to us through our humanity—through his feel for the tragic." It was Siskind's tragic view of life, as well as his abstract and formalist style, to which Chiarenza could relate directly.

At one point in his turbulent career, Siskind placed himself firmly at the antipodes from Minor White. He emphatically rejected Eastern philosophies, with their ideas of oneness and their technique of contemplation. He felt the essential problem for an artist was to deal with "the conflicting forces within us. That is what the Christian religion is. This is our culture." Chiarenza, who had been successfully freeing himself from what he perceived as Minor

White's domination and strict dogmas, found Siskind's idea of conflict close to his own heart. Yet, for all that he was attracted to Siskind's art and philosophies, writing about him in many essays and in a definitive biography based on his thesis, Chiarenza soon found himself in a peculiar predicament. Because he had written so much about Siskind, and, more important, because the uninitiated tended to confuse the distinctions between one kind of abstraction and another, Chiarenza's own work became identified with that of Siskind. With his own art proceeding in a vastly different direction, he was made to feel as if he were living in Siskind's shadow. It was a difficult situation for a proud, articulate man.

Chiarenza had been longing for a nontraditional school for photographers, on the order of Nathan Lyons's Visual Studies Workshop in Rochester. With Warren Hill, a Cambridge fashion photographer, and the material support of Don Perrin, he cofounded in 1971 an ambitious enterprise called Imageworks, which offered itself as a center for all aspects of photography, from gallery space to education. Unfortunately, he was once again ahead of his time, and Imageworks foundered in 1973, after two years of far too rapid expansion. It was not until the founding of the Photographic Resource Center (PRC), largely through the efforts of Carl's good friend, the photographer Chris Enos, Carl himself, and Eelco Wolf of Polaroid Corporation, that Chiarenza's vision of a true center for New England photography was accomplished later in the 1970s. He managed to persuade Boston University to offer a substantial space for the activities of the PRC, and, as one of the directors of the center, he encouraged the funding of numerous activities of interest, including lectures by, and grants for, renowed photographers and critics.

MENOTOMY Among his many activities, Chiarenza was on the lecture and workshop circuit in the early seventies. In August 1974, he was teaching one of the Ansel Adams summer workshops at Yosemite, along with Jerry Uelsmann and Robert Heinecken, a photographer whom he had met in 1963 and who became one of his closest friends. Among the assistants assigned to the workshop was a young woman with cropped blond hair and a quiet but very energetic personality. Heidi Katz had been Heinecken's graduate student and teaching assistant at UCLA. She was both filmmaker and photographer and would later teach at the University of Hartford. Carl recalls that he paid little attention to her at first. By that Christmas, however, he had succumbed entirely. He sent her a plane ticket to come east to spend the holidays. They have been inseparable ever since.

Carl and Heidi bought a house in Arlington, Massachusetts, not far from Boston, in 1976. In 1978, they made their marriage official. Son Jonah was born in 1980, by some curious circumstance on the same day as the birthday

of Ansel Adams. Gabriella followed in 1983, born on the same day as Carl's first daughter, Suzanne. If asked to sum up his feelings about his second wife, Carl says, "Heidi is fantastic!" She has been, in fact, a source of tremendous emotional support during some trying years. With her excellent visual training and professional experience, she has also helped Carl through some aesthetic decisions, including encouraging his recent creation of diptychs and triptychs.

Arlington was originally called *Menotomy,* its American Indian name. It is a name that has meant a great deal to Chiarenza, as he used it for many of his prints in homage to an area known as Menotomy Rocks, a park nearby where he took many long walks, both for relaxation and inspiration, although he never brought along a camera. Chiarenza has profound feelings about landscape. Nature is for him "a sustaining structure," a source for connection, both an idea and a reality. As he observes, "Our landscape is indeed in the mind, but the mind now survives in an environment which is neither the natural one of the nineteenth century and earlier, nor the urban one of the first half of the twentieth century. It is a more thoroughly technological environment, yet it remains as mysterious and as full of unknown forces as it has been throughout its tradition." He believes strongly that landscape is an idea, a construct out of which he makes his art. He sees that art as being imbued with both traditional concepts of landscape and a response to the new environment.

In 1979, Polaroid Corporation invited Carl, along with several other well-known photographers, to try his hand at using a powerful new tool: its 20 × 24 camera. Chiarenza had already experimented with the SX70 color film in the mid-1970s. The 20 × 24 experiment was to have a profound effect on him; not that it turned him from black-and-white photography to color. Carl had been used to taking his 4 × 5 camera outdoors with positive/negative Polaroid film. Suddenly he found that working exclusively in the studio was much to his liking. Since 1979, many of his prints have as their subjects imaginary landscapes created in the studio, all photographs of collages fabricated to be photographed, all based on Polaroid positive/negative film elaborately manipulated in the darkroom.

Philosophically, Chiarenza has always been attuned to the idea of an "unfixed, indeterminate, changing and fluctuating world." To watch him at work is a revelation of his intuitive approaches to this world of flux. He allows chance to operate in this construction of his subject. What is so surprising is that while his prints are large, his collages are relatively tiny, sometimes no more than five inches by three inches. They are composed of discarded materials, often from film wrappings, scraps of paper, torn strips. He roughly previsualizes the negative, but given the flexibility of the Polaroid negative, he freely rephotographs, moving a feathery piece of scrap here, crumpling silver paper, knowing that the darkroom will offer even greater opportunities for con-

trol. Unlike Ansel Adams, for example, who produced more than eight hundred prints of his famous *Moonrise over Hernandez,* Chiarenza, in the tradition of the printmaker even more than the photographer, sees no value in attempting to make perfectly equal replications of a print. He tends to limit himself to editions of no more than five to ten large prints, and his essential approach is not far different from that of a painter-etcher's manipulation of successive states of a plate.

Like an etcher, too, Chiarenza is infatuated with the potential densities of black. In the many variations of black, he expresses his sense of mystery and the unknown. Recently, he finds that the pictures coming back from satellites and interplanetary probes, as well as from science fiction, have greatly attracted him. Many of his prints now reflect an increasing obsession with the mysteries of the physical universe. In typical fashion, he comments briefly about his use of blacks and silvers as a reflection of the unknowable universe: "We have no answers." Pause. "There are stars in it." The blacks, which he says can be obtained in no medium other than photography, and which depend greatly on the paper he uses—Medalist, when it was available, now Galerie—are a symbol for a fundamental existential anxiety he experiences, whereas he sees his modulations toward grays and lighter silvers as a kind of optimistic counterpoint.

The idea of musical counterpoint is always present. Chiarenza admits to a longing to make pictures with the expressive qualities of Beethoven quartets. More than the polyphony he loves in Bach, he has a passion for the drama of Beethoven. As he works in his studio, he listens to a wide range of music, from the baroque to modern jazz. Beethoven's late quartets, Schumann's, Mozart's, Haydn's, and Shubert's outpourings, all match his own romanticism. The separate phases of his diptychs and triptychs resemble the movements of a quartet, a sonata, or the variations of a concerto.

Curiously, perhaps, for a musician who has played the Mozart clarinet concerto, as well as intensely personal jazz, it is only photography that has come to satisfy both his creative needs and his highly sophisticated aesthetic. That aesthetic, like music, includes the use of tones, motion, time, and space. He recognizes that many photographers have felt a close bond between music and the camera image. Frederick Sommer, a surrealist photographer and collagist, made abstract drawings that he invited friends to try to play as music. Paul Caponigro claimed recently that he was temporarily renouncing photography to return to his piano. Ansel Adams was a musician before becoming a photographer. Alfred Stieglitz called his pictures of clouds *Songs of the Sky*. Younger contemporaries like Michael A. Smith, who once tried to make pictures like the diagrams of bird song, and Barbara Crane, who attended concerts with a sketchpad to draw the patterns that music evoke, acknowledge their

debt to music. For a medium that once promised to supply the closest possible representation of the natural world in all its material details, it may seem odd that photography has been trying to emulate the thrust of Walter Pater's dictum: "All art approaches the condition of music." Music, the most abstract, nonrepresentational of all the arts, nevertheless conjures up visions.

Chiarenza admits a kinship with the abstract expressionists, but does not recall being thoroughly exposed to their work until he knew Siskind. His statements often resemble the philosophy of that art movement: "The transformations which take place in my photographs suggest a vital life force which, while unknown, insists forcefully on its presence. It lives in a space that often defies definition. Its shapes hover in a richly palpable blackness and appear as temptations composed of sensuous silver grays and whites. The photographic presence is magical-alchemical. In a sense my photographs attempt to present evidence of the unknown, to testify to its significance, and to suggest the importance of its pursuit."

NOUMENON The neo-Platonic aspect of Chiarenza's spiritual vision might be epitomized by his series called *Woods,* in which only the idea of trees is expressed. And in the pictures he titles *Noumenon* can perhaps be found his personal idea of spirit and his evocation of the unknown. His profoundly mystical and poetic approach to photography does not preclude his continuing admiration for artists like Goya or prophets like Nietzsche, nor does he forego a habitual, palpable, and despairing cynicism, clearly the indication of an idealist's soul that has found no lasting peace.

The well-known photographer and educator, Jerome Liebling, has observed, "Carl Chiarenza's photographs are private dramas. They are not simple relationships, but tensions trying to reach an equilibrium. A slight push or shove and the pictures will come crashing." Liebling also considers that Chiarenza creates a visual terrain in which he knows where he is situated, and which he tightly controls to keep out intrusions. It is the tensions created by this control that increase the similarity of Chiarenza's prints to the passions of the late Beethoven quartets, profoundly internalized revelations of the artist's personal despairs.

One of the most fascinating prints Chiarenza made in 1975 is the abstraction *Somerville 17.* Like a vision of a moonrise amid the ruins of a modern city, the combination of biomorphic forms and the austerity of repeated verticals create a mysterious mood, mysterious but not at all pessimistic. It is like observing the creation of a new world.

In *Rockland 2,* 1979, one of Chiarenza's best-known prints, the division of the surface of the print has an insistent rhythm, with the flamelike central

black shape the beating heart of the structure. What is astonishing about this picture is that its content is simply the exposed ends of some warped plywoods he found in his perambulations, a typical example of Chiarenza's transformations.

The shift from the vibrating structure of *Rockland 2* to *Arlington 2* of that same year introduces the new phase of Chiarenza's work occasioned by the interaction with the Polaroid 20 × 24 and his discovery of the delights of working in the studio, fabricating imaginary landscapes. Manipulating both light in the studio and the printing in the darkroom, Chiarenza manages to offer a rocky, somewhat inimical landscape such as one might find on a desolate plateau, whether of this world or another it is hard to say. The mood is that of deep night, a night in which no stars appear, yet in which mysterious light plays on its surfaces.

Menotomy 382, 1983, is another dream landscape, closely resembling real landscapes through which a brilliant river might course, the distant mountains shimmering with reflected light and the foreground impossibly distant, as if the viewer were flying over the terrain toward the eerie light emanating from behind the mountains. This tension between unreality and reality demands resolution, an equilibrium that only the viewer can establish and that requires contemplation to achieve. All of Chiarenza's work requires close attention, like the complex and dissonant chords of modern music.

Woods 529, 1983, suggests not trees and leaves, but vegetation growing in deep woods, with the dappled light of such a glade expertly transmitted by Chiarenza's control of the direction of his highlights. This is nature revealed as a not unfriendly but hardly welcoming entity, with a life evolving out of some unfathomable principles. It is a wood in which arcane sacrifices might occur, where implacable gods announce their unique powers.

The term *noumenon* signifies ineffable spirit, and in *Noumenon 180,* 1984–85, can be found a vision of the heavens, primordial matter coalescing into cloudlike shapes. In *Noumenon 304/305,* 1984–85, Chiarenza moves out of the single photograph into a vertical diptych in which creative spirit now includes time as well as matter. The forms shift, like the transformations of evolution. An equilibrium may be reached, but the implication is that the forms will continue to shift. This continued growth and change is strongly demonstrated in the horizontal triptych, *Noumenon 245/249/247,* worked on from 1984 to 1985. Eons seem to pass between each of the three images, almost as if we are watching the origin of mountains. In an elegant diptych, *Noumenon 444/441,* also from 1984 to 1985, the transformation is not as violent, yet it has a decisiveness to it that matches Chiarenza's firm belief in the evanescence of the material world. Everything changes. Everything endures phases of an eternal flux. Such continual transformations, moment-to-moment, are perhaps best

epitomized in the monumental *Menotomy Sextet,* 1982, in which forms attract, repel, grow, collapse, ceaselessly experiencing a never-ending creation.

Chiarenza has noted an increasing desire to shift the direction of his photography, but he knows how slowly such change might come, if ever. He seeks new textures, new resonances for his collages. As an artist who relies upon the mysteries of chance, and on the moment-to-moment changes in his aesthetic and emotional responses to the landscape, he knows that inevitably his own conceptual strategies, even his fundamental ideologies, will continue to grow and to be transformed.

From *Chiarenza: Landscapes of the Mind* (Boston: David R. Godine and the Polaroid Corporation, 1987).

NOTES

SYNTAX OF REALITY

This is a paper read at the symposium "The Art History of Photography: Recent Investigations," sponsored by IMP/GEH, where it was held in February 1975. The symposium was organized by Robert A. Sobieszek

1. Henry Peach Robinson, *Pictorial Effect in Photography* (1869; reprint ed., introduction by Robert Sobieszek, Pawlet, Vermont: Helios, 1971), pp. 51–52.

2. These pictorial comparisons are available in Estelle Jussim, *Visual Communication and the Graphic Arts: Photographic Technologies of the Nineteenth Century* (New York: R. R. Bowker Co., 1974), pp. 169, 171.

3. Remarks of John P. Davis in "A Symposium of Wood-Engravers," *Harper's New Monthly Magazine,* vol. 60, no. 357 (February 1880), p. 447.

4. A. V. S. Anthony, "An Art That Is Passing Away," *Wood Engraving; Three Essays by A. V. S. Anthony, Timothy Cole, and Elbridge Kingsley* (New York: The Grolier Club, 1916), p. 13.

5. Remarks of John Tinkey in "A Symposium of Wood-Engravers," op. cit.

6. Quoted in Frank Weitenkampf, *American Graphic Art* (New York: Holt, 1912), p. 159.

7. Dora Read Goodale, "Sympathy with Nature in Modern Art," *The Monthly Illustrator,* vol. 5, p. 157 (n.d.).

8. Elbridge Kingsley, ms. of autobiography. Forbes Library, Northampton, Mass., p. 184.

9. William M. Laffan, *Engravings on Wood by Members of the Society of American Wood-En-gravers* (New York: Harper, 1887), n.p.

10. Philip Gilbert Hamerton, *Thoughts About Art,* rev. ed. (Boston: Roberts Brothers, 1871), p. 128.

11. Kingsley, ms. of autobiography, Forbes Library, Northampton, Mass., p. 130.

12. Ibid., p. 97.

13. Ibid., p. 137.

14. Kingsley, "Originality in Wood-Engraving," *Century Magazine,* vol. 38, no. 4 (August 1889), p. 578.

15. Kingsley, ms. of autobiography, Forbes Library, Northampton, Mass., p. 164.

16. John C. Van Dyke, ed., *Modern French Masters* (New York: Century, 1896), p. VII.

17. Philip Gilbert Hamerton, *The Art of the American Wood-Engraver* (New York: Scribner, 1897), p. 137.

TECHNOLOGY OR AESTHETICS: ALFRED STIEGLITZ AND PHOTOGRAVURE

1. Jonathan Green, ed., *Camera Work: A Critical Anthology* (Millerton, N.Y.: Aperture, 1973), p. 13.

2. Ibid.

3. Doris Bry, *Alfred Stieglitz: Photographer* (Boston, Museum of Fine Arts, 1965), p. 15.

4. See the extended discussion of the problems of defining the term "photograph" in "The Syntax of Reality."

5. Beaumont Newhall, *Frederick H. Evans* (Millerton, N.Y.: Aperture, 1973), pp. 18–19.

6. Ibid., p. 19.

7. Alfred Stieglitz, quoted in Nathan Lyons, ed., *Photographers on Photography* (Prentice-Hall in conjunction with George Eastman House, 1966), p. 131.

8. Publicity brochure for *Camera Work,* courtesy of Janet Lehr, New York.

9. Ibid., n.p.

10. Alfred Stieglitz, quoted in Lyons, *Photographers,* p. 133.

11. Ibid.

12. Ibid.

13. Ibid., p. 134.

14. Ibid.

15. Ibid.

16. Doris Bry, *Alfred Stieglitz*, See list of plates, pp. 27–28.

17. Marianne Margolis, *Alfred Stieglitz: Camera Work;* an index to the plates (New York: Dover, 1978).

18. Helmut and Allison Gernsheim, *The History of Photography* (New York: McGraw-Hill, 1969), p. 469.

19. Weston Naef, *The Collection of Alfred Stieglitz: Fifty Pioneers of Modern Photography* (New York: Viking Press, 1978), p. 37.

20. Boston Museum of Fine Arts, Print Department. *Exhibition Illustrating the Technical Methods of the Reproductive Arts from the XV Century to the Present Time, with Special Reference to the Photo-Mechanical Processes;* 8th January to 6th March 1892. Mudge, Boston (1892).

21. Herbert Denison, *A Treatise on Photogravure* (Rochester, N.Y.: Visual Studies Workshop, 1974). (Visual Studies Reprint series; reprint from the 1895 edition published by Iliffe, London.)

22. Nancy Newhall, *P. H. Emerson: The Fight for Photography as a Fine Art* (Millerton, N.Y.: Aperture, 1975), p. 3.

23. Naef, *The Collection*, p. 30.

24. Ibid.

25. Green, *Camera Work*, p. 18.

26. Stieglitz, quoted in Lyons, *Photographers*, p. 133.

THE ETERNAL MOMENT: PHOTOGRAPHY AND TIME

1. Marcus Aurelius, *The Thoughts of Marcus Aurelius Antoninus*, bk. IV, trans. John Jackson (London: Oxford University Press, 1906), p. 43.

2. Cornelius Benjamin, "Ideas of Time in the History of Philosophy," in *The Voices of Time*, ed. J. T. Fraser (New York: Braziller, 1966), p. 24.

3. Quoted in James N. Powell, *The Tao of Symbols* (New York: Quill, 1982), p. 163.

4. Joost A. M. Meerloo, *Along the Fourth Dimension: Man's Sense of Time and History* (New York: John Day, 1970), p. 198.

5. Quoted in Meerloo, *Along the Fourth Dimension*, p. 197.

6. George Kubler, *The Shape of Time* (New Haven: Yale University Press, 1962), p. 16 ff.

7. Henri Cartier-Bresson, Introduction to *The Decisive Moment*, quoted in *The Camera Viewed*, vol. 2, ed. Peninah Petruck, p. 17.

8. Petruck, *The Camera Viewed*, vol. 2, p. 18.

9. Powell, *The Tao of Symbols*, p. 165.

10. Meerloo, *Along the Fourth Dimension*, p. 97.

11. Ibid., p. 142.

12. Quoted in Stephen Kern, *The Culture of Time and Space, 1880–1918* (Cambridge, Mass.: Harvard University Press, 1983), pp. 143–144.

THE SUBJECT BEAUTIFUL
An address to the Honors Convocation of Simmons College, October 28, 1981.

QUINTESSENCES: EDWARD WESTON'S SEARCH FOR MEANING

1. Edward Weston. "Photography," 1934, in Peter C. Bunnell. ed., *Edward Weston on Photography* (Salt Lake City: Peregrine Smith Books, 1983), p. 74.

2. Nathan Lyons, "Weston on Photography," in Beaumont Newhall and Amy Conger, eds., *Edward Weston Omnibus* (Salt Lake City: Peregrine Smith Books, 1984), p. 170.

3. Weston, "Random Notes on Photography," 1922, in Bunnell, p. 31.

4. Weston, "Statement," 1931, in Bunnell, p. 67.

5. Ibid.

6. Weston, "Photography Not Pictorial," 1930, in Bunnell, p. 58.

7. Weston, "Light vs. Lighting," 1939, in Bunnell, p. 100.

8. Ibid., p. 101.

9. Nancy Newhall, ed., *Edward Weston: The Flame of Recognition* (Millerton. N.Y.: Aperture, 1971), p. 34.

10. Frances D. McMullen, "Lowly Things That Yield Strange, Stark Beauty," in Newhall and Conger, *Omnibus*, p. 41.

11. Edward Weston, *The Daybooks of Edward Weston*, vol. II. *California*, ed. Nancy Newhall (Millerton, N.Y.: Aperture, 1962).

12. Weston, *Daybooks*, p. 225.

13. Newhall, ed., *Flame of Recognition*, p. 8.

14. Weston, "Form," 1957, in Bunnell, p. 158.

15. Lyons, p. 170.

16. Janet Malcolm, "The Dark Life and Dazzling Art of Edward Weston," in *Omnibus*, p. 161.

17. Ibid.

18. *Flame of Recognition*, p. 42.

19. Weston, "Photographic Art," 1940, from the *Encyclopaedia Britannica*, 14th ed., in Bunnell, p. 132.

THE REAL THING: MUSEUMS AND COMMUNICATION

Note: This polemic was originally an address to the Annual Joint Meeting of the Board of Trustees with the Visiting Committee of the International Museum of Photography at George Eastman House, Rochester, New York, April 25, 1979. It has been greatly shortened and edited to remove specific recommendations to the International Museum of Photography's Trustees. The intention here is to generalize about the functions and responsibilities of museums.

TRASHING THE MEDIA: TAKING ON THE WORLD

Note: The following is a slightly edited version of a featured lecture presented at the National Conference of the Society for Photographic Education, Minneapolis, March 15, 1985.

1. Hilla Rebay, "The Beauty of Non-Objectivity," in *Modern Art and Modernism: A Critical Anthology,* ed. Francis Frascina and Charles Harrison (New York: Harper & Row, 1982), p. 145.

2. Douglas Davis, *Artculture: Essays on the Post-Modern* (New York: Harper & Row, 1977), p. 49.

3. Rebay, "The Beauty of Non-Objectivity," p. 148.

4. During his lecture, a young man turned to a colleague of mine and asked, "What's a garret?" A garret is the part of the house immediately under the roof, or part of the roof, usually of a multistoried dwelling. In the nineteenth centry, garrets were the cheapest lodgings available. Poor, struggling artists, therefore, notoriously lived and died in freezing garrets. *La vie boheme*—bohemian life—was the life of the garrets.

5. Ernst Fischer, *The Necessity of Art: A Marxist Approach,* trans. Anna Bostock (London: Penguin Books, 1963), p. 204.

6. Walter Benjamin, as quoted by Eugene Lunn, *Marxism and Modernism* (University of California Press, 1982), p. 164.

7. Frederic Jameson, "Postmodernism and Consumer Society," in *The Anti-Aesthetic,* ed. Hal Foster (Bay Press, 1984), p. 114.

8. Ibid., p. 115.

9. Hans Magnus Enzenberger, "The Industrialization of the Mind," in *Mass Media: Forces in Our Society,* ed. Francis and Ludmila Voelker (New York: Harcourt Brace Jovanovich, 1970), p. 41.

10. Ibid., p. 42.

11. Ibid., p. 47.

12. Rozsika Parker and Griselda Pollock, *Old Mistresses: Women, Art, and Ideology* (New York: Pantheon, 1981), p. 119.

13. George Gerbner, "Cultural Indicators: The Third Voice, "in *Communications Technology and Social Policy,* ed. Gerbner, Gross, Melody (Wiley, 1973), p. 558.

14. Ibid.

15. This and the following lists are from: Harold Osborne, *Aesthetics and Art History* (New York: Dutton, 1968).

16. Arthur Asa Berger, *Media Analysis Techniques* (Sage Publications, 1982), pp. 105–106.

17. Ibid., p. 101.

18. Donald B. Kuspit, "An Appeal for Empathy," *Art in America,* November 1984, p. 114.

19. Ibid., p. 115.

20. Ibid., p. 117.

21. Patricia Bosworth, *Diane Arbus* (New York: Knopf, 1984), pp. 363–64.

22. John Naisbitt, *Megatrenda: Ten New Directions Transforming Our Lives* (Warner Books, 1984), p. 36.

23. C. Ray Smith, *Supermannerism: New Attitudes in Post-Modern Architecture* (Dutton, 1977), p. 48.

24. Quoted in the Mt. Holyoke *College Alumni Quarterly,* Spring 1985. I have slightly altered the translation for easier comprehension and added emphasis in the last sentence.

STARR OCKENGA'S NUDES: SOME NOTES ON THE GENRE

1. All Sir Kenneth Clark's quotations are from his book *The Nude: A Study in Ideal Form* (Garden City, New York: Doubleday Anchor, paperback edition, 1956).

2. See John Berger's *Ways of Seeing* (London: BBC and Penguin, 1972), chap. 3.

3. The quotation from Duane Michals is from Jain Kelly, ed., *Nude: Theory* (Lustrum Press, 1979).

4. All the quotations from the Book of Genesis can be matched in almost any edition of the King James version of the Bible.

5. Mark Twain's *Letters from the Earth* is available in paperback from Harper & Row (Perennial Library), 1974.

6. The quotations from Starr Ockenga are from a series of conversations and two extended interviews conducted from March 1982 to August 1982; some comments were corrected or amended later.

I am indebted to Professor Elizabeth Lindquist-Cock of the Massachusetts College of Art for her relaying to me her students' responses to the Ockenga exhibition and for her suggestions about the inclusion of comments about Robert Heinecken.

ICONS OR IDEOLOGY: STIEGLITZ AND HINE

1. Quoted by Geraldine Pelles, *Art, Artists and Society* (Englewood Cliffs, N.J.: Prentice Hall, 1963), p. 18.
2. Ibid., p. 19.
3. Quoted from Proudhon's *Du principe de l'art et de sa destination sociale,* in Philip Gilbert Hamerton, *Thoughts about Art* (Boston: Roberts, 1871), p. 319.
4. Ibid., p. 320.
5. Edward Lucie-Smith, *Symbolist Art* (New York: Praeger, 1972), p. 143.
6. Vincent Tomas, "Introduction" to Leo N. Tolstoy, *What Is Art?* trans. Almyer Maude (New York: Bobbs-Merrill, 1960), p. vii.
7. Tolstoy, *What Is Art?* trans. Almyer Maude (New York: Bobbs-Merrill, 1960), pp. 142–43.
8. Ibid., p. 51.
9. Herbert J. Seligmann, "A Vision Through Photography," in *America and Alfred Stieglitz* (New York: Literary Guild, 1934), p. 121.
10. Ibid., p. 124.
11. Ibid.
12. Wassily Kandinsky, *Concerning the Spiritual in Art* (New York: Dover, 1977), p. 34.
13. Quoted in Etienne Gilson. *Painting and Reality* (New York: Meridian, 1957), p. 258.
14. Herbert Read, *Art and Society,* 2nd ed. (New York: Pantheon, 1945), p. 2.
15. Lewis Mumford, *The Condition of Man* (New York: Harcourt Brace, 1944), p. 413.
16. Ibid., p. 420.
17. Northrop Frye, "The Critical Path," in *Theory in Humanistic Studies; Daedalus,* Spring 1970, p. 315.

PROPAGANDA AND PERSUASION

1. Quoted in William Stott, *Documentary Expression and Thirties America* (New York: Oxford University Press, 1973). p. 30.
2. Stott, *Documentary,* p. 23.
3. Stott, *Documentary,* p. 14.
4. Stott, *Documentary,* p. 62.
5. Jacques Ellul, *Propaganda: The Formation of Men's Attitudes* (New York: Vintage Books, 1973), p. 25.
6. Stott, *Documentary,* p. 62.

7. Tony Schwartz. *The Responsive Chord* (Garden City, New York: Doubleday, 1979).
8. See Béla Balázs, *Theory of Film: Character and Growth of a New Art* (Dover, 1970).
9. Ellul, *Propaganda,* p. 266.

FROM THE STUDIO TO THE SNAPSHOT: AN IMMIGRANT PHOTOGRAPHER OF THE 1920s.

This article is based on the lecture given at PhotoHistory III, the Third International Symposium on the History of Photography, held at the International Museum of Photography at George Eastman House, Rochester, New York, 9 October 1976. The lecture was titled: "An Immigrant Photographer of the 1920s: Apprenticeship, Aesthetic Milieu, Business Adventures."

1. John Szarkowski, *Looking at Photographs* (New York: The Museum of Modern Art, 1973), p. 10.
2. Ibid., p. 14.
3. John Szarkowski, *The Photographer's Eye* (New York: Museum of Modern Art, 1966), p. 7.
4. Lady Elizabeth Eastlake was wife of Sir Charles Eastlake, President of the Royal Academy in 1852 and then of the newly inaugurated Photographic Society of 1853. The Newhall choice, therfore, may be partly based on the extrinsic interest of the subject's having been a "famous person," especially one connected with photographic history itself.
5. *Encyclopedia Judaica* (Jerusalem: Encyclopedia Judaica; New York: Macmillan, 1971–74. vol. P, p. 24.
6. Ibid. See pages 24 through 28 for a discussion of the dispersion and economic plight of Russian Jews.
7. The resurgence of "ethnicity" in the 1970s is an indicator of how deeply national origins figure in the concept of self and individuality.
8. See, for example, "Are We Facing an Immigration Peril?" *The New York Times,* 29 January 1905; quoted in a most useful compilation by Allon Schoener, ed. *Portal to America: The Lower East Side 1870–1925* (New York: Holt Rinehart and Winston, 1967), p. 25. The *Times,* of course, also had many good things to say about the immigrants.
9. Boris Ossipovich Jussim. Response to a questionnaire submitted by the author. For the sake of brevity; this will be designated *MS. Q1.*
10. Cecil Roth, ed. *Jewish Art, an Illustrated*

History (New York: McGraw-Hill, 1961), p. 30. See the introduction to this fine book for a useful survey of the problems of iconoclasm.

11. Boris Jussim, *MS. Q1*.

12. Ibid.

13. Ibid.

14. Manya Aaronovna Glusker, wife of Boris Ossipovich Jussim. Response to a questionnaire submitted by the author. For the sake of brevity, this will be designated *MS. GQ1*.

15. See Robert Taft, *Photography and the American Scene* (New York: Dover, 1938), pp. 352–54. L. W. Seavey was called by Wilhelm Vogel "the first background painter of the world," not only in the sense of his having been largely responsible for introducing the painted background, but because of his international reputation.

16. Boris Jussim, *MS. Q1*.

17. Ibid.

18. Ibid. *MS. Q1* relates a vivid memory of the photographer's working from 7 A.M. to 3 P.M. one Sunday without eating. After rushing into the kitchen to grab a quick bite, he became so violently sick with acute indigestion that a doctor had to be summoned to save his life. Within one hour, however, he was back at work behind the camera.

19. Boris Jussim, in a letter concerning the gold mine adventures, which for brevity will be called *MS. Q4 (Canada)*.

20. Boris Jussim, *MS Q1*.

21. Paul Strand, "Comments on the Snapshot," in Jonathan Green, ed. *The Snapshot, Aperture,* vol. 19, no. 1 (1974), p. 46. Also published as a separate book.

22. Ibid., p. 49.

23. Ibid.

24. Steven Halpern, "Souvenirs of Experience: The Victorian Studio Portrait and the Twentieth-Century Snapshot," in Green, ed., *The Snapshot,* (Ref. 21), p. 64.

25. Erving Goffman, *The Presentation of Self in Everyday Life* (Garden City, New York: Doubleday, 1959), p. 252.

26. Ibid., p. 253.

IMAGINATION, PHOTOTECHNICS, AND CHANCE: THE WORK OF BARBARA CRANE

1. Gyorgy Kepes, *Language of Vision* (Chicago: Paul Theobald, 1944), p. 15.

2. László Moholy-Nagy, *The New Vision,* 4th rev. ed. (New York: Wittenborn, 1947), p. 10.

3. John Szarkowski, *Mirrors and Windows: American Photography since 1960* (New York: Museum of Modern Art, 1978), p. 25.

4. Ibid.

5. Ibid.

6. Quoted in Jill Johnston, "The New American Modern Dance," in *The New American Artists,* ed. Richard Kostelanetz (New York, Horizon, 1965), p. 192.

7. Cyril Barrett, *Op Art* (New York: Viking, 1970), p. 186.

8. Morse Peckham, *Man's Rage for Chaos* (New York: Schocken, 1967), p. 11.

9. George Kubler, *The Shape of Time: Remarks on the History of Things* (New Haven: Yale University Press, 1962), p. 33.

10. Ibid., p. 35.

PICTURE CREDITS

Front cover photo. Carl Chiarenza. *Noumenon 245/247/249*, 1984–86. Courtesy Carl Chiarenza.

Frontispiece. Anne Noggle. *Estelle Jussim*, 1985. Courtesy Anne Noggle.

Back cover photo. Barbara Crane. *Morton Arboretum, Chicago Repeat Series*, 1973–74. Courtesy Barbara Crane.

1. Matt Mullican. *The Bulletin Board*, 1982. Courtesy Mary Boone Gallery. Photo Zindman/Fremont.

2. Elbridge Kingsley, his wife and friends, with camera, 1882. Courtesy the Forbes Library, Northampton.

3. Henry Peach Robinson. *Rest*, 1869, etching from photograph. Courtesy the International Museum of Photography.

4. Thomas Moran landscape from Longfellow's *The Hanging of the Crane*, 1875, engraved by W.J. Linton. Private collection.

5. Elbridge Kingsley. *Gate of Cemetery*, ca. 1870, wood engraving. Courtesy the Forbes Library, Northampton.

6. Elbridge Kingsley. *New England Forest*, 1882, wood engraving. Courtesy the Forbes Library, Northampton.

7. Elbridge Kingsley with friends and family in cart, 1882. Courtesy the Forbes Library, Northampton.

8. Elbridge Kingsley. *In the Shadow of Mount Holyoke*, 1889. Courtesy the Forbes Library, Northampton.

9. Elbridge Kingsley. *Evening by the Lakeside*, 1886. Courtesy the Forbes Library, Northampton.

10. Elbridge Kingsley. Photomechanical engraving from his own photograph, ca. 1908. Courtesy the Forbes Library, Northampton.

11. Alfred Stieglitz. *The Steerage* (1907), reprinted in *Camera Work*, 1911. Courtesy the International Museum of Photography at George Eastman House.

12. Henri Cartier-Bresson. *Behind the Gare St.*

Lazare, Paris, 1932. Courtesy Magnum Photos.

13. Eadweard Muybridge. *Dog, Galloping; Mastiff "Dread,"* 1886. Courtesy the International Museum of Photography.

14. Vaughn Sills. *Self, Nova Scotia Landscape, Grandmother*, 1985. Courtesy Vaughn Sills.

15. Edward Weston. *Pepper #14*, 1929. Courtesy the Center for Creative Photography.

16. Edward Weston. *Wrecked Car, Crescent Beach*, 1939. Courtesy the Center for Creative Photography.

17. Jill Krementz. *Susan Sontag*, 1974. Courtesy Jill Krementz.

18. Starr Ockenga, Untitled, 1980. Courtesy Starr Ockenga.

19. Starr Ockenga. *Bev and Cliffie and Jan and Dereck*, 1981. Courtesy Starr Ockenga.

20. Alen MacWeeney. *White Horse, Donegal, Ireland*, 1965–66. Courtesy the Center for Creative Photography.

21. Boris Jussim. *Portrait of Manya Aaronovna*, ca. 1916. Courtesy the Jussim family.

22. Boris Jussim. *Snapshot of Manya in California*, ca. 1960. Courtesy the Jussim family.

23. Sally Mann. *Jenny and Her Mother*, 1984. Courtesy Sally Mann.

24. F. Holland Day, *An Ethiopian Chief*, 1897. Courtesy the International Museum of Photography.

25. Jerome Liebling. *Sarah*, Miami Beach, Florida, 1977. Courtesy Jerome Liebling.

26. Jerome Liebling. *Handball Player, Miami Beach, Florida*, 1977. Courtesy Jerome Liebling.

27. Barbara Crane. *Bus People*, 1975. Courtesy Barbara Crane.

28. Barbara Kasten. METAPHASE 1, 1986. Courtesy Barbara Kasten.

29. Carl Chiarenza. *Noumenon 247*,(detail of triptych) 1984–85. Courtesy Carl Chiarenza.

TEXT CREDITS

BIBLIOGRAPHY

BOOKS BY ESTELLE JUSSIM

Visual Communication and the Graphic Arts: Photographic Technologies in the Nineteenth Century. New York: R.R. Bowker, 1974; reissued in paperback edition, 1987.

Slave to Beauty: The Eccentric Life and Controversial Career of F. Holland Day, Photographer, Publisher, Aesthete. Boston: David R. Godine, 1981.

Frederic Remington, the Camera, and the Old West. Fort Worth, Texas: Amon Carter Museum, 1983.

Landscape as Photograph, with Elizabeth Lindquist-Cock. New Haven, Connecticut: Yale University Press, 1985; reissued as paperback, 1987.

Stopping Time: The Photographs of Harold Edgerton, ed. Gus Kayafas. New York: Harry N. Abrams, 1987; also translated into French and German.

MAJOR ESSAYS IN BOOKS

"The Photographs of Jerome Liebling: A Personal View." In *Jerome Liebling Photographs 1947 to 1977.* Carmel, California: Friends of Photography, 1971.

"Imagination, Phototechnics, and Chance: The Work of Barbara Crane." In *Barbara Crane Photographs 1948–1980.* Tucson: Center for Creative Photography, 1981.

"The Elegant Beauties of Rudolf Eickemeyer." In *Eickemeyer,* ed. Mary Panzer. Yonkers: Hudson River Museum, 1986.

"The Optical Fantasies of Barbara Kasten." In *Barbara Kasten Constructs.* Boston: New York Graphic Society, 1985.

"The Heart of the Ineffable." In *Mothers and Daughters.* New York: Aperture, 1987.

"Mysteries and Transformations." In *Carl Chiarenza: Photographs.* Boston: David R. Godine and Polaroid Corporation, 1988.

"From Pictorialism to Modernism: 1890–1920." In *Decade after Decade.* Boston: New York Graphic Society, 1988, in conjunction with opening of new building of the Center for Creative Photography, Tucson, Arizona.

"John Pfahl's Niagara." In *Arcadia Revisited.* Albuquerque: University of New Mexico Press, 1988, in conjunction with exhibition.

"The Tyranny of the Pictorial." In *Eyes of Time, A History of American Photojournalism.* Boston: New York Graphic Society and George Eastman House, 1988.

"Changing Technology Changes Graphic Design," In the Walker Art Center, Minneapolis, catalog for a graphic design exhibition, 1989.

"The Psychological Portrait." In the National Gallery of Canada catalog for the retrospective Yousuf Karsh exhibition, 1989.

ARTICLES

"The Syntax of Reality: Photography's Transformation of Wood-Engraving into an Art of Illusionism." *Image,* International Museum of Photography, December 1976.

"The Research Uses of Visual Information." In special issue on Trends in Scholarly Resources, *Library Trends,* April 1977.

"The Invisibility of Sexist Discrimination." *The Simmons Review,* April 1977.

"From the Studio to the Snapshot." *History of Photography* (London), July 1977.

"The Media Age: Some Brutal Truths." *Views: Journal of the New England Educational Media Association,* Fall 1977.

"Looking at Winners." In *The Art of the State/ The State of the Art,* Massachusetts Arts and Humanities Foundation, 1978.

"Photographs and History," bilingual edition. Published as a separate from the proceedings of the *Eyes of Time* Conference, at the National Photography Collection of Canada, Ottawa, 1978.

"Camera and Conscience," essay-review of Naomi and Walter Rosenblum's *America and Lewis Hine*. In *History of Photography* (London), January 1978.

"On Photomorality: Susan Sontag." *History of Photography* (London), April 1978.

"Photography as History." Report of the *Eyes of Time* Conference, *Afterimage*, Fall 1978.

"Icons or Ideology: Stieglitz and Hine." In special issue on photography of *The Massachusetts Review*, Winter 1978.

"Technology or Aesthetics: Alfred Stieglitz and Photogravure." *History of Photography* (London), January 1979.

"Arles: 10th Anniversary of *Les rencontres internationales de la photographie*." *Afterimage*, September 1979.

"Errol Jackson and Henry Moore: The Photographer and the Sculptor." *Afterimage*, January 1980.

"The Highest Form of Art." *History of Photography* (London), April 1980.

"The Controversy over Color." *New Boston Review*, August 1980.

"The Ethnocentric Icon." *New Boston Review*, December 1980.

"Looking at Literati." *New Boston Review*, February 1981.

"George Eastman's Extravaganza." *New Boston Review*, September 1981.

"The Royal Road to Drawing." *New Boston Review*, May 1981.

"F. Holland Day: Photographer, Bibliophile, Aesthete." *American Photographer*, October 1981.

"Photography and Aesthetics." *The Simmons Review*, November 1981.

"Homage to Cartier-Bresson." *New Boston Review*, April 1982.

"Photography and Popular Culture: The Exhibitions of Barbara Norfleet." *The Boston Review*, Summer 1982.

"A Dead Straight Photograph: The Landscapes of Michael A. Smith." *The Boston Review*, January 1983.

"F. Holland Day's Nubians." *History of Photography* (London), Spring 1983.

"The Manifold Shapes of Time." *Polaroid Close-Up*, April 1983.

"Starr Ockenga's Nudes: Some Notes on the Genre." In special issue *Women: Arts* of the *Massachusetts Review*, Summer 1983.

"The Fighting Photo-Secession." *The Boston Review*, Summer 1983.

"Looking for the Present: Sheila Metzner's Photographs." *The Boston Review*, January-February 1984.

"The Art of Aaron Siskind." *The Boston Review*, Summer 1983.

"Gesture and Image, Idea and Medium." *The Boston Review*, December 1983.

"The Manifold Shapes of Time and Space." *Arizona Highways*, January 1984.

"The Stieglitz Mystique." *History of Photography* (London), April 1984.

"The Miller-Plummer Collection." *The Boston Review*, May 1984.

"Video: The Wanton Art." *The Boston Review*, Winter 1984.

"A Celebration of Redheads: Joel Meyerowitz." *Polaroid Close-Up*, Winter 1984.

"Propaganda and Persuasion." In special issue, *Observations: Essays on Documentary*, Friends of Photography, July 1985, pp. 103–114.

"Repeated Exposure." *Photographies*, no. 8, September 1985.

"Touched by Life: Anne Noggle/Dorris Ulmann." *The Boston Review*, February 1986.

"The Self-Reflexive Camera: Photography and Postmodernism." *The Boston Review*, March 1986.

"Quintessences: Edward Weston's Search for Meaning." In special Edward Weston issue, Friends of Photography *Untitled* series, April 1986, pp. 51–61.

"Musings on the Roles of Role Models." In special issue of the *Journal of the Catskill Center for Photography*, n.d.

LECTURES

"An Immigrant Photographer of the 1920's." Paper read at the Third International Symposium on the History of Photography, called *Photo-History III*, International Museum of Photography at George Eastman House, October 8, 1976.

"Photography and the Printed Page." Paper read at Pennsylvania State University, April 11, 1977.

"Lee Friedlander: Discontinuities in Time." Paper read at Institute of Contemporary Art, Boston, April 27, 1977.

"Alfred Stieglitz and Photogravure." Paper read at Print Society of the Museum of Fine Arts, Boston, February 21, 1978.

"Aesthetics and Ethics: Stieglitz and Hine." Paper read at School of the Museum of Fine Arts, Boston, April 24, 1978.

"Marshall McLuhan and the Written Word." Keynote address to open two-week national conference on Improving Communication Skills for Young Adults, under the auspices of the Rockefeller Foundation, Andover, Mass., June 27, 1977.

"Boston and Its Photographic Luminaries." Paper read at Photographic Resource Center, Cambridge, September 27, 1977.

"Photographic Fables for Our Time, or, Why We Are Not There Yet." Sixth of the special lecture series *Toward the New Histories of Photography*, Art Institute of Chicago, April 27, 1979.

"The Real Thing: Museums and Communication." Address to the Board of Trustees and Visiting Committee's Annual Meeting, George Eastman House, Rochester, N.Y. April 25, 1979.

"Communications Dynamics for Management" and "Non-Verbal Communication for Management." Two lectures at the Institute *Library Management without Bias*, M.I.T. Endicott House, May 3, 1979.

"The War Between the Media" and "Photographic Journals for Amateur Photographers." Two lectures at the 1979 International Photography Conference, *The Published Photograph*, at the Camden Arts Centre, London, June 21–22, 1979.

"Photography—Human Communication" and "Words and Images—Photographs in Books and Films." Two lectures (Keynote Summary and featured lecturer) 10th Anniversary, *Les rencontres internationales de la photographie*, Arles, France, July 1980.

"The Legacy of the Nineteenth Century: Stieglitz and the Aesthetic Movement." Paper read at Boston University, September 20, 1980; for the Symposium on Treasures of the Royal Photographic Society.

"Stieglitz and the Aesthetic Movement." Paper read at the Museum of Fine Arts, Houston, Texas, for the Shartle Symposium of Photography, October 26, 1980.

"Photography and the Printed Page." Paper read at University of Texas at Austin, October 30, 1980.

The Anne Burnett Tandy Lectures in American Civilization, Amon Carter Museum, Fort Worth, Texas:

"In Pursuit of the Indians: Mr. Remington Learns His Trade." March 22, 1981;
"The Camera, the Horse, and the Cowboy: Mr. Remington and Mr. Muybridge." March 26, 1981;
"Glorious Dreams and Painted Nostalgia: Mr. Remington Paints for *Colliers'*." March 29, 1981.

"Photographic Fables for Our Time." Paper read at Smith College, April 1, 1981.

"Facing the Camera: Coburn's Celebrities." Paper read at Wellesley College, February 8, 1983.

"Coburn in Context: The Portraits." Paper read at the Currier Art Museum, Manchester, New Hampshire, April 1, 1983.

"Photography and Persuasion." Paper read at Hampshire College, Amherst, Mass., March 3, 1984.

"The Fighting Photo-Secession." Paper read at the Cleveland Museum of Art, March 25, 1984, in conjunction with Photo-Secession exhibition.

"The Poster in Photography." Paper read at the Walker Art Center, Minneapolis, April 16, 1984, as part of a special lecture series featuring media and communications critics and historians.

"Trashing the Media, Taking on the World." Keynote address to the Society for Photographic Education's National Conference, Minneapolis, March 15, 1985.

"Alvin Langdon Coburn: From Mysticism to Modernism." Paper read at the IBM Gallery of Arts and Sciences, New York City, in conjunction with exhibition *Treasures of George Eastman House*, July 10, 1985.

"Photographic Fables for Our Time." Paper read at Wadsworth Athenaeum, Hartford, Conn., February 13, 1986.

"The Will to Truth." Keynote address as associate conference coordinator for *Oppression: The Visual Document*, a national symposium on documentary film and photography at the Southeast Center for Photography, Daytona Beach, Florida, February 18, 1986.

"Cross-Currents: The Poster within the Photograph from Dada to Postmodernism." Paper read at New Mexico Photographic Society, Santa Fe, NM, March 15, 1986.

"Alvin Langdon Coburn: From Mysticism to Modernism." Paper read at the International Museum of Photography, Rochester, N.Y., October

16, 1986. Joint sponsorship by George Eastman House and the Visual Studies Workshop.

"Alvin Landgon Coburn: From Mysticism to Modernism." Paper read at the International Center for Photography, New York City, February 19, 1987, in conjunction with exhibition on Coburn.

"The Photographer and the Place." Paper read at Smith College, November 12, 1987.

"The Eternal Moment: Photography and Time." Paper read at special Rochester Conference *On Time,* University of Rochester, January 13, 1988.

"The Photographer and the Place." Paper read at Arthur M. Sackler Museum at Harvard University, March 12, 1988.

"The Photographer and the Place." Paper read at Manhattanville College, October 17, 1988.

INDEX

Estelle Jussim is one of the most highly re-
garded and influential voices in photography
and other media. Award-winning author of
Slave to Beauty and the pioneering *Visual
Communication and the Graphic Arts*, Jussim
has charted new ground in the investigation of
the meaning of images. This volume is the
first compilation of her work.

Estelle Jussim writes, unconventionally, on
the social impact of photography, refusing to
subscribe to any narrow critical ideology. An
art historian and a communications theorist,
she incorporates postmodern, deconstruction-
ist, and feminist viewpoints in her assess-
ments of various photographers, movements,
and institutions. Wide-ranging in interest,
Jussim's writing is remarkably bold and
controversial.

Divided into three sections—"Visual Com-
munication," "Genres," and "Bio-History"—
The Eternal Moment includes essays that as-
sess how aspects of the medium such as early
wood-engraving or the role of the museum af-
fect communication in a visual culture; survey
various photographic subjects such as the
nude, the landscape, and the ethnocentric
icon; and reveal the work of some of the
greatest practitioners of the medium.

In "Visual Communication" Jussim ex-
plores the interplay between technology and
aesthetics in photography, and probes the
unique, powerful relationship of photographs
to time. The essay "Quintessences: Edward
Weston's Search for Meaning," examines the
discrepancies between that artist's pronounce-
ments and his photographs.

Included in "Genres" is "Propaganda and
Persuasion," in which Jussim offers astute
observations on how *meaning* is produced,
transmitted, and interpreted. In "Looking at
Literati" she focuses on Jill Krementz's abil-
ity to capture the spark of personality in her
portraits of writers. "Starr Ockenga's Nudes"
is an insightful analysis of the ways in which